Witness to Phenomenon

Witness to Phenomenon

Group ZERO and the Development of New Media in Postwar European Art

JOSEPH D. KETNER II

Bloomsbury Academic
An imprint of Bloomsbury Publishing Inc

B L O O M S B U R Y
NEW YORK · LONDON · OXFORD · NEW DELHI · SYDNEY

Bloomsbury Academic

An imprint of Bloomsbury Publishing Inc

1385 Broadway	50 Bedford Square
New York	London
NY 10018	WC1B 3DP
USA	UK

www.bloomsbury.com

BLOOMSBURY and the Diana logo are trademarks of Bloomsbury Publishing Plc

First published 2018

© Joseph D. Ketner II, 2018

Library of Congress Cataloging-in-Publication Data
Names: Ketner, Joseph D., II, 1955- author.
Title: Witness to phenomenon: Group ZERO and the development of new media in postwar European art/Joseph D. Ketner II.
Description: New York: Bloomsbury Academic, An imprint of Bloomsbury Publishing Inc, 2017. | Series: International texts in critical media aesthetics; vol. 12 | Includes bibliographical references and index.
Identifiers: LCCN 2017026066 (print) | LCCN 2017026765 (ebook) | ISBN 9781501331183 (ePDF) | ISBN 9781501331190 (ePUB) | ISBN 9781501331176 (hardcover: alk. paper) Subjects: LCSH: Zero (Group of artists) | Nouvelle tendance (Exhibition) | Art, European–20th century–Themes, motives.
Classification: LCC N6494.Z47 (ebook) | LCC N6494.Z47 K48 2017 (print) | DDC 700.94/0904–dc23 LC record available at https://lccn.loc.gov/2017026066

ISBN: HB: 978-1-5013-3117-6
ePDF: 978-1-5013-3118-3
eBook: 978-1-5013-3119-0

Series: International Texts in Critical Media Aesthetics

Cover design by Clare Turner and Eleanor Rose
Cover image © Heinz Mack

Typeset by Deanta Global Publishing Services, Chennai, India
Printed and bound in the United States of America

To find out more about our authors and books visit www.bloomsbury.com. Here you will find extracts, author interviews, details of forthcoming events, and the option to sign up for our newsletters.

CONTENTS

LIST OF ILLUSTRATIONS

Cover

ZERO—Edition, Exposition, Demonstration, Düsseldorf, 1961. Atelier Mack. Photo: Paul Brandenburg.

Introduction

Chapter 1: Europe After the Rain: *Un art autre, art informel*

Chapter 2: "Does Contemporary Painting Influence the Shape of the World?": The Problem of Painting and the Question of Reality

Chapter 3: ZERO, the New Tendency, and New Media

Chapter 4: Artists' Actions into Theater

Chapter 5: Aistheton: Immersive Multimedia Environments

Chapter 6: The Vision of Television

Chapter 7: Coda

ACKNOWLEDGMENTS

This publication focuses on the second generation of post–Second World War European artists who came of age in the 1950s and rejected modern art, specifically painting, as a valid medium to render the altered reality of postwar culture. These children of the war developed strategies to solve the problem of painting by creating collage and assemblage, kinetic art, light works, performance, and new electronic media for their vocabulary of art. This occurred across Europe, in Amsterdam, Antwerp, Düsseldorf, Milan, Paris, and Zagreb. The younger generation distanced themselves from their predecessors by eschewing the mark of the individual artist's touch and advocating an artistic experience based on physical phenomenon. They invited collaboration and formed a transnational artistic sensibility that transcended geopolitical distinctions. In 1957 these artists began to assemble into groups, beginning with Group ZERO in Düsseldorf (1957–66) and expanding over the next decade to include Azimuth in Milan (1959–60), Nouveau Réalisme (1960–66) and GRAV (1960–68) in Paris, Nul in Amsterdam (1962–66), and Nove Tendencije (New Tendency) in Zagreb (1962–65). In this book I focus on Group ZERO and its three principal participants—Heinz Mack, Otto Piene, and Günther Uecker—and connect them to the network of artists working across Europe from approximately 1955 to 1970.

Group ZERO captivated my attention and has dominated my work for over a decade. My choice of this subject resulted from a combination of personal associations and fortuitous encounters. It is the result of many people's input and involvement. I hope to appropriately acknowledge them and express my gratitude for this rewarding period of my career. Please excuse me if I have overlooked someone.

My perspective on postwar art evolved from a combination of my curatorial practice and art historical research, and has been shaped by nearly twenty years of conversation with some of the principal artists and curators involved in this movement. I first met Udo Kultermann in the 1980s, when I was director of the Washington University Gallery of Art (now the Mildred Lane Kemper Museum) and Udo was a professor of architecture. We worked together on a retrospective of Howard Jones (1993), a postwar new media artist. Washington University has an excellent collection of European *art informel* that stimulated my interest in the subject. While there I co-organized an exhibition with Dennis Adrian, Richard Born, and Reinhold

Heller at the Smart Museum of the University of Chicago on *Jean Dubuffet* (1985).

When I became the director of the Rose Art Museum at Brandeis University in 1998, I met and befriended Otto and Elizabeth Goldring Piene. Learning for the first time about the wondrous work that Otto created over his career, I had a realization. In graduate school I learned the standard narrative of postwar art history in the United States that the "transition from the old testament to the new" began with the "Holy Trinity" of Robert Rauschenberg, Jasper Johns, and Frank Stella in the 1950s.[1] However, this perspective completely ignored the role of European artists. My curiosity was piqued and I began to research Otto, Group ZERO, and their colleagues.

When I was the chief curator of the Milwaukee Art Museum, I had the good fortune to work with another excellent collection of *art informel*, the Mrs. Harry Lynde Bradley Collection, which expanded my knowledge of the period. With my valued assistant curator John McKinnon, we drew from that collection and organized an exhibition, *Sensory Overload* (2007), which traced an artistic lineage from László Moholy-Nagy and the Bauhaus, through ZERO, to contemporary new media artists. At that time I hosted a symposium in recognition of the 50th anniversary of the founding of Group ZERO (2008), and enlisted Mack, Piene, and Kultermann's endorsement of this book project.

Then, in April 2010, Otto Piene experienced a terrible flood in Massachusetts. He recruited me to salvage sixty years of papers and, subsequently, to organize them, a process that I have continued with the encouragement of Elizabeth Goldring Piene. This natural disaster was the fortuitous circumstance that immersed me in Otto's work. In 2010 and 2011, I received grants from the Gerda Henkel Stiftung, the ZERO Foundation, Düsseldorf, and the Deutscher Akademischer Austausch Dienst (DAAD) to work with Piene's papers, to research at the ZERO Foundation (as the first research fellow), and at the Zentralarchiv des internationalen Kunsthandels (ZADIK), Cologne. As a result I became familiar with over sixty years of accumulated archival information about postwar art in Central Europe. I appreciate the support of these foundations, agencies, and archives and particularly wish to thank Irene Hofeditz at the Henkel Stiftung; Mattijs Visser, director, and Dirk Pörschmann and Tiziana Caianiello, research associates at the ZERO Foundation; Brid Schenkl at DAAD; and Günter Herzog at ZADIK.

I benefited also from the support of collectors, benefactors, family, and friends, who contributed to a ZERO Project Fund that I established at Emerson College, to help fund my research activities. Those contributors included Gerald and Sandra Fineberg, Christine Symchych, Lisa Ketner, and Kristin Ketner Pak. During these years working in both Germany and the United States, I became friends with Heinz and Ute Mack and Otto and Elizabeth Goldring Piene, with whom we shared many informal conversations and dinners, as well as more formal interviews about their life work.

The manuscript for the book derived from a sequence of exhibitions, lectures, and essays for various museums, institutions, colleges, and universities. The first chapter results from my early research on *art informel* beginning in the 1980s at Washington University, and was substantially expanded in my lectures on postwar art at the Milwaukee Art Museum, where I also hosted an exhibition on Francis Bacon, curated by Michael Peppiat. Chapter 2 is an expansion of the lecture, "The Light Paints," that I gave at MIT in conjunction with Otto Piene's exhibition of his *Light Ballet* in 2011. Chapter 3 draws from two essays that I wrote for Heinz Mack's *Mackazin* (Sperone Westwater, 2011) and Otto Piene's *Sundew* (Sperone Westwater, 2016). The chapters on immersive multimedia and experimental television grew out of a series of lectures that I have given in Germany, at the György Kepes Society in Hungary, and at the Goethe Institut, Boston.

In working with these artists, I have had the extraordinary opportunity to participate in the recreation of a number of immersive multimedia environments originally made by these artists in the 1960s. Otto gave me the opportunity to participate in the recreation of his slide-projection piece, *Proliferation of the Sun* (1967) at the ZERO Foundation (2010) and the Moderna Museet (2011). We also produced a monumental Sky Art event for the closing ceremonies of the 150th anniversary of MIT (2011). In the process of working with Otto I met and befriended Aldo Tambellini and his partner Anna Salamone, who invited me to have access to his archives and art collection. With Aldo, I have produced several recreations and new immersive installations including *Black Zero* (1965) at the Chelsea Museum, New York (2011); *We Are the Primitives of a New Era* (James Cohan Gallery, New York, 2013); and *Atlantic in Brooklyn* (1972) (The Boiler Room, Brooklyn, 2015). Otto and Aldo provided me the opportunity to work directly with them. These projects gave me tangible, visceral experience of the work that these men produced and, consistent with their phenomenological art practice, I gained knowledge about their work through the sensory experience of their installations.

My thoughts on Group ZERO and postwar European art have been shaped by the commentary of my colleagues involved in the various exhibitions, lectures, essays, and events that I have produced. I am grateful to my dear friend David Anfam for reading several sections of the manuscript and offering his critical insight. I translated most of the German archival sources, but I have benefited from the review and assistance of native speakers, professionals in the fields of art and language, Hans Nicholas Lauer and Dagmar Oldfield in German, and Stephanie Molinard in French.

I also wish to acknowledge the enthusiastic support of the editors of the Bloomsbury Publishing series "International Texts in Critical Media Aesthetics," Francisco Ricardo and Jörgen Schäfer. Francisco's enthusiasm for the topic as a new chapter in new media studies and Jörgen's diligent reading of the text have enormously improved the manuscript in preparing it to join the other publications in this distinguished series.

A revival of interest is occurring across the United States and Europe in the art history of post–Second World War Europe, including exhibitions focusing on Group ZERO at the Guggenheim Museum, New York; the Martin-Gropius-Bau, Berlin; and the Stedelijk Museum, Amsterdam (2014–15). This publication participates in the wave of renewed interest. My access to the archives, and my personal relationships and interviews with the artists, have allowed me access to valuable, previously unpublished material. The primary information and the first-person insights of the artists have transformed my ideas about the artistic development and the philosophical thinking of this generation and, hopefully, will shape the publication as a distinctive contribution to the literature.

Note

1 Robert Rosenblum quoted by Sam Hunter, *A View from the Sixties: Selections from the Leo Castelli Collection and the Michael and Ileana Sonnabend Collection* (East Hampton, NY: The Guild Hall Museum, 1991), 1.

Introduction

Group ZERO formed during the period of reconstruction in Germany around three principal artists—Heinz Mack (b. 1931), Otto Piene (1928–2014), and Günther Uecker (b. 1930) (Figure 1). They participated in a trend among the second postwar generation to produce "new tendencies" in art in response to the dramatically altered European culture after the Second World War. ZERO artists aspired to create a new artistic identity by charting a direction away from the tradition of modern painting, particularly the gestural expressionism of their predecessors: the first postwar generation *art informel* and Tachist painters. In 1957 Mack and Piene, fresh from the Düsseldorf Art Academy and the University of Cologne, began to host exhibitions in their bomb-damaged atelier. These evening exhibitions (*Abendausstellungen*) lasted only the duration of a night and consisted of a variety of activities including readings, performance, music, and light displays. They generated a sensation and catalyzed cultural activity in Düsseldorf, participating in the artistic transformation of the city into one of the principal art centers in Europe over the succeeding decades. Their work resonated internationally, making them the first group of postwar German visual artists to be critically regarded in Europe and the United States.[1]

In April 1958, in collaboration with Yves Klein, Mack and Piene announced their identity as Group ZERO at their seventh evening exhibition, for which they published a magazine that sardonically asked, "Can contemporary painting influence the shape of the world?"[2] They questioned the validity of painting as an appropriate medium to grapple with the drastically altered social and political reality of postwar Europe. With the publication of *ZERO* they articulated some of the ideas that characterized the art of their generation, and launched a dynamically creative period that lasted nearly a decade until they disbanded in 1966. Initially, they too produced paintings, moving to monochrome, in Piene's view, not to create physical objects, rather a "source of energy. 'Optical energy.'" Klein ventured further, recognizing "that we are living in the atomic age, where everything material and physical could disappear." Therefore, he made immaterial paintings.[3] Group ZERO and their pan-European network of colleagues generated a continuous stream of innovative artistic statements through the 1960s, incorporating nontraditional materials and new technologies to create

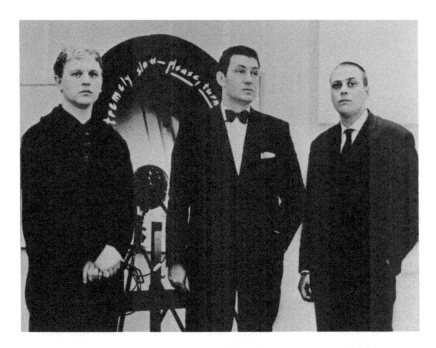

FIGURE 0.1 *Heinz Mack, Otto Piene, and Günther Uecker at* Nul *Exhibition, Stedelijk Museum, Amsterdam, 1962. Atelier Mack. Photo: R. Van den Boom.*

kinetic art, light installations, public performance, and land art. By the end of the decade they produced immersive multimedia installations to stimulate the sensorial faculties and utilized communication media of video and television to disseminate their artistic and political positions. Such dynamic and diverse artistic activity offered new directions for the visual arts, altering the material forms and the studio practice of making art, creating models for the subsequent development of conceptual art, minimal art, land art, and new media in the 1960s and 1970s.

ZERO artists participated in a pan-European phenomenon. Beginning in the mid-1950s progressive artists across Europe—in Amsterdam, Düsseldorf, Milan, Paris, and Zagreb—assembled into groups, working individually and collectively to chart new artistic directions that contemporaries described as "new tendencies." The German artists established Group ZERO (1957–66) at an early point in this development, with a number of artists' groups forming across Europe in quick succession—Gruppo Enne (Gruppo N, 1958) in Padua, Gruppo T (1959) and Azimuth in Milan (1960), Nouveau Réalisme (1960–66) and GRAV (1960–68) in Paris, Nove Tendencije (New Tendency) in Zagreb (1961–73), and Nul in Amsterdam (1961–66). Sharing the motivation to reject modern painting, but often working in divergent manners, these artists communicated with each other and participated in each other's projects and exhibitions.

Initially, institutional and gallery support for these artists was scarce and they resorted to organizing their own exhibitions, publishing their own magazines, and working with the few curators and gallerists of their own generation, who did support the "new tendencies." The network expanded along axes that linked the major European art centers where the artists congregated and held exhibitions such as *Vision in Motion* in Antwerp (1957), *The Red Painting* in Düsseldorf (1958), *The New Artistic Conception* in Milan (1960), *Nove Tendjencije* in Zagreb (1961), and *Nul* in Amsterdam (1962). With each new exhibition new contacts were made and new ideas were hatched, generating a precipitous pace of artistic innovations, each attempting to further stretch the boundaries of the artistic enterprise. Piero Manzoni's *New Artistic Conception* exhibition (1960) and its accompanying artists magazine, *Azimuth*, included many of the "new tendency" artists, whom he felt dismissed "allusion, expression and representation." Curator Udo Kultermann recognized that these "new tendencies" artists were still "largely unknown . . . [and] not the subject of official debate." He contrasted the "new tendency" artists with their predecessors, *art informel* and *Tachism* painters, noting that their "dynamic compositions come from both the emotional and physical energy of the act of painting . . . [while] the young artists seek the material to make the elements of the design themselves dynamic." On the one hand, "the observer remains passive," and on the other, "their active participation in the observation of the picture is required for its effect."[4]

Critics who were accustomed to the vocabulary of abstract painting in *art informel* and *Tachism* struggled to understand the innovative work of these artists, describing them broadly as advancing "new tendencies" in art. In 1959 Klaus Jürgen-Fischer, an artist and editor of the art magazine *Das Kunstwerk*, curated an exhibition in Milan, *Nuove tendenze tedesche* (New German Tendencies), the first formal use of this expression to characterize the work of the younger generation of artists.[5] Over the subsequent years, critics often employed the term "new tendencies" as an adjective to describe this particular generation of adventuresome artists.[6] In 1962, in the aftermath of a successful international exhibition in Zagreb of the Nove Tendencije (1961), featuring many of the ZERO artists, some Yugoslavians, and the French GRAV (Groupe de Recherche d'art visuel), adopted "New Tendency" as its formal name,[7] with the purpose to present the "evolution of artistic research on the visual, spatial and kinetic."[8] I will use this term in each of these manifestations as was appropriate to the artists and critics' usage and as it evolved over the period of this study.

Official recognition of ZERO and the new tendencies occurred in 1960 with two exhibitions: Kultermann's *Monochrome Painting* at the Schloß Morsbroich in Leverkusen and at the Venice Biennale. Kultermann's landmark exhibition introduced a new phenomenological approach to painting, as opposed to a painterly expressionism, and included many of the "new tendency" artists. At the Venice Biennial the judges awarded the main prizes to some of the principal European *art informel* painters

(Emilio Vedova, Jean Fautrier, and Hans Hartung). Yet, they awarded the Prize for a Young Painter to Piero Dorazio, signaling their awareness that a fundamental artistic transition was occurring.[9]

For their sources the younger generation explored two streams of early twentieth-century art: Marcel Duchamp and Dada, and László Moholy-Nagy and the Bauhaus. These precedents had been disparaged and largely forgotten over the previous twenty years, displaced by the tradition of modern, mainly French, painting. This was especially true "in France at the end of the fifties, no-one paid much attention to one of Jacques Villon's brothers, Marcel Duchamp . . . and . . . the Bauhaus movement was almost totally unknown."[10] The second generation of postwar artists resurrected these interwar traditions as models for responding to the tragedy of war that they had experienced. These historical precedents provided a vocabulary of forms, materials, and concepts for artists seeking to liberate their work from the dominant medium of painting. One thread of postwar new tendency artists—Wolf Vostell, Nouveau Réalisme, Azimuth, and Fluxus—eagerly responded to Dada's nihilistic attitude against modernity and rational scientific thought. Duchamp's ready-made and Schwitters' collage served as important examples of visual critiques of culture for younger artists developing a vocabulary of social protest. For another group—ZERO, Gruppo Enne, Gruppo T, and GRAV—it was Moholy-Nagy's and the Bauhaus approach to embracing art and technology to create a "culture of light" that would benefit society.[11]

The artists who participated in ZERO exhibitions represented a diversity of media, stylistic approaches, and artistic influences. Yet, they all shared a rejection of painterly expressionism and a common embrace of existentialism and phenomenology. This accounts for the seemingly contradictory appropriation of both Bauhaus art, design, and technology and Dada collage, performance, and irony. Correspondingly, the group identities of these artists were initially nebulous, unlike manifesto-driven early modern avant-garde groups. The ZERO artists advocated having no formal organization, no program, and no fixed ideology. In conversation, when critic John Anthony Thwaites asked Piene to explain Group ZERO, the artist responded: "It's not a style, it's not a group. It's not a movement. And I don't want it to become one." Thwaites then asked, "What is it, then?" Piene "shrugged his shoulders. 'A point of view.'"[12]

After a period of dramatic expansion, the network of ZERO-affiliated artists began to diverge along ideological divisions and retracted into separate camps. By 1963 their differing material forms and intellectual interpretations created fissures between various artists. A period of methodological conflicts ensued, causing many of the artists to disassociate themselves, and the network of "new tendency" artists began to contract, eventually leading to the dissolution of each group. In 1966 ZERO disbanded, and by 1968, the year of the student riots, most of the other groups had dissolved or had sputtered into dysfunction. This occurred parallel to the escalating climate

of political dissent, during which ZERO's romantic aspiration of bringing "beauty to the world," so critical to the postwar Germans in particular and Europeans in general, seemed irrelevant to the next generation who were born after the war. The third generation, the so-called grandchildren of the war, had no direct experience of the war, but erupted with difficult questions for the previous generations.

While ZERO and new tendency artists are well known in Europe, they are less well known in the United States. The second generation of postwar European artists, who had been largely neglected by art history, has been subject to a broad reconsideration over the past decade. The 2014 Solomon R. Guggenheim Museum exhibition brought ZERO back into the English language discussion of postwar art. But there is still much to learn about this transformative group of artists. This publication expands the art historical narrative of postwar art by reinserting Group ZERO and "new tendency" artists into the narrative and connecting them with larger discourse on postwar art. The artistic relevance of their work to current culture is particularly evident. In our contemporary mediated world, the work of these artists is relevant and ripe for reconsideration. The artists of Group ZERO and the new tendencies were recently identified as "the final taboo of contemporary art: the last movement that still lies outside of the margins of official art history."[13]

In this book I will trace the historical trajectory of the German Group ZERO and their connections with the international network of artists, identifying their critical artistic developments and their significant exhibitions between approximately 1955 and 1970. While the focus will be on three principal German artists involved in ZERO, the other international artists will be treated in their relationship to the Germans. The works of Yves Klein, Piero Manzoni, Jean Tinguely, and other postwar European artists have been thoroughly examined in other publications. Further, I will develop new connections between the ZERO artists and Joseph Beuys, Nam June Paik, Wolf Vostell, and the formation of Fluxus in Europe.

Established critics and art historians such as Anna Klapheck, Hannelore Schubert, and John Anthony Thwaites, who wrote for the *Rheinische Post*, *Das Kunstwerk*, and the *Deutsche Zeitung*, respectively, reviewed the ZERO artists. These critics grasped the novelty and vitality of their work, and through their essays and articles they chronicled the dramatic transformation of art in Germany in the late 1950s. Klapheck, the mother of painter Konrad Klapheck, taught art history at the Düsseldorf Art Academy and an essential part of the reemergence of the academy in the larger art world. Schubert was an art historian who, in addition to publishing essays in the leading German journals, hosted a regular radio program on West German Broadcast that established her as an authority on artistic matters in the minds of the German public. Thwaites had been a British Consul, who retired to Düsseldorf, where he participated in the reconstruction of the cultural life of Germany. Subsequently, a number of younger critics and curators participated in the

new artistic tendencies and interpreted the forms and meaning for postwar Europeans, including Rochus Kowallek, Udo Kultermann, Günter Meisner, Jürgen Morschel, Wieland Schmied, and Hans Strelow.

In charting the art historical and conceptual development of ZERO in chapters 2 and 3, I will construct an historical narrative as it was experienced by the artists and interpreted by the principal curators and critics of this period. Much archival material on these people has only recently been made accessible through various archives and provides a new accounting of the artistic events of this period. These resources, viewed in the context of the sociopolitical circumstances of the period, offer an alternative account that differs from the received narrative of postwar art history. They reveal new interrelationships between artists and ideas that substantively influenced the course of art. History, so tied to the constructs of memory, is constantly evolving through a process of renegotiating remembered pasts. The past several generations of scholars have correctly disparaged the practice of historical research for organizing a teleological progression to establish a canonical view from an ideological position. However, in the words of Andreas Huyssen, history "remains an essential component of the power of memory discourse itself," and "the seduction of the archive and its trove of stories of human achievement and suffering has never been greater."[14]

Much of the art created between 1955 and 1970 was made in response to the perceived problem of painting. The validity of painting had been threatened since the invention of photography, and the question took even greater urgency in the wake of the Second World War. The empires of Europe had for the second time in thirty years attempted to destroy one another. The devastation of the war dismantled the architecture of modern European culture. The continent's illusion of its position as the bearer of humanity's highest cultural achievements was reduced to rubble. In the words of historian Tony Judt, "By 1940, to observant Europeans, the grandest of all Europe's illusions—was now discredited beyond recovery—[that] was 'European civilisation itself'."[15] Proponents of twentieth-century European "civilization" advocated that its supreme expression was found in modern art, specifically abstract painting. Painting served, in the words of Yve-Alain Bois, as a "model" of modern culture.[16] The Second World War shattered the faith of many avant-garde artists, writers, and thinkers in modern European culture. Their reaction was to abandon the forms of art associated with the society that nearly destroyed itself. "All over Europe there was a strong disposition to . . . start afresh."[17] In the words of Günther Uecker, who lived through the war as a boy, "With this heightened awareness of the annihilation of people all over the world, of this mass murder . . . one could not stand in a meadow and paint flowers."[18] But what was one to do? As Piene said, "We were against almost everything around us," and then asked, "But what were we for?"[19]

ZERO and the new tendency represent the second postwar generation, the so-called middle generation, who were born circa 1930. They were too

young to be perpetrators or resistors in the war, but they were old enough to witness the catastrophe at a formative age of their lives, indelibly shaping their worldview. They too associated the principal "model" of European culture with painting. In view of the destruction of the war, many doubted the very notion of the humanities. The scientific and technical advances achieved during the war, particularly atomic physics, electromagnetic technology, and space exploration, spawned an expansion of the conception of reality beyond the merely visible, to encompass the invisible micro- and macro-cosmos. This had profound repercussions on art and its relationship to the question of "reality." These social and historical circumstances fostered a shared artistic sensibility among the second generation to collectively develop a new gestalt for their era that the cultural imperatives of modern painting could no longer satisfy.

Throughout the 1950s and early 1960s the various artists and critics of the new tendencies discussed the nature of the new, altered reality of postwar Europe and the form that art should take to convey the new reality. Was the artistic form of the new reality to be revealed, in the words of Pierre Restany, in "the passionate adventure of the real" (1960)?[20] Or was it to be found in abstraction as a reflection of the new knowledge in physics and human physiology, as viewed by the artists of GRAV, who wrote that "any formal artwork is, first and foremost, a visual reality"?[21] Artists of the second generation turned to the ascendant philosophy of phenomenology for conceiving an art that responded to the new postwar reality. As it was espoused by Nicolai Hartmann, Martin Heidegger, and Edmund Husserl in Germany, and Maurice Merleau-Ponty in France, phenomenology served as the intellectual basis for producing and interpreting art grounded in the physical and ontological nature of materials and the physiological experience.

The artists' various interpretations of phenomenology are reflected in their writings and remarks. Mack and Piene studied philosophy at the University of Cologne, learning phenomenology and employing it as their theoretical foundation. GRAV artist Joel Stein wrote that in the art of the "new tendencies," "a picture is no longer an artwork, outcome of a person's sensibility and expression of personality, but a purely visual phenomenon" (1961).[22] The artists aspired to stimulate spectators' senses with sight, sound, and touch and, thereby, animate the spectators' engagement in the artistic experience. This was not simply to titillate the senses, but to bring about awareness and understanding of physical reality that transcended painted representations of objects or abstracted emotions. This was a fundamental transformation of the function of the art as an object, into art as an experience, a change in the relationship between the artist as the maker of an object and the viewer as the receiver of that object. The conceptual application of this theory introduced fundamental changes to the visual arts, divorcing the artistic enterprise from the mark, the touch and individual expression. It resulted in the transformation of the static objet d'art into a sensory and tactile experience, dematerializing and democratizing the

experience of art into one that could be appreciated by many, not just the cognoscenti. A critic observed that the artist's role transformed from being a "creator of meaning to . . . a witness of phenomena."[23]

The new tendencies in postwar art were an international phenomenon. Adventuresome second-generation postwar artists across Europe, Japan, and North and South America—essentially all of the countries impacted by the Second World War—reacted against modern art, the culture of their predecessors. They all doubted the tradition of painting as a valid medium for rendering the reality of postwar culture and responded by reconceiving the form and the function of art. It became the new model of a progressive generation born out of rebellion *against* modernism and *for* the creation of a new artistic statement. The question of the proper form of postwar cultural expression generated great debate. In the wake of the war, artists, critics, and philosophers argued humanity's presence in art. They took strident positions on whether abstract or representational painting best represented the new reality. The younger generation of artists matured through these great cultural debates and changed the conversation. Such artists as Klein and Tinguely in France; Yayoi Kusama from Japan; Nam June Paik from Korea; Enrico Castellani, Gianni Colombo, and Manzoni in Italy; Allan Kaprow and Robert Rauschenberg in the United States; and Group ZERO and Wolf Vostell in Germany developed strategies to solve the problem of painting and the question of a phenomenological "reality" by developing new media other than painting, employing collage and assemblage, monochrome painting, kinetic art, light works, and performance to generate sensory experiences. In the 1960s they expanded into immersive multimedia and evolved into the communication and information media of television and video.

Peter Bürger's *Theory of the Avant-Garde*[24] has shaped the dialogue on the early modern art movements and their successors for most of the past thirty years. He discussed the artists of the postwar generation as the last modern artists, the last gasps of modernism, and pinned appellations on this generation that draw comparisons to their historical precedents, such as Neo-Dada and neo-avant-garde. These determinants typecast the work of these artists strictly in relationship to the historical moderns and restrict the possibilities of nuanced interpretations. Bürger and other scholars of his viewpoint do not consider the dramatically changed historical circumstances of the post–Second World War period, nor do they reflect upon the artists' expressed intentions relative to the social milieu in which they worked. Hal Foster has suggested that the term "neo-avant-garde may be at once too general and too exclusive to use effectively today."[25] By dismissing the postwar revivers of the art and technology and Dada movements, the so-called neo-avant-garde, as failed imitators of a failed modern project, Bürger does not articulate the differences, sometimes contradictory, between the repetition and imitation of a historical model and its transformation into something appropriate for the particular cultural needs of postwar era.[26] Others have described those cultural needs as an extension of reconstruction-era bourgeois gratification and as a spectacle to distract people from the historical tragedy

that they were attempting to forget.[27] However, the sensorial spectacle that these artists created can also be viewed as a psychologically necessary salve for healing the wounds of trauma for those who witnessed the carnage and were attempting to address the question of humanity in postwar European culture (*Menschenbild* = image of humanity). Further, interpreting their work as mere spectacle does not adequately address the expressed intention of these artists to jolt people from the complacency of consumer culture and begin to construct a new cultural identity beyond materialist consumption. As Piene succinctly stated, in his opinion art was by its very nature spiritual and, therefore, in opposition to "the material."[28]

Bürger later clarified his position and noted that modern art is not really part "of a uniform project but rather . . . a historical movement of conflicting and antagonistic tendencies."[29] Yes, ZERO and the new tendency artists' work and their conceptual foundation are rife with contradictions and divergent beliefs. Walt Whitman claimed "contradiction" as his own domain, that is, the domain of the artist, when he wrote, "Do I contradict myself? Very well, then I contradict myself, I am large, I contain multitudes."[30] Certainly, ZERO's stated ambition to harmonize the relationship between man, nature, and technology harkens back to the utopian Bauhaus ambition to unify art and society. Their simultaneous embrace of Dada performance and protest with Bauhaus art and technology open a seam of apparent contradiction. By crafting an amalgamation of the two very different early modern art precedents, they clearly did not practice a superficial repetition of interwar Bauhaus thinking. Instead, to paraphrase Foster, ZERO and new tendency artists attempted to connect with a past artistic practice that provided a model of how to deal with their postwar historical trauma, and then they transformed that model in order to "disconnect" from the culture that they had inherited.[31]

Witness of Phenomenon positions Group ZERO and other second-generation "new tendency" artists, not merely as a neo-avant-garde reviving traditions of the Bauhaus and Dada, but as progressive movements that rebelled against the generation of perpetrators and resistors, appropriated the art and concepts of their interwar predecessors, and applied the ascendant philosophy of phenomenology to create a *new* ideological foundation for a *new* vocabulary of forms and *new* media for art that reflected the *new* social and scientific reality of postwar Europe. The artistic contributions of ZERO and "new tendency" artists seem especially relevant as vital precedents when viewing the subsequent development of contemporary art and digital media. The final three chapters of this book examine three genres of art that played significant roles in the development of contemporary art: artists' actions (happenings), immersive multimedia environments, and experimental television. I examine each of these genres to discuss the fundamental contributions of Group ZERO to these areas and connect them to the scholarly narrative as they are revealed in the archival resources. With this perspective perhaps we can appreciate Foster's question, "Does the neo-avant-garde act on the historical avant-garde in ways that we can only now appreciate?"[32]

Although this publication places Group ZERO in a broad context of post–Second World War European art history, it concentrates on the three German artists Heinz Mack, Otto Piene, and Günther Uecker. The cultural climate in postwar Germany was unique and considerably more complex than elsewhere. After a decade of National Socialist control and the eradication of modern art, an entire generation had been severed from the progress of European art and culture. The physical devastation of the land and the psychological impact on people resulted in a distinctive artistic development unlike in other regions of Europe and the United States. After the cessation of combat came a devastating vacuum. The recognition of the National Socialists' crimes against humanity caused an emotional burden of collective guilt and complicity among German citizens. The concept of the Zero Hour (*Stunde Null*) was imposed on this period by outside scholars, but it does not adequately explain the circumstances of the German people as they considered how to rejuvenate their culture. Germans not only faced the physical reconstruction of their cities, but also confronted the rehabilitation of their beliefs and culture. Further, reflecting on the burden of recent German history, how would one create a new culture? To quote German art historian Eduard Trier, "The year 1945 was not only apocalyptic, but also had been paralyzing."[33]

The conception of the "Zero Hour" or a "tabula rasa" was not a realistic proposition for understanding the challenge that artists and intellectuals confronted in 1945. Perhaps more appropriate is the theory of Anselm Haverkamp, who postulates that the decade following the war was an "incubation period" during which the historical trauma of a total collapse of the German worldview needed to be digested and considered before a new concept of German culture could appropriately be formulated.[34] Haverkamp's premise is convincing in recognition of the fact that the departure from the basic tenets of modern painting would occur in the mid-1950s in the hands of the second generation, the so-called middle generation, who were old enough to witness the war, but were too young to be perpetrators or resistors. The German writer Alfred Andersch articulated the challenge to the younger generation, "the necessity of achieving through an original act of creation, a renewal of German spiritual life."[35] Certainly, the fashion of *art informel* could not answer the difficult questions raised by the experience of these young Germans, Mack, Piene, and Uecker, who willingly assumed the challenge of attempting "an original act of creation." Considering Haverkamp's concept of the incubation period and Andreas Huyssen's ideas on the construction of historical memory to resolve emotional trauma, the development of second-generation postwar art in Germany can be interpreted as a reflection of the country's social and individual psychology.[36]

In order to assess the degree of artistic departure that ZERO and the new tendency artists fostered, it is necessary to examine them in comparison to the artists against whom they rebelled. The first generation of postwar *art informel* and *Tachism* artists proclaimed an end to modernism. Curator

Michel Tapié and artist Jean Dubuffet were leading voices of the immediate postwar period and clearly expressed their contempt for modern art in their lectures and essays. Despite the language of change, *art informel* was still essentially a form of painterly expressionism that perpetuated modern French painting, as realized by Pierre Soulages. The artists of the first postwar generation were enmeshed in the tradition painting in which they were trained and from which they could not extract themselves, despite the cataclysm of the war. Not until the second generation matured in the 1950s did artists produce work that began to dismantle painting. The second generation, baptized in the theater of war, responded by expanding the form, function, and media of art. They liberated art from the notion of the artist's touch and from the shackles of style and appropriated found objects to produce collage and assemblage, or natural elements and new technologies to divorce the hand through sound, light film, video, and television, and immersive multimedia environments emphasizing the ephemeral, performative aspects of durational, sensory artistic experiences.

After the war, artists across Europe debated the form of the new culture that they were all engaged in molding. Beginning in 1948 the debate in Paris and Venice centered on the question of whether abstraction or representational art would be the more appropriate form for representing the transformed realities of post–Second World War Europe. The *Darmstädter Gespräch* (Darmstadt Conversations) inaugurated its series of dialogues in 1950 on the reconstruction of German culture with the topic of the *Menschenbild* (the image of humanity).[37] The Bauhaus teacher Moholy-Nagy entered the debate in his posthumously published *Vision in Motion* (1947), in which he penned a section "in defense of 'abstract' art" advocating the liberation of art from an imitation of nature and the "philosophy connected with it."[38] And the French critic Charles Estienne recognized as early as 1946 in his essay "Painting and the Epoch" that a return to representation was irrelevant to postwar reality.

> Today, the work inspired by Titian and Raphael will probably be false, ambiguous and obscure . . . [and] dangerously out of date formulas. The era of Italian perspective and the imitation of nature was succeeded by the era of relativity and atomic physics Finding the human again via the human form—via the formal—appears to me to be difficult and anachronistic. Those who attempt to do so belong to another epoch, however great they might be.[39]

Notes

1 Dieter Honisch, "1956-1970: Auf der Suche nach der eigenen Identität," in *Kunst in der Bundesrepublik Deutschland, 1945-1985*, edited by Dieter Honisch. Exhibition catalogue (Berlin: Neue Nationalgalerie, 1986), 19.

2 ZERO 1, 1958, in *ZERO* (Cambridge, MA and London: MIT Press, 1973), 3.

3 ZERO 1, op. cit., 20–21, 10–11.

4 Piero Manzoni, "Free Dimension," and Udo Kultermann, "Eine neue Konzeption in der Malerei," in *Azimuth 2*, (1960), edited by Enrico Castellani and Piero Manzoni, (Milan, 1960), n.p.

5 Klaus Jürgen-Fischer, *La Galleria Pagani del Grattacielo presenta Nuove tendenze tedesche, 1959*. Exhibition catalogue (Milano: Galleria Pagani del Grattacielo, 1959).

6 Alexander Leisberg, "Neue Tendenzen," *Das Kunstwerk*, vol. 10-/XIV (April/ Mai 1961): 3–34; Klaus Jürgen-Fischer, "Post Scriptum 'Neue Tendenzen'," *Das Kunstwerk*, vol. 5–6/XV (November/December 1961): 72; John Anthony Thwaites, "Tendenzen—neu und alt," *Deutsche Zeitung mit Wirtschaftszeitung* (Köln—Stuttgart) (March 23, 1964).

7 *Nove tendencije 1*. Exhibition catalogue (Zagreb: Galerija Suvremene Umjetnosti, 1961); *Nove Tendencile 2*. Exhibition catalogue (Zagreb: Galerije Grada Zagreba, 1963); see also Margit Rosen, ed. A *Little-Known Story about a Movement, a Magazine, and the Computer's Arrival in Art: New Tendencies and Bit International, 1961-1973*. Exhibition catalogue (Karlsruhe, Germany and Cambridge, MA/London: ZKM/Center for Art and Media and the MIT Press, 2011).

8 "Information pour la presse," galerije grada zagreba, 1963. Mack Archiv, ZERO Foundation, Düsseldorf.

9 Letter from Piero Dorazio to Howard Wise, July 2, 1960. Howard Wise Gallery Records (SC 17), folder 622 [1/2]. Harvard Art Museum Archives, Harvard University, Cambridge, MA.

10 Catherine Millet, *L'art contemporain en France*. (Paris: Flammarion, 1987), 14, cited in Marion Hohlfeldt, "Strategies for a participation The Group de Recherche d'Art Visuel (GRAV) under the sign of games," in *Strategies de Participation—GRAV—Groupe de recherché d'art visuel—1960/1968*. Exhibition catalogue. (Grenoble: Le Magasin—Centre Nationale d'Art Contemporain de Grenoble, 1998), 37.

11 László Moholy-Nagy, *Malerei, Fotografie, Film (Painting, Photography, Film)*. Bauhaus Bücher 8. (München: Langen, 1925). See also Achim Borchardt-Hume, *Albers and Moholy-Nagy: From the Bauhaus to the New World*. Exhibition catalogue. (New Haven, CT: Yale University Press, 2006), 96.

12 John Anthony Thwaites, "Reaching the Zero Zone," *Arts magazine*, vol. 10, no. 36 (September 1962): 16.

13 Massimiliano Gioni and Carrion-Murayari, eds., *Ghosts in the Machine* (New York: New Museum and Skira Rizzoli Publications, Inc., 2012), 10.

14 Andreas Huyssen, *Present Pasts: Urban Palimpsests and the Politics of Memory* (Stanford: Stanford University Press, 2003), 5.

15 Tony Judt, *Postwar: A History of Europe Since 1945* (New York: Penguin Group, 2005), 5.

16 Yve-Alain Bois, *Painting as Model* (Cambridge, MA: MIT Press, 1990). Bois's ideas are developed further in Chapter 3, "The Problem of Painting and the Question of Reality."

17 Judt, *Postwar*, 61

18 *Günther Uecker: Twenty Chapters* (Ostfildern-Ruit: Hatje Cantz, 2006), 12.

19 Otto Piene, "Zero and the Attitude," unpublished manuscript written in spring 1965. Otto Piene Archives, Düsseldorf, 4.

20 Pierre Restany, *Les Nouveaux Réalistes*. Exhibition catalogue (Milan: Apollinaire Gallery, 1960).

21 GRAV, Assez de mystifications (*Enough Mystifications*) (September 1961), n.p. Otto Piene Archives.

22 Joel Stein writing in the catalogue for *Nove Tendencije* (1961) quoted in, *Strategies of Participation*, 70.

23 Jeff Kelly, "Les expériences américaines," in *Hors limites*. Exhibition catalogue (Paris: Centre Georges Pompidou, 1994), 50, quoted in *Strategies de Participation*, 38.

24 Peter Bürger's *Theory of the Avant-Garde* (Originally published in 1974. Minneapolis, MN: University of Minnesota Press, 1984), attempted to define the modern avant-garde, and the work of those who revisited the historical avant-garde as the neo-avant-garde. Both of these forms Bürger concluded were failures in achieving their artistic intentions.

25 Hal Foster, "What's Neo about the Neo-Avant-Garde?" *October*, vol. 70, The Duchamp Effect (Autumn 1994): 22.

26 Dirk Pörschmann, "Reine Momente der Klarheit. Otto Piene und die Idee Zero," in *Otto Piene: Spectrum*. Exhibition catalogue (Dortmund: Museum am Ostwall, 2009) quotes Peter Weibel from his essay "Re-Präsentation des Verdrängten. Die Kunst als Spiegel des sozial Unbewussten?" in *Trajekte. Zeitschrift des Zentrums für Literatur- und Kulturforschung Berlin*, vol. 7, no. 13 (September 2008): 29–35, "Die Neo-Avantgarde ist nicht eine rein formale Wiederholung der historischen Avantgarde. Sie ist eine wirkliche Nachkriegskunst, eine Kunst von Erinnerung, Vergessen, Unterdrückung, Traumata und die Wiederkehr des Verdrängten" [The neo-avant-garde is not a purely formal repetition of the historical avant-garde. It is a real art of recreation, an art of memory, forgetting, oppression, trauma, and the return of the repressed]. See also Jaleh Mansoor, "Marshall Plan Modernism: The Monochrome as The Matrix of Fifties Abstraction" (Ph.D. Dissertation, Columbia University, 2007), 34–35 and 221–25, for another view on the shortcomings of Bürger's thesis relative to the development of monochrome painting among postwar European artists, Lucio Fontana, Yves Klein, and Piero Manzoni, noting that these artists differed from historical modern art by their insistence on the physical presence of their bodies in the creation of their paintings.

27 Benjamin H.D. Buchloh, "The Primary Colors for the Second Time: A Paradigm Repetition of the Neo-Avant-Garde," *October*, vol. 37 (Summer 1986): 51, establishes the position that "the primary function of the neo-avant-garde was not to reexamine this historical body of aesthetic knowledge, but to provide models of cultural identity and legitimation for the reconstructed (or newly constituted) liberal bourgeois audience of the postwar period. This audience sought a reconstruction of the avant-garde that would fulfill its own needs, and the demystification of aesthetic practice was certainly not among those needs. Neither was the integration of art into social practice, but rather the opposite: the association of art with spectacle. It is in the spectacle that the neo-avant-garde finds its place as the provider of a mythical semblance of radicality, and it is in the spectacle that it can imbue the repetition of its obsolete modernist strategies with the appearance of credibility." It is important to recognize that Prof. Buchloh is a member of the third postwar generation of Germans, and rightly challenges his fathers. See

also Guy Debord's *Society of the Spectacle* (Paris: Buchet-Chastel, 1967) to be discussed in Chapter 5.

28 Heinz-Norbert Jocks, *Das Ohr am Tatort: Heinz-Norbert Jocks im Gespräch mit Gotthard Graubner, Heinz Mack, Roman Opalka, Otto Piene, Günther Uecker* (Ostfildern: Hatje Cantz, 2009), 97. See also Wieland Schmied, "Etwas über ZERO, " in Dirk Pörschmann and Mattijs Visser, eds. *4321 ZERO* (Düsseldorf: Richter/Fey Verlag GmbH und ZERO Foundation, 2012), 16, "ZERO war durch seine Besinnung auf die Natur und die Mittel, die diese bereitstellte, vor einer Verherrlichung des Konsums gefeit". (ZERO was protected from the glorification of consummation by a reflection on nature and the means that it provided.)

29 Peter Bürger, "The Significance of the Avant-Garde for Contemporary Aesthetics: A Reply to Jürgen Habermas," *New German Critique*, no. 22, Special issue on Modernism (Winter 1981): 21.

30 Walt Whitman, *Song of Myself* (New York: Powegen Press, 1936). The poem first appeared in 1855 in Whitman's self-published first edition of *Leaves of Grass*.

31 Foster, "Neo-Avant-Garde," 5.

32 Ibid., 8.

33 Eduard Trier, "1945-1955: Framentarische Erinnerungen," in edited by Dieter Honisch, *Kunst in der Bundesrepublik Deutschland*, 10.

34 Anselm Haverkamp, *Latenzzeit: Wissen im Nachkrieg* (Berlin: Kulturverlag Kadmos, 2004). See also "Latenzzeit. Die Leere der Fünfziger Jahre: Ein Interview mit Anselm Haverkamp von Juliane Rebentisch und Susanne Leeb," *Texte zur Kunst*, vol. 12, no. 50 (2003): 45–53.

35 Quoted by Stephen Brockmann, "German Literature, Year Zero: Writers and Politics, 1945-1953," in *Stunde Null: The End and the Beginning Fifty Years Ago*, edited by Geoffrey J. Giles. Occasional Papers No. 20 (Washington, DC: German Historical Institute, 1997), 61–2.

36 See Huyssen, *Present Pasts*.

37 Hans Gerhard Evers, ed., *Das Menschenbild in unserer Zeit: Darmstädter Gespräche* (Darmstadt: Darmstädter Verlagsanstalt, 1950).

38 László Moholy-Nagy, *Vision in Motion* (Chicago: Paul Theobald, 1947), 150.

39 Charles Estienne, "Painting and the Epoch," 1946, reprinted in Guilbaut, *Be-Bomb*, 277.

CHAPTER ONE

Europe After the Rain: *Un art autre, art informel*

Max Ernst's painting *Europe after the Rain* (1940–42, Figure 1.1) serves as a prophetic metaphor for the physical destruction and emotional despair that would await Europe at the end of the Second World War. His response to the First World War was to join Dada in Cologne. Subsequently, he moved to Paris, where he became a founding member of André Breton's surrealist movement. He parted ways with Breton in 1938 and fled to southern France as war appeared on the horizon. Ernst had foreseen the impending cataclysm in 1935: "I see barbarians looking toward the west, barbarians emerging from the forest, barbarians walking to the west." He did not escape the barbarians by hiding in the provinces, however. Upon the German invasion of Poland in 1939, the French interned him as an enemy alien. The Germans arrested him again in 1940, when they invaded France; he eventually escaped and crossed the Pyrenees to Madrid, from where he emigrated to the United States, traveling with Peggy Guggenheim.[1]

While in southern France, Ernst began a new series of works, including *Europe after the Rain*, in a new technique, *décalcomanie*. He applied pigment, diluted with vehicle, to the canvas and pressed it against another surface to generate automatic images. The chance process evoked subconscious images, which Ernst then inpainted among the ridges of pigment. Redolent of the primeval German Urwald, these paintings embody, critic Suzi Gablick said, a "sense of growth and decay, of past giving way to future, the hint of forces beyond control, of days before the human span. Here time does not pass."[2]

In *Europe after the Rain*, Ernst clearly references Adolf Hitler's war, symbolized by the lance-wielding figure confronting the female figure of Europa, who turns her back on him in disgust at her ravaged landscape. Ernst implied his own view of Europe and its culture as a petrified, denuded landscape.[3] The oracular imagery of Ernst's painting, initiated during a tense period of inner emigration and completed in exile during the climax of the

FIGURE 1.1 *Max Ernst,* Europe After the Rain, *1940–1942, oil on canvas, 21 9/16 × 58 3/16 in. The Ellen Gallup Sumner and Mary Catlin Sumner Collection Fund. 1942.281. Wadsworth Atheneum Museum of Art, Hartford, Connecticut. Photo: Allen Phillips/Wadsworth Atheneum.*

conflict,[4] portends the physical destruction of Europe, the emotional horror at the inhumanity, and the shared postwar sentiment on the grim prospects for Europe's future.

The devastation of the Second World War was on a scale unprecedented in human history. The nations of Europe had for the second time in thirty years attempted to destroy one another. Many historians view the Second World War as a continuation of the conflict that began with the First World War and was left unresolved by the Treaty of Versailles in 1919. As historian Tony Judt noted, "World War I destroyed old Europe; World War Two created the conditions for a new Europe." Most of the death and destruction occurred in the initial German invasions of other nations and in the final counterattack by the Allied forces. The most significant proportion of the destruction occurred in the final three years, with daily bombing raids over Germany and the scorched-earth advance of the Soviet Union westward. In the final assault on Berlin, in May 1945, the city absorbed forty thousand tons of bombs, rendering seventy-five percent of the buildings uninhabitable.[5]

The loss of life, vastly greater than in any previous conflict, was as staggering as the physical damage. Approximately forty-one million people died in Europe during the Second World War. Judt has observed that this number was equivalent to the population of France at the outbreak of war.[6] The losses on the battlefield and among civilians were compounded in the final months of the war by the discovery of the concentration camps. The first photographs of the death camps were released in April 1945. Then, only a few months later, in August, the United States dropped atomic bombs on Japan, incinerating two cities. These events forced the recognition that for the first time in history human beings possessed the capacity to cause our own extinction.

It was a psychological shock to recognize the horrors of which humanity is capable. Not only did the war destroy the institutions of society in which

people were raised; the very foundation of morality was suspect. People wondered how they should respond to the death and destruction that they witnessed, and how they could reconcile their moral and ethical beliefs with the reality of the world.

> All over Europe there was a strong disposition to put the past away and start afresh, to follow Isocrates' recommendation to the Athenians at the close of the Peloponnesian Wars: "Let us govern collectively as though nothing bad had taken place." Without such collective amnesia, Europe's astonishing post-war recovery would not have been possible. To be sure, much was put out of mind that would subsequently return in discomforting ways.... The price paid was a certain amount of selective, collective forgetting, notably in Germany.[7]

Communal and individual emotional responses to the conclusion of the conflict took three forms: jubilation and relief, existential questioning of the war and its aftermath, and resolve to reconstruct their culture.

How did artists respond to this physical, emotional, and moral devastation? What did they create? In the first decade after the war, art took several paths that paralleled the collective psyche and evolved with the changing political dynamics. Initially, Europeans witnessed a recapitulation of prewar modernism in their attempt to rebuild their cultural foundations, while other artists attempted to render the existential reality, as either a physical or an emotional state, through figuration or abstraction. And, among those interested in a new artistic identity for postwar Europe, there emerged a style of painterly expressionism that drew from the painterly tradition of modern art and from the subconscious, irrational content of surrealism and that has come to be called *art informel*. *Art informel* became a style of painting that appeared across the world that had been affected by the Second World War. However, after a decade, the formlessness of *informel* had become formalized into academic pictorial rhetoric. In the changing historical climate of the mid-1950s, it ceased to resonate with the European psyche.

At the end of the combat, Europe initially expressed a feeling of relief and euphoria. Immediately after the Nazis left Paris, in August 1944, Pablo Picasso, one of the modern artists to remain in Europe during the war, painted his *Cock of the Liberation* (1944, Figure 1.2). The French cock proudly crows to announce the retreat of German troops from Paris. His puffed chest leads the viewer's eye to the rising sun that promises a new and fertile future for Europe. The jubilation, however, was quickly replaced by a realization of the enormous effort necessary to rebuild Europe.[8] Writer Simone de Beauvoir realized at this moment that although the fighting was over, the war "remained on our hands like a great, unwanted corpse, and there was no place on earth to bury it."[9] Yet the devastation was not just perceived as a tremendous burden; it was also viewed as clearing away the past for a new beginning. Philosopher Italo Calvino described the potential for optimism at this grave moment, asserting

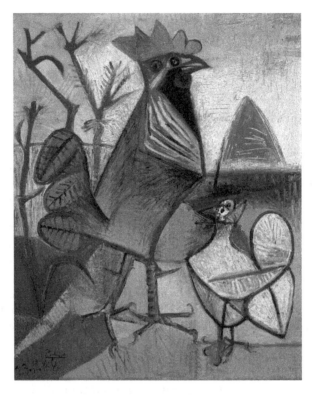

FIGURE 1.2 *Pablo Picasso,* The Cock of the Liberation (Le Coq de la Liberation), *1944, oil on canvas 39 1/2 × 31 3/4 in. (100.33 × 80.65 cm). Milwaukee Art Museum, Gift of Mrs. Harry Lynde Bradley M1959.372. Photo: Larry Sanders. © 2017 Estate of Pablo Picasso/Artists Rights Society (ARS), New York.*

that the crushing of fascism engendered "a dream of revolution which would take off from a tabula rasa."[10] The postwar mindset vacillated between these theoretically contradictory, but psychologically compatible, positions: a desire to return to the comfort of the prewar culture and a resolution to make a new beginning. Europeans wanted, as art historian Sarah Wilson has described it, "caesura, continuity and catharsis."[11]

This chapter outlines some of the manifestations in the visual arts among the first postwar generation of artists, from the revival of several forms of modernism to existential purgings of subconscious agony, and the development of an international style of gestural expressionism, *art informel,* that by 1955 became fossilized as the artistic establishment against whom the second postwar generation rebelled. The account begins with events at the end of the war in 1945 and closes with the deaths of some of the leading artists of this period—of Willi Baumeister, Karl Hofer, and Nicolas

de Staël in 1955, and Jackson Pollock in 1956—at precisely the time when the second generation came of age.

In the visual arts, Europeans immediately attempted to reclaim a semblance of their past and to establish continuity with their prewar lives, resulting in the resurrection of interwar modernism, with the Ecole de Paris (School of Paris) at its fulcrum. In France, Germany, Italy, and Spain the cultural reconstruction began with the major artistic figures of the prewar generation returning from exile or resurfacing after nearly a decade of inner emigration, each country attempting to resuscitate their culture by reviving successful interwar artistic practices.

The French hosted a *Salon d'Automne* in fall 1944, only a few months after the Germans had evacuated, and prior to the cessation of combat in Europe. The *Salon de Libération* announced the return of the Ecole de Paris and provided a forum to lionize Picasso, whom the French championed as the postwar Jacques-Louis David. Picasso, the leading artist who remained in Paris during the war, "alone fortified the world around him during the Occupation. . . . He gave back hope to those who were starting to wonder about our chances of salvation. His confidence . . . that better days were ahead, brings gratitude from all intellectuals, all our country's artists."[12] These words indicate the importance that people placed on reconnecting with their cultural identity before the war as vital to their psyche as they were trying to recover from the traumatic experience of the war.

Whereas the traditional *Salon d'Automne* essentially perpetuated the Ecole de Paris,[13] two new Salons in France after the war revived other styles of prewar modernism. The *Salon de Mai* formed during the war by Gaston Diehl as an act of resistance to the Nazis presented its first public salon in 1945, consisting primarily of figurative and surrealist artists, and was supported by the critic Jean Cassou (later director of the Musée National d'Art Moderne in Paris). In 1946, a rival group of prewar modernists—Robert Delaunay, Albert Gleizes, and Nelly van Doesburg (widow of Theo van Doesburg)—formed the *Salon des Réalités Nouvelles*, under the influence of Galerie Denise René, to encourage the continuation of geometric abstraction.

The city of Paris itself occupied a special position in the postwar recuperation. It was the only major cultural center in Europe that did not suffer massive bombing and survived physically intact. Furthermore, in the minds of the French, Paris was the home of modern art's greatest achievement—painting—and had been for the previous century. Many postwar voices heralded the French resurrection. In 1946, the critic Léon Degand announced, "France and the School of Paris remain, until times change, the magnificent center from which the most exalting radiance pours forth."[14] Charles de Gaulle's provisional government in France, heeding Jean Cassou's boast that modern painting was "a manifestation of the genius of the French . . . [that brings] glory to our country,"[15] encouraged the perception that Paris remained the cultural center of the Western world.

This perspective was assisted by the return of many exiled artists and by the recognition of the Ecole de Paris at the Venice Biennale, which awarded successive prizes, beginning with its first postwar exhibition in 1948, to Braque, Matisse, and Dufy.[16] The exalted position of Paris as the center of modern art for most Europeans persisted another decade. On West German Radio in 1957, the German art critic Hannelore Schubert said, "Paris is still the hub of modernity."[17]

Hungry for artistic rejuvenation, artists from Europe, Japan, and the United States traveled to the historical font of modern art. The Belgian, Danish, and Dutch artists Karel Appel, Corneille, and Asger Jorn came to Paris in 1948, where they formed Co.Br.A (not in their native cities of Copenhagen, Brussels, and Amsterdam). The Americans Sam Francis, Al Held, and Ellsworth Kelly traveled on the G.I. Bill to study at the French academies, learning French techniques in order to form their own postwar painterly and constructivist abstraction. The Catalonian artist Antoni Tàpies came to Paris seeking the work of the émigré surrealist Joan Miró. And the Germans Karl Otto Götz, Gerhard Hoehme, Heinz Mack, and Otto Piene came to Paris to absorb the tradition of modern painting. A brilliantly colored Matisse still-life painting left an indelible impression on the young Mack, who was, in his words, raised in a world where everything was brown and green.[18]

However, the allure of Paris and its bright canvases and painterly facture was difficult to reconcile with the reality of the immediate postwar years. At this time Europeans feared that in the absence of governmental institutions, food, and a functioning currency, the continent could sink into anarchy.[19] Even in the eyes of Parisian devotees the city and its hallowed modern art were not relevant to the severe social and political conditions. The French critic Julien Alvard wrote in 1951, "Isn't she [Paris] now an old capital with the heavy makeup of a Western world already long past maturity and slowly rotting into a frivolous Byzantinism? What should be said about this so-called superiority in the arts, of this imperialism which is no longer but a shadow of a shadow?"[20] Geometric abstraction came to be perceived as largely irrelevant, earning it the appellation *abstraction froid* (cold abstraction). Even for Picasso and the other Ecole de Paris artists, reality meant a harsh confrontation with death and destruction. Rarely did Picasso directly address the tragedy of the war. However, he said, "I have not painted the war because I am not the kind of painter who goes out like a photographer for something to depict. But I have no doubt that the war is in these paintings that I have done."[21] Indeed, as many artists asked themselves, what painted image can convey the devastation and carnage, as had the photography of Margaret Bourke-White, Robert Capa, or W. Eugene Smith without degenerating into spectacle?

The experience of the war gave birth to existentialism, whose principle exponent was the philosopher Jean-Paul Sartre.[22] His response to the work of some of the postwar artists, particularly Alberto Giacometti and Wols, led

him to write art criticism, following on his essay "L'existentialisme est un humanisme" ("Existentialism and Humanism, 1946"). Sartre's existentialist views are perhaps most succinctly expressed in a line from one of his plays, *Morts sans sépulture* (The Victors) (1940), in which a character asks, "Can you still see sense in living when there are men who beat you until they break your bones?"[23] The distraught faces and distended forms of Francis Bacon's menacing monsters embody this existential mood, as do Alberto Giacometti's emaciated human beings. Giacometti subverted the staple of French art, the female nude, transforming a lush, fecund beauty into a gaunt, wiry figure (Figure 1.3).[24] In his portraits, the eyes are not windows into the soul; the sitters' empty eye sockets reveal, instead, a hollow, battered postwar psyche.

The artistic situation in Germany mirrored that of her neighbors. By reaching back to the German Expressionists and French painting, postwar German artists attempted to establish a continuum from which they could

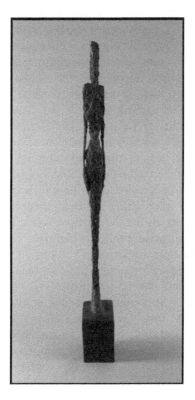

FIGURE 1.3 *Alberto Giacometti,* Tall Figure, *1947, bronze, 79 1/2 × 8 5/8 × 16 1/4 in. (201.9 × 21.9 × 41.3 cm). The Pierre and Maria-Gaetana Matisse Collection, 2002 (2002.456.111). The Metropolitan Museum of Art, New York. Art © Alberto Giacometti Estate/Licensed by VAGA and Artists Rights Society (ARS), New York. Image Source: Art Resource, New York.*

revive German art. Over twelve years of indoctrination, the National Socialists had successfully excised modern art from German culture. The postwar survivors felt the necessity of reconstructing a bridge to their own past as well as to the European culture from which they had been segregated.

Germany's physical devastation was more significant than that of most other European nations. Correspondingly, the German social and psychological profile was drastically different, as well. Across Europe political and cultural figures asked the "German question," why had Germans invaded their neighbors three times in the previous seventy years?[25] The "German question" carried the accusation of German guilt, while the German people sought individual and social mechanisms for absolving guilt. Germans grappled with their role as the perpetrators of a war in which they had suffered total defeat, and bore the burden of collective and individual responsibility for the barbaric actions of the Nazis.[26] The physical and emotional survival of the German people was among the principal concerns of those charged with rebuilding. When Konrad Adenauer was appointed mayor of Cologne in 1945, he explained, "There are two aspects of reconstruction which we consider of equal importance. One, the material rebuilding of the city. But just as important is the creation of a new spiritual life. . . . Fifteen years of Nazi rule have left Germany a spiritual desert." Having survived the war, Adenauer recognized the necessity for each citizen to question recent history and, in seeking answers, turn "to religion and art."[27] For the people attempting to carve out an existence in the rubble, basic subsistence was the chief concern. The German art historian Eduard Trier wrote, "The year 1945 was not only apocalyptic, it was paralyzing. . . . The thought of art was in the minds only of a few people. Initially, even the artists had other concerns."[28] According to another art historian, Eberhard Roters, who chronicled art after the war in Berlin, in addition to the circumstances that other German citizens confronted, artists struggled to secure materials for their artistic work. In this situation, Roters continued, it was not surprising that the Germans had "a deep affinity" for the existentialist philosophy of Sartre,[29] and turned to the Germans Martin Heidegger and Karl Jaspers for similar philosophical views.[30]

Nonetheless, Germans began to host art events immediately after the conclusion of the war. Perhaps in response to the cessation of daily bombings, the Germans, too, experienced elation. "The end of the Nazi era was the beginning of a cultural euphoria," wrote Tilman Fichter. "Just three weeks after the unconditional, total surrender, among the rubble of Berlin stirred new theater and opera life."[31] Parallel to the performing arts was the rejuvenation of the visual arts.[32] The sculptor Hans Uhlmann hosted the first postwar art exhibition in Berlin early in the summer of 1945. Uhlmann worked in a cubist sculptural style firmly rooted in the tradition of modern art. The National Socialists declared him a degenerate, yet he continued working, clandestinely, in his studio, in an act of inner emigration. After the collapse of the Third Reich, he was eager to show his friends and colleagues

what he created in defiance of the Nazis. Shortly thereafter, Uhlmann and Heinz Trökes, a modern painter, with the support of the German counsul, opened Galerie Gerd Rosen on Kurfürstendamm, within the shadow of the heavily damaged Kaiser Wilhelm Church. Trier observed, "The brash optimism to open up a gallery for modern art on a ruinous boulevard in the destroyed city center was a sign of encouragement for many."[33]

Both the Allied commanders and the German leadership recognized that restoration of a cultural identity, uninfluenced by the Nazi past, was a significant element in the reconstruction of Germany.[34] In 1946, Germans organized the *General German Art Exhibition* in Dresden, under the direction of Will Grohmann. In this exhibition the organizers featured German artists who had been cast out by the Nazis, and attempted to begin the process of reintroducing the modern art of the interwar years and of erasing the memory of the Nazi past. In Germany the discussion of reviving modern traditions meant two principal models of modern painting, either German expressionism or the Ecole de Paris. The two principal figures were Willi Baumeister, who worked in an abstract style reminiscent of that of the painterly German Blaue Reiter and French modern masters, and Karl Hofer, who practised the German Expressionist idiom.

Baumeister had studied painting in his native Stuttgart. After service in the First World War, he met Wassily Kandinsky and Paul Klee, who influenced his future direction in painting, which he then taught at the Städel School in Frankfurt. Upon assuming power in 1933, the Nazis immediately dismissed Baumeister, declaring him degenerate. He continued to work in his painterly style, in private through the National Socialist and war years. After the war, the provisional government appointed him to the academy in Stuttgart in 1945 (Figure 1.4). His observation on the artistic situation in Germany at that time is revealing: "The year 1945 did not bring general artistic rebirth in Germany as had occurred in 1919. The enthusiasm of the creators was inhibited by the many years of thorough deception and intimidation. The youth had seen no real contemporary art."[35] In 1949, with a group of abstract painters, including Fritz Winter and Rupprecht Geiger, he formed Zen 49. Teaching and promoting the cause of modern art in postwar Germany, Baumeister published *The Unknown in Art* (1947), a collection of essays disseminating his philosophy on the spiritual and unconscious sources of artistic inspiration, in emulation of his mentor Kandinsky's *Concerning the Spiritual in Art* (1912). This book contributed to the debate over the form of postwar art in Germany.

In disgust at the First World War, Karl Hofer revolted and decided to wield his painting to redress "the petrol-stinking world of civilization, the world of Satan." Practicing an expressionist form of figure painting, he believed in "the salvation of humanity through art." However, upon the ascendancy of the National Socialists he attempted to protect his teaching position at the Academy of Art in Berlin, appeasing the Nazis, and even divorcing his Jewish wife. His overtures were unsuccessful, and the Nazis

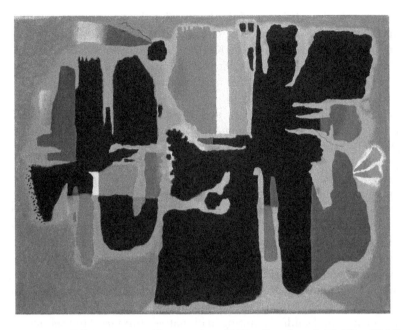

FIGURE 1.4 *Willi Baumeister,* Kessaua-Aru, *1955, oil on board, 38 3/4 × 50 1/2 in. (98.43 × 128.27 cm). Milwaukee Art Museum, Gift of Mrs. Harry Lynde Bradley M1962.1134. Photo: P. Richard Eells. © 2017 Artists Rights Society (ARS), New York/VG Bild-Kunst, Bonn.*

denounced him as a "Marxist-Jewish element" and relieved him of his position in 1936. During the war he suffered the near total loss of his accumulated work in a bombing raid that left him bereft and depressive. After the war he was reappointed to the Academy of Art and revived his revolutionary spirit, advocating the cause of figurative expressionism, then described as critical realism, to confront the moral wrongs of German society (Figure 1.5).[36] Baumeister and Hofer were the leading representatives in reviving modernism for Germans, and they worked to rebuild the bridge to their lost past and to European culture in general. By the end of the decade, when Germany and Europe were divided into west and east, with politically determined artistic styles, these two choices—Baumeister's abstraction or Hofer's representation—assumed highly charged political dimensions. Until his death, Hofer epitomized the figurative expressionism favored by many of the liberal, socialist, and anti-fascist elements in postwar Germany.

Simultaneously, there existed a desire to craft a new identity, to break from the German past and initiate a new beginning. When the bombs finally stopped exploding, one journalist wrote, "Here we stand . . . lonelier than any people has ever been on this earth. And we lean our foreheads on the ruined walls. And our lips whisper the old human question: 'What is to

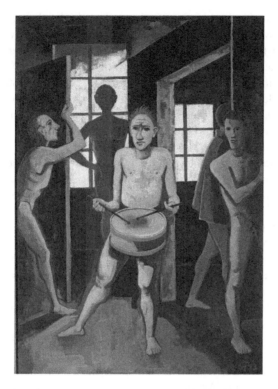

FIGURE 1.5 *Karl Hofer,* Die schwarzen Zimmer (II. Fassung), *1943, oil on canvas, 149 × 110 cm. Staatliche Museen zu Berlin, Nationalgalerie. Acquired by the state of Berlin. © 2017 Artists Rights Society (ARS), New York/VG Bild-Kunst, Bonn. Photo: bpk/ Jörg P. Anders.*

be done?'" The writer then proposed, "Let us make a new beginning."[37] Dismayed by the older generation, who brought on the destruction, people turned to German youth to lead. Contemporary writers encouraged the younger generation to realize the magnitude of their predicament and attempted to motivate them. Alfred Andersch, a radio spokesperson and writer with Group 47, challenged them: "The younger generation stands before a tabula rasa, before the necessity of achieving, through an original act of creation, a renewal of German spiritual life."[38]

Subsequently, this moment was called the *Stunde Null* (zero hour). But the term was not part of German parlance at the time. The first such reference came in the title of the Italian director Roberto Rossellini's 1948 film, *Germania, anno zero.* Only many years later was the term adopted in the literature on German art and culture of this generation.[39] In fact, in hindsight, it is clear that the artistic achievements of the first postwar generation did not constitute the new cultural beginning for which so many hoped. The generation the German journalists addressed had been raised

under the indoctrination of the Nazis, and with the defeat of the Nazis their worldview collapsed. The second generation of postwar Germans, the children of the war, has been described as the "lost generation" or the "fatherless generation."[40] On a visit to Frankfurt in 1947, Walter Gropius wrote about this generation: "My impressions were devastating. . . . It is unimaginable how deeply, spiritually and physically, destruction has struck. . . . The younger generation that grew up under Hitler is cynical, and relations with them are very difficult."[41] Reflecting on this moment, the German author Karin Kiwus, who grew up in the aftermath of the war, asked, "How have we actually begun anyway?" She clarifies that the moment was not a zero point, or a new beginning, but "a process that began as a promising attempt at a reorientation [and] that was demolished by the increasing hardening of the political-ideological opposites."[42] The process she described lasted a decade.

Fashioning a new beginning implied forgetting the immediate past. Contemporary German writers expressed a common sentiment, described by Karl Jaspers: "One simply does not want to suffer anymore. One wants to escape the misery [and] to live, but does not wish to ponder. . . . One does not want to be burdened by guilt."[43] Indeed, the collective amnesia of Germans was evident to observers, both German and international, in the rehashed modern art that they created. The American art historian Bernard Myers wrote in 1951: "Perhaps the most astonishing aspect of the postwar artistic situation in Germany is its complete lack of direct response to the conditions of the time. We may assume that the preponderant interest in various forms of abstraction . . . represents an attempt to escape from the unpleasant realities of a bombed out world."[44] This attitude expressed the shame and embarrassment of members of the older generation. However, some were critically examining German society after the war, such as the Group 47 authors of so-called *Trümmerliteratur* (rubble literature). Author Heinrich Böll remarked, "To offer our contemporaries an escape into some idyll would have been too cruel for words." The expressionist painter Hans Grundig, who had been interned in a concentration camp, expressed the same concern when he saw an exhibition of his colleagues' work in 1946 and complained: "Here one can see everything that was hidden during the Fascist years. . . . But it is shameful to consider the spiritual profiles of such work. . . . The worst thing is that there is no reflection of the terrible years that we have been through."[45]

Scholars and popular writers have published an extensive body of literature on postwar German selective memory. At the time, Theodor W. Adorno wrote about the complexities of "coming to terms with the past" and criticized his fellow Germans for "wiping it from memory."[46] Doctors Alexander and Margarete Mitscherlich applied psychological theory to Germans in order to understand collective behavior that they described as "the inability to mourn."[47] More recently, the cultural theorist Andreas Huyssen asserted that the repetitive desire for a *Wendezeit* (turning point)

reveals "the double-edged desire simultaneously to remember and to avoid the past, a habitus of memory politics that is more than simple forgetting or repression." His hypothesis is that the German discourse on new beginnings from 1945 onward exposes the complexity in their "multilayered traumatic experiences" and their inability to psychologically resolve those experiences.[48] Although the cultural historian Anselm Haverkamp warned against couching analyses of cultural production in terms of psychology, he justified his own use of psychoanalysis as a useful tool to help understand the creative expression of people who have suffered trauma.[49] Haverkamp appropriated the term "latency" from psychoanalysis to propose that the sequence of cultural revivals in postwar Germany was one of artistic incubation. He compared this cultural phase to the biological stage of infancy, when it appears that there is no growth, but concluded that this dormancy is an essential prerequisite for all future growth.[50] Haverkamp's adoption of a term from psychoanalysis to describe a cultural phase resonates as a relevant metaphor. This situation was recognized by Lucio Fontana, who began his *Manifesto blanco* (1946) with the sentence, "Art is in a period of dormancy."[51] Despite proclamations of a cultural void in the first decade after the war, the issue of the form and meaning of art stirred fierce debates among postwar Europeans, because much was at stake in formulating the postwar cultural identity, and the social and individual psychology of the period profoundly influenced the understanding of the "reality" of postwar society.

In Germany, the immediate postwar debates about whether abstract art or representational art best reflected the new reality had a distinctively political dimension. The Allies, whose chilly postwar relationship opened a growing chasm between the west and the east, divided Germany up into zones of occupation. The occupying powers jockeyed for control over the German populace, as they tried to move them away from a fascist mentality. In much of Europe, the Communist Party held great allure as the opponent of fascism in the 1940s, and of the perceived cultural imperialism of American capitalism. However, the Germans had experienced the wrath of the Soviet Union at the end of the war, and few were inclined toward communism. Nonetheless, in the Soviet sector of occupation, the Russians had begun to impose their cultural standards on the Germans. In 1947, a Soviet functionary gave a speech in East Berlin announcing that socialist realism would become the official style of the eastern zones. The west followed with its own cultural program, focused on modern abstraction. [52] A pan-European debate ensued over abstraction versus representation.

This debate was a central topic at the 1948 Venice Biennale and at the 1948 *Salon d'Automne* in Paris. Charles Estienne had recognized as early as 1946 the difficulty the public would have accepting abstraction as a means of depicting the contemporary world. "For the wider public, an abstract painting is a painting in which one can no longer recognize anything of the real, that is, of the external visible world," Estienne wrote. Yet, he

advocated for abstraction as the best medium to render the postwar reality: "It is thus these 'abstract' painters who lead the game. . . . Through emotion they preserve an essential contact with external reality, however apparently distant it might be."[53]

The 1948 Venice Biennale was the first presentation in Italy after the war of the work of Picasso. Picasso's support of the Communist Party rallied many European artists, who were communist sympathizers, to Picasso as a stylistic exemplar. Renato Guttuso, an Italian figurative painter active in the Communist Party, wrote in the Biennale catalogue that Picasso was the one to emulate as the style for the communist future.[54] On the opposite side of the debate were Emilio Vedova and the American Abstract Expressionists, whose works were on display in Peggy Guggenheim's collection during the Biennale. Vedova, a fierce leftist, created new geometric abstractions for this Biennale, presenting a foil to Picasso's figuration.[55] The question of figurative or abstract painting clashed again, a few months later, at the September *Salon d'Automne* with two versions of figuration: the muscular realism of Bernard Buffet's *Woman with Net* (1948) and the socially conscientious André Fougeron's *Women at the Market* (1947). While Buffet advocated a realistic view of man as "an eater of red meat, of French fries, or fruit and fromage, and a girl chaser,"[56] Fougeron, an active member of the French Communist Party, offered a stark portrayal of frowning French women picking over the scant offerings of the fishmonger.[57] The decision to become an abstract or a figurative painter became a statement not only of one's artistic ambitions but also of one's political beliefs.

The debate over abstraction or figuration, a question that the Germans described as the "formalism debate," held both political and social ramifications for the Germans. After nearly a decade of being indoctrinated by the Nazis to believe that abstraction and expressionist figuration were degenerate, Germans had to learn a completely new artistic vocabulary. While the postwar German art scene was polarized around the abstraction of Baumeister and the critical realism of Hofer, any form of modernism caused consternation among the German burgers.[58] The dubious populace found its voice in Hans Sedlmayr, a conservative Austrian critic, who published *Verlust der Mitte* (The Lost Center, 1948) to denigrate modern abstract art as an index of the depravity of modern society. It caused considerable consternation among Western progressives, who advocated abstract painting, which, in their view, reflected the advances in science that had revealed a reality that was not visible to the eye. The art historian Adolf Behne explained, "Natural science, chemistry, physics, biology reveals a new structure of the world to us." He continued, "Modern art . . . does not turn itself away from nature, rather it turns its back on the Sunday-afternoon-picnic version of nature."[59] The discussion came to a head at the Darmstadt Conversations in 1950. The series of periodic symposia was organized by Darmstadt architect Otto Bartning, who was motivated to publicly address major issues confronting German society. The conversations began

with a session on the question of "The Image of Man in Our Time" (Das Menschenbild in unserer Zeit) headlined by the presentations of Sedlmayr and Baumeister. Sedlmayr warned of the destruction of the image of man in the course of European art and was subjected to intense criticism from the audience, including Baumeister, Johannes Itten, and Alexander Mitscherlich.[60] Baumeister was to deliver his refutation of Sedlmayr, "What Is the Position of Abstract Art to the Image of Man," but did not because Sedlmayr left after his harsh reception.[61]

A younger generation of artists and critics, the second postwar generation, distanced themselves from these debates. They found the Ecole de Paris, *abstraction froide* (cold abstraction), and critical realism to be lacking. Many of these artists and critics called for a new beginning. The metaphor of "zero" and "a new beginning" was prevalent across the rest of Europe in the dialogue of artists and critics. They believed that their circumstances required a clear break from tradition. French art critic Michel Tapié appropriated the idea of the "tabula rasa"[62] and applied it to those artists who he felt made "a genuine departure from zero."[63] Karel Appel sought "to start afresh," distancing himself from the formalities of past painting.[64] Estienne, an astute observer of painting in postwar Paris, remarked that "a good number of isolated practitioners . . . began from zero again, and not from geometry but from matter, from the very substance of their painting."[65] It was Tapié who finally changed the conversation, finding "all the quarrels about figuration versus non-figuration . . . completely irrelevant." He believed that the central artistic question facing his generation was the freedom of individual subconscious expression unencumbered by traditional aesthetics. He advocated a "turbulent anarchy . . . a completely different art that is not satisfied with non-objectivity . . . an other kind of art,"[66] *un art autre*, an art of pure expression that has become known as *art informel*.

Art informel artists responded to postwar life by rejecting the Ecole de Paris and the geometric *abstraction froide* (cold abstraction) of the prewar generation and created what the French described as *abstraction chaude* (hot abstraction). They rejected the social reportage of Marxist figurative painting. They looked instead to work by the untutored, unsocialized, and unschooled—the art of children, the naïve, and the "insane" (the artists' choice of words)—and viewed the work of these outsiders as a vision of culture unencumbered by the politics of the previous decades. Across Europe, artists began to explore the essence of raw materials and to mold an emotive content from painterly expressive styles that expressed their dissatisfaction with modern culture. As Tapié observed, this new artistic sensibility announced itself in three exhibits in Paris at the Galerie René Drouin between October 1945 and May 1946 of Jean Fautrier, Wols, and Jean Dubuffet.[67]

In the first exhibition (October to November 1945) Jean Fautrier displayed a group of paintings, *Otages*, that he created while in hiding from the Germans at an asylum outside Paris. His thickly textured surfaces

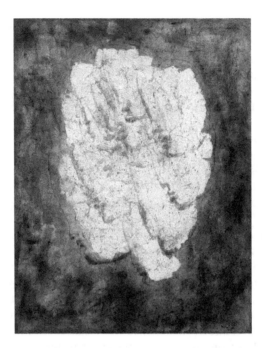

FIGURE 1.6 *Jean Fautrier,* Oradour-sur-Glane, *1945, oil, water-based paint, and dry pigment on paper mounted on canvas, 57 1/8 × 44 3/8 in. (145.1 × 112.7 cm). The Menil Collection, Houston. Photo: Paul Hester. © 2017 Artists Rights Society (ARS), New York/ADAGP, Paris.*

created with a mixture of pastes and layers of paper mounted on canvas covered with sensuous colors evoke the memories of a German massacre of 642 people from the village of Oradour-sur-Glane (Figure 1.6).[68] Fautrier's approach touched the wounded emotions of postwar Europeans. Francis Ponge proposed Fautrier's strategy for how artists should respond to the war: "There can be more delight (and less effectiveness) in the denunciation of horror as such, in its horrific, purely realistic representation, than in the attempt to transform horror into beauty." Ponge asserted that in his abstract images, "Fautrier shows us tumescent faces, crushed profiles, bodies stiffened by gunfire, dismembered, truncated, eaten by flies."[69]

Immediately following Fautrier's exhibition, the Galerie René Drouin presented the work of Wols (Alfred Otto Wolfgang Schulze), a German émigré who, like Ernst, had been held in confinement for about a year after the outbreak of the war. During his detention he developed an approach to creating abstract imagery that conveyed the emotional horror of the war. His furious slashes, scrawls, drips, and smears were divorced from traditional paint application and composition (Figure 1.7).[70] In the overcharged words of Guilbaut, "What we have is painting as vomit. . . . the announcement of the final literate decrepitude of modern painting in

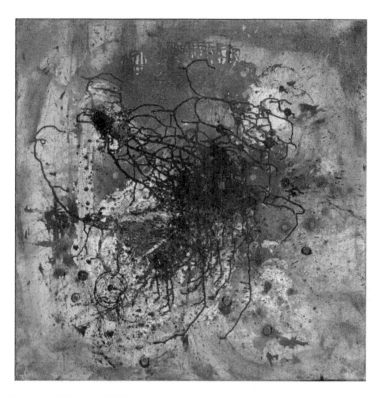

FIGURE 1.7 *Wols,* It's All Over, *1946–47, oil on canvas, 31 7/8 × 31 7/8 in. (81 × 81 cm). The Menil Collection, Houston. Photo: Paul Hester. © 2017 Artists Rights Society (ARS), New York/ADAGP, Paris.*

a furor of colors and scratches, of the marks of knife cuts—a literal ritual killing."[71] The exhibit of small watercolors and drawings on paper were in boxlike frames and dramatically illuminated. Although virtually no one took notice,[72] Drouin was moved to give Wols oils and canvases to produce paintings for his second exhibition in 1947. More people noticed the second exhibit, including Georges Mathieu, who remarked, "After Wols, everything has to be done anew."[73]

The third exhibition at Galerie Drouin was Jean Dubuffet's *Mirobolus, Macadam et Cie, Hautes Pâtes*, in March 1946. Inspired by the work of children, Dubuffet created works into which he traced the designs in emulation of crude scratchboards. He began to work with thick plasters and paste in May 1945. Upon seeing the exhibitions of Fautrier and Wols, he developed this work further into thickly textured works described by Dubuffet and Ponge as "matter paintings," given the emphasis on the materiality of their surfaces (Figure 1.8). In the catalogue for the exhibition, Dubuffet wrote entries for the various works as parodies of a proper museum catalogue. He described one painting as "rough matter, matte at places and

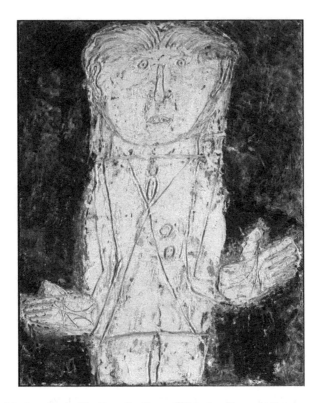

FIGURE 1.8 *Jean Dubuffet,* Jean Paulhan, *1946, Acrylic and oil on masonite, 42 7/8 × 34 5/8 in. (108.9 × 87.9 cm). The Jacques and Natasha Gelman Collection, 1998 (1999.363.20). The Metropolitan Museum of Art, New York. © 2017 Artists Rights Society (ARS), New York/ADAGP, Paris. Image: Art Resource, New York. Photo: Malcolm Varon.*

shiny at others, or as if it had been cooked and had vitrified. Figure with colors of caramel, eggplant, blackberry jelly, and caviar, adorned with egg-white holes in which a syrupy varnish of a molasses color has accumulated here and there."[74] The exhibition caused a scandal, both because some in the artistic community found the work repulsive and because the paintings reminded the food-deprived Parisians of their predicament.

The work of Fautrier, Wols, and Dubuffet, and the writings of intellectuals such as Tapié and Sartre, promoted the new artistic approach across the continent. Sartre's commentary reinforced his existentialist viewpoint manifest in the three artists' paintings, which responded to the needs of the continent to mourn and to exorcise its demons. In the painterly turmoil of these artists, postwar Europeans discovered an artistic style and sensibility that provided an emotional and psychological release. Some observers described the work of these painters as "lyrical abstraction,"[75] but that did not convey the works' existentialist content. In a 1952 manifesto-like

treatise, Tapié promoted *un art autre* as the appellation for the "formless," "expressive" new painting. Despite his efforts, artists and critics commonly used the term *informel* to discuss these works.[76] In Jean Paulhan's historical analysis of the movement, *L'art informel: Eloge* (1962), he argued that Tapié's use of the term "informel" to describe Wols's work encompassed the range of forms and the range of indefinite meanings within these works, and proposed *art informel* as the more appropriate term for this style of painting.[77] Over the decades, *art informel* has become part of art-historical parlance to describe this phase of postwar painting, when, in the words of the contemporary writer Rene Guilly, "the essential discovery of contemporary painting [was] freedom."[78]

In 1948, Tapié curated *Vehemences confrontées* (Opposing Forces) that expanded this group of postwar abstract painters to include Hans Hartung, Willem de Kooning, Mathieu, and Jackson Pollock. In their paintings Tapié saw anarchy and rebellion against traditional form, composition, and pictorial design, which he considered subservient to the raison d'etre of painting, the expressive, emotional impulses of the artist.[79] In his romanticized formula, the artist delved into his subconscious and allowed it without preconception to appear on the canvas. Tapié viewed these automatic techniques drawn from surrealism in opposition to the rational and formal qualities of modernism. He articulated his position most aggressively in his essay for the exhibition, stating that these painters "approached the indefinite domain of the informal with [their] own temperament, in a freedom with regard to what is called Art." This approach to art, Tapié declared, marks "the end of the History of Art."[80]

Tapié argued that *art informel* was a gestalt of the postwar spirit and that this artistic position represented a new, international artistic sensibility that had emanated from Paris and spread across the Western world.[81] Despite Tapié's nationalist rhetoric, many artists across Europe and the United States developed their painterly expressionism independently. Each of the groups in the Netherlands, Germany, Italy, and Spain practised a painterly abstract style that expressed the anxiety and mourning of the postwar spirit. Each of them attempted to create an art from the chaos of the subconscious, in an intentionally antimodern gesture. Pan-European *informel* was abstract, aggressively painterly, gestural, and expressionistic, and sought to reveal a primal expression of humanity.

Both the Netherlandish group Co.Br.A. and the Catalonian painter Antoni Tàpies fell into the sphere of *art informel* while working in Paris. In an interview, Appel clarified his artistic goals and practice: "The Cobra group started new, and first of all we threw away all these things we had known and started afresh like a child-fresh and new. . . . The paint expresses itself. In the mass of paint, I find my imagination and go on to paint it."[82] Sponsored by the French government, Tàpies came to Paris in 1950 as a surrealist painter and in the vortex of *informel* created his own matter paintings, in which, in his words, "the dramatic sufferings . . . the cruel fantasies . . . [that] appeared to inscribe themselves on the walls around

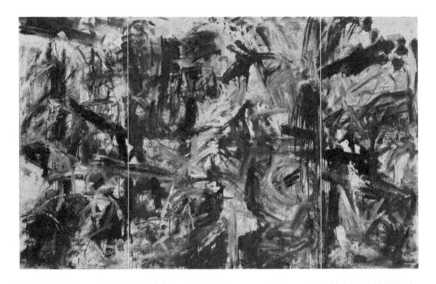

FIGURE 1.9 *Emilio Vedova,* Scontro di Situazioni '59 I-1, *1959, Vinyl distemper, oil, sand, charcoal, and pigments powder on canvas, 275 × 444 cm. © Fondation Gandur pour l'Art, Geneve, Switzerland. Photo: Sandra Pointet.*

me."[83] These remarks echo the ideas of Tapié's *un art autre* and Dubuffet's conception of *art brut.*

Italy and Germany experienced the wave of *art informel* in the 1950s, in distinctive political circumstances as former Axis powers. The Italian *informel* period was largely dominated by three figures: Burri, Fontana, and Vedova. With a strong history of visual culture, and a proud tradition of early modern Futurism, the immediate postwar years in Italy were marked by a reaching back into the past to reconstruct visual culture in the wake of fascism. Beginning with the 1948 Venice Biennale, the Italians were fully engaged in postwar European culture. Vedova began to execute his paintings with an aggressive painterly attack, marked by a peculiar strategy: he painted with his eyes closed (Figure 1.9). In these works, as Germano Celant has written, Vedova "was unleashing great storms of paint, titanic encounters between hefty thrusting forms and reckless slashes of pigment. The tempestuous compositions corresponded to the inner human condition— what Vedova called 'the data of interior equivalences'."[84] This resulted in a painterly dynamism that was the basis of his artistic recognition.

Burri and Fontana took no part in the debates, but they would prove to be the most influential on the succeeding generation of artists. Contemporary and historical critics and scholars consider Burri and Fontana as working in the *art informel* idiom, despite the artists' objections to such designations. Burri also insisted that his torn, burned, and sewn painting contained no political commentary. His path to art epitomizes the effect the war had on the psyche of some Europeans. While serving as a medical doctor in the Italian

Army during the African campaign, he was captured by the English in 1943 and sent to Texas as a Prisoner of War (POW) in 1944. There he turned to recreational painting, using materials provided by local YMCA volunteers, as a vehicle for exorcizing the demons of the war. Based on his wartime experiences, Burri thought that humanity did not merit a cure.[85] When he was released in 1946, he returned to Italy and in 1947 moved to Rome to pursue a career as an artist. He brought with him many of the burlap sacks (*sacci*) that he had used for canvas in the POW camp. Two experiences altered his work: the Venice Biennale of 1948 and a trip to Paris where he met Miró and visited René Drouin, in whose gallery he probably saw the French *art informel* artists Wols, Fautrier, and Dubuffet. At this point Burri began to use burlap not just as support, but as the essential material of his paintings.

He worked on his *sacci* for four years before he exhibited them in 1952. These powerful works immediately attracted attention, and Burri was rewarded with exhibitions across Europe and the United States. In his art he used the scraps of society—burlap, bits of rag, and found objects—as his materials (Figure 1.10). Early critics read Burri's *sacci* paintings as metaphorically representing stitched wounds. Certainly, this was relevant to Burri's war service as a combat surgeon. Despite the fact that he resisted such readings of his works, he continued to develop techniques, such as his torching of plastics or welding of scrap metal that invited such interpretations. Jamie Hamilton has said that "Burri's 'wounds,' and their curious stitches, like Fautrier's *Otages*, expressed a direct struggle with the moral implications of the war and effectively claimed responsibility for its destructive potential, the horrible weapons it had unleashed, and Italy's fascist past."[86]

Fontana was a key figure in Italian postwar art, who, beginning in 1949, developed a distinctive body of work that stands outside the sphere of *art informel*. Fontana had returned to his native Argentina to escape the Second World War. Once the conflict ended, Fontana came back to Italy, in 1947, bringing with him the *Manifesto blanco*, which he had drafted with his students at an art school in Argentina. The language of the manifesto harks back to the Italian futurists of the early twentieth century. In it, Fontana declares:

> We are carrying forward the evolution of art. . . . What is needed is the transcending of painting, of sculpture, of poetry, and of music. . . . The evolution of man is a march toward movement developed in time and space We are abandoning the practice of known forms of art and embarking on the development of an art based on the unity of time and space.[87]

Fontana and his students had not yet developed the art forms to match their rebellious proclamations, however. Only in 1949 did Fontana exhibit his extraordinary *bucchi* (holes) (Figure 1.11) and black-light environment at the Galleria Naviglio in Rome. The gesture of puncturing the canvas, the picture plane, was of monumental significance. That gesture—which

FIGURE 1.10 *Alberto Burri,* Sacco 5P, *1953, burlap, acrylic, fabric, thread, plastic, and Vinavil on canvas, 150 × 130 cm. © 2017 Fondazione Palazzo Albizzini Collezione Burri, Città di Castello/Artist Rights Society (ARS), New York/SIAE, Rome. Image: SCALA/Art Resource, New York.*

he subsequently developed into *tagli* (cuts) in 1959—straddled the gestural expression of *art informel* and a new position in postwar European art. [88]

Over the few years leading up to the division of the country, modern art had a considerable presence in Germany. In addition to the reappointment of "degenerate" modern artists to academic positions and the return of exiled artists, art exhibitions circulated throughout the country and art magazines were founded. *Bildende Kunst* (Berlin) formed in 1947 and emphasized the work of the German expressionists and critical realism, particularly that of Karl Hofer, one of the magazine's founders, until in 1949, it was transformed into an organ for socialist realism by the Soviet administrators of the zone. In Baden-Baden, Woldemar Klein established *Das Kunstwerk* in 1946, devoting one of its first issues to international and German abstract painting, including the works of Baumeister, Hans Hartung, Ernst Wilhelm

FIGURE 1.11 *Lucio Fontana,* Concetto spaziale, *1949, paper mounted on canvas, 100 × 100 cm. Galleria Nazionale d'Arte Moderna, Rome. © 2017 Artists Rights Society (ARS), New York/SAIE, Rome. Mondadori Portfolio/Art Resource, New York. Photo: Alessandro Vasari.*

Nay, and Fritz Winter.[89] At the same time a series of exhibitions organized by the occupying countries circulated modern art throughout Germany. Because the National Socialists had pillaged the museums of their modern art works, the only sources of modern art for the Germans were other countries and the private collections that had been kept sequestered during the war.[90]

A significant collector of modern art was the Stuttgart doctor Ottomar Domnick. A neurologist and psychiatrist, Domnick collected modern art during the war and was committed to promoting it in the postwar period. In 1947 he published an essay on modern French painting. Then, with the encouragement of the allied authorities, Domnick let his collection

FIGURE 1.12 *Hans Hartung, T1937-33, 1937, oil, black chalk, and pastel on canvas, 97 × 130 cm. Collection Fondation Hartung-Bergman. © 2017 Artists Rights Society (ARS), New York/ADAGP, Paris.*

travel across Germany in 1948. The success was such that he followed by curating an exhibition that traveled to seven venues in Germany in 1948, introducing Germans to *art informel* including the work of the German émigré Hans Hartung and the Frenchman Pierre Soulages.[91] Many artists and critics working at that time credited Domnick's collection and traveling exhibition with an important role in the dissemination of modern art in postwar Germany.[92]

Hans Hartung was directly involved in French *art informel*, working in Paris with other artists in the sphere of Galerie René Drouin and Michel Tapié. After studying painting at the Academy of Fine Art in Leipzig, and the academy in Dresden, he had moved to Paris in 1932 to embark on his career as an artist (Figure 1.12). At the beginning of the war he joined the French Foreign Legion, and suffered severe injuries in combat, resulting in the amputation of a leg. He was granted French citizenship in 1946. Germans held conflicting feelings about Hartung as a hero of the French resistance and a French citizen.

Some Germans held greater respect for those who had remained in Germany during the war, with whom they had a shared experience. Such a painter was Fritz Winter, who came to be recognized by Germans as one

FIGURE 1.13 *Fritz Winter,* Black Action, *1955, oil on canvas, 45 1/8 × 57 3/4 in. (114.62 × 146.69 cm). Gift of Mrs. Harry Lynde Bradley M1961.77. Milwaukee Art Museum. Photo credit: Efraim Lev-er. © 2017Artists Rights Society (ARS), New York/VG Bild-Kunst, Bonn.*

of their most significant postwar artists, along with Willi Baumeister, a fellow member of Zen 49. Winter had worked in the modern style until the National Socialists declared his work degenerate. He was then drafted and sent to the Russian front, where he was captured. He was not released until 1949. He immediately banded with a group of artists and became active in the postwar art movements, working clearly in the gestural European *art informel* style (Figure 1.13).

The art historian Eduard Trier described Karl Otto Götz as "one of the thriving and active German artists after 1945, who experienced a creative euphoria like never before."[93] Considering the desperate straits of most Germans and German artists, this is a remarkable statement. Götz had fought in the war, manning a radar station in Norway for the Nazis. Immediately after the war, Götz, eager to continue his art practice, contacted Grohmann and Baumeister to reestablish artistic connections. Through his contacts, Götz was able to work and then to travel to Amsterdam and Paris in 1949 and 1950, where he, too, came under the spell of the new *art informel*, and he worked in the sphere of Co.Br.A., Hartung, Soulages, and

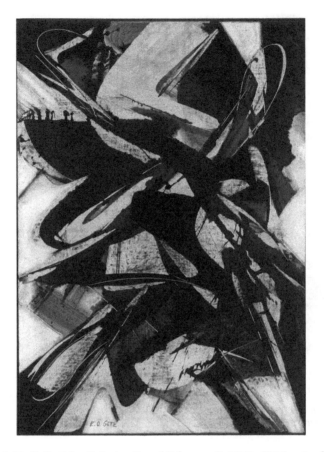

FIGURE 1.14 *K.O. Götz*, Painting Dated February 3, 1953, *1953, mixed media on canvas, 125 × 90 cm. Staatliche Kunsthalle, Karlsruhe. © 2017 Artists Rights Society (ARS), New York, VG Bild-Kunst, Bonn. Photo: Annette Fischer/Heike Kohler. bpk Bildagentur/ Art Resource, New York.*

the Nina Dausset Gallery. When Götz returned to Frankfurt, he formed with Bernard Schultze the Quadriga group of German *informel* artists. As a soldier, Götz had become intrigued by the electronic signals of the radar and while off-duty used oscillators to create among the earliest known electronic pictures. However, they were ephemeral and no longer exist. In his signature works of the 1950s, Götz translated these electronic pictorial effects into his paintings, which are extraordinary attempts to visualize the invisible electromagnetic spectrum (Figure 1.14). Götz and Schultze were active throughout the 1950s in creating and spreading *art informel* throughout Germany.[94]

The international ascendancy of *art informel* was deeply rooted in political, social, and economic developments in Europe between 1948 and 1952. During these years, Europe was stabilized socially and economically, principally by the European Recovery Program, popularly known as the Marshall Plan.[95] Of course, the economic benefits were extraordinary, but the principal benefit was the transformation of the European mindset from one of doom to one of optimism. This is reflected in the changes in European culture at this moment. Parallel to the economic recovery was a cultural transition away from the prewar modernisms that dominated the immediate postwar years and toward a new postwar, pan-European sensibility in painting, *art informel*. By the end of the economic stimulus plan, Europe was a stable, reconstructed society with a level of comfort that had not been a part of European life for nearly twenty years. At this point, a new phase in the artistic development of the first postwar decade materializes. It is reflected in the change in sensibility among the *art informel* artists of the 1950s, away from the aggressive, existentialist emotions in the radical paintings of Dubuffet, Fautrier, and Wols, Tapié's painters of *un art autre*. At this time painters began to generate formulaic, mannered versions of what Tapié had proclaimed was a total freedom of expression. When *art informel* achieved official sanction, it began to lose its resonance with Europeans.

Art informel became institutionalized in October 1953, when a group of *informel* artists in Paris established a salon of their own, which they called the October Salon. In a review of the exhibition, the art magazine *Art d'aujourd'hui*, a staunch supporter of the Ecole de Paris and geometric abstraction, derisively described the painterly style of this group as *tachistes*, or little patches of paint. The artists, including Jules Bissier, Bernard Dufour, and Serge Poliakoff, sought to distinguish themselves stylistically from other *informel* painters and appropriated the name. Charles Estienne viewed the transition of this style from a fringe avant-garde art movement to an international phenomenon. In his article "A Revolution, Tachism" Estienne viewed the Tachists, not disparagingly, but as the next new manifestation of art. He viewed the rebellious younger generation as having "violently" broken with the elder generation around 1952 to 1953. Taking exception with *Art d'aujourd'hui* dismissing, "'spots' or 'patches' (*taches*)," Estienne sees these painters as exercising "a total liberty of expression, which each time means to begin from zero. The patch, if one can put it like this, is the zero degree of plastic writing, the zero degree of the birth of the work."[96]

Estienne invokes the nearly decade-old expression of "the zero degree" to champion his new favorite painters, the Tachists. These artists were a slightly younger group of Parisians, who evolved from the painterly application of subconscious emotions to the canvas to composing layers of colored pigment to generate their design and textural pictorial effects. With such an approach to constructing a painting, Tapié's ambition to free oneself from design had been lost. The style once deemed anarchistic had become academic. Indeed, the manner began to be practised at academies across Europe, including the

Düsseldorf Art Academy. At the same time that the October Salon was held, Düsseldorf painters associated with the art academy banded together to form a self-described *Tachism* organization, Group 53. Under the direction of Gerhard Hoehme, Group 53 was one of the principal artistic voices of Western Germany and engendered other similar groups in that country.[97] However, they were destined for a short life. This style of painting was being taught in the academy, and some of the groups' younger members would soon depart from *Tachism* and form new artistic tendencies.

By the mid-1950s, some of the principal modern, *informel*, and expressionist painters of the first decade died: Baumeister, Hofer, Pollock, and de Staël. Their proclamations of a zero degree and a new beginning were no longer relevant to artists, critics, or citizens. Across Europe, critics were disillusioned with the newest manifestation of postwar painting, *Tachism*. Michel Seuphor commented on this predicament: "For five or six years, the neoexpressionistic, tachistic or informel painting finds itself at a dead end. Unable to continue."[98] Alain Jouffroy wrote in 1956 about "The Situation of Young Painting in Paris," complaining, "It is not brilliant." He condemned both the younger and the older artists of the previous decade as out of touch and irrelevant. Jouffroy echoes Estienne's disdain for geometric abstraction, and also considers abstract expressionism as "too limited to explosion," and views the new Tachists as "Vague and arbitrary." In a final gesture of heresy to the elder generation, he compared Sartre, "who pierces his own hand with a knife to prove his freedom to himself," to a group of adolescents "who in the middle of the night went out naked in Nantes to manifest their freedom."[99]

Mathieu's painting performances were a symptom of the degeneration of the subconscious, existentialist angst of *art informel* into self-indulgent theater. Mathieu began to stage dramatic painting performances with musical accompaniment. In 1954 at the *Salon de Mai*, Mathieu, dressed in medieval costume, painted a monumental canvas on the theme of the *Battle of the Bouvines*, before an audience while being filmed by Robert Descharnes. Mathieu continued these popular performances across Europe, including Germany, and in Japan, employing a variety of dramatis personae. This theatrical parody of painting and indulgence of the artistic ego incensed many artists of the second generation who were just coming of age. Barnett Newman described it as a "burlesque of immediacy."[100] Otto Piene claims to have been disgusted with Mathieu's performance in his studio in 1958, stating that the experience confirmed his artistic direction away from expressive, gestural painting.[101]

Across the continent, the vibrant, existentialist expression that had excited so many Europeans for the previous decade had run its course. In Düsseldorf, the academy institutionalized *Tachism* in its painting program. Although Group 53 was instrumental in disseminating abstract art throughout Germany, its vitality quickly dissipated. Anna Klapheck, an art historian at the academy and the critic for the *Rheinische Post*, reviewed the

annual Group 53 exhibition in 1957 by asking: "Tachism—The End or the Beginning?" She continued to describe the public response, a public that she described as "not just the petty bourgeois and the eternally ill-intentioned," who rumbled that the exhibition was "irrefutably the end of painting and its absolute end point. . . . These are psychograms and cardiograms, subjective releases maybe, but not pictures."[102] And John Anthony Thwaites recognized the limitations of *informel* and *Tachism*, and realized that it was not the departure for which so many had hoped. "*Informel* had dissolved the last remains of the Renaissance view of painting. . . . But with each passing year it became clearer, that no Cezanne had come forward. It was not a viable basis for future art. On the one hand, because Informel had created no concept of space, and on the other because it derived from a naïve spirit [*Geist*]."[103]

Clearly, the work of the *informel* and *Tachism* painters, who had been so highly praised over the previous decade, had diminished in importance among some of the more progressive minds in European art. The social and political environment and the psychological profile of Europeans demanded a new and different artistic perspective. A second generation of postwar artists was just coming of age, searching for a new mode of artistic practice with the realization that they must transcend the act of painting.

Notes

1 William S. Lieberman, *Max Ernst*. Exhibition catalogue (New York: Museum of Modern Art, 1961), 18, 19.

2 Suzi Gablick, "The Snake Paradise: Evolutionism in the landscapes of Max Ernst," *Art in America*, vol. 63 (May 1975): 38.

3 Günter Metken, "Europa nach dem Regen: Max Ernsts Dekalkomanien und die Tropfsteinhöhlen in Südfrankreich," in *Städel-Jahrbuch*, edited by Klaus Gallwitz und Herbert Beck, vol. 5 (München: Prestel Verlag, 1975), 293.

4 Werner Haftmann, *Verfemte Kunst: Malerei der inneren und äußeren Emigration*. (Cologne: DuMont Buchverlag, 1984), 211–15.

5 Tony Judt, *Postwar: A History of Europe Since 1945* (London: Penguin Books, 2005), 6. Judt also observed, "But the whole of Europe lived for many decades after 1945 in the long shadow cast by the dictators and wars in its immediate past. That is one of the experiences that Europeans of the post-war generation have in common with one another and which separates them from Americans, for whom the twentieth century taught rather different and altogether more optimistic lessons." My historical summary of the Second World War is largely drawn from Judt's transformative study *Postwar*, 6, 13–14, 16.

6 Ibid., 17–18.

7 Ibid., 61–2.

8 Ibid., 86.

9 Quoted in Frances Morris, *Paris Post War: Art and Existentialism 1945-55*. Exhibition catalogue (London: Tate Gallery, 1993), 15.

10 Calvino quoted in Judt, *Postwar*, 64.

11 Sarah Wilson "Paris Post War: In Search of the Absolute," in Morris, *Paris Post War*, 25.
12 Guilbaut, *Be-Bomb*, 21; Louis Parrot, "Hommage à Pablo Picasso qui vecut toujours de la vie de la France," *Les Lettres francaises* (October 7, 1944), 1, quoted in Guilbaut, *Be-Bomb*, 22. Much of the discussion of postwar French art between 1945 and 1955 relies on the seminal work of Serge Guilbaut and Francis Morris, *Reconstructing Modernism: Art in New York, Paris, and Montreal 1945-1964*, edited by Serge Guilbaut (Cambridge and London: The MIT Press, 1990); Morris, *Paris Post War*; and Serge Guilbaut, *Be-Bomb: The Transatlantic War of Images and all that Jazz. 1946-1956*. Exhibition catalogue (Madrid: Museu d'Art Contemporani de Barcelona and Museo Nacional Centro de Arte Reina Sofia de Madrid, 2007). The sections on postwar German art over this period rely heavily on the following four resources: *"Als der Krieg zu Ende war," Kunst in Deutschland 1945-1950*. Exhibition catalogue (Berlin: Akademie der Künste, 1975); Dieter Honisch, *Kunst in der Bundesrepublik Deutschland, 1945-1985*. Exhibition catalogue (Berlin: Nationalgalerie Staatliche Museen Preußischer Kulturbesitz, 1985); Eckhardt Gillen, *Deutschlandbilder. Kunst aus einem geteilten Land*, Exhibition catalogue (Martin- Gropius-Bau Berlin, Cologne, 1997); Stephanie Barron and Sabine Eckmann, eds., *Art of Two Germanys: Cold War Cultures*. Exhibition catalogue (New York: Abrams in association with the Los Angeles County Museum of Art, 2009).
13 Morris, *Paris Post War*, 16.
14 Leon Degand, "Of the Entire World," originally published as "Du monde entire," in *Les Lettres françaises* (Paris) (December 6, 1946), reprinted in Guilbaut, *Be-Bomb*, 275.
15 John Anthony Thwaites, "Abstract Art and the Geni Francais," unpublished text written in 1949 referencing Cassou's "Les Premiers Maitres de l'art Abstrait" (Paris: Editions Pierre a Feu, Mai 1949). John Anthony Thwaites Papers, Zentralarchiv des internationalen Kunsthandels, Cologne.
16 Morris, *Paris Post War*, 16.
17 Hannelore Schubert, "Gibt es wieder eine Düsseldorfer Malerschule?" *WDR Nachtprogramm*, (Thursday, July 9, 1957). Otto Piene Archive.
18 Heinz-Norbert Jocks, *Das Ohr am Tatort: Heinz Norbert Jocks im Gespräch mit Gotthard Graubner, Heinz Mack, Roman Opalka, Otto Piene, Günther Uecker* (Ostfildern: Hatje Cantz, 2009), 39.
19 Judt, *Postwar*, 6, 13, and 21.
20 Julien Alvard (June 1951), p. 25, quoted in Guilbaut, *Reconstructing Modernism*, 66.
21 Morris, *Paris Post War*, 155.
22 Ibid., 16
23 Jean-Paul Sartre, *Morts sans sépulture* (The Victors) in *Three Plays by Jean-Paul Sartre* (New York: Alfred A. Knopf, 1949), 267.
24 Morris, *Paris Post War*, 40.
25 Many scholars have grappled with "the German question" as a construct for interpreting twentieth-century European history, see Stefan Wolff, *The German Question since 1919: An Analysis with Key Documents* (New York: Greenwood Publishing Group, 2003).
26 As early as 1946 Karl Jaspers published *The Question of German Guilt* (Heidelberg: 1946), in which he stated unequivocally, "Guilt, therefore, is

necessarily collective as the political liability of nationals," but he denied German guilt as "moral and metaphysical, and never as criminal guilt." Quoted in John-Paul Stonard, *Fault Lines: Art in Germany 1945-1955* (London: Ridinghouse, 2007) 76.

27 Konrad Adenauer in 1945 and in 1966, quoted in Stonard, *Fault Lines*, 259, 260.

28 Eduard Trier, "1945-1955 Fragmentarische Erinnerungen," in *Kunst in der Bundesrepublik Deutschland, 1945-1985*, 10.

29 Eberhard Roters, "Bildende Kunst," in *"Als der Krieg zu Ende war": Kunst in Deutschland 1945-1950*, 10, 9.

30 Stonard, *Fault Lines*, 75.

31 Tilman Fichter, "Ungemalte Deutschlandbilder," in *Deutschlandbilder*, 38.

32 See Sabine Eckmann's list of exhibitions in Berlin in her essay "Ruptures and Continuities: Modern German Art in between the Third Reich and the Cold War," in Barron and Eckmann, *Art of Two Germanys*, 50.

33 Trier in *Kunst in der Bundesrepublik Deutschland*, 9. Stonard also notes that the writer Viktoria Ehrig described the opening of the gallery as the "first sensation in the ruined metropolis." See Stonard, *Fault Lines*, 37.

34 Stonard, *Fault Lines*, 139, 151–52.

35 Willi Baumeister Tagebuch, October 20, 1945, quoted in *Kunst in der Bundesrepublik Deutschland*, 10.

36 *Kunst in der Bundesrepublik Deutschland*, 100.

37 Ernst Wiechert, "Rede an die deutsche Jugend," 1945, quoted in Brockmann, "German Culture at the 'Zero Hour'," 9.

38 Alfred Andersch, 1949, quoted in Brockmann, "German Culture at the 'Zero Hour'," 17–18. Brockmann also quotes Hans Werner Richter, 1946, echoing this sentiment when he wrote, "The only possible source for a spiritual rebirth lies in an absolute and radical new beginning."

39 See Brockmann, "German Culture at the 'Zero Hour'," 12, and Sabine Eckmann in Barron and Eckmann, *Art of Two Germanys*, 49.

40 Laurel Cohen-Pfister, "History, Memory and Narrative," and "An Aesthetics of Memory for Third Generation Germans: Tanja Dückers, *Himmelskörper*," in *German Literature in a New Century: Trends, Traditions, Transformations*, edited by Katharine Gerstenberger and Patricia Herminghouse (New York: Berghahn Books, 2008), 120. See also Alexander Mitscherlich, *Society without a Father* (New York: Harcourt Brace & World, 1969).

41 Walter Gropius, 1947, quoted in footnote 27 cited in Yule F. Heibel, *Reconstructing the Subject: Modernist Painting in Western Germany, 1945-1950* (Princeton: Princeton University Press, 1995), 19.

42 Karin Kiwus in her introduction, "Zur Ausstellung," to the exhibition "*Als der Krieg zu Ende war*," 4.

43 Karl Jaspers, quoted in Brockmann, "German Culture at the 'Zero Hour'," 11.

44 Bernard Myers, "Postwar Art in Germany," *College Art Journal*, vol. 10, no. 3 (Spring 1951): 251–56, 260. Originally cited in Stonard, *Fault Lines*, 33.

45 Heinrich Böll, 1977, and Hans Grundig, 1946, quoted in Stonard, *Fault Lines*, 33, 84.

46 Theodor W. Adorno, "What Does Coming to Terms with the Past Mean?" translated and reprinted in Geoffrey H. Hartman, *Bitburg in Moral and Political Perspective* (Bloomington: Indiana University Press, 1986), 115.

47 See Alexander and Margarete Mitscherlich, *Die Unfähigkeit zu trauern. Grundlagen kollektiven Verhaltens* (München: Piper, 1967). The application of theories of individual psychology applied to society has flaws in terms of imposing an individual analysis over a whole society and, therefore, not allowing the variations of response that emanated from differing war experiences. As we have read, Böll and Grundig despaired of the war and expressed their grief over its repercussions.

48 Andreas Huyssen, *Present Pasts: Urban Palimpsests and the Politics of Memory* (Stanford: Stanford University Press, 2003), 145–46.

49 "Latenzzeit: Die Leere der Fünfziger Jahre. Ein Interview mit Anselm Haverkamp von Juliane Rebentisch und Susanne Leeb," *Texte zur Kunst* vol. 12, no. 50 (2003): 45.

50 Ibid. See also Haverkamp, *Latenzzeit*.

51 *Manifesto blanco*, reprinted in Celant, *Italian Metamorphosis,* 709.

52 Guilbaut, *Be-Bomb.*

53 Estienne, "Painting and the Epoch," 1946, op. cit.; Guilbaut, *Be-Bomb*, 277, 278, 279.

54 Celant, *Italian Metamorphosis, 5.*

55 Ibid., 24.

56 Buffet quoted from his Manifeste de l'homme temoin (Manifesto of Man as Witness) in Guilbaut, *Reconstructing Modernism,* 47.

57 Guilbaut, *Reconstructing Modernism,* 44.

58 Many art and culture historians have addressed the relationship between the German "Volk" and art. See Walter Grasskamp, *Die unbewältigte Moderne: Kunst und Öffentlichkeit* (München: Beck, 1989); Hans Belting, *Die Deutschen und ihre Kunst* (München: C.H. Beck, 1993).

59 Adolf Behne, "Was will die moderne Kunst?" *Bildende Kunst*, vol. 2, no. 1 (1948): 3, 4.

60 Hans Gerhard Evers, *Das Menschenbild in unserer Zeit. Darmstädter Gespräch* (Darmstadt: Neuer Darmstädter Verlag, 1951).

61 Stonard provides a good description of the proceedings in his *Fault Lines,* 251–58.

62 Michel Tapié, "Becoming of an Art Autre," originally published as "Devenir d'un art autre," in *Combat* (August 30, 1954), reprinted in Guilbaut, *Reconstructing Modernism, 562.* Also see Tapié's use of the term in his essay "Andere Strukturen—Neue Räume," (Mai 1958) for the Galerie Schmela. Alfred Schmela Papers, 2007. M.17, Box 15, F2A. Getty Research Institute.

63 Michel Tapié, "Vehemences confrontees," 1951, reprinted in Guilbaut, *Be-Bomb,* 540.

64 Margarlit Fox, "Karel Appel, Dutch Expressionist Painter, dies at 85," *The New York Times* (May 9, 2006), A25.

65 Charles Estienne, "Revolution, Tachism," originally published as "Une revolution: le tachism," *Combat*, no. 4 (March 1, 1954): 1–2, reprinted in Guilbaut, *Be-Bomb, 555.*

66 Tapié, "Vehemences Confrontees," 1951, reprinted in Guilbaut, *Be-Bomb,* 544; Michel Tapié, "Jackson Pollock is with Us," originally published as "Jackson Pollock avec nous," in the catalogue of Pollock's exhibition in the Studio Paul Faccehtti, Paris, 1952, reprinted in Guilbaut, *Be-Bomb,* 530;

Michel Tapié, "Andere Strukturen—Neue Räume," (May 1958). Alfred Schmela Papers, 2007.M.17, Box 15, F2A. Getty Research Institute.

67 Michel Tapié, "Becoming of an Art Autre," originally published as "Devenir d'un art autre," Combat (August 30, 1954) reprinted in Guilbaut, *Be-Bomb*, 562–64. This well-known history merits a summary here as the foil against which Group ZERO and the new tendency artist rebelled.

68 The most through explication of Fautrier's work is Curtis L. Carter and Karen K. Butler, eds., *Jean Fautrier 1898-1964*. Exhibition catalogue (New Haven and London: Yale University Press, 2002).

69 Morris, *Post War Paris*, 20.

70 For more about Wols, see *Wols: Retrospective*, exhibition catalogue (München: Hirmer Verlag in association with the Kunsthalle, Bremen, and the Menil Collection, Houston, 2013).

71 Guilbaut, *Reconstructing Modernism,* 60.

72 Ewald Rathke wrote in his essay "Wols," in Gillen, 1997, op. cit., p. 86, that the exhibition "blieb praktisch unbemerkt" [remained practically unnoticed].

73 Mathieu quoted in Morris, *Post War Paris*, 182.

74 Tapié quoted in Hal Foster, et al., *Art Since 1900* (London: Thames and Hudson, 2004), 371.

75 Lawrence Alloway, "Introduction," in *Art in Western Europe: The Postwar Years, 1945-1955*. Exhibition catalogue (Des Moines, IA: Des Moines Art Center, 1978), 11.

76 Morris, *Post War Paris*, 45.

77 Carol J. Murphy, "Re-Presenting the Real: Jean Paulhan and Jean Fautrier," *Yale French Studies*, no. 106, The Power of Rhetoric, the Rhetoric of Power: Jean Paulhans Fiction, Criticism, and Editorial Activity (2004): 83.

78 The most ambitious exhibition on this subject employs "informel" as its title to reference these works. Kay Heymer, Susanne Rennert, and Beat Wismer, eds., *Le grande geste! Informel and Abstrakter Expressionismus 1946-1964*. Exhibition catalogue (Düsseldorf: Museum Kunstpalast, 2010). Heymer quotes Guilly, critic and writer for *Combat*, as the epigram for his essay, 12.

79 Morris, *Post War Paris*, 45, 21–2.

80 Ibid., 45. Morris quotes this statement from Basil Taylor, "Art," *The Spectator*, vol. 16 (September 1955): 362. However, the sentence does not appear in the translation of Tapié's essay reprinted in Guilbaut, *Be-Bomb*, 540–45.

81 Tapié wrote the essay for Pollock's first solo show in Paris (1952).

82 Fox, "Karel Appel," (May 9, 2006): A25.

83 William Grimes, "Antoni Tàpies Spanish Abstract Painter, Dies at 88," *The New York Times* (February 6, 2012).

84 Celant, *The Italian Metamorphosis,* 28.

85 Hamilton, "Strategies of Excess," 35, 36.

86 Ibid., 51–52.

87 *Manifesto blanco*, 1946, reprinted in Celant, *The Italian Metamorphosis,* 709–10.

88 Germano Celant's catalogue for the *Lucio Fontana* at Gagosian Gallery, New York, is an excellent source of information on the artist (Milan: Skira and the Gagosian Gallery, 2012).

89 Barron and Eckmann, *Art of Two Germanys,* 53, 52.

90 Stonard, *Fault Lines*, 182–89.

91 Ibid., 213–14.

92 See John Anthony Thwaites, "Anno 1954," op. cit; Eberhard Roters in "Als der Krieg zu Ende war," 11; Eduard Trier, "1945-1955: Fragmentarische Erinnerungen," in Honisch, *Kunst in der Bundesrepublik Deutschland,* 12; and Karl Otto Götz, *Erinnerungen, 1945-1959* (Aachen: Rimbaud Verlag, 1994), 17 ff.

93 Eduard Trier, "1945-1955: Fragmentarische Erinnerungen," in Honisch, *Kunst in der Bundesrepublik Deutschland,* 11. The most comprehensive study on Götz is Joachim Jäger, Udo Kittelmann, Alexander Klar, and Walter Smerling, eds., *K.O. Götz*, exhibition catalogue (Köln: Wienand Verlag, 2013).

94 Götz, *Erinnerungen 1945-1959*, 10, 12, 17, 60, and 79–99.

95 Judt, *Postwar*, 90–99.

96 Charles Estienne "A Revolution, Tachism," (1954) reprinted in Guilbaut, *Be-Bomb*, 554–57.

97 The only comprehensive study on this organization is Marie-Luise Otten, *Gruppe 53. Auf dem Weg zur Avantgarde.* Exhibition catalogue (Heidelberg: Edition Braus im Wachter Verlag für das Museum der Stadt Ratingen, 2003).

98 Michel Seuphor quoted by G. Joh. Klose, "Zwei neue Zeitschriften," *Nordrheinische Zeitung* (May 24, 1958). Otto Piene Archive.

99 Alain Jouffroy, "The Situation of Young Painting in Paris," originally published as "Situation de la jeune peinture a Paris," *Preuves*, no. 68 (October 1956), reprinted in Guilbaut, *Be-Bomb*, 672, 676.

100 Fred Gross, "Mathieu Paints a Picture," (2008), http://web.gc.cuny.edu/ArtHistory/part/part8/articles/gross_print.html. This performance was followed by an article "Mathieu Paints a Picture" with an essay by Michel Tapié published in *Art News*, 53/10 (February 1955): 50–53. See Remy Golan, "L'Eternal Décoratif: French Art in the 1950s," *Yale French Studies*, no. 98, The French Fifties (2000): 106, 109.

101 Otto Piene in conversation with the author. March 30, 2012.

102 Anna Klapheck, "Tachismus—Ende oder Anfang?: Zur Ausstellung der "Gruppe 53" in der Kunsthalle Düsseldorf," *Rheinische Post* (January 30, 1957).

103 John Anthony Thwaites, "Yves le Phenomene ist tot: Ein Nachruf für Yves Klein," *Deutsche Zeitung*, Nr. 136 (June 14, 1962): 14.

CHAPTER TWO

"Does Contemporary Painting Influence the Shape of the World?": The Problem of Painting and the Question of Reality

A host of first-generation postwar artists and critics across Europe issued proclamations and manifestoes that rejected the centuries-old traditions of European art. The rhetoric was aggressive and violent, like the war that had recently ended. In his vituperative essay "Véhémences confrontées" (1951), art critic Michel Tapié called for anarchy and abandoning the traditional formalism of European painting. He proposed a total immersion in the artist's subconscious, to achieve an uninhibited freedom of expression and, through this freedom, the liberation of art and "the end of the History of Art."[1] Jean Dubuffet advocated an *art brut*, modeled on the art of asylum patients and the troweling techniques of lathers. He dissociated himself from the art of the academies and aligned himself with production outside the accepted boundaries of art. He rejected painterly finesse and created coarse "matter" paintings. In his 1951 lecture at the Arts Club of Chicago, "Anti-cultural Positions," he announced: "I have the impression that a complete liquidation of all the ways of thinking whose sum constituted what has been called humanism and has been fundamental for our culture since the Renaissance, is now taking place."[2] Similar declarations by the adherents of *art informel* and *art brut* followed. Georges Mathieu claimed that "everything has to be done anew"[3]; Karel Appel said, "The Cobra group started new, and first of all we threw away all these things we had known and started afresh like a child-fresh and new"[4]; and the Italian Nuclear

Painters Enrico Baj and Sergio Dangelo announced that they wanted "to strike down all 'isms' of a painting that falls invariably into academicism . . . [in order to] reinvent painting."[5]

These artists sought to purge themselves of the art associated with the culture that created the war and aspired to, "the zero degree of the birth of the work,"[6] a new artistic beginning. The pontifications of these *informel* artists and their spokespersons were sincere, yet in retrospect they seem to be only rhetorical gestures. Despite their language of rebellion, these artists employed a basic art vocabulary that was entrenched in the tradition of painting. They had trained in this tradition and could not extract themselves from it. A new beginning in 1945 was unrealistic. Rather, as Anselm Haverkamp has postulated, the decade following the war was an "incubation period," when new cultural tendencies were gestating.[7] The more profound departure from the basic tenets of modern painting occurred in the mid-1950s, in the hands of the next generation, the second postwar generation, those who were old enough to have witnessed the war but too young to have been perpetrators or resistors, the children of the war. This generation associated the destruction of Europe and the demoralization of the European psyche with the culture of their fathers, the culture represented by modern art. The children confronted the necessity of constructing a new culture for the reality of the postwar period, in defiance of the fathers. As Mack remembers, he "felt, even in the face of the rubble of a world war disaster, a call to forge a new reality."[8]

During the mid-1950s a group of adventurous artists appeared in Europe, the UK, the United States, and Japan, who rebelled against the gestural painting of *art informel* and abstract expressionism, and imagined new cultural identity. This generation recognized, as Pierre Restany declared, "Painting is dying."[9] Questioning modern painting as a valid form of expression, they forged a substantive departure from the style, practice, and ideological foundation of modern art. The artists who reached maturity in the mid-1950s decisively altered the form, the media, and the visual appearance of art.

The validity of painting had been threatened since the invention of photography when French academic painter Paul Delaroche was reputed to have bemoaned, "From today painting is dead."[10] The question of painting's relevance was resurrected in the aftermath of the First World War, when Dada and surrealist artists introduced ready-mades, collage, and autonomous processes such as Ernst's *frottages* and *décalcomanie* to breach the sanctity of the painted surface and to divorce art from the touch of the creator. In the 1920s these artists and intellectuals grappled with the fact that photography and mechanical reproduction violated the aura of originality inherent in painting. Alexander Dorner and Erwin Panofsky carried on a public debate in the German newspapers sparked by Dorner's 1929 exhibition of reproductions with original works of art in Hanover. In Dorner's essay "The End of Art," he questioned the relationship between,

and the purpose of, the original versus the reproduction, to which Panofsky replied that if the originality of art was no longer recognized, it would indeed signal "the end of art."[11] This so-called reproduction debate occurred several years before Walter Benjamin elaborated on these issues in his oft-cited essay "The Work of Art in the Age of Mechanical Reproduction" (1936).[12] The surrealist author Louis Aragon addressed "the problems of painting" in his essay "Challenge to Painting" (1930). He reminded his readers that "painting has not always existed" and he imagined "its end, as for any other concept." Despite the fact that "painters are still in love with painting," he predicted, "The day will come when no one will paint any longer."[13]

The problem of painting took even greater urgency in Europe in the wake of the Second World War. Grave doubts about European culture ensued in the wake of the most devastating conflict wrought by mankind. Europe's illusion of embodying civilization's greatest achievements "was now discredited beyond recovery."[14] Proponents of twentieth-century European culture advocated that its supreme expression was found in modern art. And modern art's greatest achievement was painting, specifically abstract painting. Even American critic Clement Greenberg, champion of American abstract expressionist painting, observed what he called "The Crisis of the Easel Picture." In this early essay Greenberg outlines the dissolution of easel painting as a window on the world into a formal, visual phenomenon, employing a vocabulary that harkens of the impending phenomenological justification of the "new tendency" artists. He argued that "this dissolution of the picture into sheer texture, sheer sensation, into the accumulation of similar units of sensation, seems to answer something deep-seated in contemporary sensibility."[15] Prior to the war, painting had served, in the words of Yve-Alain Bois, as a "model" of modern culture.[16] But the Second World War shattered the faith of avant-garde artists, writers, and thinkers in this model, and they abandoned the forms of art associated with the society that brought Europe to the brink of ruin. Traditional cultural expression was challenged in the aftermath of this conflict. Writers and artists across Europe asked what was the proper means of resuscitating humanism, or whether that was even possible. In the oft-quoted words of Theodor W. Adorno, "To write lyrical poetry after Auschwitz is barbaric."[17] Fontana echoed Adorno in his journal *Il Gesto* in 1955, stating, "Painting after Hiroshima and Nagasaki is impossible."[18] To excerpt Adorno's remark from his discussion of cultural criticism makes his statement and Fontana's echo appear totally nihilistic. Poet Paul Celan later elaborated on Adorno's statement and agreed that "after Auschwitz no poem is possible," and followed with the necessary option, "unless because of Auschwitz the remembrance is the reason for the 'speech of poets'."[19]

The debate on modern art and painting circa 1950 revolved around the formal questions of whether abstract art or representational art was more appropriate for rendering the "reality" of postwar Europe. These debates ignited with the 1948 Venice Biennale and the *Salon d'Automne*

and continued with a series of ideological debates throughout Europe. In Germany competing cultural leaders took firm positions in the art magazines *Bildende Kunst* and *Das Kunstwerk* and in the *Darmstadt Conversations*, on the appropriate subject for art being either the visible reality of the natural world or the abstract, scientific reality of the technological world. Tapié correctly identified that the issue is not representational versus abstract art; rather it is a question of artistic expression relevant to contemporary reality. Despite the official proclamations endorsing modern art, the argument neither dissipated nor adequately addressed the artistic development of postwar Europe. In Germany abstract painting remained a charged proposition, even after Bode organized the first *documenta* in 1955 to endorse the history of modern art. As Günter Grass recalled: "Berlin. . . . Arguments about everything. Representational versus nonrepresentational art: Hofer on one side, Grohmann on the other. Over here and over there: here Benn, there Brecht. Cold War by loudspeaker. And yet the Berlin of those years, for all the shouting, was a place as silent as the dead."[20]

For Germans in the decade following the war, the psyche was reflective, questioning horrors of the Nazi regime and contemplating the reconstruction of their discredited identity. In literature, writers such as Heinrich Böll created what critics called *Trümmerliteratur* (rubble literature). German *Tachism* paintings, epitomized by Gerhard Hoehme and Group 53, conveyed the social psychology of the time by building up their picture surface with the gesture of their brush or the facture of their palette knife in dark, thickly labored canvases. Piene described this sentiment as a "poetry of catastrophe," satirizing the words of one German critic who had termed it a "poetry of paint material."[21] In their dialogues on the direction of art, the small group of artists around Piene and Mack in their "Ruinenatelier" clearly understood the relationship between the catastrophe of war and the turbid moroseness of *Tachisme*. Piene remarked: "We hated the development of the post-war German spirit, and we angrily resented the pessimistic humanism which occupied literature and the fine arts in the Fifties, when miserableness was a fashionable convention."[22] He recognized, "We were against almost everything around us (like the Dadaists were after World-War I)," and then asked, "But what were we for?"[23] ZERO artist Günther Uecker, reflecting on this moment, did acknowledge what they could not do, "With this heightened awareness of the annihilation of people all over the world, of this mass murder . . . one could not stand in a meadow and paint flowers."[24]

In this chapter I examine the second postwar generation of artists, who developed into Group ZERO and the pan-European new tendencies, and their perception of the problem of painting and its ability to render the postwar reality. Over a period of approximately five years between 1955 and 1960 these artists formulated their answers to the problem of painting, and their solutions were tied to their evolving social and philosophical conception of the reality of the second postwar decade. The chapter will focus on the founding figures of Group ZERO, Mack and Piene, and follow

their network of colleagues across Europe, artists whom they met in the academies, and at the galleries and exhibitions in Antwerp, Düsseldorf, Milan, and Paris. As they participated in one another's exhibitions the network of their associations stretched across the continent and the stimulus of sympathetic individuals spurred new forms of art, one motivating the next in a catalytic creative sequence. By the end of the decade, these innovations led to the dissolution of the static objet d'art and the creation of kinetic, ephemeral, sensory artistic experiences. Mack remarked, "Everything revolved around . . . the question of how and where the boundaries of art could be transgressed."[25]

The language for articulating these artistic developments derived from the newly ascendant philosophy of phenomenology as it was practiced in Germany by Nicolai Hartmann, Martin Heidegger, and Edmund Husserl, and in France by Maurice Merleau-Ponty. The artists, particularly Piene and Mack, who received advanced degrees in philosophy from the University of Cologne in 1955, derived their conception that materials of art could be the source of energy to catalyze sensory experiences. Their interpretations of phenomenology linked the existential view of postwar life with the scientific justification for abstract art based on physiological sensations, physics, electromagnetics, and consumer products as the basis of the second generation's interpretation of the new reality of their generation. Initially, these ideas found material form in the resurrection of the 1920s media of monochrome painting, collage, and kinetic sculpture. Although these are formally and visually divergent, the artists viewed them as differing interpretations of the same philosophy. This phase of postwar new tendencies in art culminated in 1960 in two exhibitions, *Monochrome Painting* (*Monochrome Malerei*, Leverkusen) and at the Venice Biennale, announcing the institutional recognition of the new tendencies in art.

When they decided to study art, Mack and Piene entered into the tepid tempest described by Grass that was marked by derivative modern painting and polarized aesthetic opinions. The Darmstadt Conversations heightened the awareness of the struggle to persuade a reluctant German public to accept modern art, a public who had been inculcated with National Socialist Realism, and nineteenth-century academic genre and landscape painting.

Piene began his art education at the College of Art in Munich in 1948, where he studied drawing under Willi Geiger. In 1950 he moved to the Düsseldorf Art Academy, where he studied painting under Otto Pankok. There he met and befriended his classmate Mack, who had enrolled in the school at the same time. The two painted their way through art history, and by the time they completed their studies, they were working in the predominant style of *Tachism*. Yet, the fashion of *Tachism* could not answer the difficult questions raised by the experience of these young Germans, who had witnessed the war. They turned to philosophy, enrolling in the University of Cologne at the time of their studies at the Düsseldorf Art Academy. In Cologne they received a foundation in the classical philosophy of Plato,

Gottfried Wilhelm Leibniz, and Immanuel Kant. But their principal subjects of study were the contemporary existentialist philosophies of Albert Camus and Jean-Paul Sartre and the phenomenology of Hartmann, Heidegger, and Husserl.[26] This education provided the intellectual foundation for their thinking about the problem of painting and the questions of postwar reality.

In the wake of the Cold War schism, the debate over figuration or abstraction as the proper form to depict postwar European reality took on a political as well as a cultural dimension. In a specifically German manifestation of the question of figuration versus abstraction, the Germans also broached the question of the *Menschenbild* (image of humanity) in the first of the Darmstadt Conversations (1950), a dialogue that they considered the "formalism debate." Piene entered into the debate in 1955, on the occasion of the inaugural *documenta* exhibition in Kassel, when he was recruited to deliver a public lecture about modern art to bolster public understanding on the subject. For his lecture, "What Is the Meaning of Modern Art?" (1955), Piene appropriated the title of Wilhelm Hausenstein's 1949 publication, in which the art historian assumed an antimodernist position and argued for the restoration of humanism through representational painting.[27] But he took a position in opposition to Hausenstein and Sedlmayr, without mentioning either by name. In this lecture Piene observed,

> Our time (and therefore our lives) is marked . . . by the fact that there have been two world wars of previously unimagined dimensions. They have sown in us, the survivors, a distrust, that manifests itself in a decisive distrust of "the merely optical," "the merely sensuous," "the mere appearance."

After undermining the physical reality of the visible world, Piene continued to develop the idea that modern knowledge and technology demonstrate another reality that is not visible to the eye. He asked the audience, "What are the phenomena of our world?" And he answered,

> We have the lights of the city
> We have speed.
> We have flight.
> We have traffic.
> We have our aspirations.
> We have the Atom bomb

After reviewing the history of modern art, referencing scientific breakthroughs of the past generations and comparing abstract paintings to microscopic views and close-up photographs, he concluded, "Modern art pursues a formal . . . design, that . . . in retrospect proves to be relative to a scientifically founded world."[28]

Piene's position echoes those of art historians Adolf Behne, Will Grohmann, and Werner Haftmann, who argued for the relationship of abstract painting to the science-based reality of the atomic age. As opposed to Baumeister's reliance on spiritual motivations and appeal to transcendence as the justification for abstract art, Behne introduced the comparisons with science and Grohmann developed the idea of comparing abstract painting to photographs—the mirror of nature and the epitome of representational imagery—that did not appear to represent actual objects.[29] Piene utilized these strategies in his lecture to reinforce his message.

Piene also obtusely referenced the Darmstadt Conversations where Baumeister and Sedlmayr presented their ideas in the session "The Image of Mankind in Our Time" by stating that our modern times also have "political conferences that strive to let the difficult remain difficult."[30] Piene was close to the debates when he studied at the College of Art in Munich under Willi Geiger, whose son, Rupprecht, was a member of Baumeister's Zen 49. At this time Sedlmayr taught nearby at the Ludwig Maximilians University and was the object of ridicule by the more progressive art students who despised his book *Loss of the Center*. They invented lyrics for a popular beer hall song with the refrain

Sieh da kommt des Sedlmayr
Und du meinst ein Mädel sei er.
[Look, here comes Sedlmayr
And you could think that he was a girl.][31]

Through the rhyme of beer hall humor, the students' lyrics expressed their disdain for Sedlmayr's regressive aesthetics and the general desire, common among art students of any time, to be progressive. The art historian and critic Anna Klapheck shared the students' sentiments and expressed concern that Sedlmayr's 1948 book *Loss of the Center* was "becoming a buzzword . . . seized upon by those who . . . want to give modern art a death blow."[32]

In this early lecture Piene articulated the basic principles that would guide his and Mack's artistic pursuits: utilizing modern science, knowledge, and materials to create physical, sensory experiences. However, just as Lucio Fontana in 1946, neither Mack nor Piene in 1955 possessed the visual vocabulary to realize their pronouncements. They were working in the newly minted French style of *Tachism* that had been introduced to West Germany by Karl Otto Götz, Gerhard Hoehme, and Emil Schumacher. Both Mack and Piene produced commendable works in this style, *Black Rotation* (1956–57, Figure 2.1) and *Barriere II* (1956, Figure 2.2), respectively. In both paintings the artists restrict the palette to black, white, and gray. While Piene demonstrates a more painterly expression in his slashes of white across the dark ground, Mack builds up his rondo format with his innate sense of structure in the spiraling blocks of black. They both emulated the dark

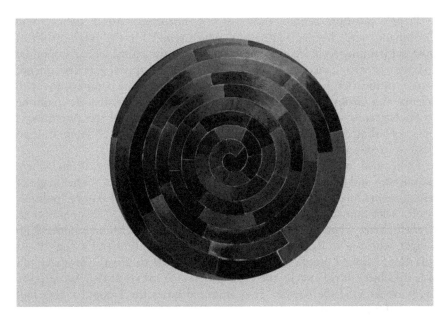

FIGURE 2.1 *Heinz Mack,* Black Rotation, *1956/57, paint on wood, 180 cm diameter. Atelier Mack. © 2017 Artists Rights Society (ARS), New York/ VG Bild-Kunst, Bonn.*

palette and thick impasto of the German brand of *Tachism* as represented by Hoehme in his *Black Spring* (1956, Figure 2.3), a style that he developed into his own tactile matter paintings.

Based on the strength of their work, Hoehme invited Piene and Mack to join Group 53, and they participated in the fourth annual exhibition in January 1957. Thwaites considered this exhibition of the group as the forum that ignited progressive contemporary visual arts in Düsseldorf, and generally throughout West Germany.[33] Over the subsequent six months a series of art events occurred in rapid succession that introduced new galleries, new artists, and new directions in art, revitalizing the art culture in Düsseldorf and sparking its transformation into one of Europe's art centers over the next several decades.

When the association was founded in 1953, little support existed for practicing artists. No private galleries existed in Düsseldorf that were interested in contemporary art, and Group 53 assumed the responsibility for developing the art and its reception for its artist members.[34] Thwaites described the work in the first exhibition of the group, "In reality they were bad. They were so bad that [Peter] Brüning and [Herbert] Kaufmann . . . withdrew." The prospects of this group were dire, so they recruited Hoehme from Paris to direct it in 1955.[35] Under Hoehme's leadership the quality of the membership improved. He relieved some amateurs and invited others to

FIGURE 2.2 *Otto Piene,* Barriere II *(1956), egg tempera on board. Otto Piene Archives. © 2017 Artists Rights Society (ARS), New York/VG Bild-Kunst, Bonn.*

join, including the promising young academy artists Mack and Piene. For the 1956 annual exhibition he secured the French critic Pierre Restany and Jean-Pierre Wilhelm, who had returned from Paris where he lived during the war, to present the opening remarks. Thwaites recounted Restany's demand that *Tachism* find "a completely new law of beauty, form and space that would simply omit all the other laws in the history of art."[36]

Thwaites remarked that the consequences of Hoehme's accomplishments were "great." Group 53 presented their new identity in the following exhibition opening on January 20, 1957, when the critics and the public erupted in a maelstrom over the new work. Hannelore Schubert chastised the artists noting, "Tachism is still not a license for uncontrolled lasissez-faire, on the contrary, it demands the absolutely precise visualization of the artist's personal experiences in the paintings."[37] Despite her criticism, Schubert believed that this was the most significant exhibition for Group 53 to date.[38] Anna Klapheck and Thwaites agreed and felt that this was a breakthrough exhibition for the development of art in West Germany. Klapheck, a journalist and advocate for new art in the Rhineland, reviewed the January

FIGURE 2.3 *Gerhard Hoehme,* Black Spring, *1956, oil, velvet, and string on canvas, 125 × 200 cm. Kunst aus NRW, Aachen-Kornelimünster. Photo Anne Gold. © 2017 Artists Rights Society (ARS), New York/VG Bild-Kunst, Bonn.*

1957 exhibit under the title "Tachism—End or Beginning?" She wrote that one could repeatedly overhear people in the crowd bemoaning, "This is now incontrovertibly the end of painting . . . its absolute end point." She noted that these remarks came from people (who had in the meantime learned to bravely swallow "abstract art"), not the "petty bourgeoisie and eternally ill-intentioned," and that this cultivated audience described the radical new works at best things that concern a medical doctor or psychologist, as the represented "'psychograms' and cardiograms', subjective releases, but not paintings." Thwaites observed that the audience was particularly agitated by two paintings by Hoehme, monumental monochromes, *Black Spring* (Figure 2.3) and *White as Ivory.* Klapheck lamented that the public did not grasp that these new paintings indicated that German artists had crossed a threshold. She beseeched her readers, "Just look at these paintings, where the tyranny of the flat surface has been fundamentally abdicated and space energetically reconquered." Her remarks echoed those of Restany from the previous year. She concluded her review adamantly stating that this was not an endpoint, but a new beginning, making special mention of the young artists Mack and Piene, whom she described as "the pure Tachists."[39] And Schubert, who had criticized most of the artists in the exhibition, specifically complimented Mack for having "found a new approach of surprisingly painterly intensity."[40]

The German audience was just becoming acclimated to abstract painting, when the younger painters began to push their work even further from

abstraction to monochrome. Hoehme's work established the benchmark and indicated the barometer of artistic interest moving toward monochromatic paintings. Mack mentioned that word had reached Düsseldorf about the Spanish *informel* painter Antoni Tàpies and his monochromatic matter paintings. He made the effort to see them in Paris in 1956, and Schmela's gallery presented Tàpies's *Grey* monochromes in November 1957.[41] Looking to these examples, Mack and Piene and others in the academy, including Uecker and Raimund Girke, were moving steadily toward a reduction in the hues in their work. Uecker's works were created by dredging his fingers through the black pigment, while Girke built up delicately mottled surfaces with a limited range of color.

Thwaites remarked that the general awareness of German contemporary art and the commercial galleries to support it had been negligible before Group 53's breakthrough exhibition caught the attention of the entire region. In his assessment of the Düsseldorf galleries, he noted that most of them sell established artists, the Expressionists and others from the 1920s. The one gallery of contemporary art, Hella Nebelung, did focus on abstract art, but primarily the more marketable Parisians. He wrote that when a younger painter thinks that his work is in line with her gallery offerings, he receives "an unpleasant surprise,"[42] when he approaches the gallery to present the work. This is precisely the reception that Mack and Piene received when they tried to exhibit commercially. Although they were freshly minted from the academy and making a positive impression on the Rhineland critics, they could not get gallery representation for their work.

Faced with limited exhibition opportunities and forced to earn a living during the day, Mack and Piene began, on April 11, 1957, to stage a series of evening exhibitions (*Abendausstellungen*) in their studios. These typically lasted only the duration of one night, and were conceived to present their and their colleagues' work to a culturally hungry community. The evening exhibitions caused an immediate sensation in Düsseldorf, attracting throngs of people who found the building in a secluded site, a *Hof* (courtyard) near the harbor and climbed the many steps to the cramped "Ruinenatelier" (Figure 2.4). It was such a tremendous success that they hosted a second evening exhibition a month later on May 9. Although some of the more skeptical journalists criticized the youthful work, the events were an artistic and social sensation. They were critically important for the young artists involved, giving them exposure to the public. Initially these exhibits were enhanced studio visits, presenting the paintings of Mack, Piene, and their colleagues from the academy and Group 53 with remarks, readings, and music. Over nine evening exhibitions were hosted over four years; these developed from simple picture shows into elaborate events with a theme, music, installations, readings, and performances, parallel to the Happenings in New York.

Within a couple of months after the sensation of the Group 53 exhibition, the artistic climate in Düsseldorf was heating up. Within weeks of the first

FIGURE 2.4 *Gladbacher Straße 69 Atelier, 1956. Atelier Mack.*

evening exhibition two progressive galleries opened in Düsseldorf: Galerie 22 and Galerie Schmela. Jean-Pierre Wilhelm and Manfred de la Motte opened Galerie 22 on May 2. Freshly returned to Germany from France where he had lived during the war, Wilhelm opened his gallery to introduce new French painting to the Rhineland and to show the work of promising young German artists. With advice from Hoehme, Wilhelm opened with an exhibition on *The Rebellion against Form*, including the new German *informel* and *Tachism* painters Brüning, Götz, and Schumacher and the American Paul Jenkins.

Alfred Schmela inaugurated his gallery on May 31, 1957, with Yves Klein's *Propositions Monochrome* (Figure 2.5). Schmela intended to open with an exhibition of Tàpies, who was already committed to another exhibition in Paris. Instead, with advice from Norbert Kricke, Schmela invited Klein, who had just exhibited his monochrome paintings in Paris and Milan.[43] On the opening night Schmela's tiny space in the old city filled quickly with the

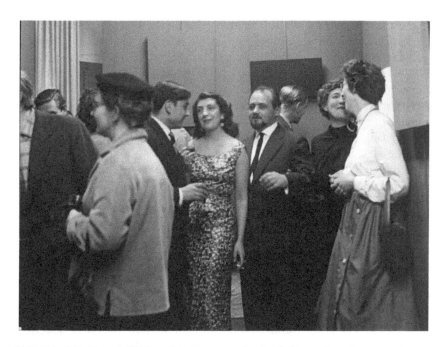

FIGURE 2.5 *Hans-J. Witkowski. Opening of the exhibition Yves. Proposition monochromes. Schmela Gallery, Düsseldorf, May 31, 1957 (from left to right: Yves Klein, Iris Clert, Alfred, and Monika Schmela, 1957. Galerie Schemla Papers, Getty Research Institute, Los Angeles (2007.M.17).*

artist, his mother Marie Raymond, and Parisian dealer Iris Clert, as well with a crowd of curiosity seekers and interested artists. Schmela and Klein's exhibition was a succès de scandale. The public was aghast at the audacity of someone presenting what critics described as interior decoration and wallpaper. One journalist derided the artist and dealer as "Comedians at Work."[44] However, the young artists in Düsseldorf, who had been developing monochromatic paintings, saw in Klein a clear direction for resolving the artistic problems that they addressed in their studios.

In the short span of seven years between 1954 and 1962, Klein created a flurry of radical artistic gestures that severed his relationship to modern art, liberated his painting from its dependence on gesture and dismantled the objet d'art. His first works suggested the subterfuge with which he approached art, publishing two catalogues: *Yves: Peinture* and *Haguenault: Peintures* (1954), reproducing images purportedly of his monochrome paintings. In a presentation that resembled commercial color swatches, Klein approached the problem of painting by revisiting the debate on the original versus the reproduction. Over the next couple of years Klein refined his monochromes, moving from multicolor to blue, and he perfected the

application of paint with rollers that was divorced from painterly, self-expression. In order to achieve a visceral intensity, he also developed a granular, dry powered pigment that he eventually patented, his signature Yves Klein Blue (IKB).[45] In January 1957 Klein inaugurated his *Proposte monocrome/epoca blu* at Galleria Apollinaire, Milan. When the exhibition was presented at the Galerie Colette Allendy in May, he launched the display by igniting a *Blue Fire Painting*, setting flares on fire, burning the canvas, and debasing the act of painting. For the Düsseldorf venue, Schmela elected to exhibit a multicolor selection of monochromes, not only the blue ones.[46]

Although Klein's exhibitions of *Proposition Monochrome* in Milan, Paris, and Düsseldorf did not attract much positive critical or popular attention, it sent shock waves through the younger generation of artists in those cities. Few took notice of Klein's Paris exhibit besides his friends and colleagues, Pierre Restany and Daniel Spoerri, with whom he was already working. The greater resonance of Klein's work occurred in Milan and Düsseldorf. In Milan Piero Manzoni responded by immediately producing his first *Achromes*, simultaneously emulating and contrasting Klein's monochromes. Fontana, Manzoni's mentor, was so moved by the work that he acquired a blue one for his collection (Figure 2.6).[47] In Düsseldorf, Mack, who first met Klein in Paris in 1955,[48] and Piene saw in Klein's paintings new directions for their burgeoning interests in monochrome, stimulating the development of their work in close association with the Frenchman.

Hannelore Schubert recognized that with the developments in Group 53, Mack and Piene's evening exhibitions, and Wilhelm's and Schmela's galleries, Düsseldorf was, once again, an "Art City." In an evening radio broadcast for the West German Radio, she asked, "Is there a Düsseldorf School of Painting again?" In the remarkably short period of six months, West Germans progressed from viewing their contemporary visual art culture as moribund to asking if, indeed, a new art had emerged in postwar Germany. In her program, Schubert reported that "the immediate attention of critical observer of Düsseldorf, after having been frozen for a long time, the situation has gradually begun to loosen, that young artists, rarely over 35 years of age . . . are attempting to break through the stagnation and seeking to pursue new paths." Her dialogue concerning the new directions in painting was delicately balanced. After having been critical of the Group 53 exhibition in January, in six months' time she became encouraged by the new painting and supported the new artistic directions, emphasizing its new structures and patterns. She acknowledged that these developments themselves may not constitute a new school and recognized that it remained to be seen whether or not it could lead to a new school. But, in conclusion, Schubert endorsed the position taken by Klapheck in January that these artists mark a new beginning and direction for the future.[49]

Mack, Piene, and other Düsseldorf artists had been moving toward monochromatic paintings, but Klein presented a more resolved approach with a single hue of vibrant intensity, which was applied with a roller

FIGURE 2.6 *Yves Klein,* Monochrome *(IKB 100), 1956, pigment and resin on panel, 78 × 56 cm. Fondazione Lucio Fontana. © Yves Klein c/o Artists Rights Society (ARS), New York/ADAGP, Paris 2017.*

to diminish the artist's touch, a quality that the Germans sought in their own work. Klein's example provided the stimulus to continue pushing the boundaries of these experiments. Piene and Mack continued to reduce the tonal range of their palettes, the visual presence of their touch, and they began to explore new media that would generate sensory stimuli when arrayed in serial structures. Experimenting with mechanical techniques and industrial substances—stencils, machine tools, metallic pigments—they minimized manual touch, distanced their work from personal narrative, and produced paintings that were visceral, sensory experiences, emphasizing the physical quality of their new materials. Mack and Piene both spoke of Klein's charismatic personality, his tremendous physical energy, producing a continuous stream of inventive, probing ideas. Piene freely

acknowledged, "Yves Klein has perhaps been the real motor in provoking a Zero movement."[50]

Forced by the economic necessity to have a paying job, Piene taught drawing at the Fashion Institute in Düsseldorf and worked as a fabricator of custom lamps. While building some illuminated brass castings, the artist had a moment of clairvoyance when he saw light passing through the metal stencils cut for the lamps, causing a sharp positive-negative effect. In the summer of 1957 he began to press paint through the stencils onto the canvas to recreate that effect, at first in black and white, later in yellow and gold. The results were the *Raster Paintings* (Screen Paintings), of which *Frequenz* (1957, Figure 2.7) is among the earliest and most daring. On this canvas Piene pressed reflective aluminum pigment through the holes drilled in the stencil to produce an even, continuous pattern over the entire surface. The

FIGURE 2.7 *Otto Piene,* Frequenz, *1957, oil and aluminum paint on canvas, 42.5 × 32 × 3.5 cm. Kunstmuseen Krefeld. © 2017 Artists Rights Society (ARS), New York/ VG Bild-Kunst, Bonn.*

regular, serial patterns activated by the reflecting light triggers a kinetic, retinal vibration. Heinz Mack remembered the moment when Piene executed his first *Raster Paintings* and said, "I witnessed the star-kissed hour."[51] At this moment Piene had the realization that not only could he use pigment as light, but he could actually use light as the source of the pictorial effect. This transformative moment in Piene's work initiated a series of new artistic materials and processes over the next decade.

Each of the critics, Klapheck, Schubert, and Thwaites, noted Mack's paintings in their reviews of Group 53 and the evening exhibitions. The critical attention and the creative energy emerging from the "Ruinenatelier" on Gladbacher Street attracted the attention of Schmela, who invited Mack to stage his first solo exhibition in the gallery in August 1957. Mack continued to restrict his palette and featured a selection of his paintings in black, white, and gray (Figure 2.8). His emphasis on a strict, serial structure generated the optical vibration that Schubert recognized in her review of his debut exhibition, as distinct from his colleagues in Group 53. She noted Mack's aim to achieve pictorial movement and identified that "he has developed in a completely different direction . . . one will have to reckon with this young painter in the future."[52]

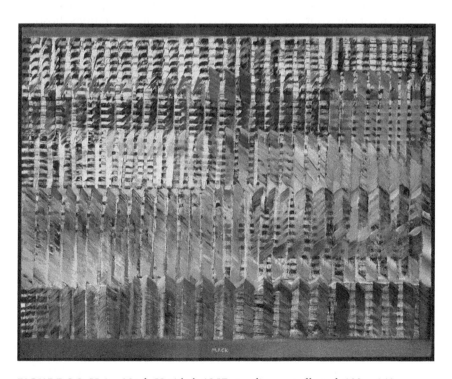

FIGURE 2.8 *Heinz Mack,* Untitled, *1957, acrylic on cardboard, 109 × 140 cm. Atelier Mack. © 2017 Artists Rights Society (ARS), New York/VG Bild-Kunst, Bonn.*

At this point Mack made an "accidental discovery" in his studio in the fall of 1957 that dramatically altered the course of his art. Mack accidently stepped on a sheet of foil on a sisal rug: "As I picked up the metal foil the light was set to vibrating."[53] When he recreated this effect by hand he realized that the reflective patterns "only require light instead of color in order to come alive."[54] At this magic moment, Mack realized the artistic quality inherent in the reflective properties of metals. The resulting vibration created a shimmering visual effect without the direct application of paint by hand, eliminating the obvious presence of the artist. This incident initiated his *Light Reliefs*, among the earliest being *Structure for Reading* (1957). In these works Mack manually rubbed the pliant foil over manufactured surfaces, embossing rows of irregular horizontal and vertical ribs into the aluminum (Figure 2.9). The patterns are reminiscent of the serial forms of his previous paintings. But, because of the light refraction, these pieces continuously change; they are never static, creating immaterial effects from material form, resting in restlessness on the retina. Light animates the art object. Yet, it simultaneously radiates a sense of calm. Klein recognized that Mack ingeniously invokes color in these industrial foil works. In his essay for Mack's exhibit at the Galerie Iris Clert, Paris, in 1959, Klein wrote, "The reliefs in aluminium of Mack . . . come from the delicate, discreet, and timid love he has always felt for color though always refusing to approach it."[55]

Mack and Piene continued to organize the evening exhibitions, hosting six between April and December 1957. Despite the popular press who criticized Mack's *Light Reliefs* as "thumbprints in aluminum,"[56] and those who questioned whether the artists should exhibit their "painting studies,"[57] the public turned out in droves. For their fourth presentation in September the press reported that cars were parked two rows deep on the street and that a hundred people crammed into the studio to hear Schubert deliver

FIGURE 2.9 *Heinz Mack,* Light Relief, *1958, light metal foil on hardboard, 32.5 × 80 × 2.5 cm. Kunstmuseen Krefeld. © 2017 Artists Rights Society (ARS), New York/VG Bild-Kunst, Bonn.*

the opening remarks for a display of the artists' new work.[58] The evening exhibitions had become the new "meeting place" for artists and their public.[59] The presence of critic Schubert legitimized the evening exhibitions. In her remarks, she shaped the dialogue around Mack, Piene, and their colleagues' artistic developments, explaining that these abstract paintings, simple in color, but complex in structure, generated an "intensity of activity from the dematerialization of color."[60] Thwaites considered the evening exhibitions to be of historical significance, noting that largely due to these events Düsseldorf was "overnight seen as the Mecca of new art in Germany."[61]

Following Schubert's appearance, the artists invited Max Bense, professor at the School of Design in Ulm, under the direction of Max Bill, to introduce a solo exhibition of artist and editor of *Das Kunstwerk* Klaus Jürgen-Fischer for the sixth evening exhibition on December 10, 1957. Bense had just published the second volume in his series of *Aesthetica: Aesthetic Information* (Baden-Baden: Aegis Verlag, 1956), in which he developed his information theory. One of the reviews of this event, "The Philosopher in the Bomb Site," reported that Bense discussed his idea of the artist as senders and the spectators as receivers of pictorial information. He advocated that modern art no longer needed to express personal emotions, but that art should explore new materials for conveying pictorial information, completely setting aside classical aesthetics.[62] Another review asked, "Do Machine Brains determine the value of art?," further noting that Bense postulated that modern artists work with signs that reflect the natural processing of information.[63] These figures, among others, helped to frame the intellectual position of Mack and Piene.[64]

Over the months since the first evening exhibition in April 1957, Mack and Piene's art and ideas crystallized. Influenced by Klein they had moved away from the dark, impasto, and touch of *Tachism* and began to employ brighter hues and a combination of mechanical and natural materials to stimulate physiological, sensory experiences in their viewers (Figure 2.10). Schubert, Bense, and the other critics recognized that they were engaged in a new visual language and articulated an intellectual interpretation for their work. Immediately after the fourth evening exhibition on September 26, 1957, Mack, Piene, and their atelier partner Hans Salentin met in their favorite pub Fatty's Atelier across the street from Schmela's gallery to discuss forming a group. Initially, Piene had wanted to call it "chroma," "chiaro" (an abbreviation of *chiaroscuro*, the Italian term for "the progression of light and shade in a painting"), or "dynamo." However, Mack and Salentin objected, and Mack relates pulling a book off the shelf and turning to the index and finding the word "Zero."[65] And they agreed on the choice. "Zero" resonated with the language of postwar art and its desire for a new beginning. The concept of "Stunde Null" was still not in the common parlance, yet it conveyed the artists' aspirations to start over. Further, the word "zero" was an international term that existed in the English, French, and Italian languages, but not in German.[66] Having agreed on the name,

FIGURE 2.10 *Otto Piene*, Hell Gelb Hell, *1958, raster painting, oil on canvas, 68.5 × 96.5 cm. Westfälisches Landesmuseum, Münster. © 2017 Artists Rights Society (ARS), New York/VG Bild-Kunst, Bonn.*

they decided to produce an exhibition and publication that would present their new artistic positions.

While planning the launch of their new group, Mack and Piene hosted a painting performance by Georges Mathieu in their studio in conjunction with the *informel* painter's exhibition at Galerie Schmela in January 1958. With television cameras filming, Mathieu confronted a 2 × 4 meter black canvas dressed in a white outfit, wearing a flight cap, and armed with brushes and tubes of red and white paint. Over the course of an hour the French painter attacked what one reviewer described as the "battlefield canvas" with dramatic gestures designed for television viewership, and produced his *Abduction of Henry IV by Archbishop Anno of Kaiserswerth* (1958, Figure 2.11). Even the local press was surprised at the theatrical bathos of this scene, invoking Freud's description of Dali, Klapheck portrayed Mathieu as a "fanatic."[67] Piene recalled that the self-indulgent display of painterly prowess disgusted him and confirmed his move away from grand, diaristic gestures.[68]

Mack, Piene, and Klein organized a presentation of monochromes on the subject of *The Red Painting* for the seventh evening exhibition on April 24, 1958. A very busy and fast year after their first evening exhibition, this presentation announced their identity as a group. Now they had a sense

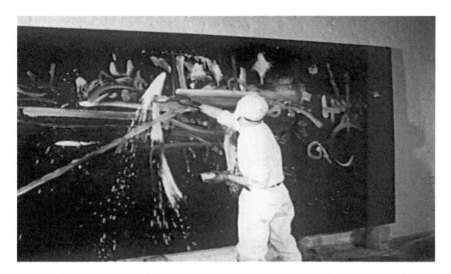

FIGURE 2.11 *Georges Mathieu painting* Abduction of Henry IV by Archbishop Anno of Kaiserswerth *during performance in Otto Piene's Atelier, 1958. From* Avantgarde, *1961 (01:29), produced by Rolf Wiesselmann, Westdeutscher Rundfunk.*

of "what they were for," and they articulated the ideas behind their work in an artists' magazine, *ZERO*. For the publication they sent letters to six prominent art figures, both progressives and conservatives, asking, "Does contemporary painting influence the shape of the world?" Most of the respondents objected to the phrasing of the question. The phrasing was, however, intended as an ironic twist on the interwar radio lectures by Gottfried Benn, titled "Can Poets Transform the World." Benn's radio hour advocated traditional lyric poetry and the view of the artist as reclusive genius. Many progressive artists, particularly Bertolt Brecht, considered Benn's views conservative and outmoded.[69] But, in Group ZERO's rephrasing of Benn, it is clear that the question of painting and reality was clearly of primary concern to these artists and elicited just such responses from the writers.

Franz Roh, the art historian and critic, objected to the question, but reworded it "to ask whether contemporary painting is able to produce a view of reality," or "to influence man . . . spiritually," to which he answered "yes." Art historian Arnold Gehlen recognized the reference to Benn's radio program and repeated Benn's wish to "isolate" himself from the contemporary world. Gehlen agreed with Benn and answered the young artists' question adamantly, "Contemporary painting produces neither the world we live in nor any world at all!"[70] These answers expressed opposing positions on the question. Yet, the question stimulated responses that touched upon the key social and artistic issues of the day, the spirituality of man, and the reality of the world in which they lived, issues that concerned the artists.

Interestingly, Mack and Piene also invited Hans Sedlmayr to contribute to the artists' magazine. Probably the most vehemently antimodern critic in Germany, Sedlmayr's submitted a scathing commentary.

> I presume that by "contemporary" painting in your question you also mean absolute or so-called nonrepresentational [abstract] painting and surrealism. . . . Absolute painting—like absolute sculpture—is. . . . The elimination of any dialogue with nature, tradition, or eternal truths. . . . In this world of (presumably) absolutely free men, painting certainly "influences the shape of the world." But this hoministic world—a substitute for the natural world . . . the world of the absurd, is only a small part of the real world. . . . It is an imaginary, unsatisfactory world."[71]

Following the responses of their invited authorities, Thwaites wrote an introductory essay, "Where Is the Color?," in which he positioned the artists in the tradition of modern painting from Kandinsky and Klee and the *informel* artists of the first postwar generation. Thwaites wrote that for the previous generations, "Rhythm was the principal and the colors were free," and recognized that the primary issue for *informel* painters was the search for form.[72] Following Thwaites, the three artists, Klein, Mack, and Piene, contributed their perspectives on painting, emphasizing color and structure. Klein wrote that he sought "a color material that is intangible. . . . to create perceptible pictorial states." Piene explained that it was his intention to "liberate light once and for all from 'illumination' . . . I use colors that have . . . light-or-energy-value, respectively, so that the movement can take place within the space of the picture . . . and this is 'optical'."[73] He wrote metaphysically about his principal concept, "Light is the primary condition for all visibility. Light is the sphere of color. Light is the life substance of both men and of painting. . . . Light creates the power and magic of a painting, its richness, eloquence, sensuality, and beauty."[74]

While Klein and Piene discussed the immaterial and metaphorical, Mack focused on the problem of form, a critical issue with *art informel* and *Tachism*. In his essay "The New Dynamic Structure," he discussed serial form as the mechanism for stimulating retinal response and creating optical vibrations. Mack recognized the mechanical nature of his serial structures, but emphasized the touch of the artist's hand as essential to elevating the form beyond a mere manufactured pattern, "The sensitivity of the artist's hands . . . escapes the danger of mechanical repetition, which continues to be uncreative." He sought to "produce virtual vibration, i.e. pure, perpetually creative movement, which cannot be found in nature. It is free of all suggestive illusion."[75] Thus, Mack used touch, not to express personal emotion, but to stimulate sensory perception.

These ideas emphasize a reality that extends beyond pictorial representation and embraced an understanding of the natural forces of the physical world. These concepts demonstrate their study of philosophy,

particularly Husserl's ideas on phenomenology and Hartmann's ontological theories, that informed Mack's experiments to pursue "a metaphysics of being . . . whose reflection consists of that which exists, of actual things."[76]In Thwaites's mind, the *ZERO* magazine was the beginning of the new art, even more so than the initial Group 53 exhibition in January 1957, because it offered "fresh and intelligent" statements that transcended the discussion of anti-*Tachism*, of new and old art, establishing a new set of aesthetic criteria.[77]

The Red Painting was the most coherent and ambitious of the evening exhibitions to date. A wide variety of artists contributed works based on the single color of red, including Rupprecht Geiger, Gotthard Graubner, Hoehme, Mathieu, Almir Mavignier, and Uecker, encompassing *Tachism*, *art informel*, and new tendencies in painting. The choice of the color red was an especially audacious one. Red, during the postwar reconstruction, was the most expensive pigment and was an expensive commodity, prized by the younger and less affluent artists in Germany.[78] An astute reviewer in the *Düsseldorfer Nachrichten* grasped that the epigram at the beginning of the *ZERO* magazine by Hegel, "red is the concrete color *par excellance*," was a challenge to painters. He continued to describe the range of artistic responses from Mathieu's "furiously-brilliant handwriting of strong expression" to Klein's painting of "simple red color."[79] Klaus Jürgen-Fischer opened the exhibition with a speech remarking that the proposition of creating exclusively red paintings was especially difficult for artists and that the results indicated the artist's sensibility, whether they would choose to use an aggressive red in intense gestures (a reference to Mathieu) or whether they chose to use colors as the source of the pictorial effect. Jürgen-Fischer had studied painting under Willi Baumeister as well as philosophy, publishing his studies as *The Mischief of Being: Phenomenological Sketches for the Critique of Ontology* (1955).[80] In his presentation he connected the metaphysics of color with the direction of the new art, and he said, that connects with "the new art connects with the heart of nature and the sensitive mechanism of the mind."[81]

The inclusion of Uecker in *The Red Painting* exhibition marked his first participation with Mack and Piene in an evening exhibition. Uecker lived in the same neighborhood as Mack, and they knew each other. Piene noticed Uecker's work hanging next to his own at the January 1958 Group 53 annual exhibition and admired it as a sympathetic work.[82] At this point Uecker was finishing his studies at the Düsseldorf Academy and had been producing a series of monochromatic paintings. He studied commercial art and painting at the art academy in Weißensee in East Berlin, where he learned the officially sanctioned Soviet Socialist Realism. Crossing over into West Berlin in 1951, Uecker saw a work by Kandinsky. It was an artistic revelation that spurred him to further study modern painting. In 1953 he emigrated to the west, moving to Düsseldorf, where he entered the academy in 1955, just after Mack and Piene left the program, where he too studied

with Otto Pankok. He discarded the traditional tools of painting and began to work the pigment with his fingers in 1956. Having been raised on a farm, it was a therapeutic gesture for the artist to work pigment like a farmer tilling soil. In 1957 he realized that the nail, an implement that he had used to construct things at home as a boy, could be a viable media for making art. He devised manifold uses of the nail and it became recognized as his essential form.[83] For *The Red Painting* exhibition he submitted one of his finger paintings of a red oval (Figure 2.12).

The success of the first issue of *ZERO* prompted Mack and Piene to work toward the eighth evening exhibition and a second *ZERO* magazine on the theme of *Vibration*, emphasizing their recent development of optical and kinetic effects. For this exhibition, and a parallel one at Galerie

FIGURE 2.12 *Günther Uecker,* The Red Picture, *1957, oil on canvas, 24 × 23 ½ inches (69.5 × 55 cm). Private Collection. © 2017 Artists Rights Society (ARS), New York/VG Bild-Kunst, Bonn.*

Schmela, Mack debuted his *Light Reliefs*. For the second issue of *ZERO*, they recruited Bense, Gehlen, and Thwaites to contribute to the periodical. Bense introduced the work of Almir Mavignier, a Brazilian painter who studied at the College of Design in Ulm under Max Bill. Bense applied his information theory to Mavignier's paintings, writing, "Communication implies use of language; hence the communication of art is likewise an act of language." The philosopher observed that Mavignier's structural patters function "on the borderline between symbol and signal, between physical science and aesthetics."[84]

In addition to announcing *ZERO* as a specific, named art movement, the artist's magazine *ZERO 1* also marked the expansion of the pan-European, American, and Asian artistic new tendencies into a network of sympathetic individuals. The connections that Klein made in Milan and Düsseldorf provided the conduit to link the Germans and Italians to the Parisians, Belgians, and Dutch. From this point forward the exhibitions and artistic advances would occur at a staggering pace, moving quickly from monochrome, into kinetic art, then to spatial environments and multimedia installations in which the objet d'art was completely dematerialized.

Klein developed the idea of making monochrome into an immaterial experience, and *in ZERO 1*, he declared, "My paintings are now invisible." Only a few days after *The Red Painting* exhibit, Klein inaugurated *La Vide* at Iris Clert on April 28, (Figure 2.13). With a pronounced awareness of performance, Klein initiated the exhibition outside of the gallery, serving blue cocktails to the attendees; then he allowed the audience to enter Iris Clert's gallery, where they found the space completely empty. "Only a solitary neon tube on the ceiling illuminated a room that seemed to contain nothing."[85] The initial response for many spectators was that the gallery contained no works of art. However, Klein had spent several days after the Düsseldorf exhibition carefully sanding and painting the gallery walls so that they would have precisely the even-textured surface that he had achieved with his roller-brushed paintings. The effect was to elevate monochrome painting to an environmental experience, where the viewers' perception was affected by sensory deprivation, forcing the retina to compensate by generating patterns. In this environment spectators entered what Klein described as a "zone of sensibility." With this installation the artist achieved the complete dematerialization of the objet d'art and created the first achromatic, environmental installation, a technique that was practised in the 1960s by the California Light and Space artists, particularly Doug Wheeler. Klein's exhibition, originally intended as an eight-day exhibition, was extended a week because of the tremendous turnout.

Klein's reputation was largely constructed outside of France. Ingrid Pfeiffer observed that Klein had a very close professional and personal relationship to Germany, earning "more recognition, success, and growth opportunities in Germany than he did in France."[86] He had an architectural-scaled commission in Gelsenkirchen, his first, and only, museum exhibition in Krefeld. Among

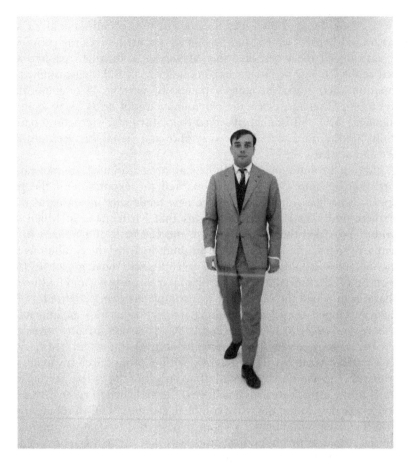

FIGURE 2.13 *Yves Klein,* La Vide, *1961, Museum Haus Lange, Krefeld. © Yves Klein c/o Artists Rights Society (ARS), New York/ADAGP, Paris 2017. bpk/Charles Wilp. Photo: bpk Bildagentur/Museum Haus Lange/Charles Wilp/Art Resources, New York.*

the artists in his circle were Norbert Kricke, Mack, Piene, Werner Ruhnau, and Uecker. He met Uecker through Arman at his home in Nice. It was here in 1957 that Klein met Uecker's sister, Rotraut, who worked as an au pair for Arman. Klein could not speak German, so Rotraut became the intermediary for Klein with the Germans.[87] Eventually, she worked as an assistant to Klein, modeled as one of his human paintbrushes, and married him in 1962, only months before his untimely death at age 34. Klein's personal associations with Düsseldorf facilitated the German artist's connections with the international network that formed over the next two years.

The network initially grew through Klein's collaboration with Jean Tinguely, whose career trajectory was intricately intertwined with ZERO

and the network of new tendency artists.[88] In 1952, Tinguely had moved from his native Basel to Paris, to work in the studio of Constantin Brancusi. By the mid-1950s he began to fabricate kinetic assemblages of debris, which he first exhibited in 1954. Alexander Calder heavily influenced Tinguely. Calder had a close relationship with Paris, first exhibiting his mobiles there in 1933, and immediately after the war Calder exhibited at Galerie Louis Carre (1946).[89] Shortly thereafter, Victor Vasarely, Yaacov Agam, Pol Bury, and Jesús Rafael Soto developed a repertoire of kinetic work that debuted at Galerie Denise René in an exhibition titled *le mouvement* (1955), which also included Calder and Tinguely. For this exhibition Vasarely wrote an essay that came to be called *The Yellow Manifesto*, in which he advocated activating painting, by creating an illusion of movement. The core artists in *le mouvement* were associated with postwar French geometric abstraction and the *Salon des Réalités Nouvelles*, but they amplified those ideas with new knowledge of optics, partially derived from Josef Albers' studies on the interaction of color and geometry.

Although Tinguely was included in *le mouvement*, his kinetic assemblage diverged from the others, being more allied with Duchamp and Dada. Tinguely readily acknowledged Duchamp's ready-mades as the source of his appropriation of found manufactured materials, and he was instrumental in resuscitating the reputation of Duchamp, who had largely been ignored by several generations of French artists.[90] Working parallel to Klein's development of monochrome, Tinguely motorized his constructions. Tinguely declared "It was by means of machines that I could do things differently. I could draw directly in space, with the materials themselves. It was very simple."[91] With these machines he made devices that could draw, make sound, and produce participatory constructions. Tinguely recognized in Duchamp and Dada a vocabulary of art outside of painting that effectively conveyed the message of a second-generation artist, who had witnessed the war and sought to critique the culture that caused it. While Klein was moving toward the immaterial, Tinguely created tangible objects that embodied movement and materialized the physics of nature. Tinguely engaged the idea of the kinetic suggested by both Duchamp and Calder to create works that reference mechanized postwar culture.

Tinguely met and befriended Klein in 1958 during their work with Werner Ruhnau on the theater in Gelsenkirchen, Germany. After Klein had created the experience of the achromatic environment of *La Vide*, which he formally titled *en sensibilité picturale stabilisée* (Stabilized Pictorial Sensibility), he began to collaborate with Tinguely, to create kinetic monochromes. Mack, who was visiting Klein in Paris in November 1958, met Tinguely and experienced this work in the studio. Mack related Klein's elation at their "sensational discovery," "a miracle."

Mack recalled that they had constructed a mechanical rotor fitted with a blue disk that was spinning so fast that it seemed to have come to

a standstill. "*Vitesse pure*" (pure speed) Tinguely explained proudly. . . .
And Yves corrected him: "*stabilité monochrome!*" (monochorome
stability). The optical sensation came about because the rotating disc had
been transformed into a volume. Into a virtual, immaterial volume. . . . I
[Mack] shouted: "It's pulsating, it's breathing, it's moving, it's stretching,
it's just air now!"[92]

The spinning disks of blue extended the possibilities of Klein achromatic
environment of *La Vide* and of transforming the "stable pictoral sensibility"
into the simultaneous optical illusion of stasis and motion, unlike its
precedent in the rotary disks of Duchamp and Man Ray in 1920.

Tinguely's relationship with Klein and Kricke led Schmela to invite him to
exhibit at his gallery in January 1959. For this exhibition Tinguely produced
a suite of music machines, his *Concert for 7 Pictures and Other Sculptures*
(Figure 2.14), sculptures that produced abstract sounds recalling the Dada
Klangmusik. These sculptures were like his meta-matics. They were fragile

FIGURE 2.14 *Jean Tinguely,* Mes étoiles—Concert pur sept peintures [My Stars—
Concert for Seven Paintings], *1957–59, sound relief, seven different reliefs, each
consisting of a wooden panel, iron plates and wires, iron sound box, electric motor,
painted black and a control panel with seven buttons, 55 × 350.5 × 32 cm. Museum
Tinguely, Basel, Donation from Niki de Saint Phalle. Photo: Christian Baur. © 2017
Artists Rights Society (ARS), New York/ADAGP, Paris.*

and frivolous, tinged with the realization of the fragility of life. For this exhibition, he conducted two performances. Klein launched the opening with brief remarks (probably translated by Rotraut Uecker). Then, Daniel Spoerri, Claus, and Nusch Bremer simultaneously read texts—"Tinguely has two cats," "Elementary Building Blocks of Matter," and "The Apparatus by Jean Tinguely," respectively—while the machines made their noise and a waltz played in the background.[93] The resultant cacophony drowned out any individual speech and resulted in an absurd presentation reminiscent of the Dada Cabaret Voltaire.[94] Later, in March he staged a stunt in which he hired a photographer to document him, ostensibly flying in a plane over Düsseldorf dropping leaflets with his manifesto *Für Statik*. Echoing a similar statement by Duchamp, he wrote:

> For Static
> Everything moves, stagnation does not exist. Do not let yourself be taken over by the antediluvian concepts of time. Away with the hours, seconds and minutes. Cease to resist the change. BE IN TIME-BE STATIC, STATIC-WITH THE MOVEMENT. . . . Cease to "paint" time. Cease to build cathedrals and pyramids that crumble like sweets. Breathe deeply, live in the now, lives on and in time. For a beautiful and absolute Reality![95]

Such a performance would have created storms of protest in Germany, where, during the war, the Allies often dropped leaflets from planes forewarning attacks or as metallic disturbances for radar in advance of bombings. However, we now know that this event was staged.[96]

The exhibition was a tremendous success and further expanded the network of artists introducing Tinguely and Spoerri into the German group as well as the French critic Restany, who wrote the essay for the exhibit brochure. For this exhibition Uecker hosted a three-day studio fest in honor of Klein and Tinguely, an artist action at his studio across the Rhine in Oberkassel. He invited the artists to participate in a costume party. When they arrived they found the studio painted in two colors—red and blue—with flying saucers hanging from the ceiling. Uecker and Klein stood in the midst of the dancing crowd with their faces painted blue. The local press described Uecker, his head covered in a net, as "looking like a frog-man in blue aspic."[97]

Significantly, the exhibit and related events demonstrated some possibilities for synthesizing Dada performance with the evolving interests in art and technology. Subsequent literature sites this as Uecker's earliest artist's action. But the artist himself views it as an extension of the parties that he hosted, both at the academy and in his studio where he would earn spare change by selling beer to the visitors for a profit.[98]The party was a riotous success and further solidified the friendships between the French and German artists. As with Klein, Tinguely immediately befriended the German artists. His

kinetic sculptures and his performances exerted a significant influence on Mack and Piene. Piene fondly remembers that during Tinguely's installation "Alfred Schmela, addressing his wife, Monika, used to shout across the room whenever the noise of the objects began to bother him, 'Mother, turn off the Pictures.'"[99]

ZERO and the new artistic tendencies of Klein, Tinguely, Mack, and Piene began to attract considerable attention across Europe. The Belgian Pol Bury and the Swiss-French artist Daniel Spoerri were organizing an exhibition in Antwerp in March 1959 to bring together the younger generation of artists. After his experience in Düsseldorf, Spoerri invited this group of French and German artists to participate in the show. Initially, Bury and Spoerri wanted to call the exhibition *le mouvement*, referencing the important exhibition at Galerie Denise René from 1955.[100] However, they settled on the title *Vision in Motion*, explicitly acknowledging the legacy of László Moholy-Nagy, whose book of the same title was published in 1947. Moholy-Nagy discussed in his new book utilizing open, dynamic display techniques for "the great 'dreamers' of mankind . . . who dared to use the potentialities of the new materials of a new age."[101] In the dramatic timber-beamed space of the Hessenhuis in Antwerp, the artists applied Moholy-Nagy's ideas and experimented with new installation design, stretching the space with objects suspended from the ceiling, dramatic light effects, and the artists' names embossed into the floor (Figure 2.15). Bury and Spoerri's design drew upon Bauhaus exhibition display, particularly Moholy-Nagy's designs for the German Werkbund exhibition in Paris (1930),[102] establishing an early model of spatial conception in postwar artistic installations. The exhibition consisted of artists including Bury and Tinguely's kinetic sculptures and Mack displaying his new *Light Reliefs*. At the opening Klein performed, "standing in the middle of the room, blowing blue smoke from a cigarette and reciting from Gaston Bachelard, 'At the beginning is a nothing, then a deep nothing, on top of that a blue depth.' After the action, only block letters remained 'Yves Klein.'"[103] Klein continued his dematerializing of the art object, now emphasizing the action of the artist as the work.

In the minds of Mack and Piene, this exhibition, and it successor *Dynamo*, were the first public pronouncements of the new artistic tendencies being practised by the younger community of artists across Europe.[104] The artists shared the recognition that they made an innovative artistic statement that forged a solid bond linking Antwerp, Paris, and Düsseldorf. These exhibitions galvanized the artists in a critical dialogue on new directions in postwar art. After the opening in Antwerp, the artists went to a local pub and took this photograph that represents the core of the Antwerp-Düsseldorf-Paris triangle: Mack, Piene, Tinguely, Spoerri, Bury, and Klein (Figure 2.16). Charged by the opening and a sense of artistic community, they discussed touring the exhibition. Bury and Spoerri, as the originators, approved Mack and Piene's effort to organize a similar exhibition in Germany. They convinced Galerie Boukes in Wiesbaden to hold the exhibition that they renamed *Dynamo*, and

FIGURE 2.15 Vision and Motion *installation, Hessenhuis, Antwerp, 1959. Photo: Filip Tas/SABAM, Brussels; Foto Museum, Antwerp.*

expanded the checklist to include other Germans and Piero Manzoni. In a display of promotional savvy, Piene suggested that the opening for *Dynamo* be scheduled on July 10, 1959, the night before *documenta* II opened in nearby Kassel.[105] For Mack and Piene the international range of artists was important, constituting the widest cast to date of the pan-European net of ZERO artists.[106]

Manzoni, about whom Mack and Piene were aware, appeared at their studio door in July 1959 while driving from Rotterdam to Kassel to see *documenta* II. Manzoni had just participated in an exhibition at a gallery called Zero in Rotterdam. He accepted the invitation thinking it was the German group with whom he would exhibit; however, it was an entrepreneurial Dutch dealer, who had appropriated the name and exhibited *informel* and *Tachism* painters. Mack and Piene subsequently wrote to the dealer insisting

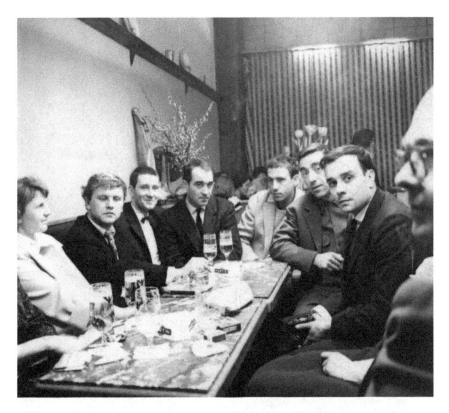

FIGURE 2.16 *In a restaurant: participating artists in the exhibition* Vision
in Motion *in Hessenhuis, 1959. From left: Margret Mack, Heinz Mack, Otto
Piene, Jean Tinguely, Daniel Spoerri, Pol Bury, Yves Klein, and Emmett Williams,
Antwerp, 1959. bpk Bildagentur/Charles Wilp/Art Resources, New York. © bpk/
Charles Wilp.*

that he cease using the name "Zero" that the Germans claimed on the basis
of two periodicals that they had published.[107] In the process, the three artists
struck up a friendship that resulted in a new artery of the pan-European
association of young artists, linking Milan to Düsseldorf. Manzoni, always
in need of money, beseeched the Germans to help, and Mack convinced Paul
Wember, director of the Museum Haus Lange in Krefeld, to purchase two
of Manzoni's paintings.[108] Manzoni's visit led to the Germans inviting him
to participate in *Dynamo*. During the fall 1959 Mack went to Milan where
Manzoni introduced him to Enrico Castellani, Piero Dorazio, and Lucio
Fontana. When Mack entered Fontana's studio, he was surprised to find
one of his own *Light Reliefs*, which Fontana had purchased from Iris Clert
Gallery in Paris, hanging on the wall of his studio.[109] These meetings further
solidified the expanding community of new tendency artists.

The synergy between Klein, Mack, and Piene culminated in a conversation between the three in Mack's old VW, while driving from Düsseldorf to Antwerp in 1959 to participate in the *Vision and Motion* exhibition. As Mack described it: "The conversation was moving non-stop, was highly inspired and inspiring, and eventually reached hallucinatory heights and creative fever. Everything revolved around the unspoken question of how and where the boundaries of art could be transgressed."[110] On this journey they articulated the fundamental principles that drove their subsequent artistic practice: to create a symbiotic relationship between man, nature, and technology. They railed against the model of museums as repositories of objects and imagined monumental, environmentally scaled installations, transplanting the artistic experience from the gallery into the urban and natural landscape. From this conversation, Klein planned his gas fire installations, Mack conceived his ambitious land art *Sahara Project*, and Piene formulated his ideas on inflatables and *Sky Art* that materialized over the course of their careers.

Since *The Red Painting* exhibition (April 1958), Piene had been evolving toward his own dematerialized painting. In *ZERO 1* he wrote that it was his intention to "liberate light once and for all from 'illumination' . . . and this is 'optical'."[111] At this time, Piene was experimenting with other materials that utilized the energy of light to expand his painting. He cut many of his own stencils for the *Raster Paintings* and began to burn candles through them, creating forms from the soot residue (Figure 2.17). With this process Piene accelerated the removal of his touch that he began in the stencil paintings. Through his use of smoke and stencils, he sought to distance himself from gestural painting and to remove the author from interfering with the sensory experience of the work. For Piene it is not the mark of the maker, but the experience of the viewer that consecrates the artwork. He wrote, "The Smoke Drawings are without 'handwriting'. The anonymity of the author remains maintained . . . I would like to step even more into the background, for my individuality as author to be even less tangible, to let a force like the light remain a sovereign effect."[112] Piene knew of Wolfgang Paalen, a German surrealist, but was unaware of the elder's experiments with candle smoke on paper in the 1930s. Piene also knew Burri, who had begun to burn his materials in the mid-1950s.[113] As opposed to the powerful emotive content of these precedents, Piene used the soot from the light of the candles to materialize the energy of light, as he had with the colors in his monochrome paintings.

The novelty and accomplishment of Piene's newest works intrigued Schmela, who invited him to have his first solo exhibition in the new gallery. For this occasion Piene wanted to introduce his most recent artistic innovation. Since late 1958 he had been experimenting in his studio with yet another use of his stencils, a performance that he titled the *Archaic Light Ballet*. Piene debuted his *Light Ballet* at the Galerie Schmela on May 9,

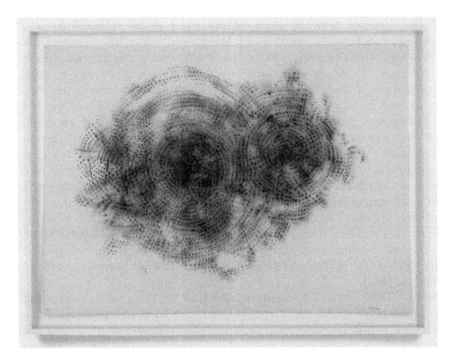

FIGURE 2.17 *Otto Piene.* Untitled (Raster-Rauchzeichnung) *[Raster-Smoke Drawing], 1959, soot on paper, 20 × 39 1/3 in. (71 × 100 cm). Private Collection. Courtesy Sperone Westwater, New York. Otto Piene Estate © 2017 Artists Rights Society (ARS), New York/VG Bild-Kunst, Bonn.*

1959 (Figure 2.18). Thwaites penned an unpublished, first-person account of this event. He described,

> Otto Piene, black in a black suit, climbed up into the window opening. In one hand he held several of his stencils . . . in the other something glistered, a bunch of big flashlights tied with a string. . . . Flecks of light began to creep across the walls and ceiling. . . . They swam. But they swam with purpose and direction. And out of all their movements rhythm grew.

As one's eye followed one's sense of the crowded room, then of the building fell away. One was part of the darkness and the night. The flecks moved faster stretching out their tiny legs of light. . . . Brightness fell all around one, so that one seemed caught up in a net of light. The distance in between the work and the spectator disappeared. One lost all sense of nearness with the other individuals.[114]

With his primitive equipment—cardboard stencils and flashlights—Piene accomplished the total dissolution of the art object into a transitory experience. He completely moved from the role of gesture as drama in

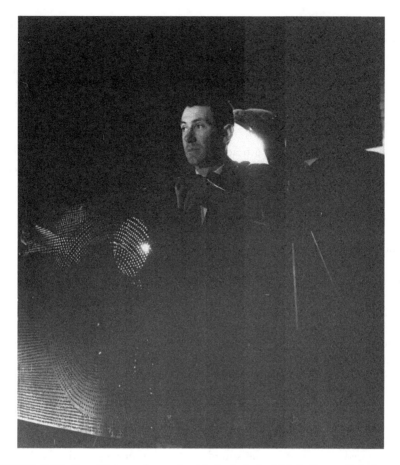

FIGURE 2.18 *Otto Piene orchestrating his* Archaische Lichtballet *at Galerie Schmela, May 9, 1959. Otto Piene Archives. © 2017 Artists Rights Society (ARS), New York/VG Bild-Kunst, Bonn.*

painting and transformed the drama into the dance of light, expanding the space as material forms dissolved. The audience marveled at the performance, unlike any they had experienced. It became a landmark in the artistic evolution of the period. Vostell cited this "demonstration" as one of the earliest artist actions in his 1965 publication on happenings.[115]

Piene came upon these ideas in the process of working in his studio fabricating custom lights. He witnessed the light flash and sparkle through the metallic screens, leading him to produce his raster paintings in the summer of 1957. The relationship is evident in a comparison between one of Piene's brass light box fixtures, a *Raster Painting*, and the *Light Ballet*. Piene orchestrated a simple lighting effect into the material form of his *Raster Paintings* and Smoke Drawings and dematerializing them again in the *Light Ballet*.[116] Only later did he learn that he "had a dozen fathers,"[117]

the most significant of whom was Moholy-Nagy. In *Painting, Photography, Film* (1925) Moholy-Nagy expressed his belief that art has progressed from pigment painting into a kinetic play of light.[118] He realized this in Berlin in 1930, where he produced a play, in which his *Light Prop* (1930) performed the leading role, without any human actors.

Equally important to Piene was the influence of Fontana, whom he described as a father figure to Group ZERO. Fontana realized the ambition expressed in his *Manifesto Blanco* for an art that dealt with the new sense of space, when he punched holes in his paintings in 1949, the *buchi*. From this point he began to title all of his works *Spatial Concept*, or *Concepto Espacial*. At the same time in the Galleria, del Naviglio produced black-light environment and followed with a number of works through which he would shine lights to create a luminous experience. This idea he transformed into a neon light installation for the 4th Milan Triennial in 1951.[119] These became landmarks in the postwar revival of light art. In his remarks for Fontana's first retrospective at the Schloß Morsbroich in Leverkusen, Piene credited the Italian's buchi, tagli (cuts), and light installations as the "tyrannicide of painting."[120]

Tinguely was also instrumental to Piene's development of the *Light Ballet*. Tinguely exhibited his noise machines at Galerie Schmela only a few months before Piene debuted his *Archaic Light Ballet*. Tinguely encouraged Piene to motorize his works. The result appeared in Piene's next exhibition at Schmela in July 1960, *A Festival of Light (Ein Fest für Das Licht)*, at which he presented his first mechanized light machines (Figure 2.19). They consisted of an array of lighting fixtures each of which were rotating, flickering, or manually turned on and off in a preplanned sequence. Piene discussed the *Light Ballet* as a "'choreographic' sequence, more or less improvised according to the sound. . . . I attempt to give the *Light Ballet* the naturalness that breathing in and out has for the man who is alive. A nuanced flow of light interests me more than a clash of contracts."[121]

With his *Light Ballet*, Piene transcended the traditional role of painting as a discrete object, coalescing painting, sound, and moving images into a multisensory experience. He dematerialized the objet d'art as had Klein the year before in *La Vide*, but Piene achieved it utilizing artificial light. Piene's *Light Ballet* essentially transformed the nature of the work of art from a static object of contemplation to an active form of engagement. He altered the subject of a work of art from a narrative based on either public or personal history—rendered figuratively, or through gesture—to the democratic sensory reception of natural forces. By orchestrating light, Piene transformed the traditional relationship between the artist and the spectator, eliminating the function of the artist's touch as evidence of the author. He said, "And the light is there and pervades and not I but the light paints."[122]

Tinguely exerted a similar influence on Mack. Mack had introduced his *Light Reliefs* at his second exhibition at Galerie Schmela in October 1958. During the opening, the gallery played electronic music by Stockhausen,

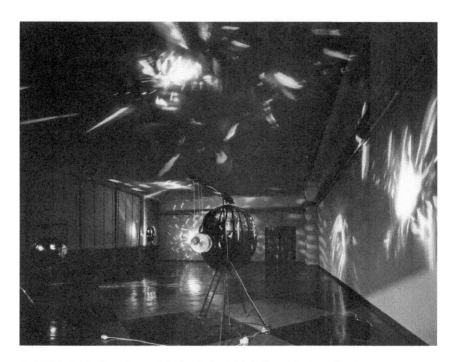

FIGURE 2.19 *Otto Piene*, Mechanische Lichtballet, *1961, at the* Otto Piene Retrospektiv, *Museum am Ostwall, Dortmund, 1967. Harvard Art Museums/ Harvard Art Museums Archives, Records of the Howard Wise Gallery (SC 17), ARCH.0000.456. Photo: Imaging Department © President and Fellows of Harvard College. © 2017 Artists Rights Society (ARS), New York/VG Bild-Kunst, Bonn.*

reinforcing the relationship between the visual and the aural. At this point the reviewers recognized that Mack had "nothing more to do with" the *Tachisme* of Wols and Pollock and their followers.[123] During his exhibition in Düsseldorf, Tinguely also encouraged Mack to motorize his light reliefs, to animate their static form and activate their visceral presence. Mack then developed his rotors, such as the classic kinetic *Silver-Rotor* (1959/1960, Figure 2.20), constructed from layered disks of aluminum and glass slowly rotating, in a viewing cabinet that produced a kaleidoscope of patterns and colors. Mack created a range of pictorial effects using simple principles of optics, geometric forms, serial patterns, and reflective and translucent materials with each work producing subtle nuances of light and motion.

The second generation of artists had been operating as a loose network, with the German Group ZERO as the only definable organization among them. ZERO served as an example for the other artists, who around 1960 began to coalesce into their own groups in their cities hosting exhibitions and producing artists' magazines in emulation of Group ZERO. European

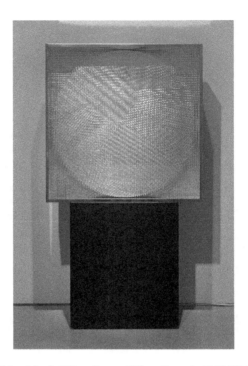

FIGURE 2.20 *Heinz Mack,* Silber-Rotor *[Silver Rotor], 1959/1960, aluminum, wood, glass, motor, 39 3/8 × 39 3/9 × 12 3/8 in. (100 × 100 × 31.5 cm). Private Collection. Courtesy Sperone Westwater, New York. © 2017 Artists Rights Society (ARS), New York/VG Bild-Kunst, Bonn.*

modern art has a long tradition of artists banding into groups, producing manifestoes and proclamations, a model continued by this generation. After participating in *Dynamo*, Manzoni returned to Milan, where he and Enrico Castellani founded their group, Azimuth, in December 1959, opened a gallery, and published an artist's paper. At this time Gruppo Enne (N) in Padua (1959), Gruppo T in Milan (1959), and *La Nuova Tendenz* (The New Tendency) established their group identities in an expanding field of new tendency artist groups.[124]

A protégée of Fontana, Manzoni was active in the avant-garde art circles of Italy in the late 1950s. He was active in securing Klein's *Proposition Monochrome* exhibition at the Galerie Apollinaire, Milan, in January 1957. The exhibit had a tremendous influence on the young Italian, moving him from *art informel* to begin his *Achromes*. Manzoni explored the potential of his colorless series by working through the ideas that he learned from Alberto Burri, Fontana, and Klein. Initially they were more heavily textured with the remnants of facture in traditional modern painting (Figure 2.21). Gradually he began to introduce found materials into the series. Then he embarked on a series of radical projects that would depart from the *objets*

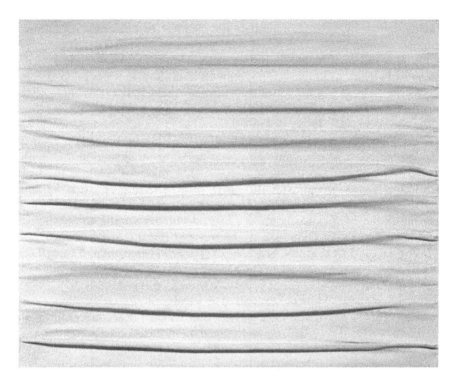

FIGURE 2.21 *Piero Manzoni*, Achrome, *1957–58, Kaolin on folded canvas, 17 ½ × 21 ¼ in. (44.4 × 54 cm). Partial and promised gift of Anstiss and Ronald Krueck Fund for Contemporary Art, 2000.309. The Art Institute of Chicago. © 2017 Artists Rights Society (ARS), New York/SAIE, Rome. Photo: Credit: Art Resource, New York.*

d'art, including his *Linea,* an infinite line that he enclosed in a box and dated with the place of its making.

Each of these ideas and activities was closely related to the ZERO artists and Klein. In 1959 Manzoni helped Klaus Jürgen-Fischer organize a *German New Tendency* exhibition for Milan that included Mack and Piene, and Manzoni participated in their *Dynamo* exhibition in Wiesbaden. He included them in his magazine, *Azimuth.* And, like the ZERO artists, Manzoni found Klein's creative spark contagious. When Klein developed his monochromes (1957), Manzoni followed with *Achromes* (1957); when Klein presented his persona reciting and smoking over his engraved signature in Antwerp (1959), Manzoni followed with his *Artist's Breath* (1960) and *Merda de artista* (1961); when Klein introduced his *Anthropometries* (1960), Manzoni followed with signing the torso of a nude model (1961). Manzoni also assumed the air of mysticism that pervaded Klein's actions. Manzoni announced, "Art is not true creation and foundation except insofar as it creates and founds where mythologies have their ultimate foundation and

their original. In order to assimilate the meaning of one's time, one must connect with one's own individual mythology at the point where it coincides with universal mythology."[125] Unfortunately, Manzoni also followed Klein to an early death in January 1963, only six months after Klein's demise.

When Manzoni and Castellani opened their gallery Azimut, they produced a magazine as a vehicle for their views. The frontispiece of their magazine was Jasper Johns's *Target* (1955), with the lead essay by Guido Ballo, "Beyond Painting," indicating their kindred rebellion against modern painting. Further into the magazine Manzoni aligned himself with the artists of "The Groupement Zero."[126] The range of work in the first edition of *Azimuth* indicates the range of artistic interests that he and Castellani embraced: Dada, Neo-Dada, ZERO, and other new tendencies. He illustrated his mentor Fontana's *tagli*, devoted a section to Schwitters and his essay on "A Definition of Merz," and illustrated Rauschenberg's *Monogram* (1955). With the first issue of *Azimuth*, Manzoni and Castellani announced that postwar art in Italy had moved beyond *Tachism* and had "eclipsed" *informel*.[127]

In January 1960 Manzoni organized an exhibition, *La nuova concezione artstica* (The New Artistic Conception), and issued the second number of *Azimuth*. Curated by Manzoni and Castellani in their Galleria Azimut, the exhibit included work by the German and Italian artists in the ZERO circle.[128] In *La nuova concezione artstica*, the young curators and artists articulated the ambitions of the progressive artistic movement of this generation for a cultural change. Castellani criticized Wols as having spawned a legion of imitators pursuing "a fashionable tendency arising out of a macabre taste for all that is pathological and materially fetid in the human condition." Manzoni claimed that "The New Artistic Conception" dismissed "allusion, expression and representation." In his essay on "A New Conception of Painting," Udo Kultermann wrote that these young painters represented the "new tendencies" and that they were still "largely unknown. . . . [and] not the subject of official debate." Kultermann recognized that their work responded "to the altered forms of modern life," and discussed how they had completely transformed the relationship of the viewer from a passive observer of artistic gestures to an active participant in the conceptual and sensory experience of art.[129] These fundamental premises united the various artists across their stylistic, linguistic, and geographical differences.

In Paris, Klein worked with Tinguely and Spoerri on a series of exhibitions. Following the examples of ZERO and Azimuth, they formed their own group with the curator and critic Pierre Restany, who had taken an interest in their work. In October 1960 Restany proposed that they form a group, which they called the Nouveau Realistes. In April 1960 they first exhibited as a group at Galleria Apollinaire, Milan, including Arman, Francois Dufresne, Raymond Hains, Klein, Spoerri, Tinguely, and Jacques de la Villeglé. Later César, Mimmo Rotella, Niki de Saint Phalle, and Christo joined the group.[130] The artists represented visually divergent stylistic practices, including the

affichistes of Hains and Villeglé; the assemblage constructions of Arman, Spoerri, and César; and, most extreme, Klein's contemplative monochromes and conceptual artist actions. Although the group issued a brief one-sentence manifesto resulting from its October meeting, Restany had already written an essay for their April exhibition in Milan that serves as a statement of their ideas. Many of his ideas echoed the antimodern basis of their colleagues in ZERO. Of Nouveau Réalisme, Restany wrote,

> What do we propose instead? The passionate adventure of the real perceived in itself and not through the prism of conceptual or imaginative transcription. What is its mark? . . . whether this be at the level of choice or of the tearing up of posters, of the allure of an object, of the household rubbish or scraps of the dining-room, of the unleashing of mechanical susceptibility, of the diffusion of sensibility beyond the limits of its perception . . .[131]

This recalls the writings of Allan Kaprow, who advocated two years earlier, "Give up the making of paintings entirely, I mean the single, flat rectangle or oval as we know it. . . . We must become preoccupied with and even dazzled by the space and objects of our everyday life."[132] Restany certainly knew Kaprow's words, but, more importantly, the similarity of their perspectives suggests a gestalt of the period. This thread of the new tendencies was indebted to Duchamp and Dada for its visual source material, its conceptual foundation, and as a model of artistic response to war. Hains and Villeglé began making their collages in 1949, and the English Independent Group artists Eduardo Paolozzi and Richard Hamilton began making them in 1952. The rest of the continent did not become aware of this work until later. In 1956 the Kestner-Gesellschaft hosted a retrospective of Schwitters initiating the resurgence of interest in his collages. The following year in Paris, the Galerie de l'Institut hosted an exhibition of Dada, and in 1958 the Kunsthalle in Düsseldorf presented a Dada exhibition that was, in the eyes of the German critics, surprisingly successful.[133]

The innovative nature of these gallery and artist-curated exhibitions caught the attention of a few progressive curators in Europe. Monochrome painting became institutionally sanctioned in two exhibitions of 1960: *Monochrome Painting*, curated by Kultermann in Leverkusen, Germany; and the Venice Biennale. Kultermann's *Monochrome Painting* exhibition was clearly shaped by *The Red Painting* exhibition held by the ZERO artists in nearby Düsseldorf in 1958. For Schloß Morsbroich, Kultermann expanded the roster to include the Italians Manzoni, Fontana, as well as transatlantic artists Yayoi Kusama and Mark Rothko. In organizing the exhibition he worked closely with the new tendency artists. In the initial stages he proposed titling the exhibition "Painting after Tachism" or "Overcoming *Tachism*." While these titles expressed the artists' rejection of *Tachism*, they were decidedly too negative, so he settled on *Monochrome Painting*.[134] In

his essay for *Monochrome Malerei* ("Monochrome Painting," a revision of his essay for Manzoni's *La nuova concezione artstica*), Kultermann states that his ambition was to present "an international compendium" of the new tendencies that diverged from gestural expression of *Tachism*. Echoing the words of Klein and Piene, Kultermann declared, "Color is materialized sensibility: condition of the anti-material, means for the liberation of people from the bondage of the material world." The diverse works in the exhibition revealed the range of interpretations of monochromatic sensibilities in Europe, Japan, and the United States. At the entrance to the exhibition visitors were greeted by a large blue monochrome by Klein, who over the previous three years had established himself in Germany as the principal artist of monochrome paintings.[135]

In her review of this exhibition, Klapheck once again posed differing perspectives on the question of the monochrome and its place in contemporary art. She viewed the monochrome as the provocateur of "a quiet revolution . . . against pathos and intense gestures" in painting. Yet, in conclusion she wrote,

> One can not expect that monochrome painting now to become a world-conquering Monochromism. For that the field of possibilities is too small. At least it incontestably brings forward an artistic phenomenon of our time, whose visualization the exhibition has succeeded in Morsbroich. Behind every artistic phenomenon rests a human one: the desire for order and peacefulness, for a balance of opposites, the human longing for peace.[136]

The monochrome was an initial attempt at breaking away from modern painting, by moving away from the mark of the artist and communicating directly with the viewer. But the new tendencies would depart from the monochrome as well, perhaps, as Klapheck has suggested, because the possibilities were limited. Instead these artists pursued the combination of the "passionate adventure of the real" and the advances in art and technology into the 1960s.

Another turning point in the institutional acceptance of the new artistic tendency occurred in 1960 at the Venice Biennale. At this Biennale the judges awarded the main prizes to some of the principal European *informel* painters: Vedova, Fautrier, and Hartung. But they also awarded a Prize for a Young Painter to Piero Dorazio, one of the painters featured in *Monochrome Painting*. This official recognition of a second-generation artist signaled the awareness that a fundamental transition was occurring. Dorazio had studied painting in Paris immediately after the war and participated in the reintroduction of abstraction into postwar Italy. Although he was exposed to the *informel* artists such as Fautrier and Wols, he too pursued painting as a vehicle for optical stimulation, not personal expression. He was interested in "the experiments in 'textures' or in the integral spatiality of

the surfaces which were conducted especially by Moholy-Nagy."[137] Dorazio explained his artistic intention to achieve "the balance and the harmony in which light-movement-texture . . . come to life" through "a very subtle build up of texture and color [of paint] while others get along as well with a few wide and decisive strokes."[138] For Dorazio abstract painting was a "universal style," a sensory experience that communicated not just with an elite, but also with a "universal civilization."[139] His words echo those of the other second-generation postwar artists who pursued new tendencies, and, although he was slightly older, he participated in numerous ZERO exhibitions and maintained a close relationship to the network of artists.

The resurrection of the interwar idea of monochrome painting in the postwar period was an example of the second postwar generation seeking models by skipping over the generation of their fathers to look at the Bauhaus, Dada, and constructivists. In the wake of *informel*'s aggressively gestural expression of the angst of the first postwar generation, the new tendency artists sought to "reinvent" painting by eliminating the mark of the maker, through either manufactured materials or processes.[140] They returned to the examples of artists who developed responses to the first war, as relevant examples for exorcizing their trauma from the Second World War. For those second-generation artists working through the tradition of painting, they looked back to Malevich, who sought "to liberate art . . . from the representational world,"[141] and Alexander Rodchenko, who "reduced painting to its logical conclusion . . . there is to be no representation."[142] These Russian constructivists dismissed the debate that raged in the 1920s between abstraction and representation, a lesson learned by the new tendency artists. But after the Second World War the first postwar generation felt compelled to revisit the debate, in their attempts to rebuild the cultural foundation of Europe, but they did not develop adequate solutions. The second postwar generation did return to the monochrome, and instead of proposing the formal solutions of the constructivists or the Dutch De Stijl to employ flat planes, squares, and pure colors, they sought a redefinition of the monochrome in terms of the technological and intellectual changes that had ensued since the war in new materials and through the philosophy of phenomenology. The pursuit of the monochrome in the 1950s stretched across the territories touched by the Second World War and included, beyond those in Kultermann's ambitious *Monochrome Painting* exhibition, Ellsworth Kelly, Barnett Newman, and Rauschenberg in the United States. It was, indeed, a gestalt of the period that satisfied a cultural impulse to work through the steps to dismantle modern art. The debate on the end of painting, or the end of art, was initiated in the 1920s with the understanding that mass production and reproduction invoked the question of artistic originality. For the postwar monochrome painters, as well as for the collage and assemblage artists, the appropriation of manufactured materials hastened the dissolution of painting. As Pierre Restany wrote, "Painting is dying. . . . The traditional pictorial means of expression have not withstood

the tremendous wear and tear of our modern times. . . . Time has passed it
by. . . . The world of today is filled with a fundamental longing for more
immediate communication and direct perception of the real."[143]

By the time the new tendency in monochrome painting was sanctified by
its institutional endorsement in the *Monochrome Painting* exhibition and
the Venice Biennale of 1960, it too was passing. Just a year earlier Haftmann
had declared in his introduction to the second *documenta* (1959) that the
international style of painting was unequivocally abstraction.[144] However,
he was too late. What began in 1957 in Düsseldorf as a "Revolution of
the Drawing Teachers,"[145] by 1960 had already superseded the problem of
painting. The progressive artists of ZERO and the new tendencies across the
triangular network between Düsseldorf, Milan, and Paris moved on to the
activation of the art experience, the dematerialization of the object, linking
art and technology, as well as the material of everyday life into a performative,
interactive, art experience. This art developed in a cultural context in
concert with the emergent new philosophy—Heidegger's phenomenology,
Hartmann's ontology, and Bense's information theory—as the intellectual
basis of developing the artistic experience from a passive, static one, into an
interactive, sensory one. Piene described his process as converting "visual
energy . . . into vital energy for the observer. . . . The manner in which the
conversion occurs is truly 'mystical'."[146] When Klapheck reviewed the Group
53 exhibition in 1957, where Hoehme's monochrome paintings caused a
sensation, she asked whether *Tachism* was the "End or the Beginning." At
the time she concluded that it was a new beginning and "contained enough
starting points from which one can proceed."[147] However, by the time of
the *Monochrome Painting* exhibition in 1960 she acknowledged that with
monochrome painting "the field of possibilities is too small" to evolve into a
"world-conquering Monochromism."[148]After just three years she recognized
that it was neither an end nor a beginning, but a transitional moment.

Notes

1 Frances Morris, *Paris Post War: Art and Existentialism, 1945-55*. Exhibition
 catalogue (London: Tate Gallery, 1993), 45. Morris attributes this statement
 to Tapié and cites the source as Basil Taylor, "Art," *The Spectator*, vol.
 16 (September 1955): 362. However, the sentence does not appear in the
 translation of Tapié's essay reprinted in Serge Guilbaut, *Be-Bomb: The
 Transatlantic War of Images and all that Jazz. 1946-1956*. Exhibition
 catalogue (Madrid: Museu d'Art Contemporani de Barcelona and Museo
 Nacional Centro de Arte Reina Sofia de Madrid, 2007), 540–45.
2 Jean Dubuffet, Notes for lecture, "Anti-Cultural Positions," 1951. William
 Eisendrath Papers, Washington University Archives, St. Louis.
3 Mathieu quoted in Morris, *Paris Post War*, 182.
4 Margarlit Fox, "Karel Appel, Dutch Expressionist Painter, dies at 85," *The
 New York Times* (May 9, 2006): A25.

5 "Manifesto of nuclear painting" (1952), reprinted in Germano Celant, *The Italian Metamorphosis, 1943-1968*. Exhibition catalogue (New York: Guggenheim Museum, 1994), 716.

6 Charles Estienne, "A Revolution, Tachism" (1954), reprinted in Guilbaut, *Be-Bomb*, 554–57.

7 Anselm Haverkamp, *Latenzzeit: Wissen im Nachkrieg* (Berlin: Kulturverlag Kadmos, 2004). See also "Latenzzeit. Die Leere der Fünfziger Jahre: Ein Interview mit Anselm Haverkamp von Juliane Rebentisch und Susanne Leeb," *Texte zur Kunst*, vol. 12, no. 50 (2003): 45–53.

8 Heinz Mack, "Traum und Wirklichkeit: Ein Kommentar," in *Gruppe ZERO*. Exhibition catalogue (Düsseldorf: Galerie Schoeller, 1988), 5.

9 Pierre Restany, "Der Kehricht von ARMAN: Ein Aspekt des neuen Realismus," May 1960. Alfred Schmela Papers, 2007. M17. Getty Research Institute, Box 1, F.19.

10 An original citation for Delaroche's now legendary quote has never been found and is believed to be the product of myth. My source for this information is Douglas Crimp, "The End of Painting," *October*, vol. 16 (Spring 1981): 69–86.

11 Ines Katenhusen, Leibniz University, Hanover, who is preparing a biography of Dorner, brought the reproduction debate between Dorner, Panofsky, and others to my attention. See Alexander Dorner, "Das Ende der Kunst?," in *Lübeckische Blätter. Zeitschrift der Gesellschaft zur Beförderung gemeinnütziger Tätigkeit* (February 10, 1929).

12 Walter Benjamin, "The Work of Art in the Age of Mechanical Reproduction," originally published in 1936, reprinted in *Walter Benjamin: Illuminations: Essays and Reflections*, edited by Hannah Arendt (New York: Harcourt Brace and World, 1968), 217–51. See also György Markus, "Walter Benjamin and the German 'Reproduction Debate,'" in *Moderne begreifen. Zur Paradoxie eines sozio-ästhetischen Deutungsmusters,* edited by Christine Magerski, Robert Savage, Christiane Weller (Heidelberg: Springer, 2007), 351–64.

13 Louis Aragon, "Challenge to Painting," originally published as *La peinture au defy* (1930), reprinted in *Surrealists on Art,* edited by Lucy R. Lippard (Englewood Cliffs, NJ: Prentice-Hall, Inc., 1970), 41, 42. See Crimp, "The End of Painting," 69.

14 Tony Judt, *Postwar: A History of Europe Since 1945* (London, New York: Penguin Books, 2005), 5.

15 Clement Greenberg, "The Crisis of the Easel Picture" (1948), reprinted in *The Collected Essays and Criticism,* edited by John O'Brien, vol. 2 (Chicago: University of Chicago Press, 1986–1993), 224.

16 Yve-Alain Bois, *Painting as Model* (Cambridge, MA and London: MIT Press, 1990).

17 Theodor W. Adorno, "Cultural Criticism and Society" (1949), in *Prisms* (Cambridge, MA: MIT Press, 1981), 19.

18 Lucio Fontana in *Il Gesto* (1955), quoted in Jaleh Mansoor, "Fontana's Atomic Age Abstraction: The Spatial Concepts and the Television Manifesto," *October*, vol. 124 (Spring 2008): 140.

19 Paul Celan, 1960, quoted in Eckhardt Gillen, *Deutschlandbilder. Kunst aus einem geteilten Land*. Exhibition catalogue (Martin-Gropius-Bau Berlin, Köln, 1997), 53.

20 Günter Grass, "Writing after Auschwitz," quoted in John-Paul Stonard, *Fault Lines: Art in Germany 1945-1955* (London: Ridinghouse, 2007), 137.
21 Otto Piene, *Jetzt*. Unpublished essay dated Düsseldorf, August 31, 1963; and Karl Ruhrberg, "Die Poesie der Malmaterie: zur Ausstellung der 'Gruppe 53'," *Düsseldorfer Nachrichten* (January 23, 1958). Otto Piene Archives.
22 Otto Piene, "Zero and the Attitude," unpublished manuscript written in spring 1965. Otto Piene Archives, Düsseldorf, 6.
23 Ibid., 4.
24 *Günther Uecker: Twenty Chapters*, 12.
25 Renate Wiehager, "Heinz Mack: Art Spaces for ZERO, Cosmos and Image, Nature and Word, Philosophy and Action," in *Mack-ZERO!* Exhibition catalogue (Bonn: Beck & Eggeling Kunstverlag, 2006), 49–50.
26 Otto Piene, "Zero and the Attitude," (1965).
27 Wilhelm Hausenstein, *Was bedeutet die moderne Kunst. Ein Wort der Besinnung* (Leutstetten vor München: Verlag Die Werkstatt, 1949).
28 Otto Piene, "Was bedeutet die moderne Kunst für gegenwärtiges Leben?" (1955). Typescript of lecture, 12–13. Otto Piene Archives.
29 See Chapter 1 for a discussion of Behne, Grohmann, and Haftmann's positions in the formalism debate.
30 Piene, "Was bedeutet," 1955, 13.
31 Joseph D. Ketner II interview with Otto Piene (February 20, 2013).
32 Anna Klapheck, "Um den 'Verlust der Mitte': Prof. Hans Sedlmayr vor der Arbeitsgemeinschaft kultureller Organisationen," *Rheinische Post* (December 16, 1950). ZADIK, Cologne.
33 John Anthony Thwaites, "I. Anno 1954," (c. 1960). ZADIK, Cologne. In this unpublished manuscript, Thwaites offers his brief history of art in postwar Düsseldorf.
34 The group adopted its name from the year it was founded in emulation of other postwar German groups such as the Group 47 *Trümmerliteratur* (rubble literature) authors and Baumeister's Zen 49. The single source for information on the group is Marie-Louise Otten, *Auf dem Weg zur Avantgarde: Künstler der Gruppe 53*. Exhibition Catalogue (Bönningheim: Museum der Stadt Ratingen, 2003).
35 The most thorough study of Gerhard Hoehme's early work is Susanne Rennert, ed. *Die Unruhe wächst: Hoehme*, exhibition catalogue (Köln: DuMont Buchverlag, 2009). See also *Gerhard Hoehme: Bildkontakte: Werke von 1948 bis 1988*, exhibition catalogue (Düsseldorf: Kunstmuseum Düsseldorf, 2000).
36 Thwaites, "I. Anno 1954," (c. 1960).
37 Hannelore Schubert from the *Kölner Stadt-Anzeiger* quoted by Thwaites "I. Anno 1954."
38 Hannelore Schubert, "Nachkriegsgeneration in Düsseldorf. Anmerkungen zur heutigen künstlerischen Situation," *Das Kunstwerk*, vol. 11 (1957/1958): 28.
39 The quotes from Anna Klapheck are from her article, "Tachismus—Ende oder Anfang? Zur Ausstellung der 'Gruppe 53' in der Kunsthalle Düsseldorf," *Rheinische Post* (January 30, 1957). Heinz Mack Archive, ZERO Foundation, Düsseldorf. The remarks by Thwaites are from his "I. Anno 1954," (c. 1960).
40 Hannelore Schubert, "Lösung vom Pariser Vorbild," *Der Mittag*, (n.d.) Otto Piene Archives.

41 Heinz-Norbert Jocks, *Das Ohr am Tatort: Heinz Norbert Jocks im Gespräch mit Gotthard Graubner, Heinz Mack, Roman Opalka, Otto Piene, Günther Uecker* (Ostfildern: Hatje Cantz, 2009), 59. Antonio Tàpies Grey paintings were shown at Galerie Schmela beginning on November 27, 1957. See Karl Ruhrberg, eds. *Alfred Schmela: Galerist. Wegbereiter der Avantgarde* (Cologne: Wienand Verlag, 1996), 29. Mack was reported to have visited Tàpies in the summer of 1957; see Anette Kuhn, *ZERO: Eine Avantgarde der sechziger Jahre* (Frankfurt am Main, Berlin: Propyläen Verlag, 1991), 15.
42 Thwaites, "I. Anno 1954," (c. 1960).
43 Olivier Berggruen, Max Hollein, and Ingrid Pfeiffer, *Yves Klein*. Exhibition catalogue (Ostfildern-Ruit: Hatje Cantz, 2004), 56.
44 For a thorough accounting of the exhibition based on the Alfred Schmela's papers, see Martin Schieder, "Alfred Schmela, Yves Klein, and a Sound Recording," *Getty Research Journal*, no. 5 (2013): 133–47.
45 Berggruen, *Klein*, 17, 19.
46 Schieder, "Alfred Schmela," 135.
47 Celant, *The Italian Metamorphosis*, 684.
48 Valerie Lynn Hillings, "Experimental Artists' Groups in Europe, 1951-1968: Abstraction, Interaction and Internationalism" (Ph.D. Dissertation, Institute of Fine Arts, New York University, 2002), 128.
49 Hannelore Schubert, "Gibt es wieder eine Düsseldorfer Malerschule?" *Westdeutscher Rundfunk, Nachtprogramm* (July 9, 1957). Otto Piene Archives.
50 Otto Piene, "The Development of Group Zero," *The Times Literary Supplement* (London) (September 3, 1964).
51 Heinz Mack, "For Otto Piene," in Ante Glibota. *Otto Piene* (Paris: Delight Editions, Ltd., 2011), 282.
52 Hannelore Schubert, "H. Mack fand zu sich selbst. Rundgang durch die Düsseldorfer Galerien," *Kölner Stadt-Anzeiger* (October 4, 1958). Otto Piene Archives.
53 Heinz Mack, "The New Dynamic Structure," *ZERO 1* (Cambridge and London: MIT Press, 1973), 14.
54 Heinz Mack, "Resting Restlessness," in *ZERO 2*, 41.
55 John Anthony Thwaites, "Reaching the ZERO Zone," *Arts magazine* 10, no. 36 (September 1962): 21.
56 "Der Daumendruck im Aluminium," *Der Mittag* (October 14, 1958). Heinz Mack Archive, ZERO Foundation, Düsseldorf.
57 H. T., "Soll man Malübungen ausstellen?" *Düsseldorfer Nachrichten* (October 4, 1957). Heinz Mack Archives, ZERO Foundation, Düsseldorf.
58 "Unter einem Löcherbild am Abend. Eintagausstellung im Kunstlabor: Brüning, Mack, Piene und Salentin." *Der Mittag* (September 28/29, 1957). Mack Archiv, ZERO Foundation, Düsseldorf.
59 "Neuer Treffpunkt 'Abendausstellung': Max Bense als Gast," *Rheinische Post* (December 18, 1957). Otto Piene Archives.
60 "Unter einem Löcherbild am Abend."
61 Thwaites, "I.Anno.1954."
62 Karl Ruhrberg, "Der Philosoph im Trümmergrundstück. Prof. Max Bense in der Abendausstellung Klaus Fischer," *Düsseldorfer Nachrichten* (December 16, 1957). Otto Piene Archives.

81 Klaus Jürgen-Fischer, Unpublished typescript of opening speech at "Das Rote
 Bild" exhibition on April 24, 1958. Otto Piene Archives.
82 Hillings, "Experimental Artists' Groups in Europe, 1951-1968," 132.
83 Dieter Honisch, *Uecker* (New York: Harry N. Abrams, 1986), 11–12, 18.
84 "Max Bense On Mavignier," *ZERO*, 30, 32.
85 Berggruen, *Klein*, 22.
86 Ibid., 55.
87 Jean Hubert Martin, *ZERO: internationale Künstler-Avantgarde der
 50er-60er Jahre: Japan, Frankreich, Italien, Deutschland, Niederlande-
 Belgien, die Welt.* Exhibition catalogue (Ostfildern: Hatje Cantz, 2006), 267.
88 For thorough information on Tinguely's biography and art work, consult
 The Museum Tinguely, Basel. The Collection (Heidelberg, Berlin: Kehrer
 Verlag, 2012); and Margriet Schavemaker, Barbara Til, and Beat Wismer, eds.,
 Jean Tinguely. Exhibition catalogue (Düsseldorf: Museum Kunstpalast in
 cooperation with the Stedelijk Museum, Amsterdam, 2016).
89 http://calder.org/life/chronology
90 Catherine Millet wrote in *L'art contemporain en France* (Paris: Flammarion,
 1987), 14, "In France at the end of the fifties, no-one paid much attention to
 one of Jacques Villon's brothers, Marcel Duchamp," quote in *Strategies de
 Participation—GRAV*, 37.
91 Guy Brett, *Force Fields: Phases of the Kinetic* (Exhibition catalogue.
 Barcelona: Museu d'Art Contemporani de Barcelona, 2000), 38.
92 Heinz Mack, "A Visit, November 1958, Paris," in Renate Wiehager, *ZERO
 aus Deutschland* (Ostfildern-Ruit: Hatje Cantz, 2000), 36.
93 Daniel Spoerri, Brief an Alfred Schmela mit Texten, 1959. Alfred Schmela
 Papers. Getty Research Institute. 2007.M.13, Box 7, F32.
94 The Cabaret Voltaire was a bar in Zürich in which Hugo Ball in 1916 set up
 a variety show of absurd performances by a group of European artists who
 had exiled themselves to Switzerland to escape the First World War. This
 group became Dada. See Richard Hülsenbeck, *En Avant Dada: A History of
 Dadaism* (Hannover: Steegemann, 1920), quoted in *Theories of Modern Art:
 A Source Book by Artists and Critics,* edited by Hirschel Chipp (Berkeley,
 CA: University of California Press), 377–82.
95 *Jean Tinguely. Meta-Maschinen.* Exhibition catalogue (Duisburg: Wilhelm-
 Lehmbruck-Museum der Stadt Duisburg, 1979), 23.
96 Julia Robinson, *New Realisms: 1957-1962. Object Strategies Between
 Readymade and Spectacle.* Exhibition catalogue (Cambridge, MA/London,
 England: Museo Nacional Centro de Arte Reina Sofia, Madrid, and The MT
 Press, 2010), 32.
97 "Ein Atelierfest unterm Dach," *Rheinische Post* (n.d.). ZADIK. See also
 Klaus Gereon Beuckers and Günther Uecker. *Günther Uecker. Die Aktionen*
 (Petersberg: Imhof, 2004), 51.
98 Beuckers, *Günther Uecker*, 51. See also Jocks, *Das Ohr am Tatort*, 125–26,
 where Uecker explains the source of his idea.
99 Otto Piene, "Mother Turn off the Picture," unpublished typescript, 1968.
 Otto Piene Archives.
100 Otto Piene, correspondence with Pol Bury and Daniel Spoerri (March 4,
 1959). Otto Piene Archives.
101 László Moholy-Nagy, *Vision in Motion* (Chicago: Paul Theobald, 1947), 260.

102 See Kai-Uwe Hemken, "Cultural Signatures: László Moholy-Nagy and the
 'Room of Today'," in *László Moholy-Nagy Retrospective*, edited by Ingrid
 Pfeiffer and Max Hollein. Exhibition catalogue (Munich: Schirn Kunsthalle
 and Prestel Verlag, 2009), 169. Mack and Piene had experience working on
 exhibition display in 1953, while students at the academy they assisted in the
 design of the science section of the Düsseldorf exhibition, "Alles soll besser
 leben."
103 Berggruen, *Klein*, 65.
104 Otto Piene, "The Development of Group Zero."
105 Renate Boukes, correspondence with Otto Piene (10 June 1959); Otto
 Piene, correspondence with Renate Boukes (June 13, 1959). Otto Piene
 Archives.
106 Jocks, *Das Ohr am Tatort*, 108.
107 Heinz Mack and Otto Piene, correspondence with Hans Sonnenberg (July 27,
 1959). Otto Piene Archives. On the basis of Mack and Piene's objection the
 gallery later changed its name to "Orez" (zero spelled backward).
108 Hillings, "Experimental Artists' Groups in Europe, 1951-1968," 159.
109 Jocks, *Das Ohr am Tatort*, 61.
110 Renate Wiehager, "Heinz Mack: Art Spaces for ZERO, Cosmos and Image,
 Nature and Word, Philosophy and Action," in *Mack-ZERO!* Exhibition
 catalogue (Bonn: Beck & Eggeling Kunstverlag, 2006), 49–50.
111 Perucchi-Petri, "Otto Piene and ZERO".
112 Otto Piene, "Rauchzeichnungen, Lichtballett, Malerei," Exhibition catalogue
 (Berlin: Galerie Diogenes, 1960). Otto Piene Archives.
113 Berggruen, *Klein*, 44.
114 John Anthony Thwaites, "The Day the Light Ballet Began," typescript. Otto
 Piene Archives.
115 Jürgen Becker and Wolf Vostell, eds., *Happenings: Fluxus, Pop Art,* Nouveau
 Réalisme (Reinbek: Rowohlt, 1965), 36.
116 *ZERO*, 172–73.
117 Otto Piene "Paths to Paradise," *ZERO*, 149.
118 Moholy-Nagy, László. *Painting, Photography, Film* (Cambridge and London:
 The MIT Press, 1967), 20–24.
119 Anthony White, "Industrial Painting's Utopias: Lucio Fontana's
 'Expectations'," *October*, no. 124, Postwar Italian Art Special Issue (Spring
 2008): 120–21. For an illustration see Celant, *Fontana*, #147, 147
120 Otto Piene, "Heute und Morgen," typescript of lecture delivered at Schloß
 Morsbroich on the occasion of Fontana's retrospective, 1962. Otto Piene
 Archives.
121 Otto Piene, "Light Ballet." Exhibition catalogue (Berlin: Galerie Diogenes,
 1960). Otto Piene Archives.
122 Otto Piene, *Das Licht malt*. Exhibition catalogue (Antwerp: Galerie Ad
 Libitum, 1961).
123 Karl Ruhrberg, "Bilder von Heinz Mack," *Düsseldorfer Nachrichten* (
 October 9, 1958). Otto Piene Archives.
124 Celant, *The Italian Metamorphosis*, 12.
125 Germano Celant, *Piero Manzoni: A Retrospective*. Exhibition catalogue
 (Milan: Skira editore in collaboration with Archivio Opera Piero Manzoni at
 the Gagosian Gallery, 2009), 85.

126 *AZIMUTH,* vol. 1, edited by Enrico Castellani and Piero Manzoni (Milan, 1959), np.

127 Celant, *The Italian Metamorphosis,* 13.

128 *La nuova concezione artistica,* January 4 to February 1, 1960. Galleria Azimut. As the editor notes, although Otto Piene is listed in the catalogue and contributed an essay to the magazine, his contractual obligations to another Italian gallery prevented his work from being included in the exhibition.

129 Enrico Castellani, "Continuity and Newness," Piero Manzoni, "Free Dimension," and Udo Kultermann, "Une nouvelle conception de peinture," in *AZIMUTH,* edited by Enrico Castellani and Piero Manzoni, vol. 2 (Milan, 1960), n.p.

130 *1960. Les Nouveaux Réalistes.* Exhibition catalogue (Paris: Musee d'Art Moderne de la Ville de Paris, 1986), is an important resource on the Nouveaux Réalistes. Two new publications have recently appeared that address differing aspects of this group: Julia Robinson, *New Realisms: 1957-1962,* and Kaira M. Cabañas, *The Myth of* Nouveau Réalisme: *Art and the Performative in Postwar France* (New Haven and London: Yale University Press, 2013).

131 Pierre Restany, Preface, *Les Nouveaux Réalistes* (Milan: Apollinaire Gallery, May 1960).

132 Allan Kaprow, "Legacy of Jackson Pollock," *Artnews* (October 1958): 56.

133 Werner Schmalenbach, *Kurt Schwitters.* Exhibition catalogue (Hannover: Kestner Gesellschaft, 1956); "L'adventure Dada, 1916-1922," Galerie de l'Institut, Paris, 1957 (citation courtesy Robinson, *New Realisms: 1957-1962,* 56); John Anthony Thwaites, "Dada hits West Germany," *Arts Digest,* vol. 33, no. 2 (February 1959): 30–37. Interestingly, the Dada phenomenon came to the United States at an earlier stage with Robert Motherwell's publication on *Dada Painters and Poets* (New York: Wittenborn and Schultz, 1951), and the Sidney Janis Gallery, New York, exhibition, *Dada 1916-1923* in 1953.

134 Udo Kultermann, Brief an Heinz Mack (January 26, 1959). Heinz Mack Archives, ZERO Foundation, Düsseldorf.

135 Udo Kultermann in conversation with the author said that Klein later withdrew his painting from the exhibition citing that many of the works in the show did not represent his sensibility and he did not want to be associated with them. Klein was known to have a fiery temper engaging in fisticuffs at the *Vision in Motion* exhibition in Antwerp in 1959 and at the inauguration of Nouveau Réalisme in his apartment in October 1960. Kultermann confirmed his story in the WDR television program *Avant-garde,* produced by Rolf Wiesselmann (1961).

136 Anna Klapheck, "Was ist monochrome Malerei? Zu einer Ausstellung in Schloß Morsbroich," *Rheinische Post* (March 26, 1960). Otto Piene Archives.

137 "GC Argan: Piero Dorzaio," July 20–30, 1959 (Berlin: Galerie Springer, 1959), np.

138 Letter from Piero Dorazio to Howard Wise, August 22, 1958. Howard Wise Papers, (SC 17), folder 623 [2/2]. Harvard Art Museum Archives, Harvard University, Cambridge, MA.

139 Dorazio quoted in Christopher Masters, "Piero Dorazio: Italian painter inspired by the revolutionary power of abstract art," *The Guardian* (May 26, 2005).

140 Benjamin H.D. Buchloh, "The Primary Colors for the Second Time: A Paradigm Repetition of the Neo-Avant-Garde," October, vol. 37 (Summer 1986): 44, where he wrote, "Inevitably, the reduction to the monochrome also implied a redefinition of the role of artists. Insofar as the work eliminates the marks of manual creation."

141 Herschel B. Chipp, *Theories of Modern Art: A Source Book by Artists and Critics* (Berkeley: University of California Press, 1968), 311–12.

142 Bois, *Painting as Model*, 238.

143 Pierre Restany, "Der Kehricht von ARMAN: Ein Aspekt des neuen Realismus," May 1960. Alfred Schmela Papers, 2007.M.17, Box 1, F.19. Getty Research Institute.

144 Werner Haftmann, "Malerei nach 1945," *documenta* (Cologne: DuMont Schauberg, 1959).

145 Karl Ruhrberg, "Die Revolution der Zeichenlehrer. Otto Pienes Lichtballett und der Rückzug auf die Nuance." *Düsseldorfer Nachrichten* (May 13, 1959). Otto Piene Archives.

146 "Interview with Otto Piene," *Kunst.*

147 Klapheck, "Tachismus—Ende oder Anfang?" *Rheinische Post* (January 30, 1957).

148 Klapheck, "Was ist monochrome Malerei?" Otto Piene Archives.

CHAPTER THREE

ZERO, the New Tendency, and New Media

With the 1960 exhibitions *The New Artistic Conception* in Milan and *Monochrome Painting* in Leverkusen, and the Venice Biennale Prize for Young Painter awarded to Piero Dorazio, Group ZERO and their colleagues became central to the conversation on progressive postwar European art. Critics referenced them as advancing "new tendencies" and "new directions," due to their anti-*Tachism* painting positions. These artists worked their way through the problems of painting, and distanced their work from the diaristic gestures of their predecessors. Yet at the moment of the critical acceptance of their paintings, they were already developing new artistic statements that completely departed from the tradition of painting. They disregarded their predecessors' debates on abstraction versus representation, preferring to address the very nature of what constitutes the work of art and the artistic experience. They abandoned the palette and easel and expanded their artistic media, incorporating manufactured materials, new technologies, consumer products, and light, transforming art from the static objet d'art into a kinetic, sensory experience. Otto Piene debated whether or not they should completely discard the easels in their studios and decided to incorporate their easels into their collaborative installations and burn the remaining ones. These artists returned to the artists of the 1920s, and revived the tradition of art and technology and synthesized it with the Dada performance, in an amalgam particular to their historical and psychological circumstances. Through the 1960s, we witness an acceleration of artistic developments, catalyzing a tremendous artistic revolution that transcended painting and embraced new technology, performance, and immersive installations.

This chapter chronicles the flourishing of Group ZERO in the early 1960s as they developed new media drawing from nature, technology, and the world around them for materials to create their work. It charts the interrelationships between ZERO and the other groups across Europe:

Nouveau Réalisme, Nul, New Tendency, and GRAV. This network of artists expanded dramatically in the first few years of the decade, growing to include as many as forty-four different artists from across Europe in an informal association of creative people who, in the words of Günther Uecker, opened a "realm of possibilities."[1] They exhibited and worked together. Their influences on one another can be seen across the geographical reach of this international phenomenon.

The pan-European recognition of ZERO and the new tendency artists resulted in an increase in exhibition opportunities. In Frankfurt, Rochus Kowallek, a progressive cultural figure, opened a new gallery, dato, with the purpose of presenting the "current data on the tendencies" in new art.[2] In an early letter to Heinz Mack, Kowallek forewarned that the monochrome phase was quickly approaching its conclusion, "The after-Tachists-Boom must indeed one day . . . end."[3] To signal his artistic program, Kowallek invited Piene to present his *Light Ballet* for the inaugural exhibition, in April 1961. With this, Kowallek became a close colleague of Piene and the ZERO artists, promoting their work in the early to mid-1960s. Following several successful presentations in Berlin, Cologne, and Düsseldorf, Piene introduced his immaterial light installation in Frankfurt under the title *The Light Paints, Not I*. Since he debuted the hand-held, *Archaic Light Ballet* at the Galerie Schmela in 1959, Piene fabricated a variety of mechanized light sculptures to produce effects on the walls of the gallery.

The response to the exhibition was enthusiastic. The *Frankfurter Allgemeine* reported that Piene's light sculptures and smoke drawings represented many of the ideas behind the new artistic directions that departed from *informel* painting. The review complemented the clarity of his ideas, expressed in the exhibition texts and in the ZERO magazines, which were "an exception to the gibberish that generally circulates in manifestos, for which one cannot be grateful enough."[4] The installation captured the imagination of writer Walter Schmiele, who recognized that Piene withdrew his authorial presence, encouraging the viewer to complete the experience by physically immersing himself and contemplating the visual effects. Schmiele observed that the responsibility for conveying meaning fell to an inanimate apparatus that the artist merely switches on, and that the artist ceded his traditional role as the intermediary. However, Schmiele wrote, "I gladly want to see his light ballet. I think it's wonderful . . . I could watch it for a long time. . . . I do not expect the operating personnel to intellectually engage me. Step away, painter, you are in the way. I want to be alone with the light. Your machine works great. Your words are superfluous."[5] Schmiele belonged to the prewar generation, was a protégé of Karl Jaspers, and was familiar with Jaspers's call for "an original act of creation." His review suggests that he may have experienced it in Piene's installation.

Only a few months later, in July 1961, ZERO launched its first artists' action, the ZERO *Edition-Demonstration-Exposition* (Figure 3.1). Uecker, who previously participated in ZERO exhibitions, formally joined Mack

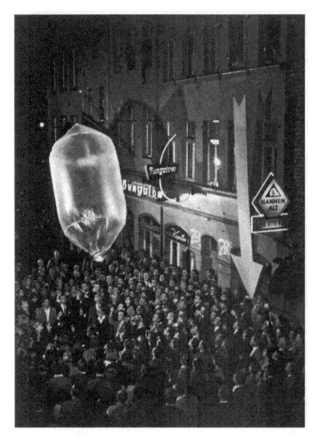

FIGURE 3.1 ZERO—Edition, Exposition, Demonstration, *Düsseldorf, 1961.*
Atelier Mack. Photo: Paul Brandenburg.

and Piene for this project as one of the principals of the group. The artists
boarded up Schemla's gallery[6] and staged a demonstration in the streets
of Düsseldorf's *Altstadt* (old city). The narrow Hunsrücken Street, lined
with tourist shops and breweries, was impassably congested. Schmela had
applied for permission from the city to block off the streets for several
hours that night to host "an artistic demonstration," in order to launch the
third issue of *ZERO* with numerous foreign guests, press, and television.[7]
The artists initiated the proceedings with Uecker painting a *White Zone*,
a large white circle on the street outside Schmela's front door, surrounded
by a cast of young women wearing conical, black capes emblazoned with
a white "ZERO" and blowing soap bubbles into the air (Figure 3.2). From
the center of the circle, they levitated a large hot-air balloon illuminated by
spotlights. Hundreds of people gathered in the narrow cobblestone streets

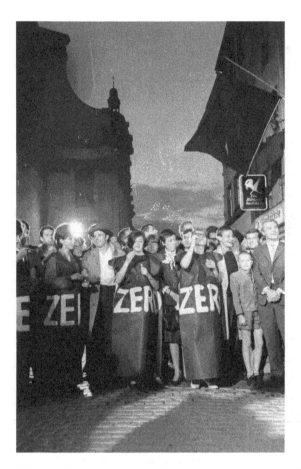

FIGURE 3.2 ZERO—Edition, Exposition, Demonstration, *Düsseldorf, 1961.*
Photo: Manfred Tischer. © Estate of Manfred Tischer.

to witness the event and participate in the action all under the bright lights of television cameras that filmed the proceedings. A large silver arrow ran the height of the building facade pointing to a porthole in the boarded entrance, through which one could view the inside of the gallery, where the artists had hung their new, and most expansive, edition of *ZERO*, a comprehensive statement of their artistic aspirations. Inside, there was a group of supporters and collectors who had received an invitation to the event, stamped "Secret" (Figure 3.3).

The large, multifaceted public street festival and artists' demonstration grew out of the group's one-night evening exhibitions, Piene's performative *Light Ballet*, and Mack's *Light Demonstration*. Uecker, the newest member of the group, was instrumental in encouraging the others to expand the performance component of their projects.[8] His festival for Jean Tinguely

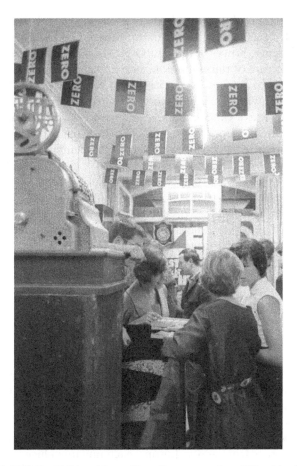

FIGURE 3.3 ZERO—Edition, Exposition, Demonstration, *Düsseldorf, 1961.*
Photo: Manfred Tischer. © Estate of Manfred Tischer.

(1959) and his close relationship with Klein and the Nouveaux Réalistes
provided examples of Dada-influenced performance that informed his
own performance. Klein released 1001 balloons in the street in advance
of his exhibition *Propositions Monochromes* in Paris (1957), and Spoerri's
simultaneous reading at Tinguely's 1959 opening at the Galerie Schmela
served as precedents for some of the actions in the ZERO demonstration.
Dada was on the minds of these artists after the proliferation of exhibitions
in Europe and the United States, including the one in Düsseldorf in 1958 that
John Anthony Thwaites reported was "enormously important," especially, he
noted, "the revolutionary element . . . because art of the present needs it for
its nourishment."[9] The critic Jürgen Morschel noted the relationship between
the ZERO demonstration and the Neo-Dada actions of the Nouveaux
Réalistes: "In some painters of the ZERO circle, such as in the actions of

Tinguely, Yves Klein, Arman, and Manzoni, or even with Daniel Spoerri, one can speak of a certain Neo-dada attitude."[10] Unlike their Nouveaux Réalistes colleagues, however, the ZERO artists staged their demonstration outside the structure of the exhibition, as a freestanding artist's action. This occurred parallel to Kaprow's Happenings in New York and Wolf Vostell's actions beginning with *The Theater Is in the Street* (1958).

The popular press ridiculed the demonstration, while the art critics announced it as an important event. The newspaper journalists strove to outdo one another in berating the novel happening. The *Düsseldorfer Nachrichten* published a photograph of the festive crowd outside Schmela's gallery with the caption "Artist's Joke in the *Altstadt*," describing the demonstration as a "tragi-comic funeral ceremony." The tabloid *Der Mittag* concluded, "'Nothing' was the deeper meaning of these goings-on, nothing just like ZERO." Another journalist dismissed the proceedings and wrote that the artists "did not appear to be terribly serious."[11] Yet the art critics found the demonstration, and especially the latest issue of the artists' periodical, to be a significant statement of the new avant-garde of the 1960s. Thwaites and Morschel considered ZERO 3 to be a "document for a new development" and a "document of the new art," respectively. Morschel positioned ZERO 3 as a "fairly comprehensive and yet concise summary of the anti- and after-Tachism tendencies."[12]

This was the most ambitious of the ZERO editions. It had been over a year in the planning and the artists conceived it as their consummate and final statement. Mack and Piene decided that this edition would feature only images and statements by the artists, without the critical interpretation that had been included in the previous two issues.[13] As Thwaites noted in his review, "Here is the tendency as it sees itself."[14] ZERO 3 included over thirty related artists from across Europe, each one introduced by the theme "dynamo." The issue begins with a special segment honoring Lucio Fontana, whom Mack and Piene valued as a model and motivator for his assault on the sanctity of painting. As Mack said, "Fontana's cut released me more [than Klein's monochrome]. This cut lacerated the curtain of the ancient temple of culture. . . . Here a new space was opened."[15]

The four principal artists involved in ZERO appeared in the artists' magazine after Fontana—first Yves Klein, then Tinguely, Piene, and Mack, followed by others. Klein contributed an essay, titled "Truth Becomes Reality," in which he outlines the experiences that shaped his artistic conceptions, beginning on the beach at Nice when as a young man he realized that the blue sky would be his realm of sensibility, and continuing to his dissolution of the objects of art. He gave Piene specific instructions, apologizing for the labor that would be involved, to burn the last page of the essay in each issue, leaving it unresolved. He asked, "Please, Piene, make it in a lovely way."[16] Tinguely contributed an expansion of his ironic essay "Static," in which he called on the reader to "Be Static!" while arguing that motion is a universal physical reality. Engineer Billy Klüver submitted his account of

Tinguely's action at the Museum of Modern Art in 1960, *Hommage à New York*, in which Tinguely's machine self-destructed. "The building parts of Jean's machine," Klüver wrote, "came from the chaos of the dump and were returned to the dump."[17]

In his essay "Paths to Paradise," Piene abandoned the philosophical tone of his earlier essays and expressed the positivism that animated ZERO activities. He wrote about departing from easel painting and moving into the realm of the universe, first with his light ballet and, eventually, when technology permits, into the sky, prefiguring his later Sky Art: "My greatest dream is the projection of light into the vast night sky, the probing of the universe as it meets the light, untouched, without obstacles/the world of space is the only one to offer man practically unlimited freedom." He also addressed his war experience, its relationship to the *Light Ballet*, and his desire to transform technology:

> Up to now, we have left it to war to dream up a naïve Light Ballet for the night skies, we have left it to war to light up the sky with colored signs and artificial and induced bursts of flame. . . . Why do we not pool all human intelligence with the same securities which attend its efforts in time of war, and explode all the atom bombs in the world for the pleasure of the thing, a great display of human perceptions in praise of human freedom?[18]

Accompanying Piene's essay were images of his various works created with smoke, fire, light, and machinery. Piene concluded his section with a grid of images that demonstrated his progression as an artist from his early pictures of *Flying People* (1952) through the light boxes that he fabricated for the lamp company, to his *Raster Paintings*.[19] Here he clearly outlines the development of his visual thinking and attempts to establish his position at the forefront of the new artistic developments of his generation.

Next, Mack diagrammed an ambitious program of thirteen stations for his proposed Sahara Project, which had been hatched in the car ride with Klein and Piene to Antwerp in 1959. Mack proposed to site monumental stellae, reflective surfaces, flapping sheets of foil, and light refractors spread across the Sahara at enormous distances that could be viewed from space. This expansive idea marks an early conception of nature, rather than the museum, as the site for art. It is one of the earliest statements of what became land art. He realized this project in the Tunisian desert in 1968. For Thwaites, this expansive proposal confirmed that among the artists included in *ZERO 3*, Mack was "the virtuoso."[20]

Many other artists contributed statements and images of their work to *ZERO 3*. Arman articulated his position on "Realism in the Accumulations." Piero Manzoni wrote about his forthcoming projects, including the egg-shaped design that he had conceived to house Piene's *Light Ballet*.[21] The theatrical nature of the artists' demonstrations and actions was discussed

by Daniel Spoerri in his essay "Spoerri's Autotheater," which involved audience interaction.[22] The issue also contained the work of a number of other artists who would become active in subsequent ZERO projects and indicate the expanded geographic reach of the ZERO network beyond the Düsseldorf-Paris-Antwerp-Milan axes. Morschel observed, "The name 'Zero' has become not only the name of a publication series, but also the name for a group of artists from different countries."[23]

Among the many foreign guests who attended the 1961 ZERO demonstration in Düsseldorf was Henk Peeters, a Dutch artist and entrepreneur. Peeters was associated with a group of Dutch *informel* painters, the Hollandse Informele Groep: Armando, Jan Henderikse, and Jan Schoonhoven. Henderikse had moved to Düsseldorf in 1958[24] to participate in the rapidly developing art community, where he befriended Uecker and occupied a studio in the same complex as Beuys. Through Henderikse, the Dutch artists knew about the Düsseldorf scene and attended the demonstration. The event sparked Peeters to return to Arnhem, open Galerie A, and invite the ZERO artists to stage their demonstration in the Netherlands in December 1961.[25] At this time, Peeters and his colleagues changed the name of their group to Nul and published their own artists' magazine.[26] While the ZERO artists were eager to expand the network of participating artists, they were not comfortable with the Dutch artists' appropriating their name (translating it into Dutch) for their own organization.[27]

The artists of Nul had been practicing their own variation of the postwar new tendencies for several years. Peeters had been creating serial imagery, through mechanical and natural processes, since 1959, when he burned holes into a canvas (Figure 3.4). The Dutch artists' exposure to ZERO motivated them to accelerate their work in this direction. Like ZERO, the Nul artists rejected artistic expressionism in favor of a focus on the physical properties of modern materials. Schoonhoven wrote, "The aim is to consolidate reality in an impersonal way as art."[28] Peeters also echoed ZERO ideas on artistic practice (and, importantly, presaged Sol LeWitt's "Paragraphs on Conceptual Art" of 1967) when he wrote: "The process of creation is . . . completely unimportant and uninteresting; a machine can do it. . . . The personal element lies in the idea and no longer in the manufacture."[29] The Nul artists were not engaged in new technology; rather, they tended toward an interpretation of reality found in everyday objects and materials, an interpretation influenced by Dada and shared by many of their colleagues among the Nouveaux Réalistes. Despite these stylistic and material differences, their aspirations resonated with ZERO. Peeters defined Nul's position thus: "Not the banality of daily life, nor simply the regularities of optical phenomena: Nul is the domain between 'Pop' and 'Op,' or, to paraphrase Piene: the quarantine zero, the quiet before the storm, the phase of calm and resensitization."[30]

With Peeters's organizational and promotional acumen, he managed to secure the Stedelijk Museum to host a Nul exhibition in March 1962. The

FIGURE 3.4 *Henk Peeters,* Pyrographie (60-06), *1960, scorch marks on plastic, 100 × 120 cm. Stedelijk Museum, Amsterdam. © 2017 Artists Rights Society (ARS), New York/c/o Pictoright Amsterdam.*

Stedelijk suddenly had an unexpected opening in its schedule and agreed to allow Peeters and his colleagues to organize an exhibition; however, the artists were responsible for the entire cost of the project.[31] In the brief time Peeters had to organize the exhibition, he assembled a host of ZERO and new tendency artists from across Europe to produce an extraordinarily ambitious show, modeled on the ZERO exhibitions. The exhibition began with Christian Megert's mirrored room *1,000 Volts*, which was contrasted with a darkened room of Schoonhoven's installation of tires. The climactic installation was the Group ZERO *Salle de Lumière* (Figure 3.5), the group's first collaborative light installation, with Piene's light sculptures, Mack's rotors, Uecker's rotating nail reliefs, and interactive components for the visitors to manipulate. Peeters arranged the installation by assigning the corner rooms of the building according to nationality. This installation plan prioritized national identities as the main organizational principle of the show, in contrast to the international spirit of Germans in Group ZERO.[32]

Thwaites reviewed the exhibition as "The Spirit of the Desert Dies," describing it as "the setting for Sartre's *No Exit*." He noted that it was unfortunate for the quality of the exhibition that three of the French artists—Arman, Klein, and Tinguely—had declined to participate. Thwaites appreciated the ZERO group's light environment and admired the new "collective atmosphere" of the installation. However, he felt that Meret Oppenheim's *Felt Cup* (1936) "said more" than Manzoni's cotton and fiber pictures, and he found the last large room of Nul artists "deadly boring." In particular, he was concerned by the derivative nature of much of the work, with "Peeters imitating Manzoni, Henderikse parodying Arman, [and] Schoonhoven transforming Piene in honeycomb."[33] Originality and imitation were significant matters to these artists, for whom accomplishments in establishing new beginnings were highly valued, and the question of originality would continually be raised throughout this period. For example, Peeters, a close friend of Manzoni, became "raging mad" when he saw that the Italian had copied his cottonball pieces.[34]

Despite Thwaites's criticism of the "mediocre Dutchmen,"[35] the exhibition was enormously popular. The Dutch artists continued to participate in ZERO projects, and they assembled a number of important projects of their own over the five years of Nul's existence, including a second *Nul* exhibition at the Stedelijk (1965), which included the first European exhibition of the Japanese group Gutai, and the ambitious *ZERO on the Sea* (1966). The latter was organized by Galerie OREZ in The Hague and involved many ZERO and Nul artists, who were commissioned to create monumental outdoor installations on the pier in the Scheveningen district. The venture was abandoned, however, owing to insufficient financing.

A few months after his participation in the *Nul* exhibition at the Stedelijk Museum, Piene presented his newest artistic innovation, fire paintings, at Galerie Schmela in September 1962. These were a natural extension of his smoke drawings begun in 1959 and, in fact, derived from the process of working on the drawings. Sometime in 1961, while using a fixative to bind the soot to the paper, Piene discovered that the substance was highly volatile and ignited into a burst of flames leaving a natural pattern (Figure 3.6).[36] Exploring the potential of the chemical residue, he began to create his fire paintings. Relating the force of fire to his wartime experience, Piene viewed his fire studio as harnessing that power to generate cosmic, organic, and botanical forms. Further, it was a reversal of his working process by rematerializing light into a tangible, pictorial form. His colleague Klein began producing fire paintings at the French Gas Company Test Center in March 1962. Previously, Klein had lit a blue monochrome with flares for his 1957 opening at Colette Allendy, and he fabricated a wall of gas torches at the Museum Haus Lange in Krefeld for his 1961 retrospective exhibition (Figure 3.7). Oral history relates that when Klein showed Alfred Schmela his fire paintings, Schmela responded that Piene was also making fire paintings. The two friends made a "gentleman's agreement" to not dispute who had

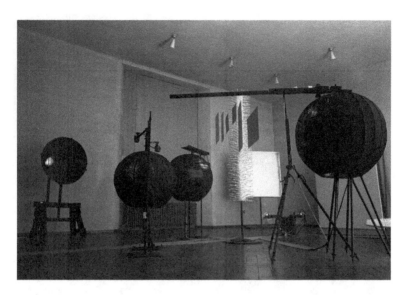

FIGURE 3.5 ZERO, Salle de Lumière, *1962, Stedelijk Museum, Amsterdam. Photo: Manfred Tischer. © Estate of Manfred Tischer.*

FIGURE 3.6 *Otto Piene,* Venus of Willendorf, *1963, oil, smoke, and fire on canvas, 150 × 200 cm. Stedelijk Museum, Amsterdam. Photo Franziska Megert. © 2017 Artists Rights Society (ARS), New York/VG Bild-Kunst, Bonn.*

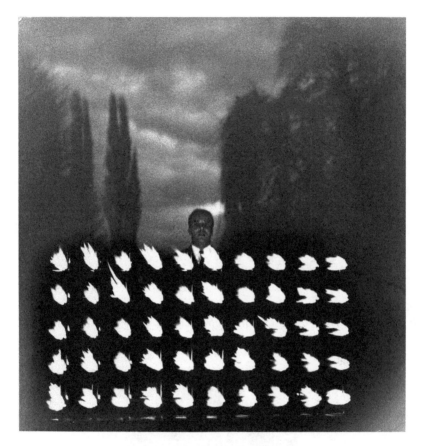

FIGURE 3.7 *Yves Klein with his work* Mur de feu *(wall of fire), January 1961. Rudi Blesh Papers, 1909–1983. Archives of American Art, Smithsonian Institution, Washington, DC. © Yves Klein c/o Artists Rights Society (ARS), New York/ ADAGP, Paris 2017.*

the proprietary right to the idea.[37] Thwaites greeted the debut of Piene's fire paintings as a new "epoch." He observed the inherent contradiction in these works, noting that Piene had spent much of the previous five years dematerializing the objet d'art and was now rematerializing it.[38] Piene's fire paintings became a genre that he would continue throughout his career, dematerializing and rematerializing energy as an essential polarity in his artistic process (Figure 3.8).[39]

The term "new tendencies" was common parlance in both the critical and the popular press during the postwar period to describe new artistic positions. The evolution of the term is worth examining in detail. In 1959, the Galleria Pagani in Milan invited Klaus Jürgen-Fischer, in his role as an

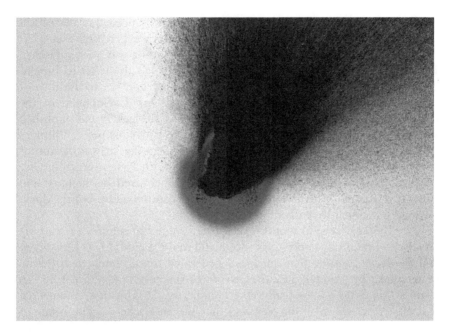

FIGURE 3.8 *Otto Piene,* Die Sonne Reist, *196, oil and fire on canvas, 26 ¾ × 37 3/8 in. (68 × 95 cm). Courtesy the artist and Sperone Westwater. © 2017 Artists Rights Society (ARS), New York/VG Bild-Kunst, Bonn.*

editor of *Das Kunstwerk*, to curate an exhibition, which he titled *Stringenz: New German Tendencies*. For this exhibit, Jürgen-Fischer gathered seven young German artists "whose work is about to become a topic of great import," including Holweck, Kricke, Mack, and himself. He had invited Piene, too, but Piene was forced to decline due to contractual agreements with another Milanese gallery.[40] Jürgen-Fischer originally intended to title the exhibit *Reduction*, based on his conception that in the work of all these artists "the means of painting and sculpture are . . . reduced to an expressive minimum."[41] In his essay for the exhibition and in his curatorial choices, Jürgen-Fischer positioned these post-*Tachism* German painters as representing "new tendencies" in art.

Subsequently, Jürgen-Fischer published an article titled "New Tendencies," in *Das Kunstwerk* (1961) under the pseudonym Alexander Leisberg. In it he identified a group of artists, himself included, who were realizing new artistic ideas. However, in this article Jürgen-Fischer reversed position and wrote that these ideas were "not fundamentally new" and that they were derivative from past and contemporary artists. Jürgen-Fischer accused Mack of plagiarizing Tàpies and Piene of appropriating the idea for *Raster Paintings* from Hajo Bleckert (an artist in the same studio complex), and his *Light Ballet* from László Moholy-Nagy.[42] The article elicited considerable

consternation among the artists, curators, critics, and dealers in the ZERO circle, who wanted to know who this unknown author, Leisberg, was.

Kowallek investigated and learned that the author was Jürgen-Fischer. The article particularly upset Piene, who wrote a lengthy letter to Jürgen-Fischer criticizing him for misrepresenting himself and his accusations of copying his studio colleagues.[43] Piene defended his development of the *Raster Paintings* and *Light Ballet* as independent of Bleckert and published his gridded diagram in *ZERO 3* in July 1961 to prove his point.[44] Jürgen-Fischer issued an acknowledgment in *Das Kunstwerk* that he was the author of the article, but continued the heated debate with Piene. Jürgen-Fischer believed that his boyhood friend Mack had uncovered his identity and annotated a copy of his letter to Piene with a caption addressed to Mack, "Copy for a cowardly pathetic skunk!"[45]

Over the next several months, the parties launched a flurry of scathing attacks and rebuttals in personal letters and in the pages of *Das Kunstwerk* and *Deutsche Zeitung* that quickly degenerated to ad hominem criticism. In reference to scandal, Thwaites wrote in his review of *ZERO 3*, "To dismiss this trend as not really new is ludicrous."[46] Thwaites commented that all art derives from the past and that Jürgen-Fischer came too late to the realization that the "new tendencies" had superseded painting. The dealer Rudolf Zwirner said, "The defensiveness of Mr. Fischer shows his insecurity as a painter . . . the typical resentments of an unrecognized artist." Bleckert entered the fray with a voice of reason, stating, "My concern is not really the priority of the method but the finding of the critic that I had improperly claimed the intellectual copyright. Here, if the intellectual copyright is understood as a quality . . . it is not capable of appropriation." Evidently, *Deutsche Zeitung* requested that Thwaites draw this debate to a conclusion, and the British critic reminded his German audience and colleagues, "It is good to have the right to disagree."[47] The vehemence of the debate demonstrates that the question of originality, a hallmark of modern art, still bore great importance for these artists.[48]

For all the uproar, Jürgen-Fischer had, in his application of the term "new tendencies" and his diagramming of the art-historical lineage of the work, established a direct connection between "new tendencies" and the second-generation postwar artists. Almir Mavignier, who emigrated from Brazil to study with Max Bill in Ulm, had been exhibiting with the ZERO artists since 1958. With a travel stipend, he visited Zagreb, Yugoslavia, in the summer of 1960,[49] where he met the art critics Matko Mestrovic and Radoslav Putar and discussed the current Venice Biennale. Mavignier and the Yugoslavs agreed that, other than Piero Dorazio's winning the Prize for a Young Painter, they saw nothing new at this Biennale. Mavignier advocated a contemporary art made by "artists who are experimenting with new ideas and new material—artists . . . who are searching for new paths and new artistic ideas." He, Matkovic, and Putar convinced Bozo Bek, the director of the Gallery of Contemporary Art, to organize an exhibition that would bring together the

progressive Yugoslavian artists, many from the group Exat 51, with other artists suggested by Mavignier from France, Germany, and Italy.[50] Mavignier proposed that they adopt the name "Nove Tendencije" (New Tendencies) and credited Jürgen-Fischer with inspiring this choice through his exhibition at the Galeria Pagani in 1959.[51] Those invited for the August 1961 exhibition included the Yugoslavian artist Ivan Picelj; French artists associated with GRAV (Groupe de recherche d'art visuel), François Morellet, Julio Le Parc, and Joel Stein; German ZERO artists Gerhard von Graevenitz, Mack, Piene, and Uecker; Italian Azimuth artists Enrico Castellani and Manzoni; the Gruppo N artist Alberto Biasi; and the independent Dorazio. Mavignier's motivation was "to show the Yugoslav public that there is a group of artists . . . today that will be called the avant-garde tomorrow."[52] Many of the artists submitted statements for the catalogue for *New Tendencies*; among the most rebellious was Morellet, who wrote, "Imagine that we are at the eve of a revolution in the arts that is as great as the revolution that exists in science."[53]

Many of the participating Western European artists were eager to expand the international network of ZERO into Eastern Europe, behind the newly constructed iron curtain. Mestrovic himself expressed concern about the political situation as it was developing in the Eastern bloc and wished to avoid inciting the politicians. "In our situation," he said, "it wouldn't be prudent to display works that are too extremist, to put together a terribly provocative exhibition, something that would hurt more than serve our efforts."[54] Despite Morellet's call for a "revolution," much of the work by these artists derived from the constructivist tradition and did not openly provoke political issues. In fact, the exhibition mirrored many of ZERO exhibitions; the work was primarily abstract, devoid of overt political statements. Furthermore, the organizers promoted the artists' groups as collective organizations to appease the Communist propagandists. The politics of the exhibition were, instead, internal.

Bek, Mestrovic, and Putar were pleased with the exhibition and immediately began to organize a second one for 1963. In the intervening time, the French artists met with the Zagreb organizers with the intention of adding ideological rigor to the group. In October 1961, the artists of GRAV, under direction from Morellet and Julio Le Parc, issued a "proposition generale," advocating a refinement of the theoretical principles of the new tendency. They wanted a definitive character for the group, based on research into the phenomenology of perception and the active engagement of the spectator in a dynamic artistic experience, which had been the basis of their founding of GRAV.

Morellet, Joel Stein, and Jean-Pierre Yvaral (the son of Victor Vasarely) had been encouraged by Vasarely to form their own group. The French had exhibited at Manzoni's Azimuth Gallery in April 1960 at the suggestion of Mavignier, and had subsequently shown their work in Padua under the name Motus. Only after these group projects had they organized themselves

into the Centre de Recherche d'Art Visuel, in July 1960 (later Groupe de Recherche d'Art Visuel, or GRAV). This original group had also included artists François and Vera Molnar, who left the group only a few months later.[55] The premise of the group was to collectively produce art experiences that actively engaged the spectator. In parallel to ZERO and other new tendency groups, they aspired to remove the presence of the artist as creator, in order to emphasize the experience of the viewer, and to challenge the notion of the objet d'art and even the use of the word "art." "The idea of the 'work of art' or the 'art piece' is dying." They wrote,

> Any formal artwork is, first and foremost, a visual reality. We assert the existence of the visual dialogue between the being and the object. And we place the formal, plastic fact not in the emotionalism of the being, or the artistic production of the work per se, but in the connection of these two poles through visual constants. Our research focuses on this immaterial plane that exists between the plastic object and the human eye.[56]

The GRAV artists participated in Bruno Munari's exhibition *Arte Programmata* (1962) in Milan. In his essay in the catalogue, Umberto Eco espoused the idea of programed art as a rational experimentation in visual communication, and the notion of the "open work of art," which requires the spectator for its completion.[57] Shortly after *Arte Programmata*, the GRAV artists realized their first collectively constructed environmental installation in *Labyrinth* (1963, Figure 3.9), which they presented at the third Paris Biennale in September 1963, under the group designation Nouvelle Tendance (New Tendency). The *Labyrinth* was an interactive sequence of rooms, each designed by one member of the group, with twenty different activities. The artists encouraged spectators to participate, with these instructions:

IT IS PROHIBITED NOT TO PARTICIPATE
IT IS PROHIBITED NOT TO TOUCH
IT IS PROHIBITED NOT TO BREAK[58]

They completed this work only months after participating in the San Marino Biennale in July and the Zagreb *New Tendencies 2* exhibition in August 1963. The San Marino Biennale acknowledged the vitality of group identity to the postwar avant-garde, and its judges awarded prizes to several of the groups: Group ZERO and Group Enne (Group N) shared the first prize, and a gold medal was given to GRAV.

For *New Tendencies 2* (1963), the French artists managed to refine the checklist of the exhibition toward their interests in visual research. Having recognized the change in the complexion of the exhibition, Piene wrote to Mestrovic and Putar, observing, "One gains the impression that you understand *nove tendencije* [new tendency] to be a new academic interpretation, which turns discoveries by creative artists into a fixed

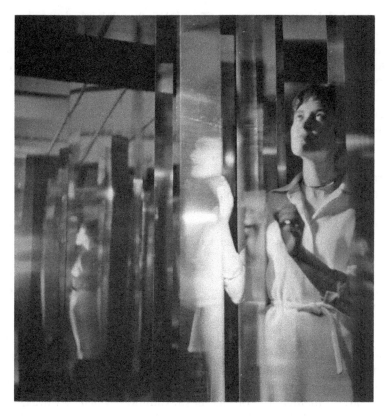

FIGURE 3.9 *Julio Le Parc,* Celule de Labyrinthe Paris, Paris Biennale *(Cell of Labyrinthe Paris 1963), 1963. Harvard Art Museums/Harvard Art Museums, Records of the Howard Wise Gallery (SC 17) ARCH.0000.1524. Photo: Imaging Department © President and Fellows of Harvard College.*

dogma—to be used by zealous students."[59] After the opening, the artists met and continued to refine the definition of their group. Gerhard von Graevenitz, a German participant active in ZERO, offered a proposal that was rejected in favor of the one that Le Parc and Morellet had developed over the previous year. At this meeting they adopted a new name, Nouvelle Tendance—Recherche continuelle (NTrc, New Tendency—Continuous Research), and defined specifically the premise of their art movement: "Primacy of research/depersonalization/open communication/collective work/development of a shared set of visual and theoretical ideas that could lead to the anonymous work." The *Bulletin* issued from this meeting listed the artists who were to be expunged from the group. The organizers expelled Mack and Uecker for possessing "no clarity of the problem," while they categorized Piene as practicing "traditional painting."[60] They felt that

ZERO and Nul artists had "strayed" and their "spirit is a little touched with Neo-Dada," an anathema to the principles of NTrc.[61]

Such a dogmatic definition of their group, and the authoritarian exclusion of some artists, demonstrated the rigidity of their aesthetic program and inflexibility of artistic relationships to which most of the artists involved in ZERO objected. Over the following months, the excommunicated Italians under Enzo Mari protested and rejected Le Parc and the Yugoslav organizers' proposal, to no avail. Yet, in response to the recognition that the group received at the San Marino Biennale, several museums requested to host the NT 2 exhibition. NT 2 was shown in Venice, then at the Musée d'Art Moderne de la Ville de Paris, and finally in Leverkusen, where Udo Kultermann included the exiled Germans.[62] The exhibition attracted international attention, leading the kinetic sculptor George Rickey to write about the New Tendency (Nouvelle Tendance—Recherche Continuelle). Rickey viewed the group as an extension of the constructivist tradition and not as a new art movement.[63] In his review of the Leverkusen venue, Thwaites found that many of the pieces were playful, "an attractive toy for children from three to five," but he considered the exhibition, "after so much effort and claim, disappointing, boring and academic."[64]

In the face of a rigid dogma, many of the artists involved in the original New Tendencies exhibits withdrew prior to the next exhibition, New Tendencies 3 (1965), if they were not already expelled. The Italians and Yugoslavs finally regained control of their group from the Frenchmen after the 1965 exhibition and turned the organization more to programed art, particularly computer art. For their next exhibition, which they titled simply Tendency 4 (NT 4, 1968), they turned their focus to "Computers and Visual Information." Responding to the advent of computer-generated imagery, the group began publishing Bit International, with inaugural essays by the information and communication theorists Bense and Abraham Moles. It became one of the early organs of computer art.[65]

The GRAV artists continued to work with the Zagreb group, including their Labyrinth in the traveling NTrc2 exhibition, as well as organizing their own events, such as a Nouvelle Tendance exhibition at the Musée des Arts Decoratifs in 1965 and a street happening, Journey in the Street, in 1966 under the collective name GRAV.[66] They exhibited with the ZERO artists in the documenta 3 addendum for Light and Movement (1964), and Denise René included them in her Mouvement 2 exhibition (1964). They regularly alternated the name under which they exhibited, switching from Nouvelle Tendance to GRAV, depending on the particular association. However, after Le Parc won the Golden Lion at the Venice Biennale in 1966, the collective nature of the group was in doubt. The artists began to develop their individual careers and departed from the central premise of the group's founding. By the time the group dissolved in 1968, each of the artists was disillusioned by their group identity and had already abandoned it.[67]

Concurrent with the new tendency argument, Piene initiated an ideological controversy of his own. By the fall of 1962, ZERO was widely accepted as the vanguard in contemporary art; Mack, Piene, Uecker, and Group ZERO were in great demand across Europe, with exhibitions and demonstrations. At this time, Paul Wember, the director of the art museum in Krefeld, invited the ZERO artists to present their work in the Mies van der Rohe Haus Lange. Wember, an adventuresome director, hosted Klein's exhibition in 1961. He proposed an exhibition of "Mack-Piene-Uecker-Mavignier." However, Mack and Piene insisted that only the three principal German artists be included, not Mavignier.[68] Because of his omission from this exhibition, Mavignier withdrew from participation in future ZERO projects.[69]

The Krefeld exhibition was the first museum retrospective of the three principal ZERO artists over the five years since the group's inception. The exhibit included Piene's paintings made by rasters, smoke, and fire; Mack's early paintings, light reliefs, and light rotors; and Uecker's nail paintings and kinetic disks. Because of the space limitations and inability to control the light, the artists did not present a *Salle de Lumière* as they had wanted (probably because of issues controlling light in the Mies van der Rohe building), but they did include some of Piene's light sculptures. The exhibition received good reviews from the West German art critics, who had watched them evolve since the evening exhibitions. Klapheck complimented their "craftsmanship and optical brilliance" in shaping the new media that each of them chose. And she addressed the question that the public continued to ask, "Is this art?" She noted that the artists rarely address the word "art" in their writings; however, the work is wrapped in theories and ideologies. Regardless of the theories, she concluded, their work "affords an extraordinary pleasure."[70] Thwaites appreciated that each of the artists developed his own visual language, yet retained a shared sensibility. He added, "The pictures are formally strong and poetic at the same time." Referencing Piene's opening speech, Thwaites agreed that the work was "so pure, so positive, so—to use the words of the new formulation—idealistic."[71]

While Thwaites embraced the concept of a "new idealism," Klapheck expressed reservations that they were "intellectual tinkerers."[72] Morschel, however, was most critical in his evaluation of the exhibition. Morschel acknowledged Mack and Piene as "the German avant-garde art of the immediate present." Yet he stated that Mack and Piene in their first museum exhibition had become "historical" and seemed to be overly concerned about "cultivating their myth." He also observed that "there is a certain ambiguity and inconsistency in their work," as they balanced constructivist rationality and Neo-Dada irrationality. Morschel made his preference clear: "Their cause is the demonstration, the action (and occasionally the wind), their work is not for the silence of the museum . . . but for the living moment."[73]

In Piene's opening talk, "The New Idealism," he declared an ideological position, unbeknownst to Mack and Uecker, in opposition to that of the Nouveaux Réalistes, who had been participants in the larger ZERO network since 1957. Contrasting the "new idealism" to the "new realism," Piene referenced the remarks of Robert Girion, the director of the Kunstverein in Brussels, at the opening of *Dynamo: Mack-Piene-Uecker* exhibit just a month earlier in December 1962.[74] Giron stated, "There are for me now two contemporary forces: the Nouveau Réalisme and ZERO," evidently motivating Piene to mull the differences between the two groups. Instead of embracing their shared rejection of painterly expressionism, Piene made a decidedly divisive statement, "the link with the 'new realists', some of whom are our friends, or were, and some of whom today are our next adversary." He continued by stating:

> The actuality of "nouveau réalisme" or "new vulgarism"—a term that a certain American group has claimed—lies in the appropriation . . . of the waste substances and objects of everyday life processed for the work of art. The purpose is to activate a shock effect on the viewer. . . . Zero in the narrower sense, that is, we, the exhibiting artists here. . . . We strive to find a new power to transform. Our work is . . . searching for the ideal.[75]

Piene's proclamation surprised his colleagues. It was not the first time Piene had expressed his reservations about the Nouveaux Réalistes and their appropriation of discarded commercial products. In a 1960 essay Piene asked a series of "Questions," among them being the question of "Turbidity," in which he ironically quotes, "The artist, who, in the face the frightening phenomena of the 'modern world', threw himself down in the forest and exclaims, timorously, 'how beautiful is the dust and the glorious mud,'" to which Piene facetiously asks, "Is turbidity more real than clarity?"[76] He also expressed reservations about Arman's *Poubelles* (Waste Bins), accumulations of trash in containers, and Manzoni's *Merda d'Artista* (Artist's Shit), cans containing the artist's feces.

Uecker agreed in principle that "in contrast to the *Nouveaux Réalistes* . . . we attempt to beautify the world with light."[77] Nonetheless, Piene's articulation of Prussian romantic intellectual idealism evoked memories of the National Socialists' strategy of subverting that tradition so as to justify the Third Reich, empower the *Volk* (People), and justify *Lebensraum* (Habitat). Piene was schooled in the tradition of German intellectual romanticism. His artistic ambition to produce "energy transfer via art" is consistent with the philosophy of Kant that he studied at the University of Cologne. For this idealist, who possessed an equally pragmatic, populist perspective—namely, that people ought to be engaged in the artistic experience—the intellectual position of Dada anti-art and irony was elitist.

Piene's position troubled his colleagues. Mack beseeched him, "I ask you very seriously, use the term 'new idealism' very carefully; I would prefer it

if it no longer appears as a battle cry. Zero is Zero, the new idealism is but a spiritual and artistic claim that I cannot, either in substance or method, continue to defend."[78] There was also consternation among the artists in the ZERO network from other countries who had direct experience with the Nazis during the Second World War. Piene's Dutch colleague Henk Peeters noted, "Innately we had great fear of idealism, and one should practice this philosophical viewpoint with caution. Idealism has led to Hitler. . . . On this point we often quarreled with the Germans . . . religion, mysticism, idealism, after '45 one needs not come to us with these things."[79] The new idealism continued to haunt Piene. After an interview with Albert Speer in *Der Spiegel* magazine in 1966, *Kunst* magazine published a one-page critique, "ZERO the New Idealism?" comparing Piene's *Light Ballet* to Speer's *Light Dome* for Nazi rallies. They related Piene's aspirations for a paradise of searchlights shining in the night sky to the Nazi application. Piene responded, accusing the magazine of "political defamation," asserting that the idea for light displays in space had originated with Paul Scheerbart and Moholy-Nagy, whose concepts were abused for purposes of fascist propaganda.[80]

While the exhibition *Mack-Piene-Uecker* was on display at the Museum Haus Lange, the Künstlerhaus in Munich hosted an exhibition of *Les Nouveaux Réalistes*,[81] permitting the German audience to compare the two groups of artists. The German and French artists had been working together, collaborating on exhibitions, and sharing artistic ideas since 1957. Klein was "the spiritual motivator" of both ZERO and the Nouveaux Réalistes. Unfortunately, only six months after Klein's death in June 1962, the formative relationship between these artists began to fray. In Piene's mind, some of the artists became "adversaries." Both ZERO and the Nouveaux Réalistes rejected modern painting and utilized new materials for their work, to engage the viewer to participate in the "new reality" of postwar European culture. They were both influenced by the interwar Bauhaus modern materials and technology and the Dada collage, ready-made, and performance. But the material forms that they fashioned were considerably different. The German ZERO artists revived the art and technology tradition of the 1920s applying natural and modern materials to create an artistic experience. The Nouveaux Réalistes, on the other hand, appropriated the detritus of the consumer world, collaged and assemblaged them, for the viewer to critically examine everyday life.

Restany connected the materials and artists' actions of the Nouveaux Réalistes directly to Dada. He advocated the appropriation of material culture into a "passionate adventure of the real in itself and not through the prism of conceptual or imaginative transcription. . . . Whether this be . . . the allure of an object, of the household rubbish or scraps of the dining-room, of the unleashing of mechanical susceptibility."[82] But he differentiated their work from the "anti-art" gesture of Dada. The Nouveaux Réalistes, in Restany's mind, gave Duchamp's ready-made "new meaning . . . Duchamp's anti-art gesture assumes positivity. . . . The ready-made is no

longer the climax of negativity or of polemics, but the basic element of
a new expressive repertory."[83] ZERO artists agreed with the positivism
of Nouveau Réalisme, but also sought a transformation of the consumer
and manufactured products that they employed in their works of art.
The factual reality of material objects was too mundane a foundation for
the more romantically inclined ZERO artists. Piene believed that "art, if
it is good, is always spiritual." The aim of ZERO artists was "to create
something as an expression of the soul . . . to contrast the material of a
spiritual world."[84]

Group ZERO pursued an optimistic artistic position after the war,
combining Bauhaus art and technology in the service of society with the
irreverence of Dada performance. Morschel preferred the Dada-inspired
demonstrations of ZERO and objected to the synthesis of the two artistic
positions. Mack and Piene, Morschel wrote, "attempted to establish a
determined position between Neo-Dada, new realism, on the one hand, and
concrete art and constructivism, on the other. . . . They are neither decidedly
pictorial nor dada."[85] Another reviewer described the ZERO demonstration
at Galerie Diogenes in 1963 as "warmed-over Dada,"[86] whereas Jürgen-
Fischer, the ZERO artists' former friend and colleague, decried their work
as "warmed-over Bauhaus."[87] Yet it is the ZERO synthesis of contradictory
artistic positions, combining their artistic sources into something new,
reincarnating them into a new artistic practice that is a central component
of their distinctive contribution to postwar culture.

The German faction of the ZERO network certainly recapitulated the basic
art and technology premises of the Bauhaus. Piene openly acknowledged the
influence of the Bauhaus at a formative stage of his artistic practice:

> The specific and clear mission of the Bauhaus was more suggestive than
> most other historical and contemporary influences: the existential, ethical
> perceived imperative to design the environment and the socio-political
> and aesthetic future as it seemed after the total defeat of the Second
> World War to be more acute than at the end of the First World War, when
> the Bauhaus was formed.[88]

In *ZERO 3* he alludes to Moholy-Nagy again, when he wrote, "I already
have my twelve searchlights."[89] But he and the ZERO artists were not
engaged in a rote resurrection of Bauhaus ideology. There are substantive
differences. The technology available to postwar artists was vastly more
advanced than that accessible in the 1920s, particularly electronics, plastics,
and aluminum. More significantly, the attitude toward technology diverged
dramatically, in no small measure due to the experience of the technological
war, the Second World War. In comparison with Piene's *Light Ballet*, Wulf
Herzogenrath identified an essential difference from Moholy-Nagy's *Licht
Requisite* (1922–30), which represented a form of kinetic sculpture that was
the realization of the aesthetics of technology. The object was as important

as its effect. For Piene, and for those of his generation, the phenomenological effect experienced by the spectator was the primary purpose.[90] Piene said that his objects could appear to be "like washing machines." He transcended the aesthetic of art and technology as a glorification of technology in service of society and created, in Lawrence Alloway's words, "a post-technocratic style."[91] From the earliest phase of ZERO, Piene believed in the essential role of the spectator in fulfillment of the creative process, "The trinity of creator, image, and viewer is incomplete where the creator underestimates the viewer."[92]

ZERO artists added to the art and technology repertoire by exploring the forces of nature (fire, wind, and water in addition to light) and employing the technologies developed during the Second World War, particularly plastics and aluminum. Piene wrote, "I am interested in the forces of nature and how natural forces meet with technical and technological forces, as they can rely and reconcile with each other, and how to evoke the forces of nature by technological means that one could not show otherwise."[93] In combination, Piene created artistic experiences that dematerialized the objet d'art and rematerialized the natural force of light energy to stimulate the sensory physiology of the spectator and transcend the mundanity of the everyday. Morschel appreciated their appropriation of modern manufactured materials, but viewed it as inconsistent with their romantic application of the forces of nature: water, wind, and motion.[94]

In their appropriation of Dada performance, ZERO artists embraced the attitude of irrational, absurd actions, but steered away from the anti-art and ironic attitude of the Cabaret Voltaire and utilized performance to generate a positive experience. Piene remarked that he "liked the Dada sense of humor and therefore had a very, very natural relationship to it, not that we liked everything. Some things I found tasteless but that wasn't the point, really."[95] Critics and reviewers of the demonstrations repeatedly referenced the Neo-Dada activities of the French and American artists as a source for such activities. However, it is important to recognize that the ZERO demonstrations and actions also came out of a series of activities in which all of the German ZERO artists participated: the annual Academy Festivals and Carnival. The ZERO network of artists' actions were orchestrated to generate just such a celebratory mood for the public. A Dutch critic, Betty van Garrel, responding to the Neo-Dada aspects of the ZERO, Nul, and Nouveaux Réalistes artists, wrote, "They are in no way the 'Nullos'."[96] The artists reframed the performance medium, saying that they wanted not "a DADA for the people" but in the words of Dada artist Hülsenbeck, "the ultimate calming of the soul."[97]

Thwaites had acknowledged the group's many artistic sources yet insisted that this distinctive combination of ideas spoke to the era:

Their understanding of technology owes much, in turn, to Moholy-Nagy. All creative art is a development from the past, under the stamp of a

new epoch. If one adds to this the influences of Dada, nuclear science, Monet, Boccioni, Man Ray, film, the postwar period, photography, space exploration, logical positivism, and many other things, it can be assumed that this vital work will continue to develop.

Considering the 1920s' influences on the ZERO artists, Thwaites distinguished between the rationalists and the irrationalists and wrote that ZERO's "origins lay not with Constructivism [but] rather with Max Ernst and Paul Klee."[98]

Some critics of ZERO viewed their positivism as a direct reflection of the German Economic Miracle and its emphasis on consumer comforts. Jürgen-Fischer, in a personal letter to Piene, in the midst of his vituperative disagreement over the "new tendencies," criticized the *ZERO 3* magazine as "a product of the Economic Miracle."[99] But Thwaites, with a firsthand knowledge of the artists' intentions, viewed their work as the transformation of manufactured materials and denied that the aspiration for a positive experience constituted conformity to consumer culture. Instead, the ZERO artists were "rejecting the joys of the 'economic miracle'."[100]The ZERO artists repeatedly condemned the postwar German emphasis on consumerism, criticizing the "soulless efficiency and shabby neatness" of contemporary German culture. Piene recognized that Chancellor Konrad Adenauer's policy of "healing by consumer goods satisfies a need of consumer society: hygiene-cleansing is prevented rather than promoted."[101] He understood that Germans needed to face the tragedy of the war, not to repress it, in order to reconstruct their society. From the beginning of his artistic career, Piene openly confronted the war and worked to transform its materials and experiences into the positivism that he advocated.

Yet, other critics dismissed ZERO for not directly addressing the war, and viewed ZERO's appropriation of the materials of the war for popular spectacle as a repression of it. In the first decade after the Second World War, Theodor W. Adorno positioned the use of technology in art as a tool of capitalism to create spectacle that encouraged complacency and to avoid coming to grips with recent history.[102] Arnold Gehlen, who had written an essay, "Change in the Identity of Images," for *ZERO 2* (1958), changed his position on the use of technology in art by the time he published the second edition of his book *Zeit-Bilder* in 1965. For the second edition, he added a chapter, "Art in the Industrial Society," in which he echoed Adorno's ideas and issued a scathing critique of ZERO's mechanized light environment, *Hommage à Fontana* (1964, Figure 3.10). He condemned the postwar revival of art and technology, criticizing the light-emanating devices in the installation, which he said "smelled of discouragement. . . . They recalled a bankrupted ghost train. . . . Neither grandeur nor . . . tenderness, not even rudeness lives. . . . The revolution has worn out."[103] Such accusations—that the ZERO artists were tools of capitalist culture, avoided recent history,

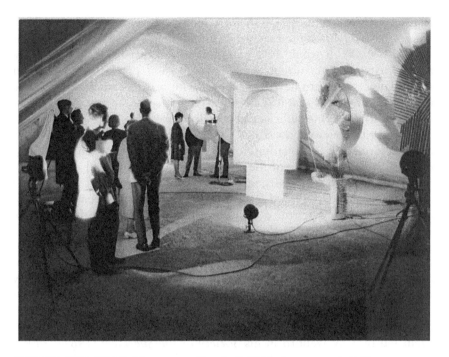

FIGURE 3.10 *ZERO*, Hommage a Fontana, *1964, documenta 3.* © *Documenta Archive/Friedmann Singer.*

and espoused a shallow artistic message—are narrow readings of ZERO and do not credit the group's contributions to the transformation of postwar German art and culture. As Huyssen proposes, coming to terms with history was a complicated process of working through memories, not a simple repression or confrontation.[104] Each of the ZERO artists had direct experiences as children of the war, and each of them determined to transform those experiences in their artistic creations.

Piene served as a boy soldier in the last year of the war, working in air defense, supporting flak guns during the furious final days of combat. He directly experienced aerial bombardment and wrote in *ZERO 3* about his desire to transform those experiences of horror into something that would link technology and nature in art for a new relationship with man. In his earliest publications he wrote about his war experiences, describing his moment of absolution, when the light glistening off the North Sea blinded him.[105] Other German artists of this generation, most notably Beuys, devised their own cleansing rituals as a spiritual purification to reconcile the trauma of the war. The ZERO group's spectacle environments and performances do indeed derive from their youthful experiences in Nazi Germany. Their modern materials were all creations of the war machine. Yet, because of their traumatic youthful experiences, their fundamental premise was to

transform those experiences into something positive, something that they did not have the luxury to experience during their formative years. Uecker wrote to Mack, "It would be a good thing to have a NATO missile there and to change it, humanize it. A good idea to paint a tank pink, or better a rocket-launcher, and to have a maneuver with war machines, how can we do it so that it's clear that it is a life-feasts; a ritual of the fantastic without intending to kill, being sufficient to ourselves?"[106]

Some critics viewed the ZERO light environments, demonstrations, and performances as relating to Nazi spectacle, but such a reading dismisses the experiences of the children of the war. Instead of imposing mass obedience on the participants in their performances, the ZERO artists orchestrated interactions that allowed each individual the choice of participating and provided the opportunity to interact with the kinetic works, creating situations that were designed to empower the spectator to apply their senses, physical and mental. Piene claimed, "We wanted to make things in the public that agree with our understanding of democratic behavior."[107] In the opinion of one scholar, ZERO consciously included materials and actions influenced by the National Socialists in an attempt to force a changing relationship with these same materials and actions.[108] Instead of the culture of complacency feared by Adorno and predicted by Guy DeBord in his *Society of the Spectacle* (1967), ZERO activates the viewer in a phenomenological experience parallel to that sought by Le Parc. "The notion of spectacle has always been pejorative when applied to the visual arts," said Le Parc. "By frankly admitting this reversal of the traditional situation of the passive spectator, we find a way around the idea of spectacle and come to the notion of activated or active participation."[109]

The theoretical issues and the methodological debates concerning ZERO existed in a different intellectual plane from the public and institutional acceptance of ZERO. Their exhibitions and demonstrations continued to flourish across the continent, leading to the first article on ZERO in an English-language magazine and their inclusion in the exhibition *16 German Painters* at the Corcoran Gallery in Washington, DC (1962).[110] Galerie Diogenes in Berlin hosted a ZERO demonstration and exposition (April 1963), following the Krefeld retrospective, with an expanded presentation of the broader ZERO group. In Berlin, only Tinguely among the Nouveaux Réalistes participated, while the Italians Castellani, Manzoni, and Gianni Colombo of Gruppo N, as well as Morellet from GRAV, took part. At Galerie Diogenes, they inaugurated the proceeding with a demonstration down Berlin's fashionable Kurfürstendamm, created a *Salle de Lumière*, and concluded with Hermann Goepfert's interactive *Light Organ* (1960). Aside from the usual resistance from people to the commotion of the festivities, the more chastened art scene in the divided city was startled by ZERO's use of new media and its artist actions. *Der Tagesspiegel* wrote that ZERO "has learned that aluminum foil, smoke soot, and nails are ever so good

as oil paints and tempera for painting material." The reviewer felt that the procession down the Kurfürstendamm contained Dada "humor," and he characterized ZERO as "a wandering circus of artist optimists."[111]

The novel developments of ZERO encouraged West German critics, artists, and dealers to advocate for their inclusion at *documenta* 3 (1964). Established in 1955 in Kassel as an international art exhibition, *documenta* initially presented Germans with modern art that had been labeled degenerate by the Nazis. The second *documenta*, in 1959, presented *Art since 1945* and focused on the Ecole de Paris, *art informel*, and American abstract expressionism. The third *documenta* planned to feature contemporary German art; however, the curator, Werner Haftmann, felt that ZERO did not merit inclusion. Uecker received an invitation to participate as an individual artist. He, Kowallek, Schmela, and others interceded and persuaded the *documenta* director, Arnold Bode, to include the other ZERO artists, who, as a group, were widely regarded as the newest German art sensation.[112] Bode found the only remaining space at *documenta*, the attic of the Fredericanum, and added a section on "Light and Movement." In his essay for the catalogue, Haftmann took pains to explain that he wished to present works not done by groups, but individual artistic creations. For Haftmann, who echoed the sentiments of Adorno and Gehlen, groups employing technical materials and justifying their work with "cybernetics" were not original, but derived their ideas from the 1920s. In the section of the catalogue that included the "Light and Movement" artists, Haftmann printed the disclaimer: "Responsibility for exhibited works: Prof. Arnold Bode."[113]

For *documenta* 3, the ZERO artists created a new incarnation of the *Salle de Lumière*, a collaboratively constructed, immersive light room environment entitled *Hommage à Fontana* (1964, Figure 3.10), in honor of the artist Piene described as a patriarchal figure of ZERO. Unfortunately, on the morning of the opening, the artists arrived to find that the maintenance crews had swept their installation aside, ostensibly because they thought the lights were simply for documenting the installation, and they rushed to reassemble the installation in time for the vernissage that evening. The room was a cooperative artistic venture that consisted of individual works, as well as collaboratively constructed pieces such as the *Silber Licht Mühle* (Silver Light Mill, 1964). As Piene has said, "The idea of collaboration is based on the insight that two people have more ideas than one, and more skills than one."[114] The group choreographed a dance of light and shadow, with shifting light sources that literally moved the visitors through the environment. Spectators experienced the ephemeral movement of light across the walls as well as the individual sculptural objects. With motors humming and electrical switches clicking, it was an immersive, multisensory experience. In describing this installation, Piene explained that his intention was to generate "force-fields over which visual energy is 'converted' into vital energy for the observer. . . . The manner in which the conversion

occurs is truly 'mystical', that is, puzzling, secretive. In any case, the equally 'mystical' union of body and mind facilitates understanding a charge caused by the conveyance of energy as an 'illumination'."[115]

The light room was a critical and popular success. Wieland Schmied, the director of Kestner-Gesellschaft, Hannover, confessed in *Die Zeit*, "I'm not sure . . . what this . . . has to do with art, but it has always fascinated me immensely, and, if vitality is a criterion of art, then these dynamos and rotors and objects are art."[116] But, Piene noted, even Schmied did not understand that "not the objects but the manifestations of light are important. Many find the apparatus ugly or less perfect than washing machines. The machines are only technical aids, bringing about constantly changing projections into space."[117] However, one London critic did grasp this concept: "The 'work of art' becomes part of man and his environment, and man and his environment becomes part of the 'work of art'."[118]

The *documenta* installation attracted international attention, garnering Group ZERO invitations to exhibit and stage festivals beyond continental Europe, becoming an international phenomenon. Concurrent with *documenta*, ZERO had its first exhibitions outside the continent, in London, where they had two concurrent exhibitions, one of Group ZERO at the New Vision Centre and another of just the three principals at the McRoberts and Tunnard Gallery. The response to this show resonated across the continent, the United Kingdom, and the United States, where the artists were greeted as avatars of a new art form. In particular, the reviewers referenced "the gradual disappearance of painting" and the "inadequacy of the term 'work of art' to describe these exhibitions."[119] Over the year there were also a host of ZERO-*Nul*-New Tendency exhibitions in Berlin, The Hague, Leverkusen, Rotterdam, and Rome. Schmied was recruiting ZERO for a festival in Hannover, and Harald Szeemann was organizing his *Light and Movement* exhibition with them for the Kunsthalle in Bern. Mack earned the prestigious Marzotto Prize (1964), and both Mack and Piene won distinctions at the Carnegie International in Pittsburgh (1964). Piero Dorazio invited Piene to be a visiting professor at the University of Pennsylvania and to have an exhibition of his work at the university's Institute of Contemporary Art.

At the same time Howard Wise, whose gallery was the principal venue for new media art in the United States, also invited the ZERO artists to exhibit. Mack and Piene, eager to secure an exhibit in New York City, agreed to both shows. With their works spread across Europe and being acquired by adventuresome collectors, Mack and Piene scrambled to secure enough works to satisfy their commitments for two exhibitions in the United States. They coordinated the borrowing of works while, in their studios, they were busy creating new works specifically for their New York debut. In order to manage their concurrent commitments, they decided the University of Pennsylvania show would include the broader network of ZERO artists, while the Howard Wise Gallery would focus on the three principals. The

artists' anxiety is evident in their correspondence as the trio attempted to manage a tight schedule. The New York presentation at Howard Wise was paramount. Although Mack complained that he was exhausted from the effort, he "wished to make it as good as possible." Only a few weeks before the opening, Uecker wrote to Piene, "Mack and I live, like you, in tension from the activity," but, "our works are . . . great and we can look forward to the exhibition in New York."[120]

For the exhibit at Howard Wise, ZERO emulated the arrangement of the light room that they had created for *documenta* 3, utilizing some of the same objects that had created such a sensation in Europe (Figure 3.11). New York responded positively to ZERO. Kinetic art, Op Art, and new media were among the current artistic trends, and the press was primed to receive the Europeans. Donald Judd, then a critic for *Arts* magazine and widely thought to be anti-European, endorsed ZERO as "unusual and unlike anything here. It is probably the best in Europe."[121] Even the notoriously conservative critic for the *New York Times*, John Canaday, despite his disdain for the "bandwagon" of kinetic art, admitted, "Mack's scintillating materials fuse form and light in mutual dependence and mutual exhilaration."[122]

The Howard Wise exhibition bolstered the reputations of all three artists. Commissions, exhibitions, and prizes followed. Mack was included in the Guggenheim International; granted support from the Rockefeller Foundation; received a commission for a public sculpture in Dallas, Texas; and won the first prize at the Paris Biennale in 1965. He was not only successful in the art market; his handsome features and long, blonde hair also earned him considerable attention on New York's social circuit, where

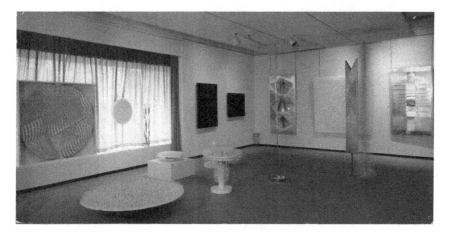

FIGURE 3.11 *Installation view of ZERO exhibition at the Howard Wise Gallery, New York, 1964. Harvard Art Museums/Harvard Art Museums, Records of the Howard Wise Gallery (SC 17) ARCH.0000.1522. Photo: Imaging Department ©️ President and Fellows of Harvard College.*

it was reported that he escorted such celebrities as the Venezuelan-American pop art beauty Marisol. Mack excitedly wrote to Piene, "N.Y. is fantastic. I love it," sharing that "everything is without doubt going great for me."[123]

Howard Wise's original invitation was for a solo exhibition of Piene; however, the artist was overcommitted. After the successful ZERO exhibition, Wise encouraged Piene to produce a solo exhibition at the earliest opportunity. Over the next year, Piene prepared a fully mechanized version of his *Light Ballet* for his exhibition at Howard Wise, which launched his personal career in the United States (Figure 3.12). In this production he included light sculptures, projected painted slides, and reflecting mirrors

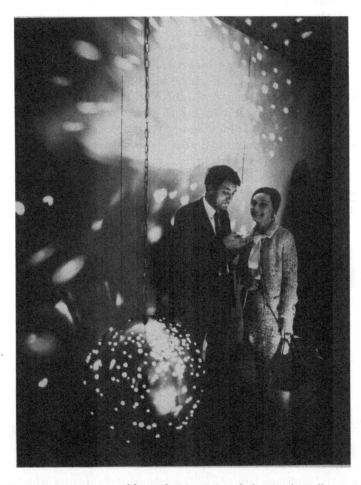

FIGURE 3.12 *Otto Piene and his wife (Nan Rosenthal) in* Light Ballet *installation at Howard Wise Gallery, New York, 1965. Harvard Art Museums/Harvard Art Museums, Records of the Howard Wise Gallery (SC 17) ARCH.0000.455. Photo: Imaging Department © President and Fellows of Harvard College.*

with which he, in his words, "created a dematerialized room."[124] The show was a sensation. The *New York Times* described the novel installation for its audience as "a high-voltage dazzler. . . . In programmed ritual, they [the light sculptures] glow and dim, surrounding viewers with endless projections of light and shadow forms."[125] Piene could proudly state that this was "the first fully programmed kinetic light exhibition in the United States."[126]

Piene basked in the attention from his Howard Wise exhibition and wrote to his London dealer:

> My show was a tremendous success. . . . Some people told me that the gallery has never seen such crowds. To be sober about it: The show has been among the top three or four exhibitions the gallery has had and is only comparable with the Len Lye, possibly the ZERO show, but, I think, had attracted a much larger crowd. Some other people told me that it was the best show I ever had—which makes sense as I have never had a show which has been so carefully prepared.[127]

Upon the heels of Piene's success, Wise offered Mack and Uecker solo shows the following season. For Mack's exhibit in the spring of 1966, he reflected

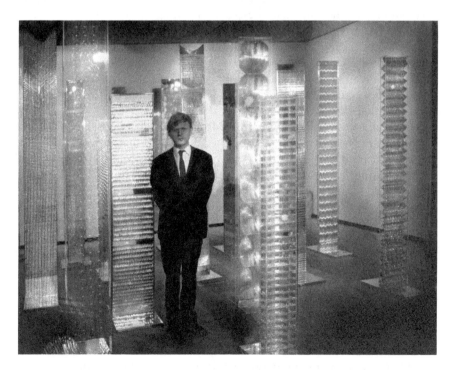

FIGURE 3.13 *Heinz Mack,* Forest of Light *stellae ensemble at Howard Wise Gallery, New York, 1966.* © 2017 *Artists Rights Society (ARS), New York/VG Bild-Kunst, Bonn.*

on his impressions of New York (Figure 3.13). Surprisingly, New York's skyscrapers disappointed Mack, who said, "They didn't seem high enough." As an artist whose fertile imagination had conceived indefinite stretches of sculptures of extraordinary height in deserts, the Arctic, and across the ocean, he had high expectations. However, after living for a year in New York, he gained an appreciation for the vibrations of light and color that flickered across the urban landscape. For his exhibition, he created "a kind of New York homage,"[128] with light reliefs, rotors, hanging pylons, and a forest of stellae, glistening and sparkling like the steel and glass towers of Manhattan. The slender, stately stellae all have the same profile, but Mack ingeniously fashions each variously with reflective wings, precious silver surfaces that emulate the multifarious visual features of the New York skyline.

The success of ZERO in America engendered a great pride in Germany, prompting the Press and Information Office of the Federal Republic to announce, "The three young men were recognized as the originators of a movement: the first international trend for 40 years to have part of its roots in Germany."[129] But by this time, ZERO had begun to dissolve. The synergy among the artists began to dissipate, and disagreements began to divide them, especially after Piene proclaimed a "new idealism" at the exhibition in Krefeld. In the fall of 1964, during the intense period of organizing the exhibitions in America, Mack beseeched his longtime colleague to abstain from referring to the new idealism as a "battle cry" for ZERO. His opposition forced Mack to inform Piene, "The ship ZERO has laid anchor and the journey is over." But he recommended that they refrain from making this public and maintained the prospect for a resolution: "What outsiders may view as midsummer flowers is, for us, already autumn, if not winter, and we should anticipate a new spring."[130]

Mack alluded to the end of ZERO during the media blitz surrounding the exhibition in New York, when he warned, "But now that we've found some success our friendship will probably end." During his solo show at Howard Wise, he publicly announced, "The ZERO spirit is still alive. But for me, no more collaborations. From now on, I take my own direction."[131] Six months later, the group agreed to "go their own ways." The artists organized a grand, final ZERO demonstration and exhibition at the Städtische Kunstsammlung in Bonn (November 1966), an extravagant demonstration and exhibition attended by thousands of revelers (Figure 3.14).[132] They secured a special train to travel from Düsseldorf adorned with a banner that read "ZERO is good for you." Then, precisely at 00:00 hour, they released hundreds of balloons to signal the conclusion of their group.

Despite the tremendous flurry of activity surrounding Group ZERO during the final year of their collective identity, the official politics of German art did not change. For the German Pavilion at the 1966 Venice Biennale, the commissioner Eduard Trier selected Horst Antes, Günter Haese, and Ferdinand Ris to represent the country. Many artists protested the selection, stating that the artistic administration of Germany was

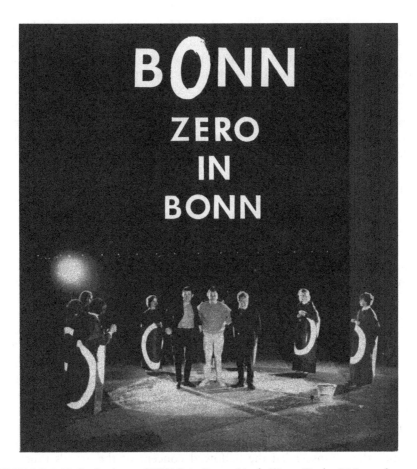

FIGURE 3.14 *Invitation to "ZERO in Bonn: Mack, Piene, Uecker," November 25, 1966. Harvard Art Museums/Harvard Art Museums Archives, Records of the Howard Wise Gallery (SC 17), ARCH.0000.1523. Photo: Imaging Department © President and Fellows of Harvard College.*

out of touch and had made "a false representation of German artistic production."[133] When the Biennale judges awarded the grand prize to Julio Le Parc of GRAV, the German critics responded. Hans Strelow wrote that the German administrators had "missed an opportunity in Venice." They could have shown Group ZERO, who were internationally recognized for their work in light and movement—the principal theme of the Biennale—and who were, after all, "simply better than their friends across the Rhine."[134]

ZERO was "the first artistic movement in German art after the war to make an international impact."[135] The ZERO artists participated in a Zeitgeist that broke from modern art and rekindled the conjunction of art

and science, employing the new media of film, video, kinetic art, light, and sound to create earthworks, interactive and installation art. They introduced a variety of concepts that have become identified with contemporary art: conceptual art, minimal art, process art, happenings and performance, and collaborative art. The artistic attitudes expressed at their demonstrations and expositions had a profound effect on a younger generation of German artists who were seeking a new voice. ZERO artists participated in steering the course of visual arts away from modern painting, and had established Düsseldorf as a center of art,[136] a position the city maintained with Beuys, Richter, Bernd and Hilla Becher, and Markus Lüpertz. Beuys attended ZERO happenings and subsequently developed his ideas on the performative role of the artist. Paik attended Piene's *Fest für das Licht*, which, Paik said, "would change my life many times."[137] But times had changed. Mack remembers this period when he grappled with the reality that current events—the assassination of President John F. Kennedy, the war in Vietnam, and the student protests—"offset the optimism that everything is 'doable'," and caused him to adjust his utopian belief in a dynamic relationship between nature, technology, and art.[138]

After the exhibitions at *documenta* in 1964 and a *Nul* exhibition at the Stedelijk in 1965, ZERO as a group essentially dissolved, as its members pursued their own projects. Despite the artists' success in the United States, this period of social and political change forced each of them to consider their artistic direction. Mack felt it necessary to consider the question "Who is who?" Who, that is, was Heinz Mack? Moving back to Düsseldorf following his Howard Wise exhibition, he spent the next year reflecting.[139] He and his peers had rejected the painterly expressionism of modern painting that was prevalent in their formative years. In their studios they transcended the hallowed concept of the artist's touch by incorporating new media and natural elements (light, fire, water) to generate movement and ephemeral effects as valid subjects for art. In philosophy they discovered the theory that the energy inherent in matter could be transferred through sensory perception. Mack, recognizing the essence of his artistic accomplishments, resolved to continue "to achieve a presence in which everything becomes more visible" because "I believe in what everybody can see!"[140]

Mack, Piene, and Uecker, individually, and in their group identity as ZERO, abandoned modern painting and challenged the limits of art and, in its early years, advocated a position "without ideology ... without a politico-cultural conspiracy."[141] With their collaborative spirit, they coalesced a pan-European Gestalt, and forged the first international artistic movement to emerge from war-torn Germany. By disregarding style and emphasizing materials, ideas, and process, ZERO prefigures much of what constitutes the physical form, conceptual basis, and studio practice of contemporary art. These influential contributions to the evolution of art in the late twentieth century can be understood by examining their contributions to

three genres of performance art, immersive multimedia environments, and experimental television.

Notes

1 Anette Kuhn, *ZERO: Eine Avantgarde der sechziger Jahre* (Frankfurt amMain, Berlin: Propyläen Verlag, 1991), 9.
2 "'Das Licht malt, nicht ich'. Zur Eröffnung der neuen Galerie 'dato' mit Arbeiten von Otto Piene," *Frankfurter Allgemeine Zeitung* (April 18, 1961).
3 Rochus Kowallek, correspondence with Heinz Mack (January 24, 1961). Heinz Mack Archiv, ZERO Foundation, Düsseldorf.
4 "'Das Licht malt, nicht ich'," *Frankfurter Allgemeine Zeitung* (April 18, 1961).
5 Walter Schmiele, "Vom Pinsel zur Lichtmühle. Auftritt eines Malers," *Handelsblatt Düsseldorf* (April 28/29, 1961). Otto Piene Archives.
6 The action of boarding up the gallery door is reminiscent of Uecker's response to protect his family home in Wendorf during the war discussed in Chapter 4.
7 Alfred Schmela, "An das Ordnungsamt der Stadt Düsseldorf, Polizeipräsidium," June 28, 1961. Getty Research Institute, Alfred Schmela Papers, 2007, M.17, Box 12, F33.
8 Heinz-Norbert Jocks, *Das Ohr am Tatort: Heinz Norbert Jocks im Gespräch mit Gotthard Graubner, Heinz Mack, Roman Opalka, Otto Piene, Günther Uecker* (Ostfildern: Hatje Cantz, 2009), 126.
9 John Anthony Thwaites, "Dada hits West Germany," *Arts Digest*, vol. 33, no. 2 (February 1959): 32, 35, 37.
10 Jürgen Morschel, "ZERO 3. Dokumente der neuen Kunst," *Schwäbische Donau-Zeitung* (July 26, 1961). Otto Piene Archives.
11 "Künstler-Ulk in der Altstadt," *Düsseldorfer Nachrichten* (July 7, 1961); "ZERO," *Der Mittag* (July 7, 1961); "Unternehmen ZERO. 'Edition, Exposition, Demonstration,' bei Schmela," *Düsseldorfer Nachrichten* (July 7, 1961). Otto Piene Archives.
12 John Anthony Thwaites, "Dokumente für eine neue Entwicklung," *Deutsche Zeitung* (August 26/26, 1961); Morschel, "ZERO 3." Otto Piene Archives.
13 At a late stage, the artists decided to omit from the magazine Udo Kultermann's essay "The New Dynamism in Painting: Remarks on the Paintings of Mack and Piene." In *4321 ZERO*, edited by Dirk Pörschmann and Mattijs Visser (Düsseldorf: Richter/Fey Verlag and ZERO Foundation, 2012), 409.
14 Thwaites, "Dokumente für eine neue Entwicklung."
15 Heinz Mack, "Traum und Wirklichkeit: Ein Kommentar," in *Gruppe ZERO*. Exhibition catalogue (Düsseldorf: Galerie Schoeller, 1988), 21.
16 Yves Klein letter to Otto Piene (July 20, 1960). Otto Piene Archives.
17 *ZERO*, 125.
18 *ZERO*, 149.
19 *ZERO*, 172–73.
20 Thwaites, "Dokumente für eine neue Entwicklung."

21 In a letter to Otto Piene (August 8, 1960), Piero Manzoni first proposed to Piene to create a "Theatre pneumatique pour licht ballets." Otto Piene Archives.

22 Spoerri introduces this idea in *ZERO 3*, prior to actually fabricating the labyrinthine collaborative venture *Dylaby* in collaboration with other Nouveau réalists at the Stedelijk Museum in 1962.

23 Morschel, "ZERO 3."

24 Bernhard Kerber, "Nul," in *Nul. Die Wirklichkeit als Kunst fundieren. Die niederländische Gruppe Nul, 1960-1965*, edited by Renate Damsch-Wiehager. Exhibition catalogue (Galerie der Stadt Esslingen/Villa Merkel, Esslingen, Ostfildern, 1993), 19.

25 Antoon Melissen, "nul=0: The Dutch Avant-Garde of the 1960s in a European Context," in *Nul=0: The Dutch Nul Group in an International Context*, edited by Mattijs Visser and Colin Huizing. Exhibition catalogue (Rotterdam: Nai Publications and the ZERO Foundation, 2011), 17.

26 Kerber, "Nul," 9.

27 From the author's various conversations with Heinz Mack and Otto Piene.

28 Kerber, "Nul," 11.

29 Melissen, "nul=0," 14–15.

30 Visser and Huizing, *Nul=0*, 9.

31 Melissen, "nul=0," 18.

32 In fact, some of the staff at the Stedelijk demonstrated their deeply held resentment of Germany by identifying the room assigned to the German ZERO artists on the floor plan with a swastika. Author in interview with Heinz Mack, August 5, 2010.

33 John Anthony Thwaites, "Der Geist der Wüste stirbt. Die Ausstellung 'Nul' im Stedelijk Museum, Amsterdam," *Deutsche Zeitung* (March 29, 1962). Otto Piene Archives.

34 Kerber, "Nul," 13.

35 John Anthony Thwaites, "Reaching the Zero Zone," *Arts magazine* vol. 10, no. 36 (September 1962): 20.

36 Jocks, *Das Ohr am Tatort*, 111–12.

37 Kuhn, *ZERO*, 77.

38 John Anthony Thwaites, "Bilder, die Zeit brauchen," *Deutsche Zeitung* (September 29/30, 1962). Otto Piene Archives.

39 Joseph D. Ketner II, "The Dematerializing and Rematerializing of Energy as Artistic Process," in *Otto Piene Sundew and Selected Works 1957-2014*. Exhibition catalogue (New York: Sperone Westwater, 2016), 5–7.

40 *Stringenz: Nuove tendenze tedesche* (Stringent: New German Tendencies) at Galleria Pagani del Grattacielo in 1959. The exhibition included Mack, but not Piene, who had conflicting gallery commitments in Milan and could not participate. This irritated Fischer who expressed this in a letter to Mack (December 8, 1959, Mack Archives) would resent Piene for his withdrawal for many years.

41 Klaus Jürgen-Fischer, correspondence with Heinz Mack (September 25, 1958). Heinz Mack Archives, ZERO Foundation, Düsseldorf.

42 Alexander Leisberg, "Neue Tendenzen," *Das Kunstwerk*, vol. 10–11 (April/May 1961): 3–34.

43 Otto Piene correspondence with Klaus Jürgen-Fischer (July 11, 1961). Otto Piene Archives.

44 *ZERO*, 172–73.
45 Klaus Jürgen-Fischer, correspondence to Otto Piene (September 5, 1961). Heinz Mack Archives, ZERO Foundation, Düsseldorf. Mack and Fischer had been boyhood friends, serving together on the editorial panel of a journal in their gymnasium.
46 Thwaites, "Dokumente für eine neue Entwicklung."
47 Some of the extensive correspondence and articles on this debate that I have quoted include John Anthony Thwaites , "Kritik der Kritik. 'Das Kunstwerk' und neue Tendenzen," *Deutsche Zeitung*, no. 150 (July 3, 1961): 14. Jürgen-Fischer's acknowledgment of Leisberg's identity appears in "Post Scriptum 'Neue Tendenzen'," *Das Kunstwerk*, vol. 5-6/XV (November/December 1961): 72. Jürgen-Fischer's letter to the editor as well as the commentary of Bleckert, Mack, Piene, Zwirner, and others appeared in *Deutsche Zeitung*, July 13, 1961; July 14, 1961; July 19, 1961; July 26, 1961.
48 After this exchange, Jürgen-Fischer's career as a painter did not advance beyond his early *Tachism*-inspired works. His resentment toward Mack, Piene, and Thwaites would linger and spoil the future relationship of the ZERO artists with *Das Kunstwerk*, the main art magazine in West Germany.
49 Kuhn, *ZERO*, 45.
50 Hillings. "Experimental Artists' Groups in Europe, 1951-1968," 478–79.
51 Almir Mavignier, "neue tendenzen 1—ein überraschender zufall," published in tendencije 4. Exhibition catalogue (Zagreb: Galerija suvremene umjetnosti, 1970), n.p., quote by Jerko Denegri, "The Conditions and Circumstances that Preceded the Mounting of the First Two New Tendencies Exhibitions in Zagreb 1961-1963," in *A Little-Known Story about a Movement, a Magazine, and the Computer's Arrival in Art: New Tendencies and Bit International, 1961-1973*, edited by Margit Rosen. Exhibition catalogue (Karlsruhe, Germany and Cambridge, MA/London: ZKM/Center for Art and Media and the MIT Press, 2011), 20.
52 Hillings, "Experimental Artists' Groups in Europe, 1951-1968," 484.
53 Rosen, *A Little-Known Story*, 21.
54 Hillings, "Experimental Artists' Groups in Europe, 1951-1968," 485.
55 *Strategies de Participation—GRAV—Groupe de recherché d'art visuel—1960/1968*. Exhibition catalogue (Grenoble: Le Magasin—Centre Nationale d'Art Contemporain de Grenoble, 1998), 54, 58.
56 *Strategies de Participation*, 63.
57 Darko Fritz, "Notions of the Program in 1960s Art—Concrete, Computer-generated and Conceptual Art. Case Study: New Tendencies," in *Editions HYX* (Architecture-Art-contemporain-Cultures numeriques), edited by David-Olivier Lartigaud (Orleans, 2011), 26–39.
58 Julio Le Parc, "Enough Mystifications." Heinz Mack Archives, ZERO Foundation, Düsseldorf.
59 Otto Piene correspondence with Putar und Mestrovic (October 3, 1963). Otto Piene Archives.
60 Nouvelle Tendance—Recherche continuelle. Mouvement international. Art visuel. *Bulletin no. I* (Août 1963). Otto Piene Archives.
61 Jean-Pierre Yvaral quoted from a letter dated December 1963 to George Rickey, "The New Tendency (Nouvelle Tendance—Recherche Continuelle)," *The Art Journal*, vol. XXIII, no. 4 (1964): 276.
62 Hillings, "Experimental Artists' Groups in Europe, 1951-1968," 522, 525.

63 Rickey, "The New Tendency," 272–79.
64 John Anthony Thwaites, "Tendenzen—neu und alt. Ausstellungen in
 Leverkusen und Düsseldorf," *Deutsche Zeitung* (March 23, 1964). Otto Piene
 Archives. Albert Schulze Vellinghausen writing for the *Frankfurter Allgemeine
 Zeitung* concurred in Thwaites opinion, describing the exhibition as leaving
 "an inartistic, stupid impression." (March 12, 1964). Otto Piene Archives.
65 Rosen, *A Little-Known Story*, 235–303.
66 *Strategies de Participation*, 41 and 42.
67 Ibid., 19.
68 Paul Wember, correspondence with Heinz Mack (November 2, 1962) and
 (November 22, 1962). Heinz Mack Archive, ZERO Foundation, Düsseldorf.
69 Almir Mavignier, correspondence with Heinz Mack (April 28, 1963). Heinz
 Mack Archives, ZERO Foundation, Düsseldorf.
70 Anna Klapheck, "Die intellektuellen Bastler. Piene, Mack und Uecker im Haus
 Lange Krefeld," *Rheinische Post* (February 2, 1963). Otto Piene Archives.
71 John Anthony Thwaites, "Der neue Idealismus. Mack, Piene and Uecker im
 Museum Haus Lange in Krefeld," *Deutsche Zeitung* (February 26, 1963).
 Otto Piene Archives.
72 Klapheck, "Die intellektuellen Bastler."
73 Jürgen Morschel, "Die Avantgarde pflegt ihren Mythos. Zur Ausstellung
 'Mack, Piene, Uecker' im Haus Lange in Krefeld," *Schwäbische Donau-
 Zeitung* (March 5, 1963). Otto Piene Archives.
74 The Brussels exhibition marked the first international exhibition of the three
 principal ZERO artists—Mack, Piene, and Uecker.
75 Otto Piene, "Ansprache zur Eröffnung der Ausstellung Mack-Piene-Uecker
 im Kaiser-Wilhelm-Museum Krefeld Haus Lange am Samstag, January 19,
 1963," Otto Piene Archives.
76 Otto Piene, "Fragen," in *Piene Texte*. Exhibition catalogue (München:
 Galerie nota, 1961), 21–22, originally published in *Monochrome Malerei*
 (Leverkusen: Schloß Morsbroich, 1960).
77 Günther Uecker quoted in the *Nordrheinische Zeitung* (November 29, 1963)
 quoted in Kuhn, *ZERO,* 47.
78 Heinz Mack, correspondence with Otto Piene (September 26, 1964). Otto
 Piene Archives.
79 Peeters quoted in Kerber, "Nul," 11.
80 "Zero der neue idealismus?" *Kunst*, no. 25 (1967): 422. Otto Piene "An
 die Redaktion 'Kunst'," (1967). Heinz Mack Archives, ZERO Foundation,
 Düsseldorf.
81 Adrian Turk, "*Les Nouveaux Réalistes* aus Paris in der Münchhner Galerie
 im Künstlerhaus," Program Monday, February 18, 1963 "Panorama,"
 Hessian Rundfunk. Otto Piene Archives.
82 Pierre Restany, "Preface," *Les Nouveaux Réalistes*. Exhibition catalogue
 (Milan: Apoliinaire Gallery, 1960).
83 Pierre Restany, "Forty Degrees Above Dada," (1961) in *Theories and
 Documents of Contemporary Art. A Sourcebook of Artists' Writings*, edited
 by Peter Selz and Christine Stiles (Berkeley and Los Angeles: University of
 California Press, 1996), 308. Yves Klein objected to Restany's essay linking
 the Nouveaux Réalistes to Dada stating, "One must not commit again this
 lamentable error." Yves Klein, correspondence with Henk Peeters (August

17, 1961) reprinted in *ZERO und Paris 1960. Und heute*, edited by Renate Damsch-Wiehager. Exhibition catalogue (Galerie der Stadt Esslingen/Villa Merkel, Esslingen, Ostfildern, 1997), 206.

84 Jocks, *Das Ohr am Tatort*, 97.
85 Morschel, "Die Avantgarde pflegt ihren Mythos."
86 Hellmut Kotschenreuther, "Ist null mal null Kunst? Bei der 'Gruppe Zero' in der Berliner, 'Galerie Diogenes'," *Nordrheinische Zeitung* (April 17, 1963). Otto Piene Archives.
87 Thwaites, "Reaching the Zero Zone," 16. Klaus Jürgen-Fischer, once a participant in the ZERO group, made this claim in an article that he wrote on "Neue Tendenzen," *Das Kunstwerk* (April/May 1961): 34. John Anthony Thwaites objected to this conclusion in his "Kritik der Kritik. "Das Kunstwerk" und neue Tendenzen," *Deutsche Zeitung* (July 3, 1961): 14.
88 Otto Piene, "Düsseldorf, 1957" (1995). Typescript dated June 1995. Otto Piene Archives.
89 Otto Piene, "Paths to Paradise," in *ZERO*, 149. Piene is referencing Moholy-Nagy's essay "Light Display Film" (Korunk, 1931), in which he outlines a scenario for creating a film with the artificial light of "Searchlight beams at night, directed at the sky." See Krisztina Passuth, *Moholy-Nagy* (London: Thames and Hudson, 1985), 316.
90 Wulf Herzogenrath, "Otto Piene, ein Bauhaus-Meister, ein utopischer Gedanke als Versuch einer Interpretation" (1973), typescript. Otto Piene Archives.
91 Lawrence Alloway, "Otto Piene" (1973), typescript. Otto Piene Archives.
92 Otto Piene, correspondence with Adolf Zillmann (November 21, 1958). Otto Piene Archives. The role of the spectator that Piene discusses in this letter is parallel to Marcel Duchamp's lecture "The Creative Act," delivered at Rice University in 1957. Piene could not have known of Duchamp's lecture, but the parallel establishes another link in ZERO and Dada thinking.
93 Otto Piene quoted in Herzogenrath, "Otto Piene, ein Bauhaus-Meister."
94 Morschel, "ZERO 3."
95 Piene responded to my question about his opinion of the 1958 Dada exhibition at the Düsseldorf Kunstverein. Otto Piene interview with the author (July 20, 2013).
96 Kerber, "Nul," 13.
97 Eduard Jellien, "Die Stunde Null. Volks- und Kunstfest in Arnheim," *Frankfurter Rundschau* (December 13, 1961). Otto Piene Archives.
98 Thwaites, "Dokumente für eine Entwicklung."
99 Klaus Jürgen-Fischer, correspondence with Otto Piene (September 5, 1961). Otto Piene Archives.
100 Thwaites, "The Story of Zero," 3.
101 Eleanor Jess Atwood Gibson, "The Media of Memory: History, Technology and Collectivity in the Work of the German Group Zero 1957-1966" (Ph.D. Dissertation, Yale University, 2008), 140–41.
102 Theodor W. Adorno and Max Horkheimer, *Dialektik der Aufklärung* (Frankfurt am Main: S. Fischer, 1969), 147, 185.
103 Arnold Gehlen, *Zeit-Bilder. Zur Soziologie und Ästhetik der modernen Malerei* (Frankfurt am Main and Bonn: Athenäum Verlag, 1965), 219.

104 Andreas Huyssen, *Present Pasts: Urban Palimpsests and the Politics of Memory* (Stanford: Stanford University Press, 2003), 145–46.

105 Otto Piene, "Vergangenheit, Gegenwart, Zukunft," Exhibition catalogue (Hannover: Galerie Seide, 1960). Otto Piene Archives.

106 Günther Uecker quoted in *ZERO aus Deutschland 1957-1966. Und heute. Mack, Peine, Uecker und Umkreis*, edited by Renate Wiehager, Exhibition catalogue (Ostfildern: Hatje Cantz Verlag, 2000), 25.

107 Otto Piene quoted in Jocks, *Ohr am Tatort*, 111.

108 Gibson, "The Media of Memory," 58.

109 Hillings, "Experimental Artists' Groups in Europe, 1951-1968," 371.

110 Thwaites, "Reaching the Zero Zone," 6–21; John Canaday, "Art," 16; "German Painters Exhibit in Washington," *The New York Times* (November 27, 1962). The exhibition generated an enthusiastic response in Germany, which was eager for international cultural attention. *Die Welt* published an article on this exhibition by Lil Picard, "Man ist brennend interessiert. . . . An den deutschen Abstrakten—Sechzehn Maler in New York" (January 2, 1963), that described a cocktail party by the German ambassador to Washington in celebration of this event. Picard also described Piene's *Light Ballet* as the "sensation of the opening evening." Otto Piene Archives.

111 Heinz Ohff, "Die goldenen sechziger Jahre. Die Gruppe 'Zero' in der Galerie Diogenes," *Der Tagesspeigel* (April 2, 1963). Otto Piene Archives.

112 The intriguing correspondence between Alfred Schmela, Rochus Kowallek, Werner Haftmann, and Arnold Bode arguing for the inclusion of the ZERO group in *documenta* III is available in both the Heinz Mack Archive, ZERO Foundation, and the Otto Piene Archives.

113 Hillings, "Experimental Artists' Groups in Europe, 1951-1968," 215–16.

114 Otto Piene, "Zero and the Attitude" (1965), typescript. Otto Piene Archives.

115 "Interview with Otto Piene," *Kunst* 3 (Mainz) (September 1964). Otto Piene Archives.

116 Wieland Schmied, "Malerei ist keine Einbahnstraße," *Die Zeit* (July 17, 1964). Heinz Mack Archive, ZERO Foundation, Düsseldorf.

117 "Interview with Otto Piene," *Kunst*.

118 Guy Brett, "Three London Exhibitions," *The Guardian* (July 4, 1964). Otto Piene Archives.

119 Charles S. Spencer, "'Group Zero' Adds Movement to Lines. Kinetic Experiments are shown at two London Galleries," *The New York Times International* (June 30, 1964); Brett, "Three London Exhibitions." John Anthony Thwaites also reviewed these exhibitions in "The Story of Zero," 2–9, where he compliments them for their "perfect fusion of nature and technology," 9. This exhibition also earned Otto Piene the invitation to publish an article on the group, "The Development of Group Zero," *The Times Literary Supplement* (London) (September 3, 1964).

120 Heinz Mack to Otto Piene (September 21, 1964), (October 13, 1964); Günther Uecker to Otto Piene (October 13, 1964), (October 17, 1964). Otto Piene Archives.

121 Donald Judd, "Mack, Piene, Uecker," *Arts magazine* (January 1965): 55.

122 John Canaday, "The Sculptor Nowadays Is the Favorite Son," *The New York Times* (November 22, 1964).

123 Heinz Mack to Otto Piene (February 22, 1965), (March 29, 1965). Otto Piene Archives.

124 Otto Piene, correspondence with John Anthony Thwaites (December 1965). Otto Piene Archives.

125 Grace Glueck, "Art Notes: Keeping up with the Rear Guard," *New York Times* (November 7, 1965).

126 Otto Piene, correspondence with Dietrich Mahlow (1965). Otto Piene Archives.

127 Otto Piene, correspondence with McRoberts (February 1, 1966). Otto Piene Archives.

128 Grace Glueck, "Art Notes. Rhapsody in Silver," *The New York Times* (April 17, 1966).

129 John Anthony Thwaites, "Mack, Piene, Uecker Win Praise Trans-Atlantically," *The Bulletin* (June 8, 1965): 7.

130 Heinz Mack to Otto Piene (September 26, 1964). Otto Piene Archives.

131 Grace Glueck in Point of View, *The New York Times* (November 29, 1964); Glueck, "Art Notes: Rhapsody in Silver."

132 Hans Strelow, "ZERO-Künstler gehen eigene Wege," *Rheinische Post* (December 8, 1966).

133 "Neue Kunstpolitik. Ein Protest deutscher Maler," *Frankfurter Allgemeine Zeitung* (1964). Heinz Mack Archives, ZERO Foundation, Düsseldorf.

134 Hans Strelow, "Die Entwicklung der Flasche im Raum. Licht, Bewegung und ABC-Kunst auf der 33. Biennale von Venedig," *Frankfurter Allgemeine Zeitung* (June 28, 1966). Heinz Mack Archives, ZERO Foundation, Düsseldorf.

135 "Paris on the Rhine," *Time* (June 2, 1967).

136 Ibid.

137 Nam June Paik, "Two Rails Make One Single Track," in *Otto Piene: Retrospektive 1952-1996*. Exhibition catalogue (Düsseldorf: Kunstmuseum Düsseldorf im Ehrenhof, 1996), 46.

138 Heinz Mack, "Traum und Wirklichkeit," in *Gruppe ZERO*. Exhibition catalogue (Düsseldorf: Galerie Schoeller, 1989), 21.

139 Joseph D. Ketner II, "Mackazin," in *Mack Szene Mack Seen Mack-A-Zine Mackazin. Die Jahre The Years Les Annees 1957-1967, vol. 2*. Exhibition catalogue (New York: Sperone Westwater, 2011). See also Heinz Mack's first edition of *Mackazin* self-published in 1967.

140 Heinz Mack essay, November 1964 (translation Heinz Mack). Heinz Mack Archive, ZERO Foundation, Düsseldorf.

141 Heinz Mack, "What Was ZERO?" in *Heinz Mack: Licht in der ZERO-Zeit*, edited by Beate Reifenscheid, Exhibition catalogue (Koblenz: Ludwig Museum im Deutschherrenhaus, 2009), 11.

CHAPTER FOUR

Artists' Actions into Theater

Artists in the ZERO network developed a rich repertoire of new media to create ephemeral experiences that stimulated the spectators' senses. Actions, demonstrations, fests, and happenings were an essential part of their work. Heinz Mack and Otto Piene launched their careers by hosting exhibitions in their studios in April 1957 that lasted only one evening, an event of limited duration that served as a temporal artistic event. With hindsight, it is possible to view the evening exhibitions as the nascent manifestation of the performative dimension of their artistic practice. Lawrence Alloway realized that the evening exhibitions "became a performance, an event in real time, without the long-term consultability of fixed objects. Even paintings, when shown at this speed, took on a kind of ephemeral configuration."[1] Yves Klein appreciated the value of artists' actions as part of his practice, when he released 1,001 blue balloons at the inauguration of his exhibition *Propositions Monochromes* at Galerie Iris Clert in Paris in May 1957 and staged an action at the opening of his *La Vide* exhibition in April 1958, by serving blue cocktails under the stoic watch of fully uniformed Republican Guards.[2]

These events orchestrated by Klein, Mack, and Piene participated in an emerging interest in actions as a means of generating public attention and communicating the artists' message. Their actions launched a decade of artists' actions and demonstrations. In Paris, in January 1958, Wolf Vostell conducted his first full-fledged happening, to which he gave the title *Das Theater ist auf der Straße* (The Theater Is on the Street) (Figure 4.1). For this action, Vostell followed a score that invited passersby to accompany Vostell on a walking tour of Paris, during which the participants were instructed to rip up the advertisements, creating De-coll/age. This action introduced improvisatory, participatory performances. In Düsseldorf, in April 1958, Group ZERO published the first issue of its artists' magazine in conjunction with the evening exhibition *The Red Painting*. Although this exhibition featured red monochrome paintings, the event itself was an artists' action.

FIGURE 4.1 *Wolf Vostell*, Das Theater ist auf der Straße, *Paris, 1958. Museo Vostell Malpartida. © 2017 Estate of Wolf Vostell/Artists Rights Society (ARS), New York/VG Bild-Kunst, Bonn.*

And in October 1958, Allan Kaprow published an article, "The Legacy of Jackson Pollock," in which he articulated the ideas that were the foundation of the activities for which he coined the term "Happening."[3] A year after the article appeared in *Artnews*, Kaprow realized his *18 Happenings in 6 Parts* at the Rueben Gallery in New York (1959). These events initiated a flood of artists' events, actions, or demonstrations on both sides of the Atlantic. After "Happening" became common parlance in America, the Europeans also adopted the term. Below, I will be using the terms "artist action," "demonstration," "fest," and "Happening" interchangeably, as these were used by the European artists.

From this beginning the artists organized a steady stream of artists' actions through the 1960s. Jean Tinguely produced mechanical performances for his audience, such as his *Concert for Seven Pictures* at Iris Clert in 1958 (and Galerie Schmela in 1959), where the kinetic objects, ersatz replacements for the artist, performed mechanical noise music for the audience. At Galerie Schmela, Daniel Spoerri conducted a simultaneous reading performance that must have rung like the nonsense recitations of Kurt Schwitters' *Sonate in Urlauten* (Primordial Sonata, 1922–32) and the Dada Cabaret Voltaire. Tinguely followed this action by staging a photo shoot that ostensibly showed him flying over Düsseldorf dropping leaflets of his manifesto "For Static."[4] Klein followed in March by reciting passages from Gaston Bachelard, while smoking a cigarette at the opening of *Vision in Motion* in Antwerp. Piene, who had been developing his light play for over a year in his studio, debuted it at Galerie Schmela in May. Vostell cites Piene's *Light Ballet* as among the earliest artist demonstrations in his 1965 publication *Happenings*.[5]

The ZERO network of artists developed their actions parallel to one another, participating in and attending each other's actions, mutually

influencing their performances. To understand the progression of influences, it is important to view the actions in sequence. The relationship between ZERO and the Nouveaux Réalistes has been recognized. The archival sources also confirm their precedence and influence on the subsequent development of Fluxus. Over the 1960s, each of the ZERO, Nouveau Réalisme, and Fluxus artists developed individual performance practices, appropriated from the Dada Cabaret Voltaire, Bauhaus festivals, and mass popular entertainment. Over the decade, the artists' demonstrations became increasingly polemical as the sociopolitical climate changed. They evolved from the playful *Costume Fest*, hosted by Günther Uecker in 1959, to aggressive political actions such as Piene's *deutschlanddeutschlanddeutschland* (1967) and Uecker and Gerhard Richter's occupation of the art museum in Baden-Baden (1968), which forced German viewers to confront their Nazi past. Among the ZERO artists, only Piene developed his actions in the context of theater, attempting to reinvent traditional theater, evolving into immersive, multimedia performance pieces in the mid-1960s. Throughout the1960s, these artists participated in what we now describe as performance art.

Artists' actions are characterized by the presence of a "performer" who engages in a non-narrative set of actions, either scripted or improvised, before an audience. Susan Sontag wrote, "The Happening has no plot, though it is an action, or rather a series of actions and events."[6] These were often produced in the streets, galleries, or public plazas, not in traditional theaters. The intention was to jolt the public from its expectations of normalcy by acting out in socially abnormal behavior. The result is a spectacle, a sensory experience, sometimes even a shock, for the audience. For the postwar new tendency artists, the experience was the physiological stimulation of the spectators' senses through actual or "real" events, the phenomenological basis of their artistic strategy.

Rose-Lee Goldberg describes performance art as "a way of bringing to life the many formal and conceptual ideas on which the making of art is based," adding, "live gestures have constantly been used as a weapon against the conventions of established art."[7] Certainly, the postwar European artists employed this strategy to animate their rebellion against painting by presenting "the theater . . . on the street." Piene echoed Vostell's concept when he wrote, "The theater is the world." He described his theater as a place "of acting, playing people—or the playing of acting people."[8] For Piene, the formality and informality of the action are interchangeable, and "the world" signifies both the physical and the metaphysical world of people and ideas. He embraced a "world" broader than Vostell's notion of "the street"—the place of everyday people and actions—or Joseph Beuys's later construction of social sculpture, "Everyone is an artist."

The concept of the artist's action might seem to contradict these artists' avowed aspiration to distance themselves from the artists' emotional presence. Yet they minimized the role of their individual personalities by employing theatrical tactics devised earlier in the century to distance the

actor's individuality, while simultaneously breaking down the separation between the audience and the actor. Actions were consistent with ZERO and new tendency artists' theoretical foundation in phenomenology, and their interest in dematerializing the static objet d'art by introducing an active human element as a component in generating a temporal artistic experience.

Mack, Piene, and Uecker's demonstrations derived from their experiences in creating the annual fests at the Düsseldorf Academy of Art (Figure 4.2), which, in turn, derived from the Bauhaus academy festivals and theories on theater. The perception of a general malaise in theater in the 1920s motivated Walter Gropius to develop the theatrical program at the Bauhaus and publish *The Theater of the Bauhaus* (1924), which advocated a "theater of totality" and the role of theater as the venue for a synthesis of the arts. Gropius wanted to "shake off the inertia" of theater, break down the separation of the audience from the performers, and "rouse the spectator . . . to assault and overwhelm him, coerce him into participation in the play."[9] In his essay, László Moholy-Nagy posits that this could be achieved by reintroducing "the theater of improvisation, the commedia dell'arte." Through the techniques of popular theater, circus, variety, and the use of masks and costumes, one could simultaneously engage the audience and distance the performers' personality. As Moholy-Nagy stated, these elements "eliminate[ed] the subjective." He credited Dada and the futurists with reviving the "theater

FIGURE 4.2 *Photo of Düsseldorf Art Academy Fest, 1951, with decorations designed by Heinz Mack and Otto Piene. Otto Piene Archives.*

of surprises," with its "elimination of logical-intellectual (literary) aspects," and thus of the linear narrative of theater.[10]

Contemporary critics also identified ZERO demonstrations as direct extensions of Dada and the Cabaret Voltaire, which had experienced a resurgence during the 1950s. Dada artists advocated a nihilistic anti-art that questioned the form, ideological foundation, and institutional structure of art. As we have established, the postwar new tendency artists were not interested in the anti-art argument. However, many of them did return to the Dada theater of the absurd as a model for expressing their disillusionment with modern art, and as a mechanism for expressing their frustrations and aspirations pursuant to their own experiences of war.

Dada writers espoused performance strategies "for communicating an intense and intoxicating life to the spectators" with a mixture of acrobatics, buffoonery, pantomime, film, and other popular performance elements.[11] These became standard repertory for ZERO demonstrations, Nouveaux Réalistes' actions, and the happenings of Kaprow, Paik, Vostell, and later Fluxus. Sontag, employing the same metaphor as Moholy-Nagy, characterized the Happening as an "asymmetrical network of surprises."[12] Creating a spectacle was central to the artists' actions of this period. The idea relates to Bertolt Brecht's theories on epic theater as opposed to dramatic theater. Brecht's strategy was to break down dramatic theater's foundation in catharsis by alienating the audience from empathizing with the actors through dissonance and distance.[13] In so doing, he appropriated "plebian spectacle" and transformed it into drama.[14] Postwar performance engaged these strategies, but the Nouveaux Réalistes, Nul, and ZERO artists advocated a more festive atmosphere that generated an aura of optimism. Fluxus and American Happenings, on the other hand, drew from the nihilism of Dada, often conveying an existential sense of meaninglessness. This strategy also relates to the alienation found in the theater of the absurd practised by such writers as Samuel Beckett and Eugène Ionesco. In the Happenings shock and danger were central tactics for generating spectacle. These artists applied Antonin Artaud's concept of the Theater of Cruelty as the mechanism that pandered to "the spectator's taste for crime, his erotic obsessions, his savagery."[15] While the postwar artists applied similar theatrical strategies in their actions, the messages diverge. A procession with balloons and costumed figures proclaimed that ZERO is for everything and for everybody. George Maciunas levitated balloons that exploded releasing his manifesto advocating to "Purge: the world of bourgeois sickness . . . PURGE the world of dead art . . . PURGE THE WORLD OF 'EUROPANISM'!"[16]

These theatrical concepts resided at the center of Group ZERO thinking about public artists' actions. Their parades, foil banners, and playful actions partake of the traditions of Dada and Bauhaus theater, combining message with mass entertainment to generate spectacle. Unfortunately, the success of these Bauhaus theater tactics between the wars led to them being appropriated by the fascists in Germany and Italy for their own purposes.[17]

The ZERO and Nouveaux Réalistes artists, on the other hand, returned to the Dada "theater of surprises" and the democratizing impulse of the Weimar era and aspired to a central precept of Bauhaus theater: "Man is the most active phenomenon of life is indisputably one of the most effective elements of a dynamic stage production."[18]

ZERO and the Nouveaux Réalistes developed actions as a prominent component of their repertoire. In 1960 six ambitious action/events by Klein, Tinguely, Mack, Uecker, Piene, and Nam June Paik characterized the range of performance that these artists practised, culminating in the ZERO *Demonstration* in Düsseldorf (1961).

In March 1960, Klein conducted his most recognized performance, the *Anthropometries*, at the Galerie nationale d'Art Contemporain, in Paris, a new series of works that entirely removed the artist's hand from making his paintings. Klein staged this event like a theater production. Entering the gallery in full tuxedo, he raised his arms to signal the string ensemble to play his *Symphonie Monoton Silence*, a single D-major chord for twenty minutes followed by twenty minutes of silence (Piene had similarly played a single A note for his 1959 debut of the *Light Ballet* at Galerie Schmela). During the silence and under the watchful eye of Klein, five nude models doused themselves with IK blue pigment, and then pressed their bodies against the large sheets of papers hung on the wall and laid on the floor.[19] Klein had distanced himself from actively applying the pigments, but demonstrably conducted the affairs. In this performance Klein literally reintroduced the body into the action of painting and conducted the creation of the painting. Furthermore, he cultivated a sense of mystery around his persona, declaring at the conclusion of the performance, "The myth is in art."

While Klein performed with his "human paint brushes," Tinguely took an entirely different approach to artists' actions. Working with Billy Klüver and Robert Rauschenberg at the Museum of Modern Art, he constructed his *Homage to New York* (1960). After seeing an exhibit of his meta-matic machines at a New York gallery, the museum invited Tinguely to conduct a demonstration of his machines in their garden under a temporary Buckminster Fuller dome. He conceived a monumental contraption that self-destructed before the assembled audience. As Klüver described it in ZERO 3, Tinguely gathered mechanical components, scrap metal, and old motors from junkyards and salvage shops, to build a 23 by 27 foot kinetic assemblage of whirling wheels, chugging engines, and smashing arms. The program began with mechanized arms striking the keyboard of the piano. After that "the process of destruction failed to go according to schedule," creating a dangerous situation for the audience. Fearing a disaster an anxious fire marshal extinguished the remaining kinetic components to the booing of the crowd, who were enjoying the spectacle.[20]

As with his drawing and sound-making machines, Tinguely's *Hommage à New York* functioned as an extension of the artist's presence, not as a mythological persona, but as a conductor of an ironic statement on postwar

technological culture. Tinguely continuously moved around the machine during the performance to ascertain the various parts worked, or self-destructed as the case may be. As he wrote in 1959, "Playing is art, so I am playing." But his play was in earnest. John Canaday, the conservative arts reviewer for the *New York Times* recognized the metaphor as demonstrating "independence against machines in a world they are beginning to control" and its ironic parody of action painting. Yet he dismissed the work as nihilistic founded on "the destruction of the pictorial image as art." He understood that the event appealed to a basic human compulsion to witness destruction, but was not willing to accept the Neo-Dada "negative creation," criticizing it as "adolescent rebellion."[21]

Günter Meisner invited Mack to have a solo exhibition in his new Berlin Galerie Diogenes in August 1960. In the former German capital political tensions were broiling as the Cold War exacerbated the division of the country just before the construction of the wall. The art scene was still enmeshed in the formalism debate over abstraction versus figuration, the antagonists represented by abstract painter Heinz Trökes in opposition to Werner Tübke and the heirs of Karl Hofer's German expressionism, now called critical realism to distinguish it from Soviet Socialist Realism.

In this cultural climate Mack's *Hommage à Georges de la Tour* was startlingly different from the work being shown in Berlin. His installation consisted of an entire wall filled with an array of his light reliefs and light rotors that created a dynamic play of light and shadow, dematerializing the objects and the space (Figure 4.3). In addition, Mack proposed a "Light

FIGURE 4.3 *Heinz Mack,* Phosphorus Wall Painting *in* Homage a Georges de la Tour, 1960, *Galerie Diogenes, Berlin. Atelier Mack. © 2017 Artists Rights Society (ARS), New York/VG Bild-Kunst, Bonn.*

Demonstration" to Meisner, a stage and film actor as well as a painter, for the cellar space below the gallery as his action in homage to the French artist's use of light. In a dramatic multimedia performance, Mack projected a detail of the flaming torch from de la Tour's *Irene's Discovery of St. Sebastian* (1646, State Museum, Berlin) onto the wall, painted another wall with phosphorescent pigments that he illuminated with an ultra-violet light, spun a kinetic rotor of phosphorescent pigment, and lit 200 candles on the floor, accompanied by an audio text on the iconography of the painting. For the dénouement, Mack read the countdown; when he reached 0, two women attired in costumes from de la Tour's painting doused the flames and extinguished the ultra-violet lights, leaving only the phosphorescent paintings on the wall by Mack centered on de la Tour's torch, glowing in the room. This exhibition marked the expansion of Mack's artistic repertoire from his light objects into a performance within an immersive environment.[22] He expanded on Piene's *Light Ballet*, with the addition of human performers, slide projections, and natural and UV light sources. But, in contrast to Klein and Tinguely, he withdrew his persona from performance and allowed the sensory experience to dominate his "Light Demonstration."

Also, late in the summer of 1960, Uecker entered the realm of action, when he took a canvas and proceeded to shoot it with arrows (Figure 4.4).[23] The resulting *Arrow Pictures* introduced a new dimension to his work that straddled the line between action and object. The artist, in the threatening gesture of shooting a bow, literally wounds painting in a manner that resonates with Lucio Fontana's violent cuts into canvas. When Uecker arrived in 1955 to study at the Düsseldorf Academy he worked through the materials and processes of painting. After he discovered in 1957 that the nail was his signature material, he periodically struggled to reconcile this unorthodox object as a valid, organizational component of his work. He tested the pictorial possibilities of other materials, including paper tubes, cork, plastics, hangers, and candle wax. He claimed, "I never reached the idea of painting. . . . My art failed on the journey towards painting."[24] On this sojourn he discovered the aggressive action of shooting arrows into canvas-covered panels. This action generated visual nuance contrasting delicate lines and violent punctures.[25]

As the evening exhibitions evolved and the works of art by the ZERO artists moved increasingly toward the immaterial, the event elements in their practice became more pronounced. In October 1960 for the 9th and final evening exhibition, Piene orchestrated a sequence of four different *Light Ballets* in a series of performances over four different days in his atelier in conjunction with an exhibition at Galerie Schmela, *Fest für das Licht* (Figure 4.5). For this occasion Piene demonstrated a range of sensory effects that he was able to produce with his light/sound environments. On the first night Piene presented a *Light and Jazz Ensemble*, and followed this by manually performing what he called his *Archaic Light Ballet*. On the third night, he created a *Chromatic Light Ballet*, as opposed to the usual white

FIGURE 4.4 *Günther Uecker shooting arrows from* 0 x 0=Kunst. Maler ohne Pinsel und Farbe, *1962, (07:34). Gerd Winkler, producer. Hessischer Rundfunk, Frankfurt.*

lights. For his grand finale, Piene presented his first *Fully Electronic Light Ballet,* for which he orchestrated a series of lights operated by various actors according to a prearranged choreography, in an immersive environment of light and sound. Both the *Archaic Light Ballet* and the fully electronic one utilized artist/actors manipulating the lights as an essential component of the experience.[26]

 These actions performed by ZERO and the Nouveaux Réalistes were informed by the nonsensical theatrics of Dada, influencing the playful nature of these demonstrations. Many of the critics and journalists observing these actions noted the connections to Dada, usually derisively, and demanded more serious endeavors from the artists, dismissing the fest, the celebration, the tricks, and jokes that attracted the curious as frivolous. One critic, echoing Canaday's comments on Tinguely's *Homage to New York*, compared the action to Dada and described it as "infantile spectacle."[27] To create a spectacle was precisely the intention of the artists. Consistent with Tinguely's philosophy that "playing is art" and the current ideas of Dutch thinker Johann Huizinga in his book *Homo Ludens*, the demonstration served as a mechanism for stimulating creativity in people.[28]

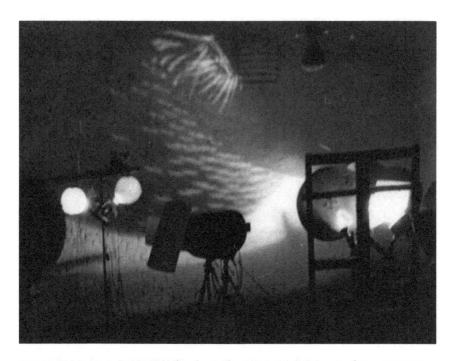

FIGURE 4.5 *Otto Piene,* Fest für das Licht, *1960. Otto Piene Archives. © 2017 Artists Rights Society (ARS), New York/VG Bild-Kunst, Bonn.*

The ZERO and Nouveaux Réalistes actions exerted a considerable influence in the nascent stages of the development of Beuys, Paik, and Vostell. These three artists attended the ZERO and Nouveaux Réalistes events, and subsequently informed their work and their participation in Fluxus.

Paik attended Piene's *Fest für das Licht,* where he met Beuys. During the same week in October 1960 Paik performed his newest "musical" piece. Paik had come to Germany, he explained, because "in 1957 new music was the center of all the arts movements and Germany was the center of the new music."[29] Paik's concept of musical performance transformed under the influence of Karlheinz Stockhausen and John Cage.[30] After experiencing a Cage-prepared piano concert in 1958, Paik submitted a new composition that combined sound and actions to the Darmstadt International Musikinstitut annual festival, but it was rejected. The Institute director, Dr. Wolfgang Steinecke, responded to Paik's proposal writing, "The description of what you are doing . . . does not give me . . . a musical idea . . . when you mentioned extra-musical elements (thrown eggs, destroyed glasses, a live, loose chicken, to drive in a motorcycle) that are so provocative." The director followed by asking whether these elements were advisable for the first debut of a composer.[31]Despite the dismissal Paik did debut the piece *Hommage à John Cage* at the invitation of Jean-Pierre Wilhelm in his

Galerie 22.[32] In this, his first mature performance, Paik combined Cage's idea of the prepared piano, Stockhausen's use of collaged sounds on magnetic tape, plus Paik performed absurd actions. Paik mixed traditional music and concrete sounds to convey to the audience that "the elevated and the ugly are inseparable."[33] He processed music with "real" sounds and realized in aural form the collage aesthetic of the Nouveaux Réalistes, bringing the concrete music of Pierre Schaeffer and Stockhausen into the gallery.

Paik repeated his distinctive amalgam of music, performance, and visual art in his second, and arguably most notorious, public performance at Mary Bauermeister's studio in Cologne, *Etude for Piano Forte* (1959–60). As the music historian Michael Nyman recounted, the performance began with a motorcycle running on stage, but no performer.[34] Once Paik returned he then began to play a Chopin Ballad, when he suddenly stopped, jumped off the stage, and, as he described in his own words, "I go to John Cage and cut his under shirt. But I found he had his short tie therefore I cut it, too and shampooed Cage (and [David] Tudor)."[35] Paik became infamous for such aggressive actions. Nyman stated, "Not for nothing did Cage say of Paik's performances that 'you get the feeling very clearly that anything can happen, even physically dangerous things'."[36]

The performances of the new music composers attracted considerable attention among the ZERO artists, who were well aware of Stockhausen's work at the Electronic Music Studio of the Westdeutscher Rundfunk (WDR), Cologne. Piene acknowledged that Cage and Stockhausen motivated the audio aspects of his light ballets. And Mack, in an introduction to a nailing performance by Uecker, discussed the relationship between Uecker's action of nailing the culturally laden object of the piano and the public. He cited the example of "the Korean music action . . . against that kind of music" and of Cage, whose "concern was to condemn the piano as a medium of the human soul."[37] The performances of these musicians informed and expanded the actions, not just the sound components, of subsequent artists' actions conducted by this generation. In turn, Stockhausen was also motivated by Paik's performances to compose a sequence of chance musical encounters that he called *Originale*.[38] The piece debuted in Cologne in October 1961, with Mack in attendance.[39]

It was at this time that Paik, Joseph Beuys, and Vostell became friends. They were all at transitional moments in their artistic careers, and were profoundly influenced by the resurgent interest in Dada, as well as the current contemporary movement, Group ZERO. Kurt Schwitters had just had an exhibition at the Kestner-Gesellschaft in Hanover in 1956, and the Düsseldorf Kunstverein hosted a significant Dada exhibition in 1958. Although this exhibition does not appear to have recreated any Dada performances, the symposium held in conjunction with the exhibit did address the principal aspects of Dada anti-art, particularly with regard to the materials and the rebellious social protest. Thwaites reported that Rhineland artists considered the exhibit "enormously important" because of Dada

use of "unconventional materials." For the contemporary German artists, many of whom were trained in traditional academies, the choice of found materials "was a protest against the elegance, the fashionable perfection, the sterile ornament of the prominent contemporary abstractionists from Hartung via Poliakoff to Manessier."[40]

Paik and Vostell began to perform together in June 1961 at a spontaneous action in Cologne.[41] Vostell had already been performing actions that occurred parallel to the first events by the ZERO and Nouveaux Réaliste artists in nearby Düsseldorf, about whom Vostell was aware. However, Vostell took a decidedly Dada approach. In his actions, he combined public performance with decollage, an activity that some of the Nouveaux Réalistes, such as Raymond Hains and Jacques Villeglé, had been doing for a decade as static objets d'art. Vostell's innovation was that he engaged the public to participate in the creation of the work.

Beuys also had close ties to the ZERO network. He began as a student in the Düsseldorf Art Academy under the principal sculptor Ewald Mataré and was acknowledged as a "master's student." Beuys was older than most of the students. A member of the generation of the "perpetrators," he served in the *Luftwaffe* (air force) during the war, and the trauma of the war had physical and emotional repercussions for the artist. This we can see from his first mature sculpture, *Torso* (1949/51), that emphasized "the fragility of the body, which appears to be held together only by the bandages and oil paints."[42] In its grim vision of humanity, this sculpture shares the emotional content with German *Trümmerliteratur* (rubble literature) and *art informel*. The existential pessimism that pervades Beuys's work also relates to the French *informel* artists, particularly Wols and Fautrier. In terms of rendering the existential human form in three dimensions, Beuys also harkens back to Alberto Giacometti's existential sculpture. During this period Beuys attended the ZERO evening exhibitions and demonstrations in Düsseldorf, and he had his studio in the same building as Mack and Piene. He witnessed the dramatic possibilities of public actions as a form of mass artistic experience. After a period of depression, from which he emerged around 1958, Beuys began to develop his mature work, combining his academy training with his experience of ZERO and his awareness of Dada.

Beuys, Paik, and Vostell became acquainted with George Maciunas, who had moved to Germany late in 1961, While the circumstances surrounding Maciunas organizing Fluxus in Germany is well known, what is often overlooked is the context of the German art community that fostered this development. Maciunas, in collaboration with George Brecht, published his *An Anthology* (1961) that carried the long subtitle, "of chance operations concept art anti-art indeterminacy improvisation meaningless work natural disasters plans of action stories diagrams music poetry essays dance constructions mathematics compositions." This sums up the materials, forms, and various artistic disciplines that Maciunas drew upon to assemble what would be called Fluxus. Certainly, Paik's performances manifest "chance

operations . . . music poetry," and they sought him out. Rolf Jährling, who ran a contemporary-art gallery out of his house in Wuppertal, learned of Paik through his performance in Stockhausen's *Originale*, and invited him to give a concert at his gallery in June 1962.[43] Paik accepted the invitation and put together a program with Maciunas and Ben Patterson, an American bass player, to perform *A Little Summer Festival: After John Cage*. The program began with a reading of Maciunas's essay "Neo-Dada in Music, Theater, Poetry, Art," while Paik acted out with a diagram behind the speaker. A few weeks later, the performance was repeated and expanded, with variations and improvisations, in Cologne, where Jährling tried to prepare his audience by informing them that the "concert" was "neither about Dada nor about music."[44] Regardless, it caused a public consternation that the performers' Dada predecessors would have appreciated.

These performances established the structure and tenor for subsequent performances that went under the name Fluxus, the first being *Fluxus— International Festival of the Newest Music*, in Wiesbaden in September 1962. When people arrived for the concert they found the playbill scribbled with the text "The lunatics are on the loose."[45] Paik's interpretation of Young's *Composition 1960 #10 to Bob Morris*,[46] which he titled *Zen for Head*, surprised even the other performers, who had no idea what to expect from Paik. Petra Stegman described how Paik "dipped his hands in a bucket with ink and stamped them on a long roll of paper stretched over the floor. He then repeated the same process with his tie, leaving a more or less straight line as a trace on the paper. Not satisfied with it, he proceeded to soak his hair in the ink in order to use it as a paintbrush and finish the drawing with it."[47] For the conclusion of the program, the group re created a popular piece from earlier concerts, Philip Corner's *Piano Activities* (1962), in which they destroyed a piano. Like the related ZERO demonstrations that preceded Fluxus, this controversial performance attracted considerable press coverage, leading to engagements across Europe, where Fluxus appeared in concert halls and on television, appealing to an audience hungry for spectacle.

At this time, political tension in Europe had intensified between the two "superpowers." Facing the reality of living under Soviet rule, many Germans fled the eastern zone and moved west, as had Uecker and Richter, where they were immediately granted citizenship. After Nikita Khrushchev demanded that the Western military leave Berlin in June 1961, the exodus achieved biblical proportions. According to the historian Tony Judt, the migration was so great that within a few months "the German Democratic Republic would soon be empty."[48] Humiliated by such widespread rejection, the Soviets immediately began constructing the Berlin Wall on August 16, 1961, and completed it through Berlin in three days. They continued the "iron curtain" across Germany and Europe, creating a divided Germany and firmly entrenching the Eastern and Western forces in the Cold War. This sociopolitical situation affected the content of the performances by Beuys, Paik, and Vostell, as well as by the ZERO and Fluxus artists. These

changes reflect a shift from concerns about the complacent lifestyle of the consumer age of reconstruction to the terror of imminent nuclear holocaust. During this period, Europeans, especially Germans, viewed their land as the demilitarized zone between the two postwar powers, which pointed their intercontinental ballistic missiles at each other and were poised to destroy the land between them.

Beuys, Paik, and Vostell engaged in dialogue about performance and its potential to address current political issues, motivating Beuys to come out of his studio and to work with Paik and Vostell and, through an introduction by Paik, with Maciunas and Fluxus. Beuys proposed to host and participate in an event at the Düsseldorf Academy of Art in February 1963, where Beuys was now a professor. This event represents Beuys's departure from fabricating existentialist sculptures of angst and signals the "advent" of Beuys as the performance artist with his first public action, *Eurasia Siberian Symphony* (Figure 4.6). Here, Beuys began playing the music of Eric Satie, demonstrating his considerable abilities as a pianist; then, he stopped, and

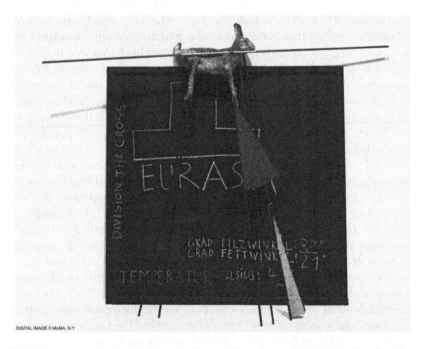

FIGURE 4.6 *Joseph Beuys.* Eurasia Siberian Symphony, *1963/1966. Panel with chalk drawing, felt, fat, taxidermied hare, and painted poles, 6' × 7' 6 ¾" × 20" (183 × 230 × 50 cm). Gift of Freeric Clay Bartlett (by exchange). The Museum of Modern Art, New York, NY. © 2017 Artists Rights Society (ARS), New York/ VG Bild-Kunst, Bonn. Digital Image © The Museum of Modern Art/Licensed by SCALA/Art Resource, NY.*

constructed an installation on stage that included tying a dead hare to the top of a chalkboard. [49] The metaphors in this performance revolved around the land and shared culture of Europe and Asia, a link that was threatened by the Cold War. With this action, Beuys announced himself as an artist with a starkly political dimension, addressing European sociopolitical history, past and present.

In September of that same year, 1963, Beuys collaborated with Vostell in his *9 No-De-Coll/age* performance, one of Vostell's most ambitious happenings. Vostell organized *9 No-De-Coll/age* in the town of Wuppertal, in emulation of Kaprow's now famous *18 Happenings in 6 Parts* from 1959. A nine-part action, Vostell hired buses to transport his audience to each location, beginning at a theater screening his new video/film *Sun in Your Head* (1963) and concluding with an exhibition of his décollages at Jährling's Galerie Parnass. The subtitle for this event was "Life as a picture or a picture as life." Vostell firmly believed that "what happens on the street, in the airport, in the supermarket, and on the highway, are [*sic*] just as important for art as any other process," an idea that Beuys appropriated when he announced "Everyone is an artist" in 1967. The nine events contained several explicitly political actions including the seventh stop, where he asked, "Is that the Wall?" Among the events was the spectacular crashing of a train into a Mercedes Benz automobile (Figure 4.7).[50] Vostell, who was the son of a rail worker, seemed to be venting the frustration that Germans felt at the older generation and the industrial complex, which had participated in the war and left them a divided nation.

The actions of Beuys, Paik, Vostell, ZERO, the Nouveaux Réalistes, and the Fluxus artists were linked by antagonism toward painting. Beuys realized this shared goal in November 1965, for his first exhibition at Galerie

FIGURE 4.7 *Wolf Vostell, 9* No-De-coll/age, *1963, Wuppertal. Museo Vostell Malpartida. © 2017 Estate of Wolf Vostell/Artists Rights Society (ARS), New York/ VG Bild-Kunst, Bonn.*

Schmela, where he staged a memorable performance, *Explaining Pictures to a Dead Hare*. When visitors arrived for the vernissage, they found the front door locked. Looking through the storefront window, the crowd saw Beuys walking from picture to picture, explaining the paintings to the dead animal. His ultimate source for his artistic presentations in both form and artistic persona was Marcel Duchamp and Dada. However, Beuys rebelled against Duchamp, too, in the well-known placard inscribed *The Silence of Marcel Duchamp Is Overrated* (1964), where he advocates a more proactive role for the artist, in place of the aloof, elitist reserve that was Duchamp's persona. Beuys chose to be an emblem of social protest through his actions. In this sense, Beuys represents the Dada tradition as it passed through the Nouveaux Réalistes, Paik, Vostell, and Fluxus. Certainly, the core concept of locking the door to Galerie Schmela to conduct his performance stems from Group ZERO's 1961 *Demonstration*. And the ZERO artists shared the ideal of social change through demonstrations, but not the aggressive protest, preferring the festive and transcendental experiences through performance, music, and objects. As Mack observed, the "event-character" of ZERO motivated many artists to pursue artists' actions. However, Mack said, "When Beuys struck . . . the Wagnerian chords . . . and laid the dead hare over the piano, then it had nothing at all to do with ZERO. But it is also not entirely unrelated."[51]

Of the three principal ZERO artists, Uecker is the one who most closely approaches the harsh cultural critique of Beuys, Paik, and Vostell. Uecker's piercing *Arrow Pictures* seared the surfaces of canvas with a degree of severity that resonated with postwar angst. At the same time his action produced art objects. When Uecker began to work with nails in 1957, he found the material that suited his sensibility (Figure 4.8). Uecker utilized the common nail—a tangible object from everyday life, rife with resonances of work and labor—for crafting objects, immaterial light effects, and expressing the wounds of a child of the war. For Uecker, the nail represented the physically "real" world, and he viewed his role as transforming that object of everyday life and activating a realm with light and movement. The nail held personal significance for the artist. He recalled his youth in Mecklenburg, when the Russian soldiers were advancing toward his village, he nailed shut the windows and doors of the family farmhouse in order to protect his mother and sisters.[52] The memory of the nail as a tool of fortification and protection remained with the artist and was resurrected when he began to utilize the nail to create art objects.

Uecker made these objects in his studio and presented them in exhibitions. Only after he performed the *Arrow Pictures* did he begin to recognize that the action of hammering was an essential aspect of the artistic experience that he generated. In 1963 he commenced a series of hammering performances where he purchased commodities, nailed them, and sprayed them with white paint to complete their transformation. At his exhibition *Flood of Nails* in September 1963, he nailed household goods such as a

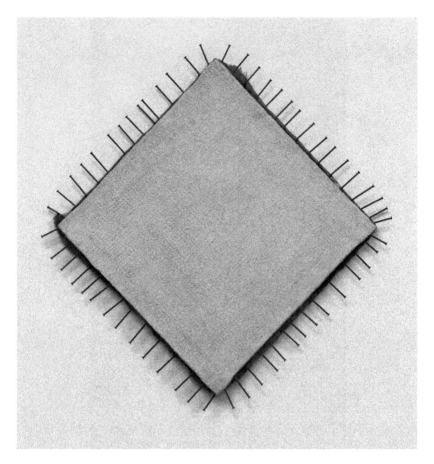

FIGURE 4.8 *Günther Uecker,* The Yellow Picture, *1957, nails and oil on canvas, 34 ¼ × 33 ½ in. (87 × 85 cm). Collection of the artist. © 2017 Artists Rights Society (ARS), New York/VG Bild-Kunst, Bonn.*

chair and a television, accompanied by the recitation by Bazon Brock of "Bedtime Stories of the Fat Man,"[53] generating a cacophony of noise. The event recalled the simultaneous reading by Daniel Spoerri for Jean Tinguely's exhibition in 1959. Uecker chose commodities and Brock's text to critique the complacency in contemporary German consumer culture.[54]

In April 1964 Uecker performed the *Nailing of a Piano* in Gelsenkirchen (Figure 4.9). Guests received an invitation to this demonstration that read simply, "Herr Uecker will nail a Piano." Mack provided the opening remarks, cautioning the audience that what they were about to witness was not "a scandal" as they might expect. Instead, he noted that this was a very special occasion because Uecker rarely had the opportunity to nail something so valuable as a piano. Mack, a pianist himself, reminded the audience that the

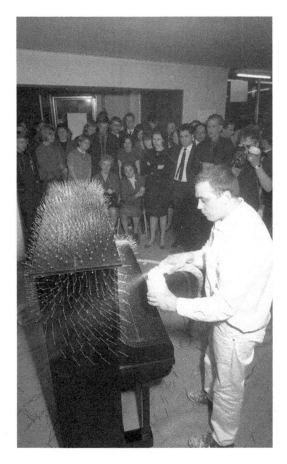

FIGURE 4.9 *Günther Uecker,* Spraying a Nailed Piano with White Paint in Pianohaus Kohl, Gelsenkirchen *(in the background critic Heiner Stachelhaus and, on the right, artist Ferdinand Spindel), 1964. Institut für Stadtgeschichte, Gelsenkirchen. © 2017 Artists Rights Society (ARS), New York/VG Bild-Kunst, Bonn. Photo: Kurt Müller.*

piano is "a cultural object," emblematic of high European culture. Although Picasso and another painter, Pavel Mansurov, had used nails in their pictures, they employed them as real objects to disrupt pictorial illusion. Uecker, on the other hand, performed a primitive cult act, transforming the piano in the process of nailing it. "It is precisely this act, the meaning of which is that a man can possess the object by penetrating it." He associated the action with African fetish figures and noted that Uecker reintroduced ancient rituals and irrational cult practice to the modern rational world.[55] Even in this industrial town that had commissioned Werner Ruhnau, Klein, and others for their theater and its decor, this event was memorable. Dressed in white,

Uecker started to nail the object with concentration, determination, and skill. One reviewer, Heiner Stachelhaus, described the artist as "possessed," and interpreted the event as a performance, which was not a scandal or a sensation, but that "the reality of the nailing of objects is so extraordinary that the voltage of the actor immediately transfers to the spectator."[56]

Stachelhaus's account of his experience watching Uecker nail the piano probably appealed to Piene, whose central premise was that the artistic experience was a form of energy—light, motion, sound—that the artist transferred to the spectator. It was a driving force behind his creation of the *Light Ballet* and the *Demonstrations* as a sensory encounter with light and movement in space. It was at this moment that Mack, Piene, and Uecker combined their ideas in a collaboratively constructed installation *Licht Raum (Hommage à Fontana)* as their submission to *documenta* 3 in Kassel (1964).

By 1963 and 1964, many of the European avant-garde associated with ZERO, the new tendencies, Nouveaux Réalistes, and Fluxus began to exhibit in the United States, to where many of them also emigrated. Maciunas moved back to New York City in the fall of 1963 and opened the Fluxshop in SoHo, while continuing to organize and participate in Fluxus Festivals. The circle of artists continued to expand, including women such as Charlotte Moorman and Yoko Ono. Moorman had been the principal organizer of New York Avant-Garde Festivals that she began in 1963 and continued annually throughout the 1960s. With the return of Maciunas, she became involved in various Fluxus performances. In 1964, she hosted the debut of Stockhausen's *Originale* in the United States. Paik moved to New York City with the *Originale* performance and met Moorman, commencing their close collaboration over the next decades. While in New York, Paik began to produce videos, combining video, television, and performance with Moorman.

A close friend of Paik, Vostell had his first exhibition in the United States at the Smolin Gallery in New York in May 1963. For Smolin Vostell installed *6 TV De-coll/ages* with television sets and his video/films.[57] The following April he returned to create one of his more threatening happenings, *You*, at George Segal's farm in Great Neck, Long Island. Vostell's intention was to force the participants "to probe the chaos and absurdity in absurd and . . . abominable scenes." In several events staged across the farm, Vostell created a sense of fear with obvious references to the Holocaust. In the concentration camp set up on the tennis courts, Vostell arranged barbed wire and actors throwing smoke bombs. People were trapped. Even the Fluxus artist Al Hansen felt "a serious threat . . . as if you have caught me against my will to view a concentration camp, as if you wanted me to see how people are bullied, and that was not all. I went away with the strange suspicion that they had discovered that I was a Jew."[58]

After his return to the United States, Maciunas had attempted to solidify his control over the Fluxus events and to establish rigid definitions of the

Fluxus program. For a group that, in the words of George Brecht, never attempted "to agree on aims or methods," Maciunas's actions caused the others to distance themselves from Fluxus. Maciunas became resentful of Moorman's avant-garde festivals, disturbed by Vostell's violence, and jealous that another person had coopted him. As ZERO and new tendency artists frayed over methodological disputes, Fluxus began to dissolve as a viable performance group in 1964.[59]

Although these groups began to unravel, 1965 was a significant year in New York for optical, kinetic, video, film, and environmental art. In January, Paik held his first New York exhibition at the New School of Social Work, where he debuted his televisions with magnetically distorted signals. In October he followed with a private showing at the Café a Go Go of his new videotapes, and in November he presented his television sculptures at Gallery Bonino. In February 1965, William Seitz opened his ambitious exhibition *The Responsive Eye*, at the Museum of Modern Art, a presentation of static works of art that gave the illusion of movement, including Mack and Piene. In November Howard Wise Gallery hosted Piene's "first fully programmed kinetic light exhibition in the United States," and Jonas Mekas held the "Expanded Cinema Festival."[60]

Having attended the exhibition of Piene's *Light Ballet*, Aldo Tambellini sought out the artist, whom he recognized as sharing similar interests in light and multimedia. Tambellini, an Italian-American artist, had been experimenting with intermedia since 1963, when he began to produce theater and dance with projected images. By 1965, he was creating cameraless films and projecting them with hand-painted slides in his multimedia theater. He produced his *Black* series of performances beginning in January 1965 in public parks, at universities, and at the Bridge Theater, in the Lower East Side of Manhattan, run by his wife, Elsa. The collaboration between Tambellini, the "guru of intermedia,"[61] and Piene garnered media attention. The *New York Herald Tribune* wrote, "The meeting of technological concepts with those of art is the purpose of 'The Center' [Tambellini's group] and 'Group Zero'."[62]

Piene's relationship with Tambellini was a natural development. At this time, Piene was developing his ideas on theater, light, and sound. They were an outgrowth of his thinking about the environmental experience of the *Light Ballet*, which he described in terms of a multimedia experience of light and sound in a space. Piene explained these experiences in terms of theatrical principles. He first published his ideas in the catalogue for his 1963 Galerie Diogenes ZERO exhibition, contextualizing the demonstration down Berlin's Kurfürstendamm, as "The Theater Is the World."[63] He had considered the relationship of his own work to theater since at least 1959, when Klein, Mack, and he had first hatched the idea of a theater in the sky and the ZERO Museum. The natural theater was filled with light projections and fata morganas, while the museum would become a space with water, blue, silver, and empty rooms for the spectator to act, swim, meditate, and

sleep.[64] The connection between human actions, light, and space would reappear in many of Piene's essays, often in the context of theater. Manzoni proposed a pneumatic theater for Piene's light ballets (1960) that was never realized, but prefigures similar constructions, such as the IBM pavilion at the New York World's Fair in 1964.

Subsequently, Piene published a series of articles dealing with the space and experience of the theater, directly invoking the Bauhaus concept of the theater of totality. He recognized the purpose of theater over the centuries had been to serve as a "vehicle . . . to transport thoughts and moods." He then asked, "Where is the theater? Is it still a mood vehicle? A doomsday barometer? What energy does it transfer? . . . Maybe it should do more gymnastics." In these essays he outlined his ambition to divorce theater from literary narrative, break down the separation of the stage and the audience, and create a multisensory experience. After accusing traditional theater of complacency, he advocated "no speech, no 'passion,' . . . the essence lies in the energy-transfer. . . . Kinetic art performs the service for the audience of arousing forces. . . . Not signs and symbols operate, but light and darkness itself in many nuances."[65] Shortly after the ZERO exhibition at Galerie Diogenes in 1963, Piene wrote to his friend Kurt Fried, who operated a gallery called Studio f in Ulm, and referenced two theater pieces on which he was then engaged.[66] One became *Fire Flower*, which he debuted at the Günter Meisner's Studio Theater Diogenes in Berlin in June 1964. *Fire Flower* was a multimedia theater piece that involved recitations of texts in an environment filled with light sculptures, light projections, and a new medium, hand-painted slide projections.

During his first trip to the United States in May 1964 at the invitation of Piero Dorazio to serve as a guest professor at the University of Pennsylvania, Piene discovered that Kodak has just released its carousel projectors. Recognizing its potential as a light source, Piene purchased one and immediately began to hand-paint slides for projection.[67] Over the next few years, Piene's multimedia theater pieces evolved. In photographs of these events (Figure 4.10), one sees a stageless environment in which Piene invited the viewer to wander through the multimedia installation as part of the total theater experience. Some texts for *Fire Flower* survive, including an epic poem, *Babylon,* in which a lion claws a mummy that "erupted fire/the flames were quartz and carbon arc." In this piece, Piene developed a mythological cast of figures who recited an Aristotelian epic. He contrasted this with a reading of "The Ironic Manifesto," in which he calls for a "harmony of nature, technology and mental faculties/art [that] becomes science/science art."[68]

Piene continued to develop his multimedia theater pieces. In 1965, he began his next production, *Light Auction New York: Blackout.* Motivated by the blackout in New York City in November 1965, Piene took this opportunity to generate a new version of the slide-projection performance. It is significant to recognize the irony that the blackout in New York City

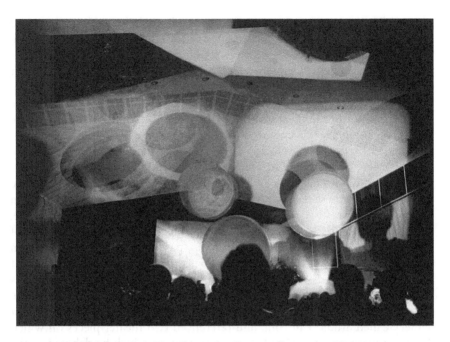

FIGURE 4.10 *Otto Piene*, Fire Flower Power, *installation for* Otto Piene
Retrospective, *Museum am Ostwall, Dortmund, 1967. Otto Piene Archives. ©
2017 Artists Rights Society (ARS), New York/VG Bild-Kunst, Bonn.*

occurred during Otto Piene's *Light Ballet* at Howard Wise Gallery and had
a profound effect on him.[69] For several months, Piene corresponded with
Peter Iden, at the German Academy for Theater Arts in Frankfurt, about
the possibility of producing one of his theater pieces. Iden had attended
ZERO events since the first demonstrations in 1961 and was a colleague of
Rochus Kowallek. Iden developed an *Experimenta* theater festival with the
intention of "assembling examples of contemporary experimental theater."
Iden invited Piene to present his *Light Auction* on this program in June
1966. His piece appeared on the same program with work by Brecht and
Samuel Beckett, exemplifying contemporary ideas of the epic theater and
the theater of the absurd. In the program notes, Iden described Piene's
theater piece as existing "between the borders of visual and performing
arts . . . using techniques of collage and montage, combining traditional
theater elements with those of the film and the visual arts."[70] Piene's text for
the piece referred to New York as Babylon (inherited from the first version
of *Fire Flower*) and expressed the artist's view of American government's
handling of the power failure that trapped 887,000 people in the subways,
while bureaucrats appeared concerned about the Dow Jones and promoted
a fear of Red China.[71] Piene's texts were increasingly scathing in their
sociopolitical commentary.

The public response to Piene's production earned him additional invitations to present his multimedia theater. The next iteration of the multimedia slide performance was *Proliferation of the Sun*, referencing Kasimir Malevich's theater production *Victory over the Sun* (1913).[72] However, Piene reformulated the constructivists' idea, emphasizing that his goal is not to control the sun but to be in harmony with it. Piene had been working on this new projection piece, a refinement of the more immersive multimedia pieces, down to four or five projectors. In February he presented a brief preliminary version of this at the Bridge Theater and was scheduled to present it again as part of a benefit in March 1966, but he was traveling in Europe working on his *Light Auction* performance in Frankfurt with Peter Iden.[73]

Recognizing the need for a dedicated space for their multimedia presentations, Piene and Tambellini opened the Black Gate Theater (upstairs from the Gate Theater) in March 1967, with the combined performances of Aldo's *Black Out* (Figure 4.11) and Otto's fully realized projection piece *The Proliferation of the Sun* (Figure 4.12). Piene's installation of *Proliferation of the Sun* included four carousel projectors operated by Peter Campus, Hans Haacke, and others, with Piene narrating the script. Beginning with instructions that the projectionists "turn your projectors on now," repeated thrice, the artist goes through a sequence of commands gradually increasing the projection speed from largo to allegro, from full color to "white out," closing with a decrescendo. The repetition of rhythm parallels the development of tape loops and serial rhythm in minimal music, especially notable in Steve Reich's *It's Gonna Rain* from 1964. Piene's awareness of contemporary sound/music was evident from his first use of the monotone electronic A in the debut of his *Archaic Light Ballet* in 1959. Again, he was at the forefront of new music with his serial repetition creating a hypnotic loop. Piene remarked, "In 1963 I started writing plays, thought I would make films thereafter; never did, became disinterested in literary aspects

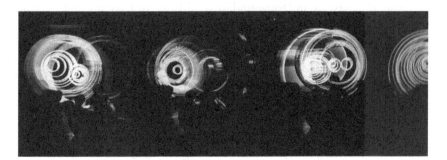

FIGURE 4.11 *Aldo Tambellini,* Black Out, *1967. Aldo Tambellini Archives © Aldo Tambellini Foundation.*

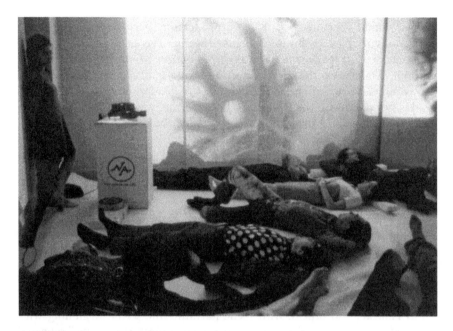

FIGURE 4.12 *Otto Piene,* Proliferation of the Sun, *1967, Black Gate Theater. Otto Piene Archives. © 2017 Artists Rights Society (ARS), New York/VG Bild-Kunst, Bonn.*

of 'light play' . . . more interested in sound, music, environment all-over-multimedia rather than two-dimensional 'screenplay'."[74] *Proliferation of the Sun* combines Piene's interest in theater, multimedia, and his fire paintings in a serial composition that utilizes repetition of texts and image as the unifying composition.

Despite Piene's optimistic worldview and his goal of harmony, the political environment of the Cold War and the hot war (Vietnam) disturbed him, and his multimedia theater pieces became increasingly politicized. The Museum am Ostwall, in Dortmund, invited Piene to have his first museum retrospective, which he called *Fire Flower Power*, in October 1967. This comprehensive presentation encompassed the entirety of Piene's work beginning with the evening exhibitions, including a series of performances. He recreated the multimedia slide presentations of *Fire Flower Power* and *Proliferation of the Sun*. And he also prepared a new artist's action titled *deutschlanddeutschlanddeutschland* (Figure 4.13). For this performance, the artist gathered a group of students, dancers, three sausage sellers, and a pig. The pig, which was reported to have been uncooperative, was led into a cage in the center of the gallery, with the sausage maker present, and a student paraded by with a Nazi flag.[75] The convergence of the dancing with wurst and the Nazi insignia thrust the Germans' repressed past into the present. The audience, which came expecting to enjoy Piene's harmonizing sensory

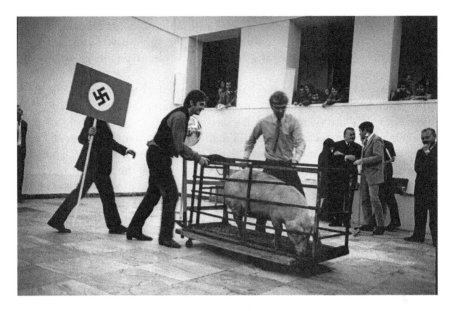

FIGURE 4.13 *Otto Piene,* deutschlanddeutschlanddeutschland, *1967, Museum am Ostwall, Dortmund. Photo: Walter Vogel. Otto Piene Archives. © 2017 Artists Rights Society (ARS), New York/VG Bild-Kunst, Bonn.*

experiences (that he also presented in Dortmund), became offended and the museum director enraged by *deutschlanddeutschlanddeutschland*. Linking together a radical juxtaposition of elements, each with potent symbolic significance, Piene vehemently expressed his political views, inditing the state of contemporary German society.

The flashpoint that Piene created in conservative Dortmund was not to be repeated. Instead, his career took a very different turn. György Kepes met Piene at his *Light Ballet* installation at Howard Wise in 1965. In 1968, Kepes recruited him to join the new Center for Advanced Visual Studies (CAVS) at the Massachusetts Institute of Technology (MIT). Kepes was a protégé of Moholy-Nagy at the Bauhaus and at the New Bauhaus in Chicago, where he headed the light department. Kepes created CAVS to foster collaboration among artists, scientists, and engineers. Piene, steeped in art and technology, thrived in this environment, forging collaborative ventures to create his vision of new "art that moves, changes color, speed and shape . . . that goes beyond the limits of studios, galleries, museums . . . that integrates the arts."[76] The result was his development of Sky Art. In May 1968, Piene took his collaborators onto the sport fields of MIT and launched his first large-scale outdoor event, *Light Line Experiment,* consisting of four 250-foot-long helium-filled tubes tied together to form a flying chain. Over the subsequent years, Piene continued to develop the Sky Art inflatables, culminating in the enormous Olympic Rainbow created for the closing ceremonies of the

Munich Olympics in 1972. The 1,500-foot-long multicolor tubes flew over the stadium as a symbol of peace and hope, bringing a welcome salve to the anguish of the massacre of Israeli Olympic team members at this ill-fated Olympics.

These works demonstrate Piene's determined effort to realize his vision of a theater in the sky. He aspired to engage the spectator in a phenomenological experience that transcended the narrative of traditional dramatic theater and employed the tactics of the Bauhaus theater of totality. He did not wish to retreat from society; he did not wish to be "a fugitive from the 'modern world'." Rather, he sought to be engaged with the modern world by utilizing "the tools of actual technical invention as well as those of nature."[77] The optimism that emanates from ZERO actions and demonstrations did distance these artists from the irony and pessimism of some of their peers. But for ZERO artists who create collaborative, communal artistic experiences that engage the public, the intellectual luxury of irony is an elitist enterprise that alienates the work from society.

Notes

1 Lawrence Alloway, "Viva Zero," in *ZERO* (Cambridge and London: The Massachusetts Institute of Technology, 1973), ix.
2 Kaira M. Cabañas, *The Myth of* Nouveau Réalisme: *Art and the Performative in Postwar France* (New Haven and London: Yale University Press, 2013), 50–51.
3 Allan Kaprow, "The Legacy of Jackson Pollock," *Artnews* (October 1958): 24–26, 55.
4 Julia Robinson, *New Realisms: 1957-1962. Object Strategies Between Readymade and Spectacle*. Exhibition catalogue (Museo Nacional Centro de Arte Reina Sofia, Madrid, and The MT Press, Cambridge, MA/London, England, 2010), 32.
5 Jürgen Becker and Wolf Vostell, eds. *Happenings. Fluxus, Pop Art,* Nouveau Réalisme (Reinbek: Rowohlt, 1965), 36. Vostell incorrectly dates Piene's Lichtballett to December 1959. It actually occurred in May 1959.
6 Susan Sontag, "Happenings: an art of radical juxtaposition," in *Against Interpretation and Other Essays* (New York: Farrar, Strauss & Giroux, 1966), 263.
7 Rose-Lee Goldberg, *Performance Art: From Futurism to the Present.* Third Edition (London: Thames and Hudson, 2011), 7.
8 Otto Piene, "'Zero' im Theater," Exhibition catalogue (Berlin: Galerie Diogenes, 1963). Otto Piene Archives.
9 Arnold Aronson, "Theatres of the Future," *Theatre Journal*, vol. 33, no. 4 (December 1981): 495.
10 László Moholy-Nagy, "Theater, Circus, Variety," in *The Theater of the Bauhaus,* Walter Gropius and Arthur S. Wensinger, eds. Originally published in 1924 (Baltimore and London: Johns Hopkins University Press, 1961), 52, 64.
11 Aronson, "Theatres of the Future," 493.
12 Sontag, "Happenings," 266.

13 Silvio Gaggi, "Sculpture, Theater and Art Performance: Notes on the Convergence of the Arts," *Leonardo*, vol. 19, no. 1 (1986): 45.
14 Darko Suvin, "Reflections on Happenings," *The Drama Review*, vol. 14, no. 3 (1970): 140.
15 Artaud quoted by Sontag in "Happenings," 271.
16 Michel Oren, "Anti-Art as the End of Cultural History," *Performing Arts Journal*, vol. 15, no. 2 (May 1993): 6. The Fluxus Manifesto is reprinted in Hall Foster, et al., eds. *Art Since 1900*, vol. 2 (London: Thames and Hudson, 2004), 463.
17 Jeffrey T. Schnapp, "Border Crossings: Italian/German Peregrinations of the 'Theater of Totality'," *Critical Inquiry*, vol. 21, no. 1 (Autumn 1994): 80–123.
18 Moholy-Nagy, "Theater, Circus, Variety," 64, 57.
19 See Nuit Banai, "From the Myth of Objecthood to the Order of Space: Yves Klein's Adventures in The Void," in Berggruen, *Klein*, 27.
20 J. W. Kluver, "The Garden Party," in *ZERO*, 120–21. Also, John Canaday, "Machine Tries to Die for its Art," *The New York Times* (March 18, 1960).
21 Canaday was so moved by the experience that he published this second article about Tinguely's action just a week later. John Canaday, "Odd Kind of Art. Thoughts on Destruction and Creation After a Suicide in a Garden," *The New York Times* (March 27, 1960).
22 *Mack. Lichtkunst.* Exhibition catalogue (Ahlen: Kunstmuseum, 1994), 180–81.
23 Renate Wiehager , "5-4-3-2-1-ZERO. Countdown für eine neue Kunst in einer neuen Welt," in *Günther Uecker. Die Aktionen*, edited by Klaus Gereon Beuckers and Günther Uecker (Petersberg: Imhof, 2004), 11. Uecker first publicly performed this action at the *Festival d'un art d'avant-garde* in Paris in November 1960.
24 Hans Ulrich Obrist, "Interview with Günther Uecker," in *Günther Uecker: The Early Years*. Exhibition catalogue (New York: L&M Arts, 2011), 9.
25 Beuckers, *Günther Uecker*, 219.
26 *Piene ein fest für das licht: rauchbilder, lichtgrafik, projektoren, lichtballett. 9. Abendausstellung.* Galerie Schmela (October 7, 1960). Otto Piene Archives.
27 "Künstlerulk in der Altstadt," *Düsseldorfer Nachrichten*, (July 7, 1961); "ZERO," *Der Mittag* (July 7, 1961); Horst Richter, "Kunststunde Null," *Kölner Stadt-Anzeiger* (July 11, 1961); Helmuth De Haas, "Tricks und Techniken des Dada, Klamauk um Zero, ein reizvolles Zeitdokument junger Künstler," *Die Welt* (July 25, 1961): 9; Eduard Jellien, "Die Stunde Null: Volks- und Kunstfest in Arnheim," *Frankfurter Rundschau* (December 13, 1961). Otto Piene Archives.
28 Johann Huizinga, *Homo Ludens: A Study of the Play element in Culture*. Originally published, 1938 (Boston: Beacon Press, 1950).
29 Nam June Paik, 1999, quoted in *Nam June Paik Fluxus/Video*, edited by Wulf Herzogenrath. Exhibition catalogue (Bremen: Kunsthalle Bremen, 1999), frontispiece.
30 See Michael Nyman, "Nam June Paik, Composer," in *Nam June Paik*, edited by John G. Hanhardt. Exhibition catalogue (New York: Whitney Museum of American Art in association with W.W. Norton, 1982), 79–90.
31 Dr. Wolfgang Steinecke, Internationales Mussikinstitut Darmstadt to Nam June Pai (May 13, 1959), Nam June Paik Archive, Smithsonian American Art Museum, Box 2, Folder 5.

32 "'On sunny days, count the waves of the Rhine . . .' Nam June Paiks
 frühe Jahre im Rheinland," in *Sediment. Mitteilungen zur Geschichte des
 Kunsthandels*. Zentralarchiv des internationalen Kunsthandels e.V. ZADIK,
 Cologne (Nuremberg: Verlag für moderne Kunst, 2005), 31.
33 Nyman, "Nam June Paik, Composer," 80. The background tapes for Homage
 can be heard on the CD *Nam June Paik. Works 1958.1979*, released by Sub
 Rosa Productions, (SR 178, EFA 27658-2, LC 6110).
34 Nyman, "Nam June Paik, Composer," 80.
35 "'On sunny days, count the waves of the Rhine . . .,'" 32–33.
36 Nyman, "Nam June Paik, Composer," 80.
37 Heinz Mack, "Vortrag von Heinz Mack zur Übernagelung eines Klaviers von
 Günther Uecker," (April 1964). Mack Archives, ZERO Foundation, Düsseldorf.
38 See Jonathan Harvey, *The Music of Stockhausen: An Introduction* (Berkeley:
 University of California Press, 1975).
39 Program for Originale, October 1961. Heinz Mack Archives, ZERO
 Foundation, Düsseldorf.
40 John Anthony Thwaites, "Dada Hits West Germany," *Arts Digest*, vol. 33, no.
 2 (February 1959): 32–37.
41 "'On sunny days, count the waves of the Rhine . . .,'" 33.
42 Carmen Alonso, "Torso," in *Joseph Beuys: Parallelprozesse*. Exhibition
 catalogue (Düsseldorf: Kunstsammlung Nordrhein-Westfalen, 2010), 19.
43 The most comprehensive study of Jährling's Galerie Parnass is Will Baltzer
 and Alfons W. Biermann, eds., *Treffpunkt Parnass Wuppertal 1949-1956*.
 Exhibition catalogue (Cologne, Bonn: Rheinland-Verlag GmbH in Kommission
 bei Rudolf Habelt Verlag GmbH, 1980).
44 Henar Riviere Rios, "Kleines Sommerfest: Apres John Cage Wuppertal, 9 June
 1962," in *"The Lunatics are on the loose . . ." European Fluxus Festivals,
 1962-1977*, edited by Petra Stegman. Exhibition catalogue (Berlin: Down with
 Art!, 2012), 17–21.
45 Stegman, *"The Lunatics are on the loose . . .,"* 49–73.
46 The score read simply: "Draw a straight line and follow it."
47 Stegman, *"The Lunatics are on the loose . . .,"* 61.
48 Tony Judt records, "30,415 people left for the West in July; by the first week
 of August 1961 a further 21,828 had followed, half of them under twenty-five
 years of age." Judt, *Postwar: A History of Europe Since 1945* (London, New
 York: Penguin Books, 2005), 249–52.
49 Thomas Crow, *The Rise of the Sixties: American and European Art in the
 Era of Dissent* (New York: Harry N. Abrams Inc., Publishers, 1996), 135–36.
 Crow is mistaken in his judgment that Beuys's performance of Satie represents
 "a vein of fin-de-siècle spiritualism." In fact, the romantic and new music
 communities disdained Satie at this time. It was John Cage who resurrected
 Satie, performed his work, and finally published an essay "Defense of Satie"
 in 1968. Beuys was aware of Cage's promotion of Satie, and I believe that he
 purposefully played this piece as a parody of classical piano literature.
50 *Das Theater ist auf der Straße. Die Happenings von Wolf Vostell/El teatro esta
 en la calle. Los Happenings de Wolf Vostell*. Exhibition catalogue (Leverkusen
 and Malpartida: Museum Morsbroich and Museo Vostell Malpartida, 2010),
 153–58.
51 Mack quoted in Jocks, *Das Ohr am Tatort*, 53.
52 Uecker quoted in Jocks, *Das Ohr am Tatort*, 118.

53 Beuckers, *Günther Uecker. Die Aktionen*, 52. The exhibition took place at William Simmat's galerie d, Frankfurt.

54 Popular humor criticized the complacency of reconstruction-era Germans as the "Die dicke Deutsche" (Fat Germans).

55 Mack, "Vortrag von Heinz Mack zur Übernagelung eines Klaviers von Günther Uecker."

56 Heiner Stachelhaus, "Günther Uecker—ein Demonstrant. Zur Eröffnung seiner Ausstellung in Pianohaus Kohl benagelte er ein Piano," *Stadt-Nachrichten* (Easter 1964). Mack Archives, ZERO Foundation, Düsseldorf.

57 The *TV Burial* is discussed in more detail in Chapter 6.

58 *Das Theater ist auf der Straße*, 57, 163.

59 Oren, "Anti-Art as the End of Cultural History," 2, 3, 7, 18.

60 Otto Piene correspondence with Dietrich Mahlow (1965). Otto Piene Archives. Piene's *Light Ballet* at Wise Gallery was discussed in Chapter 3, and the "Expanded Cinema Festival" will be discussed in Chapter 5.

61 Sal Fallica, "Cinema Circuit: Intermedia at The Gate," *The Torch* (Undergraduate newspaper of St. John's University, Jamaica) (May 1, 1967). Aldo Tambellini Archives, Salem, Massachusetts.

62 "The Galleries—A Critical Guide: Quantum 2," *New York Herald Tribune* (January 16, 1965). Aldo Tambellini Archives, Salem, Massachusetts.

63 Otto Piene, "'Zero' im Theater," n.p.

64 Renate Wiehager, "Heinz Mack: Art Spaces for ZERO, Cosmos and Image, Nature and Word, Philosophy and Action," in *Mack-ZERO!* Exhibition catalogue (Bonn: Beck & Eggeling Kunstverlag, 2006), 49–50.

65 Otto Piene, "Der Schlaf und das Theater," *Theater heute*, no. 5 (May 1965). Typescript; Otto Piene, "The Theater that Moves," *Arts* (September 1967), Typescript. Otto Piene Archives.

66 Otto Piene, correspondence with Kurt Fried (November 1, 1963). Otto Piene Archives.

67 Otto Piene, "The Proliferation of the Sun," in *Die Sonne kommt näher. Otto Piene. Frühwerk*. Exhibition catalogue (Siegen: Museum für Gegenwartskunst, 2003), 52–53.

68 Typescript texts "Babylon" and "The Ironic Manifesto" (1964). Otto Piene Archives.

69 Otto Piene, interview with the author (December 7, 2009).

70 "Programm der 'Experimenta I' 1966," Deutsche Akademie der Darstellenden Künste e.V., Frankfurt am Main. Otto Piene Archives.

71 *Die Lichtauktion oder New York ist dunkel*, excerpts from typescript manuscript (June 1966). Otto Piene Archives.

72 Piene, "The Proliferation of the Sun" (2003), 53. Piene noted that in Germany he used a different title for this theater piece, *Die Sonne kommt näher* (The Sun Is Approaching), altering the audiences' interpretation of the piece.

73 Elsa Tambellini to Otto Piene, February 22, 1966. Otto Piene Archives.

74 Otto Piene quoted in Ante Glibota, *Otto Piene*. Paris: Delight Editions, 2011, 471–72.

75 *Otto Piene: Spectrum*. Exhibition catalogue (Dortmund: Museum am Ostwall, 2009), 7.

76 Otto Piene, "Death Is So Permanent." *Artscanada* (Toronto: Society for Art) (1968): 16.

77 Otto Piene, "Group Zero," *London Times Supplement* (September 8, 1964).

CHAPTER FIVE

Aistheton: Immersive Multimedia Environments

While postwar artists performed actions, demonstrations, fests, and happenings, they were also expanding their repertoire of new media, employing light, motion, and the new technology of the postwar age. Otto Piene, as part of his process to expand his conception of theater, was simultaneously working away from more traditional notions of narrative and stage and moving toward activating space through the presence of new light, sound, and projection technology. In so doing he was participating in a global fascination with new media to create immersive multimedia environments. While in some installations he sought to stretch the boundaries of theatrical practice, in others he worked toward creating what scholars have described as "the technological imaginary," a deployment of new technology to transform physical, virtual, and conscious realms.[1] Between approximately 1955 and 1970 many ZERO and new tendency artists worked in parallel directions to realize installations that expanded into fully immersive, mediated environments that dissolved the so-called fourth wall of the theater and immersed the spectator in a multisensory experience. In essence the artists sought to create a Wagnerian *Gesamtkunstwerk* (total work of art) by synthesizing a variety of traditional art media—visual arts, film, sound, design, and theater—into a space that enveloped the viewer and stimulated a range of the spectator's senses. The distinction between artists' actions and the multimedia environments of the 1960s is primarily the diminished presence of the artist/actor and the physical and psychic engagement of the viewer through technological and spatial means. Furthermore, the multimedia environments employed phenomenology and communications theories to convey meaning and ideas through the spectators' senses.

As I have established, many postwar artists viewed painting as an unsuitable medium for their generation. By the 1960s some progressives

also considered the "obsolescence" of cinema, and others claimed, "There is nothing in theatre which will excite."[2] They sought a new grammar for art subverting traditional visual, theatrical, cinematic, and musical conventions. They drew from the interwar historical precedents and added the new technological advances in slide projectors, video, television, and synthesizers. Independent filmmakers expanded on the cinematic imaginary through a range of projection techniques, including multiple screens to fill the spectators' field of vision. Graphic and interior designers devised the conception of a total space. Artists melded their own combinations of these media to challenge traditional disciplinary distinctions and to create a new art form, called variously intermedia, electromedia, or expanded cinema. I will discuss each of these terms as they were used by the artists and embrace the range of works under the umbrella term "immersive multimedia environments."

Multimedia environments produced a dynamic, multisensory experience that was called "synesthesia" in the 1960s.[3] The artists sought, not simply to titillate the senses, but to bring about an awareness and understanding of physical reality that transcended the mere painted representations of objects or abstracted existential emotions. These artists turned to phenomenological philosophers to fashion a new artistic reality. In "The Origin of the Work of Art" (1935-6/1956) Heidegger identified the "thing" of art, "the aistheton, that which is perceptible by sensations in the senses,"[4] referencing Plato's dichotomy, distinguishing "aisthesis" from "noesis," that which is cognitive and non-sensory. Immanuel Kant initially proposed the importance of sensory perception in the 1760s, when he postulated that, not just reason, but also sensory experience was an important component in constructing knowledge.

The manifestoes and essays written by the artists and curators in this manuscript clearly articulate their aspiration to generate sensorial experiences that communicated meaning to postwar audiences. Piene and Heinz Mack studied philosophy at the University of Cologne and were steeped in both the existentialism of Jean-Paul Sartre and the phenomenology of the German philosophers. In the postwar period Piene invoked Kant in his ambition to generate "energy transfer via art," which in his mind is "a most fascinating miracle."[5] In their assertive position paper "Enough Mystifications" (1961) the French group GRAV expressed their fundamental premise, "That artistic reality must be situated within the relationship that exists between the object and the human eye."[6] For this generation of artists triggering the biological reality of sensory perception, often through the energy of electronics, was a means of re conceiving humanities values for the new physical reality of post–Second World War culture. It offered a democratic artistic experience that broke down the elitist exclusivity of high art. All people, regardless of education and social status, could participate. Further, it was believed that such experiences could communicate meaning and stimulate the spectator's innate creative ability. To stimulate several of the senses simultaneously,

artists began to integrate the various fields of visual arts, film, music/sound, performance, and architectural space to generate a synesthesia. Influenced by the ideas of communication and information theorists, artists sought to wrest the postwar media network from corporate consumer marketing, and develop it into a new social consciousness. Critic Gene Youngblood wrote, "The intermedia network, or global communications grid, taps knowledge sources that always have existed in discrete social enclaves around the planet and saturates them into the collective consciousness." For Youngblood, "expanded cinema" was "expanded consciousness."[7]

The demand for such experiences reflects the dramatic shift in the worldview engendered by the Second World War: technology, physics, nuclear power, and the first views from space of planet Earth. The expansion of the physical and metaphysical reality resulted in a tremendous fascination with creating a sensory expansion that reflected the reality that exists beyond the visible world. Using new media and technologies, artists designed immersive installations to unfold in actual time and space. These appeared across the range of countries directly affected by the Second World War, suggesting that the sensorial, artistic experience became an aspect of postwar recovery, a cultural response to the trauma of the previous decades. Some scholars suggest that the scintillating sensorial artistic experience served as a salve for the wounds of the war.[8] Second-generation postwar artists working in these various countries independently developed cultural positions that emphasized the participatory, interactive, sensorial nature of the art. In the minds of the artists such an experience provided the opposite of the elitist modernism and dictatorial fascist cultures that they experienced as youths. Artists recognized the role of the audience and activated the spectators' senses, making the viewers self-aware, and intuitively stimulating their innate creative ability. It also communicated new cultural values outside of the mainstream consumer culture against which many artists of this generation rebelled. Through the 1960s these immersive environments evolved and in the hands of individual artists or groups they communicated the postwar sensibility through several strategies—enhanced sensory perception, sensory overload, or sensory deprivation—to induce perceptual states that actively engaged the spectator and instilled meditative consciousness and, by the end of the decade, to spark political protest.

This chapter will trace the development of immersive multimedia environments in postwar Europe and its subsequent flourish in the United States in the 1960s. I will chart the associations between ZERO, Gruppo T and Gruppo N in Italy, and GRAV in France, who were all constructing immersive sensory environments. Then, the chapter will migrate to New York with some of the European artists in the mid-1960s. Here, they began to collaborate with Americans working in the same vein and the immersive installation became a transatlantic artistic phenomenon that crossed over into popular culture. I will examine a sequence of events and installations that occurred in 1965, the seminal year of this transition, especially focusing

on Jonas Mekas's Expanded Cinema Festival in New York. At that time four specific artists and an artists' collective—Piene, Aldo Tambellini, USCO, Stan VanDerBeek, and Andy Warhol—proved influential and who I argue established what Richard Kostelanetz called "the critical values" of mixed-means performance.[9] At this time, the avant-garde multimedia experience was appropriated into mass culture and transformed into the psychedelic disco and the rock concert light show, in which form it returned to Europe in Günther Uecker's Düsseldorf nightclub *Creamcheese*. I will examine each of these in terms of their visual form, the intended content, and their sources in painting, kinetic art, light art, film, exhibition design, and sound.[10]

Again, it was the interwar period that supplied the instrumental precedents for postwar immersive multimedia environments. The 1920s witnessed the first manifestations of light art, environmental installations, abstract-cameraless film, theater, and sound. New scholarship has revealed parallel work by artists in England, Eastern Europe, and the Soviet Union,[11] but for the second-generation ZERO and new tendency artists, the models known to them were primarily Dada, the constructivists, the Bauhaus, and the futurists. The conception of an environmental installation is often attributed to Kurt Schwitters, who built his *Merzbau* from debris collected in the streets of Hanover, Germany, transforming his apartment into a protective womb to assuage his traumatic experiences in the First World War. Although only few actually saw Schwitter's original *Merzbau*, it achieved a mythic status among postwar artists.[12] In the same city, Alexander Dorner commissioned El Lissitzky to design *The Abstract Cabinet* (1927), a room environment that comprised painting, interior design, graphic design, books, and sound in an interactive installation that captured the ethos of Weimar modernity. The Bauhaus was instrumental in developing environmental, spatial installations that employed new media—light, film, and photography, industrial design and mechanics—particularly under László Moholy-Nagy's guidance shifting the school from craft to industrial design. In the landmark German Werkbund Pavilion at the Musée de'Arts Decoratifs in Paris (1930), Dorner invited Walter Gropius, Moholy-Nagy, and Herbert Bayer to design an installation where they activated the sculptural quality of the displays, transforming the exhibition hall into a dynamic space. These installations transformed future art exhibition design, integrating the spectator in a three-dimensional space with a variety of media.

In attempting to realize a "culture of light," Moholy-Nagy conceived his *Light Prop for an Electric Theater* (1930) to integrate his ideas about light, motion, and technology with the concept of the theater of totality. He envisioned art on a trajectory from pigment painting into a kinetic play of light.[13] Closely connected to Moholy-Nagy's conception of light was the development of abstract film, especially the work of Walter Ruttmann and Hans Richter, whose abstract, colorful shapes illuminated the room, which Ruttmann described as "Painting with Time" (c. 1919).[14] The audio track was a significant component of the durational experience of these films and

was often derived from new forms of twentieth-century music. Sound and noise as an artistic medium, as distinct from a musical idiom, emerged in the atonality of Arnold Schönberg and in the *intonarumori* (noise intoners) of Italian futurist Luigi Russolo.[15]

Among the first generation of postwar artists there were three particular painters who departed from painterly expressionism and sought a perceptual experience with environmental dimensions: Barnett Newman, Mark Rothko, and Lucio Fontana. Newman and Rothko, alone among the American abstract expressionist and Color Field painters, expressed the desire to create an environmental, sensory experience with their paintings. Rothko requested that his works in the 1955 Sidney Janis Gallery exhibition be hung in close proximity to "break down the walls"[16] of the space and create a perceptual continuity between the work and the viewer. Rothko's development of the environmental perceptual experience is most fully realized in his *Seagram Murals* (1958), which was Udo Kultermann's rationale for including Rothko in the *Monochrome Painting* (1960) exhibition and selecting his work as the cover image for the catalogue.[17] Fontana, who the ZERO and New Tendency artists viewed as a patriarchal figure, reintroduced light installations in the postwar period, beginning with the Ambiente Nero in the Galleria del Naviglio in 1949.[18] These realized Fontana's intention to achieve "the synthesis . . . of physical elements—color, sound, movement, time, space—forming a physical, psychic unity . . . an art which must be communicated through new techniques and mediums."[19]

Each of these historical precedents served as a model for the next generation, who emulated these ideas in pursuit of environmental sensory experiences through monochrome painting and kinetic art in the mid-1950s. Yves Klein's three-dimensional monochromatic sensory environment *The Void* (1958) was an achromatic experience in which the sensory deprivation of the spectator forced the optical nervous system to generate its own images. Like Klein, Fontana also realized the potential of expanding the monochrome experience into the space of the room (1961). Enrico Castellani, Manzoni's partner in Azimuth, was influenced by Fontana to create a white monochrome environment that recalls Fontana's installations (1967).

Pol Bury and Daniel Spoerri integrated monochrome and motion in their installation of *Vision in Motion* (1959)—in a dramatic arrangement that emphasized the spatial qualities of the environmental experience. Their design emulated the Bauhaus tradition of exhibition display, particularly the German Werkbund exhibition in Paris designed by Bayer and Moholy-Nagy in 1930.[20] In the timber-beamed space of the Hessenhuis in Antwerp, Bury and Spoerri applied Moholy-Nagy's ideas, stretching the space with objects suspended from the ceiling, dramatically illuminated with sharp spot lights. Installing objects in space, on the wall, and on the floor (the artists' names), the design forced the viewers to physically move their bodies and their eyes through the entirety of the room, literally *Vision in*

Motion. In this installation Bury and Spoerri established an early model of spatial conception in postwar art installations. Previously, Mack and Piene had experience working on exhibition display in 1953, while students at the academy they assisted in the graphic design of the science section of the Düsseldorf exhibition, "Alle sollen besser leben" (Everyone should live better). The installation designed by friend Peter Esleben also emulated the total space of Bauhaus exhibition design.[21] Later, Willem Sandberg and Pontus Hulten bestowed institutional credibility on these two important tendencies—monochrome and movement—in their exhibition *Bewogen Beweging* (Moving Movement) of 1961 at the Stedelijk Museum (Figure 5.1). Inspired by *Vision in Motion*, the museum engaged Spoerri as advisor, and he transformed the moving movement into a dynamic spatial installation with strategies to physically engage the spectators in the exhibition.

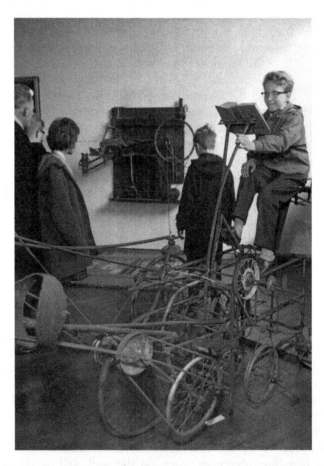

FIGURE 5.1 Bewogen Beweging (Moving Movement) *exhibition, Jean Tinguely installation, 1961, Stedelijk Museum, Amsterdam. National Archive/Collection Spaarnestad/Anefo. Photo: de Nijs.*

As I discussed in previous chapters, the three principal German artists in Group ZERO created distinctive approaches to light art that employed the spatial play of light and shadow as an ephemeral, immersive environmental experience. Piene began working with light as a fabricator of custom lamps in 1956 and debuted his manually operated *Light Ballet* in 1959. Mack developed his distinctive *Light Reliefs* with reflective foil on 1957, and then animated them mechanically into his *Light Dynamos* in 1959. These he arrayed across gallery walls to create a reflective ensemble that dematerialized the environment. Uecker created his first light work while working with Mack to light his nail reliefs for a photo shoot and recognizing the kinetic light and shadow effects in a series of rotating disks that he called constellations (Figure 5.2). ZERO presented their first collaborative kinetic light installation, *Salle de Lumière*, at the *Nul* exhibition in the Stedelijk Museum in 1962. The room contained Piene's light sculptures, Mack's rotors, and Uecker's rotating nail reliefs, some with interactive components for visitors to manipulate. In this installation, they collectively designed their installation, so that their works would interact in an orchestrated visual sequence that encompassed the entire room.

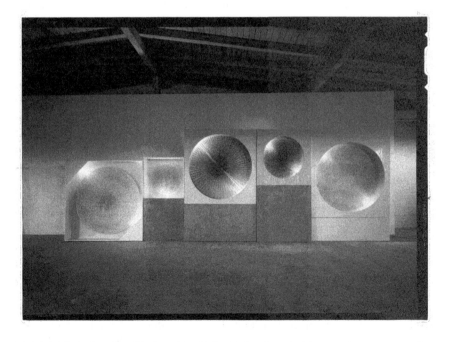

FIGURE 5.2 *Günther Uecker,* Five Light Disks, Cosmic Vision, *1961-1981, nails on canvas on wood, wooden case, electric motor, spotlight, 94 ½ × 283 ½ × 15 ¾ in. (240 × 720 × 40 cm). Private Collection. Courtesy L&M Arts. © 2017 Artists Rights Society (ARS), New York/VG Bild-Kunst, Bonn.*

Although many Italian artists were aware of Piene's light ballets and ZERO's light rooms, it was primarily the light environments created by Fontana in the early 1950s that influenced them. Two groups in particular were involved in developing art and technology into environmental, sensory and participatory installations: Gruppo Enne (N), based in Padua, and Gruppo T, from Milan. For their first exhibition, *Miroriama* (1960, Milan), Gruppo T fabricated a *Large Pneumatic Sculpture* (1960) that consisted of inflated plastic tubing with which the spectator could interact.[22] The Italian artists interested in new media were closely connected. Gianni Colombo of Gruppo T briefly joined with Castellani to found *La Nuova Tendenz* (The New Tendency) before they both split into their differing factions. Bruno Munari, a futurist artist from between the wars, however, brought them all together in an innovative exhibition *Arte Programmata* held in Olivetti's showrooms in Milan (1962) before traveling to Venice, Rome, Düsseldorf, and later to the United States. Munari invited Gruppo N and T, GRAV, and new tendency artists to participate in an ambitious display of art created through a systems approach. These artists, Munari wrote, "conduct researches with a view to re-founding a true, objective visual language," based on "scientifically established facts and from technical and psychological data concerning creation and perception."[23] The introductory essay written by Umberto Eco advocated art made by reasoned mathematical principles, either for order or for chaos, produced with new materials that has the potential to alter "our ways of thinking, seeing and feeling."[24]

Often overlooked in the history of radical exhibition display techniques is *Dylaby*, a remarkable exhibition Spoerri curated for the Stedelijk Museum in 1962. An abbreviation of "Dynamic Labyrinth," *Dylaby* consisted of six consecutive environments designed by four Nouveaux Réalistes, a Dutchman and an American: Niki de St. Phalle, Robert Rauschenberg, Martial Raysse, Spoerri, Jean Tinguely, and Per Olof Ultvedt. Spoerri had worked with Stedelijk director Willem Sandberg on the installation of *Bewogen Beweging* (Moving Movement) (1961) and was invited to conceive and organize another exhibition based upon his ideas of the "Autotheater" published in *ZERO 3*. In his essay Spoerri outlined the general concept to invite individual artists to design a series of rooms that were playful in nature, forced interaction, made noise, and "optically dynamic phenomenon."[25] As the visitor entered *Dylaby*, Spoerri attempted to disorient their conditioned sensory responses. One room was arranged to appear as if it was laid on its side (Figure 5.3). Unlike the sensory stimulation of the ZERO and Italian light rooms, or the mathematical foundation of *Arte Programmata*, the installations in *Dylaby* engaged the audience in a series of assemblage constructions described as embracing elements of an amusement park, theater, and the surreal.[26]

The playful interaction of *Dylaby* also characterizes the *Labyrinth* constructed by GRAV for the 3rd Biennale of Paris in 1963. Although they do not cite it, they were certainly aware of Spoerri's sensational *Dylaby* in Amsterdam the previous year and perhaps of Duchamp's labyrinthine

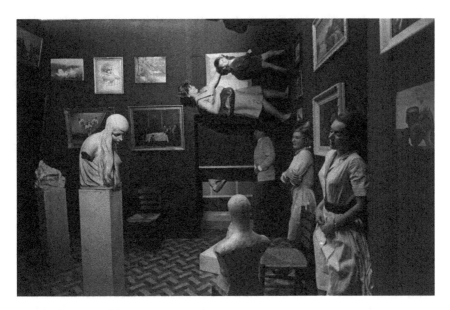

FIGURE 5.3 *Installation by Daniel Spoerri*, Dylaby, *1962, at the Stedelijk Museum Amsterdam.* © *Nederlands Fotomuseum, Rotterdam. Photo: Ed van der Elksen.*

installation, *16 Miles of String*, for the *First Papers of Surrealism* exhibition in New York (1942). For their first collaborative work, GRAV constructed a sequence of twenty rooms with which the spectator would interact in different ways. Visitors climbed steps to enter, moved through gauntlets of reflective mobiles, turned knobs, and generally experienced total sensory engagement with the environment. Although the *Labyrinth* was a collective project, and the artists refused to identify who conceived which section, it is clear that particular artists created certain environments/objects. François Morellet's room was an optical illusion based on the mathematical juxtaposition of colored squares. Joel Stein produced an illuminated kaleidoscope and Julio Le Parc hung one of his *Continuous Mobiles*. Over the next few years the group continued to develop and expand the *Labyrinth*, exhibiting it across Europe.[27]

The international success of the *Light and Movement* section at *Documenta* 3 in 1964 attracted considerable international attention for European artists working with the kinetic play of light. The interest in optical, kinetic, and moving image art was also ascendant in the United States and Group ZERO received invitations to exhibit at the University of Pennsylvania and at Howard Wise Gallery in New York. Many of the artists based in Europe began to move to, or return to, the United States beginning in 1963 with Piero Dorazio and George Maciunas; in 1964 they were followed by Mack, Piene, and Nam June Paik. In New York they

met with other artists, including Tambellini and independent filmmakers such as Stan VanDerBeek, all of whom were developing their own versions of intermedia, electromedia, and expanded cinema. The interests of the European and American artists merged and resulted in a series of exhibitions, performances, and events in 1965 in New York that crested into a phase of immersive, multimedia installations that crossed the Atlantic and the Pacific and evolved from avant-garde light installations into pop culture.

First, in January 1965 Paik had his first exhibition in the United States at the New School of Social Research after moving to New York in 1964 to perform Karlheinz Stockhausen's *Originale*. By this time Paik had evolved from avant-garde musical performance into new media: video and television. From the time of his first *Exposition of Music and Electronic Television* for Galerie Parnass in 1963, he developed an integration of performance, sound, and electronics into a new art, as he described it as "art for a cybernetic life." At the New School, Paik showed many of the pieces he had fabricated for Galerie Parnass, including his electronic manipulation of television signals and his magnetic tape sound pieces. He followed this in October, when he debuted for friends at the Café a Go Go, a still newer media, video. Then, in November Paik presented an aggregate of these works at Galerie Bonino.[28]

In February 1965 the Museum of Modern Art hosted *The Responsive Eye*, considered to mark the climax of Op Art. The exhibition focused on still, not kinetic, works of art, in the words of curator William Seitz, "to dramatize the power of static forms and colors to stimulate dynamic psychological responses."[29] The sensory basis of Op Art originated in European geometric abstraction and kinetic art, particularly the visual kineticism of Victor Vasarely and others in *le mouvement* exhibition at Galerie Denise René in 1955. A decade later *The Responsive Eye* included many of these Europeans, plus ZERO and new tendency artists such as Castellani, Piero Dorazio, GRAV, Gruppo N, Mack, Piene, Le Parc, Ivan Picelj, and Morellet, and introduced the new work produced by the pupils of Joseph Albers, who was teaching his color theories at Yale University, including the cover image by Richard Anuszkiewicz and Julian Stanczak.[30] Critics observe this exhibition as marking the climax for Op Art and its subsequent precipitous decline.

In November 1965 Piene launched his career as an independent artist in the United States with an installation of his *Light Ballet* at Howard Wise Gallery. In this fully mechanized installation he included a variety of light sculptures, projected painted slides, and reflecting mirrors on the floor and suspended from the ceiling, to cast light around the entire room. The installation achieved Piene's ambition, "the inclusive use of all the space"[31] to create "a dematerialized room."[32] This he accomplished through a variety of visual and aural devices: a wall punctured to produce galactic points of light spread across what appeared to be vast depths of space; light disks on the floor whirring with rotating bulbs that cast swirling flowers of light across the walls; iridescent neon red metallic poppy plants flashing on and

off in steady measure. Both the mechanical devices and audio recorders generated electronic sound, sometimes harsh and aleatory, other times soft and soothing, then followed by silence and the vacuum in which only the light exists. The sound does not function like serial music in the musical sense of accompaniment for the light; rather it contributes an additional dimension of aural rhythm. The effect is a sensory enhancement that causes one to lose the sense of gravity, giving the spectator a sense of levitation as the walls dissolve around him. As Youngblood remarked, "The artist's exquisitely delicate sense of proportion and balance . . . is always stunning to behold."[33] Since his debut performance of the *Archaic Light Ballet*, Piene developed this form over the decades as his signature artistic expression (Figure 5.4).

In his essays on the *Light Ballet*, Piene noted that his intention was to reduce the presence of the artist and to dematerialize the art object into a sensory experience for the spectator. He said, "And the light is there and pervades and not I but the light paints."[34] This statement confirms that Piene still viewed his new medium in terms of painting, echoing Ruttmann's essay on "Painting with Time" (c. 1919), in which he declared film to exist

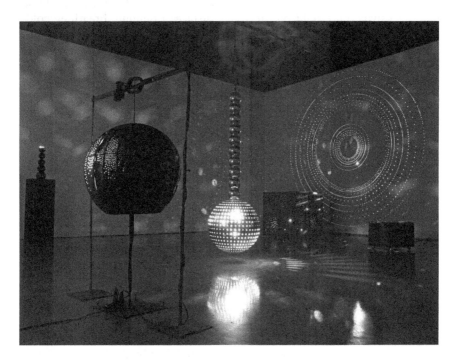

FIGURE 5.4 *Exhibition installation of* Otto Piene, Lichtballet *on view at MIT List Visual Art Center, Cambridge, MA (October 21 to December 31, 2011).* © *2017 Artists Rights Society (ARS), New York/VG Bild-Kunst, Bonn. Photo: Günther Thorn.*

"somewhere between painting and music."[35] Further, Piene wanted to generate the impression that "the light 'passes all the way through' him; he 'feels like a part of the light'" so that the spectator became "the center of the action." Unlike some other artists, Piene did not want to aggressively assault the senses, rather to achieve "a nuanced flow of light." In this manner the *Light Ballet* harmonized with the natural rhythms of the human being, and possesses "the naturalness that breathing in and out has for the man who is alive."[36]

In his foreword for the Howard Wise exhibition, he clarified the political dimension of his work as an "alternative" to the complacency and stagnation instilled by postwar consumer culture. Rejecting both consumer culture and the resignation to its fate, Piene proposed a different approach, a "spiritual renewal" and "hope in view of a catastrophic past." In fact, the artist directly related the *Light Ballet* to his personal purifying encounter with light during and in the days after his service in the war. Conscripted as a fifteen-year-old boy, Piene had fought as a flak gunner and recalled the terrifying streaks of light in the sky in *ZERO 3*. Upon the cessation of combat, he was freed. Deciding not to immediately return home, he traveled north toward the sea, where he witnessed the sun reflecting off the Elbe River, "sparkling like quicksilver, pure light on the water surface, a blinding breathing cold-hot plane."[37] His cleansing through light helped to assuage the trauma of combat for the young soldier and served as his biblical absolution. The experience of the *Light Ballet* as a psychological salve of war, which helped to transport Germans from the painful memories, was confirmed by German commentators of the period, particularly Walter Schmiele, who wrote about his experience of Piene's *Light Ballet*, "the question of where we are with our 'tragedy,' . . . this question is left aside. . . . Only alone is one to speak of it."[38]

An especially ambitious event for immersive multimedia environments in 1965 was the Expanded Cinema Festival organized by Jonas Mekas. The press release for the festival announced that the Film-maker's Cinematheque would devote the entire month of November "to an extensive survey" of the "startling" developments in recent cinema that included "multiple screens, multiple projectors . . . merger of live performers and screen action; moving slides; kinetic sculptures; hand held projectors; balloon screens; videotape; video projections; various light and sound experiments."[39] This ambitious program responded to the exciting transformations of cinema in the hands of the independent filmmakers. The burgeoning avant-garde film movement had begun in the United States in the late 1950s with such figures as Stan Brakhage, Bruce Conner, Len Lye, and Harry Smith. Mekas, a Lithuanian, a child of the war, was captured and forced into labor by the Nazis. He came to the United States in 1949 as a refugee, where he became a filmmaker and along with his brother started the *Film Culture* magazine in 1954. As the independent film movement expanded around him he organized the Film-Maker's Cooperative in 1962 and operated the Film-maker's Cinematheque

(1964) in a number of locations before settling into the Anthology Film Archives in 1969. Through his reviews in the *Village Voice*, he became the voice of avant-garde film in the 1960s.

By the mid-1960s Mekas witnessed the expansion of film from its theater setting to incorporate a sensory assemblage of film, theater, music, and performance. Robert Whitman and Elaine Summers had been projecting images during performances at the Judson Memorial Church in New York City since around 1960. Bruce Conner introduced the quick splice to create a fast-paced sequence of images popularized in his cult classic film *Cosmic Ray* (1962) that he expanded into a three-screen projection in 1965.[40] Other independents such as Stan Brakhage, Harry Smith, and Len Lye had been developing cameraless films that focused on purely abstract images, often painted directly onto the film and, in the cases of Smith and Lye, with jazz music audio tracks. These postwar filmmakers derived their grammar of abstract film from such 1920s filmmakers as Walter Ruttmann, Hans Richter, Viking Eggeling, and Oskar Fischinger. These filmmakers attempted to synthesize painting, motion, and sound, all ideas ultimately derived from Marinetti's futurist manifesto on cinema as the vehicle for the synthesis of the arts. Smith had been making cameraless films since the 1930s and only debuted his work at the Film-maker's Cinematheque in 1964.[41] Equally influential to the postwar multimedia explosion in the 1960s was the work of New Zealand artist Len Lye. Working in London, Lye began to work with cameraless films in 1926. Unable to afford a camera, he painted directly on film. His *Colour Box* (1935) became internationally recognized in the cinema and his subsequent films as *Free Radicals* (1958), produced in the United States, established an important model for postwar American independent filmmakers in their cameraless work.[42] Brakhage expressed an aesthetic that echoed the phenomenological foundations of the European ZERO and new tendency artists, when he wrote, "Imagine an eye unruled by manmade laws of perspective, an eye unprejudiced by compositional logic, an eye which does not respond to the name of everything but which must know each object encountered in life through an adventure in perception."[43]

Mekas wrote that his intention in organizing the Expanded Cinema Festival was to "pull out these artists, whose work I had followed privately for years, into the light of day."[44] He first applied the term "expanded cinema" to the works of Robert Whitman. Mekas came from a film background, but the term encompassed a far greater variety of artistic forms. The participants in the festival declared that "painting is dead" and "movies are dead," and that expanded cinema was a "relentless merging of creative elements."[45] The festival comprised thirty programs by twenty-two artists and two artist groups—filmmakers, visual artists, and musicians— in a diverse array of screenings and performances, encompassing a wide variety of multimedia, environmental forms. The festival opened on November 1 with a performance by Angus MacLise and music by the Velvet Underground, and closed on December 5 with a light and sound

production by La Monte Young and Marian Zazeela.[46] In a review of the Expanded Cinema Festival, *The Nation* critic Howard Junker wrote that the most memorable performances at the festival were by Paik, VanDerBeek, Tambellini, USCO, and Rauschenberg's happening.[47] I will focus on four of the artists in Junker's reviews who produced multimedia experiences— Paik, VanDerBeek, Tambellini, and USCO—and discuss their influence, and Piene's, on Warhol's formation of his *Exploding Plastic Inevitable* and his reinterpretation of the avant-garde immersive multimedia environment into a popular culture phenomenon. These six artists were instrumental in developing multimedia and demonstrate the range of sensory strategies employed in immersive environments.

Paik performed on the second evening of the festival with Charlotte Moorman in a program that extended from Paik's performances and Dick Higgins's concept of intermedia, his term for Fluxus performances. Paik opened with his second public screening of his videos, then screened two different versions of his proto-structuralist *Zen for Film* (1962) accompanied by his own compositions. The subsequent performances involved a combination of Moorman playing cello and Paik performing actions while screening films by Robert Breer and VanDerBeek. His program notes cued him to execute a "head-strike" in fortissimo, "thrust [his] hand and tongue," and do his "finger play" in a sequence of choreographed segments. Moorman read from a text, then performed on cello, and after her solo, Paik sprayed something, possibly at the audience.[48] At the symposium on expanded cinema held at the New York Film Festival the following September, John Gruen reported that Paik had pulled his pants down and revealed his posterior to the audience, not, in Gruen's mind, as juvenile protest, but as an act of cinematic realism.[49] Paik's performance with Moorman constituted a statement on the expanded status of cinema, combining music, film, performance, and new electronic media (television and video) in an environmental experience.[50]

USCO, a collective group, staged two multimedia performances for the Expanded Cinema Festival, which they titled *Hubbub*.[51] The installation comprised a single screen with multiple images from six different projectors and an array of kinetic sculptures, audiotapes, and some performers doing live actions in what Mekas described as a meditative experience.[52] USCO, an acronym for "Us Company," presented itself as a multidisciplinary collective with the expressed purpose of elevating consciousness through the orchestration of projected images and text. The principals in the organization—Michael Callahan, an electronic musician from the San Francisco Tape Music Center; Steve Durkee, a painter; his wife, Jane Durkee, a printmaker; and Gerd Stern, a poet—collaboratively utilized a variety of visual, aural, performative, and interactive media to produce their environments. "We are all one." Their first performance was in 1963 at the San Francisco Museum of Art and over the subsequent four years of their existence evolved the technology and imagery of their multimedia

environments. They first worked under the name USCO at a performance at Brandeis University in 1965 with their message of peace, love, and the unity of the human race.[53] They viewed their roles as navigators in altering the audiences' consciousness.[54] Timothy Leary considered their installations as a "simulation" of the psychedelic experience.[55]

Yet to interpret USCO as a 1960s, psychedelic, flower child, communal experience trivializes the intellectual basis of the group's idealism, which was grounded in a solid foundation of media and information theory. At a formative stage of developing his ideas Stern had received a copy of Marshall McLuhan's *Report to the National Association of Educational Broadcasters* (1960), which was the basis of the media philosopher's landmark publication *Understanding Media* (1964). For their 1963 performance in San Francisco, Callahan, Durkee, and Stern staged a child at the entrance distributing leaflets that quoted McLuhan, "The movement of human information at approximately the speed of light has become by far the largest industry in the world," and proceeded to produce a multimedia mélange of textual and pictorial images for their audience.[56] In their conception of their roles as "navigators," Stern was referencing Norbert Wiener's term "cybernetics," derived from Greek for "steersman." These sources informed the messages and the strategy for USCO in conveying information that they hoped would elevate the consciousness of their audience. "What USCO learned from McLuhan about new media," Michel Oren recognized, "was the

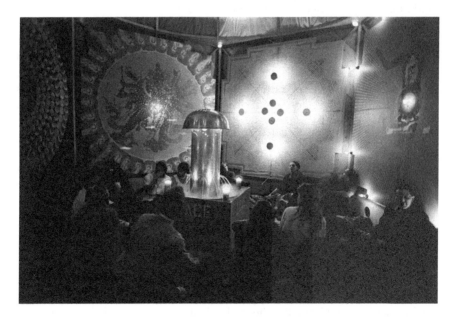

FIGURE 5.5 *Visitors in the USCO Tabernacle, 1966. Photo: Robert R. McElroy © Evelyn McElroy.*

importance of their effect rather than content of approaching them through
nonlinear thinking."[57]

USCO sought to stimulate their audience's senses, to create a
transcendent "effect" through physiological sensory stimulation utilizing
a synesthetic mélange of new visual and aural media. In an interview
Steve Durkee remarked, "I'm interested in sensitization—an awareness of,
rather than acceptance of, the world."[58] Stern recognized that the medium
of transmitting "this experience . . . resides in the nature of light."[59] The
light, or electromagnetic energy, that is projected through machines,
emanates from paintings, or derives from aural sources all contributed
to Stern's conception of the "vibrational universe" and were the vehicles
of USCO's communication (Figure 5.5). Although the group vocally
separated themselves from the political and social protests of the period,
Oren observed, "[It] did offer an implicit critique through its alternative
vision."[60] And the group conveyed that alternative social reality through
their nuanced, meditative projection of light, text, sounds, and images.
Mekas asked if artists understand "the meaning and effect and power (both
healing and damaging) of colors and lights."[61] Stern's recognition of light
as the medium of an enhanced sensory experience parallels that of Piene.
Comparable to contemporary German views that Piene's *Light Ballet* served
as a salve for war trauma, and to Piene's expressed intention to offer an
alternative to postwar consumer complacency, contemporary scholars view
the function of USCO's performance "in helping people overcome trauma
and numbing generated by these [mass] media."[62]

VanDerBeek presented a selection of his films with multiple screens and
multiple projectors at the Expanded Cinema Festival. His program was
eagerly anticipated by the artists and filmmakers who had heard that he had
been building a multimedia Movie-Drome in Stony Point, New York, since
1963, but few had seen it. At the Cinematheque he used four movie projectors
and three slide projectors, some of which were held by the projectionists,
who moved around the theater freely improvising the image projections.
This provided the audience with a semblance of the effect that VanDerBeek
would present at his Movie-Drome for those who took the bus excursion
upstate.[63] VanDerBeek overwhelmed the crowd with his barrage of images
splashed across the theater in a collage of visual information. It was an
early form of information aesthetics, employing the strategy of information
overload that, in the artist's mind, approximated the processing of images in
the contemporary media world. In Mekas's mind, "It works!" and was "the
most dazzling pieces of 'expanded' cinema" in the entire festival.[64]

VanDerBeek studied at Black Mountain College and had experienced
Cage's *Theater Piece #1* (1952), which left an indelible impression on
his formative ideas of the possibilities of intermedia.[65] At an early stage
of his work as a filmmaker, he had asked, "What the film experience is
about," and concluded that the filmmaker "is dealing with the substance
of our visual reality." With echoes of Moholy-Nagy, VanDerBeek tried to

create "motion, time, space, light, shadow," in order to achieve and the technological imaginary, "the thin edge between the dream state and the objective world."[66] To recreate this perceptual state between the conscious and subconscious, VanDerBeek built a domed structure from a grain silo on his property in upstate New York, where he projected dozens of films and slides across the hemisphere of the surface. Inside his Movie-Drome, VanDerBeek invited visitors to lie on the floor and gaze onto the spherical projection screen and absorb the multisensory environment, "The full flow of color, sound, synthesized form, plastic form, light and picture poetry."[67] (Figure 5.6)

Although he does not cite the example, VanDerBeek's Movie-Drome is clearly derived from Charles and Ray Eames's multi-screen projections in Buckminster Fuller's geodesic dome (1959). The array of projections across the seven screens used by Eames to project *Glimpses of America* in Moscow in 1959 closely approximates Bayer's *Diagram of 360° of Vision* (1935) that he employed in his 1938 installation of a Bauhaus exhibition at the Museum of Modern Art.[68] Like Eames and Bayer, VanDerBeek wanted to stretch and to fill the visual field of the spectator, providing an array of visual information at different levels of the perceptual field. VanDerBeek viewed his purpose as educational, to orchestrate new technology to create "an experience machine or 'culture-intercom'."[69] VanDerBeek speaks about building a dictionary of

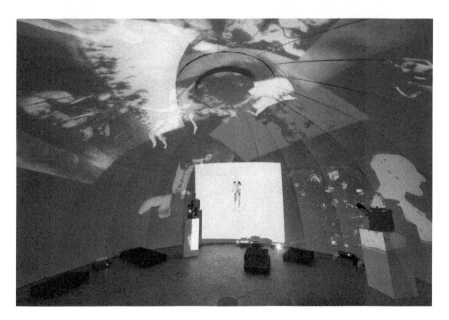

FIGURE 5.6 *Stan VanDerBeek,* Movie-Drome, *(1963-66). Recreation installation view,* Ghosts in the Machine *(2012). New Museum, New York. Photo: Benoit Pailley.*

visual forms and communicating information through a flood of thousands of images. His ideas informally relate to the communications theories of Claude Shannon and Norbert Wiener that drove Eames's cinematic productions. They advocated that all information systems, verbal and visual, constructed the communications network for humans as individuals and in a social system.[70] Through the flood of popular culture imagery in his Movie-Drome, VanDerBeek expressed a similar sentiment. He hoped that his Movie-Drome would communicate visually "the non-verbal basis of human life, thought, and understanding, and to inspire all men to goodwill."[71]

Tambellini was also included in the Expanded Cinema program. He produced his immersive multimedia environment, *Black Zero*, in concert with Ron Hahne and Ben Morea (Figure 5.7). This was the current

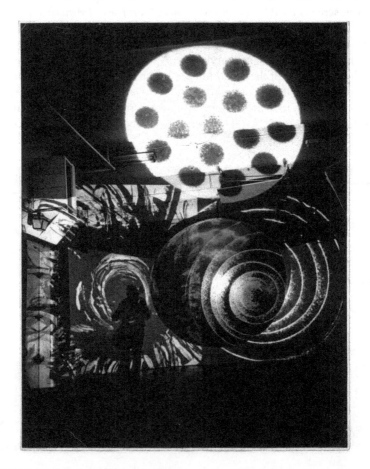

FIGURE 5.7 *Aldo Tambellini,* Black Zero, *1968. Calo Scott performing for Brooklyn Intermedia Festival. Aldo Tambellini Archives © Aldo Tambellini Foundation.*

manifestation of his evolving "electromedia" work that began with *Black* in January 1965. In a typically frenetic environment of his flashing *Lumagrams* and flickering films, Calvin C. Hernton provided an African American vocal cadence, reciting his poem *Monster Demon, Jitterbug in the Street*, while a duet of Bill Dixon and Allan Silva improvised free jazz on trumpet and bass. A black balloon was gradually inflated during the performance, both serving as a screen for Tambellini's projections and determining the duration of piece. At the denouement of the performance, when the balloon seemed ready to explode, Tambellini walked onto the stage and burst the balloon with a hatpin. The press release announced that *Black Zero* was "not a play. It is not a 'happening' nor a film. It is a Space-Light-Motion Event built on a series of experiences designed to bombard, propel and blast the audience into . . . 'The New Reality'."[72]

Tambellini had been developing his intermedia practice since 1962 when he formed "The Group Center" in lower Manhattan, "a community of the arts . . . of poets, actors, dancers, painters, musicians, photographers, sculptors, film/makers" to produce a synthesis of alternative film, theater, and visual arts.[73] Tambellini had a stroke of creative brilliance, a *felix culpa*, in 1963, when he pulled discarded boxes of slides of his own paintings out of the trash and began to use the slides, not as reproductions of his paintings, but as a reincarnation into new artworks. He punched, painted, scratched, and burned these slides, then projected them from the rooftop onto the buildings in the Lower East Side of Manhattan, resulting in luminous, monumental works. The tremendous scale dramatically changed the nature and experience of the artwork and Tambellini began to project his *Lumagrams* onto Group Center performances. He quickly recognized the potential to activate the still celluloid frame onto a filmstrip and he began to create handcrafted films that he described as "paintings in motion."[74] He treated film stock as roughly as his slides, attacking it with workshop tools, chemicals, and kitchen utensils. Over the course of the year Tambellini expanded his performances to include the slides, cameraless films, dancers, musicians, balloons, and spoken words.

Mekas described Tambellini's performances as a classic example of Higgins's concept of intermedia, as art that exists between traditional media and appeals to the spectator's senses.[75] Combining the various media into a single performance, Tambellini practiced a sensory overload that, in the words of Mekas, "bombard, propel and blast" the audience. The frenetic abstract films, flashing slides, the avant-garde jazz, and the dangerously expanding balloon backed up Umbra poet Herndon, reading "monster demon," threatening the audience, "one day a million psychiatrists will drop dead . . . your sons are all punks."[76] To achieve the dynamics of the performance Tambellini contrasted the strident texts and visual effects with the "beautiful flowing motion and sound in the dancing and music," achieving a dramatic "theater of the senses."[77] The artist conceived this assault on the complacent viewer's senses not simply to annoy them, but

to activate their recognition of the postwar reality and to initiate their "psychological reorientation."[78] He pursued this through his use of "Black," which he considered the manifestation of light and space. Like Piene, he felt that the medium of his communication was light, or electro magnetic energy, "Light is energy, and the same energy which moves through us is the energy which moves through the universe. It is the same energy we have discovered in the atom."[79] Tambellini had a direct sociopolitical purpose to his work. From his founding of "The Group Center" in 1962, he was an activist,[80] having staged protests at the Museum of Modern Art in 1962, 1963, and 1964, and then in 1968 leading a procession in a "Black Mass" to the Lincoln Center to protest the Vietnam War. The artist viewed *Black Zero* as "a vehicle for expressing . . . man's new relationship with the world . . . and the violent social revolution now sweeping the world . . . in an abstract way, of course."[81]

Mekas's Expanded Cinema program launched a tidal wave of response. Six months after the program he wrote in *Movie Journal*, "Suddenly, the intermedia shows are all over the town. . . . Thus Pandora's box was opened."[82] Clubs began to open up in the Lower East Side that popularized the multisensory environment for dancing, music, and psychedelia. The multimedia craze in the late 1960s was largely the result of the artists featured in the Expanded Cinema Festival and Warhol. As reported in *The Nation* and confirmed by Mekas, Warhol presented only single-screen projections at the festival. The program does not note the titles of the films that Warhol presented, and Mekas could not recall any specific films, except to note that one contained Mario Montez.[83] However, contemporary reports indicate that Warhol was clearly impressed by what he saw at the festival. He remarked to *The Nation*, "Everyone is being so creative for this festival that I thought that I would just show a bad movie."[84] Aside from Warhol's dismissive remark about his own film, the festival motivated him to embark on a new venture to develop his own immersive multimedia environment as a backdrop to a rock and roll band.

Warhol was a pop art celebrity, so the public was shocked when he announced at the opening of his *Flowers* exhibition at Sonnabend gallery Paris in May 1965 that he had "retired" from art and planned "to devote his life to the cinema."[85] At the height of his fame as a pop artist, he walked offstage. Warhol had been attending the Cinematheque screenings regularly for several years and had befriended Mekas, engaging him on some of his film projects such as the shooting of *Empire* (1964), for which Mekas awarded Warhol the annual prize for Independent Filmmaker of the year from the Film-Maker's Cooperative (1964). In presenting the award Mekas remarked, "His camera . . . stays fixed on the subject like there was nothing more beautiful and no thing more important than that subject. . . . A new way of looking at things and the screen is given through the personal vision of Andy Warhol; a new angle, a new insight—a shift necessitated, no doubt, by the inner changes that are taking place in man."[86] Warhol's development

of a non-narrative cinematic style of visual stasis was vastly different from that of any of the other filmmakers at the Expanded Cinema Festival.

Mekas recommended his assistant, Barbara Rubin, to work with Warhol in developing his own version of expanded cinema.[87] Only a few weeks after the Expanded Cinema Festival, Rubin took Warhol and some of his factory friends to Café Bizarre to hear the Velvet Underground.[88] He met with the group and they agreed to perform under the pop star's management. He selected a German chanteuse, Nico, to be their lead singer and he began to develop a multimedia show to accompany them that he called "Up-tight." Certainly, Warhol should have known the Velvets because of their performance to open the Expanded Cinema Festival, if not because of Rubin. Using the expertise provided by Rubin, Warhol and the Velvets began to rehearse with multiple projections, spotlights, and strobes. Their debut performance occurred in January 1966 for a psychiatrist's convention at the Delmonico Hotel. The band played, and films by various filmmakers were projected on the walls of the ballroom. Warhol and Mekas shined spotlights on the psychiatrists, asking them crude, provocative questions and causing considerable consternation.[89] One doctor demurely reflected the questions stating, "We're fascinated by the mass communications activities of Warhol and his group." Despite the doctor's spin, it was not successful. Another doctor complained that "it seemed like a whole prison ward had escaped."[90]

Similar responses ensued from successive performances in February at Rutgers and March at the Cinematheque. Warhol's initial forays into this genre as *Up-tight* failed miserably. Following another poor performance at the University of Michigan on March 12, 1966, Warhol significantly revised his multimedia installation.[91] In April 1966, he moved his new show downtown, rented a nightclub, The Dom, and reintroduced the Velvet Underground with *The Exploding Plastic Inevitable* (EPI). This edition of the performance included Warhol's own films, strobe lights, theater gels, and slides projected from the balcony of the hall onto the stage and filling the room (Figure 5.8). The show ran for the month of April and generated a sensation. Within weeks the EPI multimedia show became a nationwide pop culture hit. It launched a host of psychedelic discos and multimedia clubs across the country, and was featured on the cover of *Life Magazine* in May 1966. Mekas viewed the EPI as an aggressive assault on the senses and the "most dynamic exploration platform for the intermedia art."[92]

Although the EPI lasted only one year, it remains fixed in popular lore and is often credited with transforming the rock concert into the popular multimedia performances as they exist today. However, this common perception does not account for the parallel development of light shows accompanied by music on the West Coast beginning with the work of Jordan Belson and John Whitney and in England with Mark Boyle and Gustav Metzger. The transition of immersive light environments in music performance was taken seriously as a new development in theater. In a 1969 article critic Robert Somma examined the new fashion of "Rock

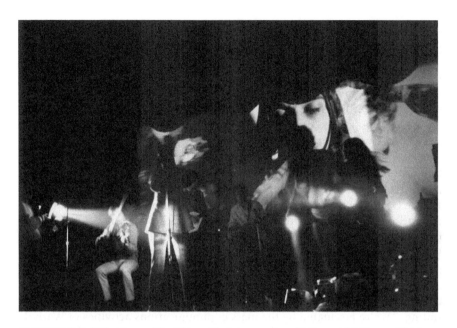

FIGURE 5.8 *Billy Name,* The Velvet Underground and Nico at the Dom, *1966, gelatin silver print, 11 × 14 in. Andy Warhol Museum, Pittsburgh, 1996.9.67. Photo © Billy Name Estate, Courtesy Dagon James.*

Theatricality" and attributed the enhancement of the rock concert with visual effects as related to the appeal of the theater experience, which "has always seemed to me primarily visceral."[93]

Like everything Warhol created, he appropriated this idea from existing sources and transformed them into something new and popular. Warhol, in his inimitable way, had introduced the vocabulary of avant-garde new media art into the domain of popular culture. Warhol's venture into multimedia had many sources. Of course, Warhol's Silver Factory had been a multimedia party for several years with films, music, reflective foil, and a cast of alternative culture figures. He had also attempted to start a pop band in 1963, and he collaborated on a film projection with sound by La Monte Young for Lincoln Center in 1964.[94] But clearly, it was Warhol's direct experience with the artists at the Expanded Cinema Festival that motivated him to embark on his own multimedia project. It was reported that Warhol took the bus trip to VanDerBeek's Movie-Drome in Stony Brook at the New York Film Festival in September 1966, where the reporter noted that he "gazed imperturbably at the ribbed, cylindrical ceiling."[95] Working with Barbara Rubin, Warhol appropriated some of the visual effects and technical devices from Piene's *Light Ballet* (which he had seen at Howard Wise Gallery), from USCO's multimedia installations, and especially from Tambellini's electromedia and VanDerBeek's Movie-Drome.

The timing of Warhol's change and his choice to rent the Dom for his April debut of the *Exploding Plastic Inevitable* specifically draws from several successful examples of immersive, multimedia programs in New York at that very moment. The Dom was the location where Gerd Stern and Jackie Cassen presented their "Theater of Light" beginning in 1965. It was only a few blocks from the Bridge Theater, where Tambellini regularly presented his works. Particularly, Warhol's alterations of his multimedia strategies relate to Tambellini, whose performance of *Black* at the Bridge on March 30 and 31 with Dixon and Silva and dancers was probably seen by Warhol.[96] The aggressive assault of Tambellini's performances and the frenetic movement of the projection equipment across the room as a setting for musical performance was obviously appropriated by Warhol for the EPI. The sensory overload of information was a strategy that Warhol drew from both Tambellini and VanDerBeek's expanded cinema. The visual relationship between Tambellini, VanDerBeek, and the new Warhol EPI is transparent and was recognized during the time by Anne Brodzky, the editor of *Arts Canada*, who observed, "It was obvious that the *Exploding Plastic Inevitable* had taken a lot of very effective devices from Tambellini's and other filmmakers' and packaged them for mass consumption."[97]

The psychiatrist who attended the first performance commented that Warhol was employing mass communication in his multimedia performances. Warhol's communication strategy was to bombard the senses with a sensory overload to break down the body's natural impulse to protect itself from overstimulation. In Mekas's mind the EPI purposefully assaulted "the contemporary generation . . . its needs and desperations are most dramatically split open." Regardless of whether critics derided the popular culture aspects of the EPI, its proselytizing of bohemian subculture, or its barrage on the senses and sensibilities, Warhol communicated with masses of people. Brandon Joseph insightfully observed that "Warhol was not simply touring the country with a rock band, but was occupying the newly emerging spaces of information. . . . Within the taut ambiguities of a contemporary dream image, one that would be seized upon by emergent forces of subcultural resistance."[98]

These artists represent what Richard Kostelanetz called "the critical values" of mixed-means performance.[99] They employed a range of strategies in the creation of their immersive multimedia environments. It is not surprising that the primary sources for Warhol's EPI were Tambellini and VanDerBeek, who also used sensory assault and information overload as central to their effect. On the other hand, the light-sound installations of Piene and USCO employed a meditative, contemplative approach that soothed the senses. Mekas described USCO's installations as communicating with the spectator through the creation of a "mystical experience."[100] Their aspiration was to create an environment that stimulated a transcendent consciousness. This, they believed, was a vehicle for overcoming media trauma and served as an alternative to consumer culture complacency. Piene

and the members of USCO did not agree with the Warhol's strategy, or its message. Electronic musician Michael Callahan described the EPI as "a flat-out unrelenting acoustic assault accompanied by a drop-dead, hipper-than-thou attitude."[101] Yet, despite the polar strategies of sensory overload versus sensory stimulation, all of the artists who created immersive multimedia environments strove to utilize the sensory experience as a communication mechanism to achieve a technological imaginary that transformed physical, virtual, and conscious realms.

Warhol introduced the vocabulary of avant-garde new media art into the domain of popular culture. The band and the show traveled for over a year until the partnership dissolved between the Velvet Underground and Warhol. Yet the EPI returned to Europe via some of the same Europeans who helped to introduce immersive light environments to New York. In 1966 both Mack and Uecker were living in New York while they had their solo shows at Howard Wise. Uecker remarked in an interview with art historian Tiziana Caianiello that he admired the pop music culture in America at that time with what was known as the "British Invasion" headlined by the Beatles.[102] He was enthusiastic about his experience attending the EPI at the Dom. When he returned to Düsseldorf he convinced his friends to join him in creating the artists' night club *Creamcheese* in emulation of the EPI (Figure 5.9). Named after a song, Suzy Creamcheese, by American rock band Frank Zappa and the Mothers of Invention, Uecker enlisted his friends to create a combination of an artist installation and pop music dance hall. He engaged Mack to make a reflecting aluminum wall behind the bar. And he recruited Gerhard Richter to contribute one of his paintings over the dance floor, while Uecker created a giant *Electric Nail* to greet customers at the entrance. Inside the space, visitors danced to the current popular bands while immersed in light projections by Ferdinand Kriwet and films by Lutz Mommartz. *Creamcheese* became the first psychedelic disco in Germany. It borrowed heavily from Warhol's EPI and the new pop discotheques in New York and spread the psychedelic disco craze across continental Europe. It also galvanized the art community in the *Altstadt* (old city). Subsequently, Konrad Fischer-Lueg opened his first gallery in the same building and Daniel Spoerri opened a restaurant nearby.[103] However, the night club still retained certain aspects of an orchestrated kinetic art installation as Group ZERO had developed in the early 1960s with discrete objects made by artists, without the frenetic disorientation and aggressive assault of Warhol's EPI.

With the establishment of *Creamcheese* we see the development of the avant-garde light and sound installation come full circle back to Europe as a popular discotheque. Piene and his colleagues in Group ZERO impacted the development of immersive environments beginning in the late 1950s. They transported their ideas to New York in 1964 in the midst of a consuming fascination with new media and environmental installations. Warhol, the

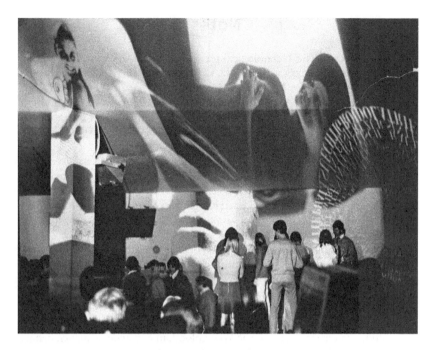

FIGURE 5.9 *Interior view of* Creamcheese *with projections by Ferdinand Kriwet, 1967. Photo: K Hassan Nilsson.*

populist appropriator of media, transformed the idea of immersive light and sound installation into a popular dance hall phenomenon. Then Uecker brought the popular psychedelic night club back to Düsseldorf and reinserted some of the avant-garde art into the discotheque experience. By introducing pop music and the dancehall feeling, Uecker achieved the Warhol effect of popularizing the arts. In their manifesto for *Creamcheese*, Kriwet stated, "Art is entertainment." But they also recognized that "art is information."[104]

Throughout the 1960s, the connection between immersive multimedia installations and theater was intimate and understood to be so at the time. The fact that *The Tulane Drama Review* published articles by USCO and VanDerBeek, as well as an analysis of the role of theater in the rock concert performance, indicates the recognition of this connection at the time. The events, installations, and performances of 1965 launched the expansive phase of immersive multimedia installations up to Osaka's World Fair in 1970 when these activities seemed to culminate and evolve into a newer phase of the technological imaginary. At that time the idea of new media evolved into yet newer forms of information media, video, computer art, television, and satellite communication.

Notes

1 Elena del Rio, "The Technological Imaginary in the Cinema of Antonioni, Godard, and Atom Egoyan" (Ph.D. Dissertation, University of California, Berkley). Ann Arbor, MI: UMI Dissertation Services, 1996; Alexander Alberro, "Periodizing Contemporary Art?," in *Theory in Contemporary Art Since 1985*, edited by Zoya Kocur and Simon Leung (Chichester, West Sussex, UK: John Wiley & Sons, 2013), 64–71. See especially, pages 67–68.

2 Noam Elcott, "On Cinematic Invisibility: Expanded Cinema Between Wagner and Television," in *Expanded Cinema: Art, Performance, Film*, edited by A. L. Rees, et al. (London: Tate Publishing, 2011), 45; Sean Kinney, *Theatre Designer* (1964) quoted in Richard Kostelanetz, *The Theatre of Mixed Means: An Introduction to Happenings, Kinetic Environments, and Other Mixed-Means Performances* (New York: The Dial Press, 1968), vii.

3 The Oxford English Dictionary (2004) defines synesthesia as "the production of a mental sense impression relating to one sense by the stimulation of another sense, as in coloured hearing," or "the use of metaphors in which terms relating to one kind of sense impression are used to describe sense impressions of other kinds." However, in the 1960s this term had a distinct definition applied to describe the multi sensory nature of immersive multimedia environments. Gene Youngblood, in *Expanded Cinema*, defined it as a multiple sensory experience of the space-time continuum, "The totality of consciousness, the reality continuum of the living present." Youngblood, *Expanded Cinema* (New York: E.P. Dutton & Co., 1970), 81, 89.

4 Martin Heidegger, "The Origin of the Work of Art," in *Poetry, Language, Thought*, originally published in 1950 (New York: Harper & Row, 1971), 25.

5 Otto Piene, "Centerbeam," in *Centerbeam*, edited by Otto Piene and Elizabeth Goldring (Cambridge, MA: Center for Advanced Visual Studies, Massachusetts Institute of Technology, 1980), 20. This concept had been with Piene since his *Raster Paintings* and was stated slightly differently in an interview with *Kunst* magazine during *documenta 3*, "When I speak of pictures as force-fields over which visual energy is 'converted' into vital energy for the observer, this refers to man as a totality. In place of the pictures you can substitute the Light Ballet. . . . The manner in which the conversion occurs is truly 'mystical'." *Kunst 3* (September 1964). Otto Piene Archives.

6 GRAV, "Assez de mystifications" (1961) in *Strategies de Participation— GRAV—Groupe de recherche d'art visuel 1960—1968*, Exhibition catalogue. Grenoble: Le Magasin—Centre Nationale d'Art Contemporain de Grenoble, 1998, 72. In their founding document "An Appraisal of Our Research," they issued a similar statement, "Any formal artwork is, first and foremost, a visual reality. We assert the existence of the visual dialogue between the being and the object. . . . Between the plastic object and the human eye," 63.

7 Youngblood, *Expanded Cinema*, 66, 41.

8 Yayoi Kusama remarked to Midori Yamamura that immersive environments served to heal emotional wounds of war, or "shutaisei," in Japanese (Midori Yamamura correspondence with the author, August 19, 2014). See Midori Yamamura, *Yayoi Kusama: Inventing the Singular* (Cambridge, London: The MIT Press, 2015).

9 Kostelanetz, *The Theatre of Mixed Means*, 275–79.
10 The chapter will not discuss either the parallel development in England with Mark Boyle and Gustav Metzger or the West Coast of the United States. These artists and regions developed their own immersive multimedia environments at the same time, but they did not directly impact ZERO and new tendency artists of Europe and the eastern United States at this time. The West Coast multimedia environments are excellently covered by David W. Bernstein, ed. in *The San Francisco Tape Music Center: 1960s Counterculture and the Avant-Garde* (Berkeley, Los Angeles, London: University of California Press, 2008); and Fred Turner in *The Democratic Surround: Multimedia & American Liberalism from World War II to the Psychedelic Sixties* (Chicago and London: The University of Chicago Press, 2013).
11 Peter Weibel, "The Development of Light Art," in *Light Art from Artificial Light. Light as a Medium in 20th and 21st Century Art*, edited by Peter Weibel and Gregor Jansen. Exhibition Catalogue (Ostfildern: Hatje Cantz, 2005), 86–407. Weibel offers the most thorough history of light art in this catalogue.
12 The Merzbau was reconstructed at the Sprengel Museum in Hannover in 1983 based on period photographs.
13 László Moholy-Nagy, *Painting, Photography, Film*. Bauhaus Book 8, originally published in 1925 (Cambridge, MA: MIT Press, 1969). Light as a medium for making art appeared consistently throughout Moholy-Nagy's publications up to his final, posthumously published *Vision in Motion* (Chicago: Paul Theobald, 1947), 166.
14 Walter Ruttmann, *Malerei mit Zeit*, c. 1919, posthumous papers, quoted in Sara Selwood, "Color Museum and Abstract Film," in *Light Art from Artificial Light*, 416.
15 James Hayward, "Musica Futurista: The Art of Noises," Liner notes to DVD, Salon LTMCD 2401. Filipo Marinetti declared in his 1909 manifesto that the futurists would pursue "sound and noise," and in 1911 published the "Manifesto for Futurist Composers," in which they encouraged composers "to abandon the old order."
16 Mark Rothko and Miguel Lopez-Remiro, ed. *Writings on Art, Mark Rothko* (New Haven: Yale University Press, 2006), 99.
17 Günther Uecker discussed the correspondence between ZERO artists and both Newman and Rothko. Uecker relates meeting Rothko at his 1964 ZERO exhibition at Howard Wise Gallery, when Rothko said, "I am actually also ZERO." Jocks, *Das Ohr am Tatort*, 121.
18 Germano Celant, *The Italian Metamorphosis, 1943-1968*. Exhibition catalogue (New York: Guggenheim Museum, 1994), 7.
19 "Manifesto blanco" (1946) reprinted in Celant, *The Italian Metamorphosis*, 711.
20 See Kai-Uwe Hemken, "Cultural Signatures: László Moholy-Nagy and the 'Room of Today'," in *László Moholy-Nagy Retrospective*, Ingrid Pfeiffer and Max Hollein, eds. Exhibition catalogue (Munich: Schirn Kunsthalle and Prestel Verlag, 2009), 169.
21 Valerie Lynn Hillings, "Experimental Artists' Groups in Europe, 1951-1968: Abstraction, Interaction and Internationalism" (Ph.D. Dissertation, Institute of Fine Arts, New York University, 2002), 123.
22 Celant, *The Italian Metamorphosis*, 12, 691.

23 Bruno Munari, "Programmed Art," *Times Literary Supplement* (September 3, 1964): 793.

24 Celant, *The Italian Metamorphosis*, 12, 696; Margit Rosen, ed. A *Little-Known Story about a Movement, a Magazine, and the Computer's Arrival in Art: New Tendencies and Bit International, 1961-1973*. Exhibition catalogue (Karlsruhe, Germany and Cambridge, MA/London: ZKM/Center for Art and Media and the MIT Press, 2011), 96–101.

25 Daniel Spoerri, "Spoerri's Autotheater," in ZERO, 219.

26 Bernd Klüser and Katharina Hegewisch, eds., *Die Kunst der Ausstellung. Eine Dokumentation dreßig exemplarischer Kunstausstellungen dieses Jahrhunderts* (Frankfurt am Main/Leipzig: Insel Verlag, 1991), 158 ff.

27 *Strategies de Participation*,119–25. The *Labyrinth* has been reconstructed and is now in Le Musee d'Art de Cholet, France.

28 *Videa 'n' Videology: Nam June Pak (1959-1973)*. Exhibition catalogue (Syracuse, NY: The Everson Museum of Art, 1974), n.p.; Flyer for "Nam June Paik Electronic Video Recorder" performance October 4 and 11, 1965, at Café au Go Go, New York. Howard Wise Gallery Records (SC 17), folder 934 [2/2]. Harvard Art Museum Archives, Harvard University, Cambridge, MA; the Gallery Bonino exhibition occurred in November.

29 *The Responsive Eye*. Exhibition catalogue (New York: Museum of Modern Art, 1965), 41.

30 Josef Albers had just published his *Interaction of Color* (New Haven: Yale University Press, 1963), a suite of prints that mirror the exercises in his course and provided American students the scientific basis for their optical work.

31 Otto Piene, "Licht Ballet," in *Otto Piene*. Exhibition catalogue (Berlin: Galerie Diogenes, 1960), n.p. Otto Piene Archives.

32 Otto Piene, correspondence with John Anthony Thwaites (12.1965). Otto Piene Archives.

33 Youngblood, *Expanded Cinema*, 299.

34 "'Das Licht malt, nicht ich': Zur Eröffnung der neuen Galerie 'dato' mit Arbeiten von Otto Piene," *Frankfurter Allgemeine Zeitung* (April 18, 1961). Piene also used this statement as the title of an exhibition later in the same year, "Das Licht malt." Exhibition catalogue (Antwerp: Galerie Ad Libitum, 1961). Otto Piene Archives.

35 Walter Ruttmann, *Malerei mit Zeit*, 416.

36 Otto Piene, "Light Ballet," n.p.

37 *Otto Piene Light Ballet*. Exhibition catalogue (New York: Howard Wise Gallery, 1965).

38 Walter Schmiele, "Vom Pinsel zur Lichtmühle. Auftritt eines Malers," *Handelsblatt Düsseldorf* (April 28/29, 1961). Otto Piene Archives.

39 Jonas Mekas, *Screenings at Film-makers Cinematheque, 1962-1968* (New York: Jonas Mekas, 2014), 130.

40 Conner first expanded *Cosmic Ray* to three screens for his exhibition at the Rose Art Museum in 1965. When I served as director of the Rose Art Museum, I discovered the original Super 8 tape loops from this exhibition and convinced Conner to digitize them into what became *Eve/Ray Forever* (1965/2006), the artist's first digitized film.

41 "The Magic Cinema of Harry Smith" (March 18, 1965), reprinted in Mekas, *Screenings at Film-makers Cinematheque*, 181–82.

42 Tyler Cann and Wystan Curnow, eds. *Len Lye*. Exhibition catalogue
 (New Plymouth, New Zealand: Govett-Brewster Art Gallery and Len Lye
 Foundation, 2009), 18. *Free Radicals* was especially influential on Aldo
 Tambellini as he developed his visual vocabulary in the early 1960s (author
 in conversation with the artist).

43 Stan Brakhage from *Metaphors of Vision* (1963), quoted in Jonas Mekas,
 "On the Expanding Eye," originally printed in *Film Culture* (February 6,
 1964) in Mekas, *Movie Journal*, 119.

44 Jonas Mekas, "On the Plastic Inevitables and the Strobe Light," originally
 printed in *Film Culture* (May 26, 1966) in Mekas, *Movie Journal*, 242.

45 "Expanded Cinema: A symposium N.Y. Film Festival 1966," *Film Culture*,
 special issue, no. 43 (Winter 1966): 1.

46 Mekas, *Screenings at Film-makers Cinematheque*, 130, 135, and 133.

47 Howard Junker, "Films: The Underground Renaissance," *The Nation*
 (December 27, 1965).

48 Paik's program occurred on November 2. Mekas, *Screenings at Film-makers
 Cinematheque*, n.p.

49 "Expanded Cinema: A Symposium N.Y. Film Festival 1966," 1.

50 I will discuss Paik's work with television and video as part of Chapter 6.

51 USCO performed on November 17 and 18, as list in the Program for the
 Expanded Cinema Festival, reprinted in Mekas, *Screenings at Film-makers
 Cinematheque*, 132.

52 USCO, "Our Time Base Is Real," *The Tulane Drama Review*, vol. 11, no. 1
 (Autumn 1966): 81; Michel Oren, "USCO: 'Getting Out of Your Mind to Use
 Your Head,'" *Art Journal* (Winter 2010): 83.

53 Jonas Mekas, "USCO: Interview with Gerd Stern," *Film Culture*, (Winter
 1966), 3.

54 Oren, "USCO," 88.

55 Mekas, "USCO," 3.

56 Turner, *The Democratic Surround*, 285.

57 Oren, "USCO," 88, 93.

58 Oren, "USCO," 93.

59 Mekas, "USCO," 3.

60 Oren, "USCO," 91.

61 Mekas, "On the Plastic Inevitables and the Strobe Light," 244.

62 Oren, "USCO," 93.

63 VanDerBeek's performance at the Film-maker's Cinematheque occurred
 on Saturday and Sunday, November 13 and 14. The press release reads:
 "A seminar will be scheduled at Stan VanDerBeek's 'Movie-Drome' for
 participants and the press. The 'Movie-Drome' is located in Stoney Point,
 N.Y.—transportation by bus will be arranged." However, it was not
 stated precisely when this occurred. Mekas, *Screenings at Film-makers
 Cinematheque*, 134. It is known that a bus trip to the Movie-Drome was
 taken as part of the NY Film Festival in September 1966, "Expanded
 Cinema," *Film Culture*, 1.

64 Jonas Mekas, "On the Expanded Cinema of Jack Smith, John Vacarro,
 Roberts Blossom, Arthur Sainer, Standish Lawder, Don Snyder, Heliczer,
 VanDerBeek," in Mekas, *Movie Journal*, 213.

65 For biographical information on Stan VanDerBeek, consult two recent
 publications Gloria Hwang Sutton, *The Experience Machine: Stan*

VanDerBeek's Movie-Drome and Expanded Cinema (Ann Arbor: UMI Press, 2009); and Bill Arning and Joao Ribas, eds., *Stan VanDerBeek: The Culture Intercom*. Exhibition catalogue (Cambridge and Houston: The MIT List Visual Arts Center and Contemporary Arts Museum, Houston, 2011).

66 Stan VanDerBeek, "The Cinema Delimina: Films from the Underground," *Film Quarterly*, vol. 14, no. 4 (Summer 1961): 13.

67 Stan VanDerBeek, "Re: Vision," *Perspecta II* (1967): 119.

68 For information on the early cinematic environments by the Eames, see Beatriz Colomina, "Enclosed by Images: The Eamses' Multimedia Architecture," *Grey Room*, #2 (Winter 2001): 5–29. And for information about Herbert Bayer's theory of 360-degree vision, see Turner, *The Democratic Surround*, 86–92.

69 Stan VanDerBeek, "'Culture: Intercom' and Expanded cinema: A Proposal and Manifesto," *The Tulane Drama Review*, vol. 11, no. 1 (Autumn 1966): 41.

70 Turner, *The Democratic Surround*, 253–54.

71 VanDerBeek, "'Culture: Intercom',"42.

72 Tambellini performed *Black Zero* on November 16 at the Astor Playhouse. Press Release for "Black Zero at the New Cinema Festival 1" (September 9, 1965), reprinted in Mekas, *Screenings at Film-maker's Cinematheque,* n.p.

73 Press Release for "The Center," 1962. Morea and Tambellini Collection, Robert F. Wagner Labor Archives, Tamiment Library, New York University.

74 Aldo Tambellini, "A Syracuse Rebel in New York," in *Captured: A Film/Video History of the Lower East Side*, edited by Clayton Patterson (New York: Seven Stories Press, 2005), 49.

75 Jonas Mekas, "On the Tactile Interactions in Cinema, or Creation with Your Total Body," *The Village Voice* (June 23, 1966), in Mekas, *Movie Journal,* 247. See also Dick Higgins, *Synesthesia and Intersenses: Intermedia* (New York: Something Else Press, 1966), in which he discusses art as existing between traditional media and appealing to the sensory apparatus of the spectator as the means of communicating its messages concerning the social problems of his time.

76 Jeremy Heymsfeld, "Space World in 'Black Zero'," *New York World-Telegram and Sun* (December 16, 1965).

77 Michael Smith, "Theatre Journal," *The Village Voice* (December 23, 1965).

78 Press Release for "Black Zero at the New Cinema Festival 1" (September 9, 1965), reprinted in Mekas, *Screenings at Film-makers Cinematheque,* np.

79 Aldo Tambellini, "Black Spiral," in *TV As a Creative Medium*. Exhibition catalogue (New York: Howard Wise Gallery, 1969), n.p.

80 "We feel the hunger of a society lost in its own vacuum and rise with an open active commitment to forward a new spirit for mankind." Press Release announcing the founding of "The Center," Ben Morea and Aldo Tambellini Papers, Tamiment Library, New York University.

81 Heymsfeld, "Space World in 'Black Zero'."

82 Mekas, "On the Plastic Inevitables and the Strobe Light," in Mekas, *Movie Journal*, 242.

83 Warhol screened his films on November 21, 22, and 23. In his review of the festival Junker notes that Warhol presented a single-screen film (Junker,

"Films: The Underground Renaissance"). Further, in my interview with Jonas Mekas, he confirmed that Warhol presented only single-screen film projections (Joseph Ketner Interview with Jonas Mekas, July 13, 2013). This contradicts David Bourdon, who wrote in his biography, *Warhol* (New York: Harry N. Abrams, Inc., 1989), 218, published twenty years after the event, that Warhol presented a split screen film with rock and roll music soundtrack.

84 Junker, "Films: The Underground Renaissance."
85 Jean-Pierre Lenoir, "Paris Impressed by Warhol Show," *The New York Times* (May 13, 1965).
86 Jonas Mekas, "Notes after Reseeing the Movies of Andy Warhol," in *Andy Warhol*, edited by John Coplans. Exhibition catalogue (New York: New York Graphic Society, Ltd., 1970), 143.
87 Joseph Ketner interview with Jonas Mekas, July 13, 2013.
88 Johann Kugelberg, ed. *The Velvet Underground* (New York: New York Art, 2009), 148.
89 Brandon Joseph, "'My Mind Split Open': Andy Warhol's Exploding Plastic Inevitable," *Grey Room*, no. 8 (Summer 2002): 88. This is an excellent source on the development of the Exploding Plastic Inevitable. Joseph establishes a chronology of Warhol's development of the multimedia from Up-Tight to the Exploding Plastic Inevitable, but does not reference Warhol's sources.
90 Grace Glueck, "Syndromes Pop at Delmonico's: Andy Warhol and His Gang Meet the Psychiatrist," *The New York Times* (January 14, 1966). See Jonas Mekas's film *Scenes from the Life of Andy Warhol* (1963–1990) for footage of this performance.
91 John Wilcock, "On the Road with the Exploding Plastic Inevitable," in Kugelberg, *The Velvet Underground*, 64–65, 149.
92 Mekas, "On the Plastic Inevitables and the Strobe Light," in Mekas, *Movie Journal*, 242.
93 Robert Somma, "Rock Theatricality," *The Drama Review: TDR*, vol. 14, no. 1 (Autumn 1969): 129.
94 Joseph, "'My Mind Split Open'," 83–86.
95 Turner, *The Democratic Surround*, 278. It is also possible that he took the bus trip in November 1965, prior to developing "Up-tight."
96 *Black*, The Bridge, with Bill Dixon, Alan Silva, and Judith Dunn (March 30–31, 1996). Aldo Tambellini Archives, Salem, Massachusetts. Warhol was a frequent visitor to the Bridge managed by Tambellini's wife, Elsa. Warhol's *Empire* (1964) debuted at The Bridge in 1964. And Chuck Workman's film *Superstar—The Life and Times of Andy Warhol* (1990, 40:50—41:15) presents a news segment that is broadcast from the Bridge in June 1965 about Warhol's films with the playbill advertising Tambellini's performance of *Black Zero*.
97 Anne Brodzky and Greg Curnoe, "A Conversation about Mixed Media from New York," *20 Cents Magazine* (Toronto) (November 1966).
98 Joseph, "'My Mind Split Open'," 98.
99 Kostelanetz, *The Theatre of Mixed Means,* 275–79.
100 Mekas, "On the Plastic Inevitables and the Strobe Light," in Mekas, *Movie Journal*, 242–43.
101 Oren, "USCO," 93.

102 Tiziana Caianiello in conversation with the author, June 2011. See
 also Tiziana Caianiella, *Der "Lichtraum (Hommage à Fontana)" und
 das "Creamcheese" im museum kunst palast. Zur Musealisierung der
 Düsseldorfer Kunstszene der 1960er Jahre* (Bielefeld: Bielefeld, 2005).
103 Caianniella, *Der Lichtraum*, 25.
104 Uwe Husslein, *Pop am Rhein* (Cologne: Buchhandlung Walter König,
 2008), 34.

CHAPTER SIX

The Vision of Television

On August 5, 1968, Otto Piene telephoned Wibke von Bonin, a producer at West German Broadcast (Westdeutscher Rundfunk, WDR) in Cologne, and proposed his idea for a "multimedia play," an "experiment in television." She enthusiastically agreed, and at the end of the month Piene and Aldo Tambellini choreographed an immersive, multimedia performance in the WDR television studios.[1] With the cameras rolling, an invited audience interacted with pneumatically inflated polyethylene tubes and inflatable sculptures in an installation of Piene's light sculptures and Tambellini's hand-painted slide projections and videos, a site-specific variation on the immersive multimedia environments that they produced at the Black Gate Theater in New York City that they founded in March 1967 (Figure 6.1). At the conclusion of the shoot, Tambellini directed the WDR studio engineers to edit a compilation of the footage with his own cameraless films, videos, appropriated broadcast television footage, and sound to produce a video montage made for television. A thirty-minute segment was aired on WDR at 10 pm on January 26, 1969, becoming the earliest broadcast of an artist's produced and engineered television program.[2] It was the realization of the two artists' ideas about the extension of their immersive, multimedia environments into the realm of broadcast television. *Black Gate Cologne* (1968) represented an early synthesis of postwar artistic vision with network television. Enthusiastic about the results, von Bonin considers this broadcast as "the first full-scale television artwork,"[3] initiating a period of experimental artists' television programming in Europe and the United States.

Piene drafted his concepts for their television studio performance in a letter to Tambellini, noting that he hoped to create a tele-visual consummation of their multimedia spectacles that would serve as a "demonstration of ideas."

The main things we are involved in at this time and in the foreseeable future seem to be means of expansion of . . . light that is visible from considerable distances; light that is made visible after it has travelled (tv)

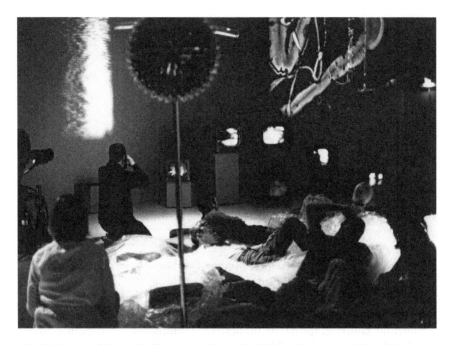

FIGURE 6.1 *Aldo Tambellini, Otto Piene,* Black Gate Cologne, *1968. Aldo Tambellini Archives © Aldo Tambellini Foundation and Otto Piene Estate © 2017 Artists Rights Society (ARS), New York/VG Bild-Kunst, Bonn.*

. . . combination of elements such as light and sound; the striving for a new monumentality, i.e. big scale; art in the sky; communication with big audiences; social and political concern; the regaining of meaning of art to the masses; the renaissance of art.[4]

In this passage Piene summarizes the motives and ambitions shared by many artists who ventured into the realm of television as an artistic medium. Piene and Tambellini viewed the relatively new medium of television as a light machine that combined audio and visual in an ephemeral sensory experience, an addition to their multimedia repertoire that could project light over vast distances and disseminate their work to literally millions of viewers. Although the domestic television apparatus itself was physically small, the broadcast functioned on an infinitely greater scale by reaching more people than any single artist's action, exhibition, or installation. Further, the television apparatus manifest the new science of postwar reality. In the words of Jud Yalkut, television represented "the intermeshing of our globe's electromagnetic exoskeleton" with the potential vision that it could one day "unite all in one glorious terrestrial aura."[5] For Piene and Tambellini broadcast television possessed the potential to become the medium of the future.[6]

Piene understood the potential for television to synthesize his practice in light art, kinetics, projections, and performance in a single device. For Piene, Tambellini, and many other artists involved in art and technology, television was a medium that merged a variety of artistic disciplines into an electronic *Gesamtkunstwerk* (total work of art). In his *Understanding Media* (1963) Marshall McLuhan devoted a chapter to television, a medium that he viewed as having "enveloped Western man in a daily session of synesthesia."[7] Indeed, television programming—both corporate network programming and artists' experimental television—synthesized theater, film, visual art, photography, and sound in the instantaneous medium of videography. Early network programming and artists' experimental television projects demonstrate a similar range of artistic influences. Corporate television programs evolved from radio plays with the addition of visuals, and appropriated traditional narrative theater and set design during its nascent stage of programmatic development. Drawing upon his Bauhaus influences, Piene subtitled *Black Gate Cologne* "A Light Play," appropriating the title of László Moholy-Nagy's 1930 film of his *Light Prop*. In his letter to invite people to participate in the studio action, he requested, with echoes of Moholy-Nagy, that they engage in "the great play/in the sense of the total theater."[8] Piene's own reference to the "Total Theater" indicates his view of the medium in presenting his concepts of artists' demonstrations, theater, and performance. Piene also emphasized the television as a medium to produce light, as did Paik, who described the electronic imagery of television as a kinetic visual art form, as "light art."[9]

Magnetic tape was the technological development that made television broadcast, both experimental and corporate television, possible. Although it is often overlooked, experimental television cannot be separated from the parallel development of sound, programmatically and technologically, as a basic component of video. The technology of magnetic tape was invented for sound recording in Germany between the wars and had been the pioneering force behind the development of electronic tape music. The relationship of magnetic tape to sound was clearly understood by a number of experimental television artists, especially Nam June Paik, Piene, and Tambellini, who developed electronic sound and image integrally as part of their work with television.[10] Videotape remained the domain of corporate commercial television until the introduction of inexpensive video recorders in the mid-1960s, when artists gained access to consumer-grade video technology. Video art grew out of the tradition of independent film and photography and in opposition to the advent of commercial television, as independent film had grown out of an opposition to commercial cinema. However, "It is essential to remember that VT [videotape] is not TV . . . though it is processed through the same system."[11]

The electronic signals that emanated from the television set were multisensory. In a review of the exhibition *TV as a Creative Medium* (1969), John Margolies excitedly wrote in *Art in America* that television

offered "direct sensory perception."[12] Not only was television an electronic generator of audio-visual stimuli, but McLuhan viewed it as "an extension of the sense of touch, which involves maximal interplay of all the senses."[13] Scholars and critics during the booming decades of television observed that its multisensory appeal was largely based on its "expanded sensory effects,"[14] similar to those of expanded cinema. Electronic engineer and artist Eric Siegel understood that the electronic energy of television worked through the viewers' audio-visual senses and transformed raw energy into "transmission ecstasy,"[15] a remark that recalls Piene's aspiration to achieve the "miracle" of energy transfer. But television was more than simply a physiological stimulus for the senses; it was an electronic, audio-visual communications system. As a tool of corporate marketing it profoundly influenced consumer culture in the West. The television was the "most efficient reproduction and distribution medium"[16] and its mass dissemination of the marketing message reached nearly every household in Europe and America by the mid-1960s in an instantaneous barrage of images and information.

The introduction of commercial broadcast television into Europe and America after the Second World War fundamentally reshaped the lifestyle and culture of both societies. The invasion of the television set into domestic settings replaced the radio as the altarpiece of the home around which families gathered and socialized. By 1960, ninety percent of American homes had a television and viewers were watching as much as seven hours of programming daily. Michael Rush wrote, "By the 1960s the total commercialization of corporate television had been accomplished, and, to media watchdogs and many artists, television was becoming the enemy."[17] The development was slower in Europe due to reconstruction. In Germany, the first commercial TV station was licensed only in 1953.[18] Initially, families gathered at the local brewery or pub to watch the single channel of television broadcast for its limited duration of evening programs. However, cultural historians could report that by the mid-1960s television had infiltrated the entirety of West Germany.[19] Within a few years after the introduction of commercial television, culture critics were concerned about the impact of it programming, which was designed to appeal to a low common denominator. Philosopher Theodor W. Adorno forecast the cultural implications of television as early as 1953 when he warned that television was the communication tool "of the cultural industry" that sought to control "public consciousness" and to create a false reality based on television's capacity to reproduce "the entire material world in an image."[20] Adorno identified early the marketing message of commercial television, cautioned its potential to manipulate social thought and behavior, and prophesied the onset of the image world in which we now live.

Although many postwar artists and cultural critics perceived commercial television as "the enemy," the instantaneous transmission of moving images and information to a mass audience also appealed to them. They had worked since the mid-1950s to cultivate an alternative culture by developing

new art media that realized the contemporary physics of time and space. Employing the vocabulary of communications and information theory, artists recognized the tremendous power of the television as a system of communication. Wolf Vostell viewed television as the medium for reaching audiences, although he did not use it as such.[21] But simply reaching the mass public with audio-visual stimuli was not enough. Frank Gillette and Ira Schneider realized that the senses alone will not provide the spectator the transformative artistic experience: "The most important thing was the notion of information presentation."[22] During this nascent stage of television broadcast programming, artists envisioned an opportunity to appropriate television for forming an alternative culture giving artists and everyday people access to communications systems and control of the dissemination of information.

Artists possessed an idealized vision of television that manifests a new phase of the technological imaginary. Paik created his interactive electronic pieces in order to "humanize technology." He remarked, "Television has been attacking us all their lives, now we can attack it back."[23] The German gallerist Gerry Schum sought to transcend the elitist exclusivity of art through video and television, "The only chance I see for the visual arts is the conscious deployment of television."[24] Piene envisioned a day when artists would run their own television stations.[25] The idealistic vision of television to catalyze a renaissance of art that would empower a mass public in the creation of a democratic culture marked the formative years of experimental television. However, artists never realized a substantive control of television broadcasting. A few progressive pockets of educational television programed in the belief that the medium could embrace both traditional narratives of corporate consumer marketing and artistic experiments in video and audio. Despite some imaginative and inventive experimental television, corporate network television totally dominated the airways by the end of the 1970s.

ZERO and new tendency artists substantively shaped the vision of experimental art television in the 1960s. In this chapter I will review the contributions of the second-generation postwar artists to the development of experimental television in its formative stage, including its relationship to network broadcasting. The formal development of experimental art television parallels, and expands upon, this generation's vision to reject traditional art forms and to embrace new media to refashion art. They eagerly incorporated the apparatus of television into their expanding practice of art and technology. Some artists utilized television technology as an electronic means to generate abstract images. Others employed the medium for its intended purpose, the transmission of electronic audio-visual signals as information and documentary reportage. Most artists working with experimental television used the medium to challenge corporate network television's marketing message and its low standard of visual and intellectual content. They shared Eric Siegel's opinion that "commercial broadcasting,

instead of exploring the medium's infinite possibilities, uses it to no other purpose than to insult the viewer's intelligence."[26] I will examine these artists' engagement with television in the 1960s, when they evolve from presenting their work on television to appropriating the TV set as a sculptural form of cultural critique and, eventually, with the advancing technical ability of the artists and the availability of equipment, utilizing television technology to generate electronic images, to shoot their own videos, and to engineer their own broadcasts in cooperation with broadcasters. In the 1960s these artists transformed television into an object and a subject of their work, as well as utilizing it as a tool of communicating imagery and information.

This nascent stage of "TV as a Creative Medium" concluded circa 1970, when experimental art became a regular aspect of public television broadcasting (WGBH, WNET, and KQED) climaxing with satellite broadcasts by Douglas Davis in 1977. 1970 was also the dawn of public access television. The US government chartered the Corporation for Public Broadcasting in 1967, established the Public Broadcasting Service (PBS) in 1969, and mandated the formation of public Cable Access TV (CATV) in 1970. Broadcasters established specific departments to program their ventures in art and culture. Each of these created an institutional structure with governmental regulations that managed the development of experimental television over the next decade. In addition, video art began to assert its own presence as a distinct medium that only utilized television as a monitor. At this time Howard Wise closed his gallery, the principal commercial site for art and technology, in order to form Electronic Arts Intermix, a nonprofit organization to support video art and artists.

Black Gate Cologne was not Piene's earliest venture in broadcast television, nor was it the first appearance of art on television. The relationship between television and art stretches back to the initial efforts by broadcast corporations to conceive the nature of programming after the invention of this new technology in the 1920s. The first television studios were formed in Europe and the United States in the 1930s; however, the equipment was in a primitive stage of technical development and it was exorbitantly expensive, accessible only to governmental agencies and corporations. In Germany Adolf Hitler boasted television coverage for the 1936 Olympics, but it was available only at a few viewing stations for a select audience.[27] Television was introduced to the public at the onset of the Second World War at the 1939 New York World's Fair.[28] Video broadcast technology continued to be developed during the war because of its potential military uses. But television was not publically available until after the war when corporations offered the first television receivers for home use in 1946.[29]

Immediately after the Second World War television broadcasting companies possessed an idealistic view of the educational and artistic potential of their new audio-visual communications medium. Although television quickly became rooted in American culture, the introduction of television was slower in Europe, due to reconstruction. However, artists'

engagement with broadcast television initially occurred in Europe, not in the United States, despite America's immersion in television.[30] Among the first generation of postwar artists, Lucio Fontana recognized the potential of television transmission as a visual art form. For Fontana the ephemeral electromagnetic signals fleeting across the screen in a matrix of kinetic spots of light realized the ambition of his *Manifesto blanco* (1946), in which he advocated "abandoning the practice of known forms of art and embarking on the development of an art based on the unity of time and space."[31] The recently established RAI television approached Fontana in 1952 to produce projects for testing their transmission signals. Fontana had just completed a sequence of his earliest light pieces, and, as Christine Mehring discovered, RAI recorded the light projections in an installation of Fontana's *buchi* (Figure 6.2).[32] Excited by the experiment, Fontana and other artists drafted a "Manifesto of the Spatialist Movement for Television" (1952), in which they claim, "For the first time anywhere, we Spatialists are transmitting, through the medium of television, our new forms of art." Such a momentous experience of transmitting his light imagery across Italy motivated him to propose a simultaneous transmission between New York, Milan, and Berlin. The 1952 videotaping of the *buchi* was just a test, and Fontana's proposal of a transatlantic transmission was not realized. Despite this, Fontana enthusiastically embraced television as a medium that could broadcast his artistic concepts "in infinite dimensions."[33]

As the latest communications technology engineers, producers, and promoters of early television programming couched their descriptions of the new medium as a contemporary kinetic audio-visual art form. From the beginning of the first German broadcast company in 1953, the producers referred to their programs as "the art form of tomorrow," or as "art on the screen."[34] American broadcast promoted its programming as visual entertainment. The infant television industry hired literally hundreds of artists, theater directors, set designers, graphic artists, and performers in order to reproduce traditional narrative theater for the television audience.[35] Both television and the culture industry recognized the potential for the medium to present visual art to a mass audience. The earliest programs were developed with art museums. In 1939 the Museum of Modern Art, New York,[36] and in 1941 the Metropolitan Museum of Art produced a series of educational art programs. Broadcasting corporations initially engaged artists and museums, envisioning the educational value of expanding visual culture across America. The Metropolitan Museum president heralded the promise of television to create "a revolution in the education of the future," comparing it to the printing press, with the prospect to develop "the visual senses of the American people," as radio had developed the "musical ear."[37] Programming included speakers, musicians performing, and broadcasts of theater. Some programs, such as the Museum of Fine Arts, Boston, "Invitation to Art" broadcast on WGBH, Boston, beginning in 1958 with Irish star host Brian O'Doherty, were extremely popular.[38]

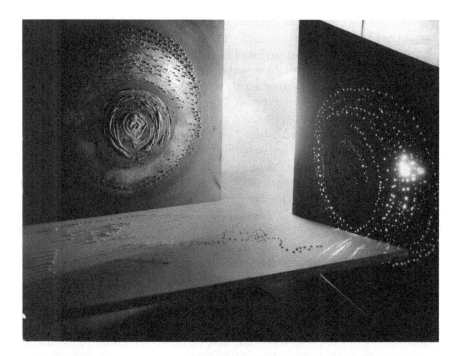

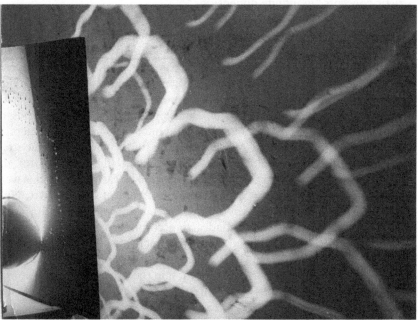

FIGURE 6.2 *Experimental broadcast by RAI-TV in Milan with works by Lucio Fontana, 1952, from Luigi Moretti "art e televisione," Spazio 7 (December 1952 to April 1953), p. 74. Fondazione Lucio Fontana. Photo: Attilio Bacci.*

Television producers also realized that the novelty of art and artists made intriguing, if sometimes offbeat, news, bringing spectacle, curiosity, and wonder to television programming. ZERO and new tendency artists appeared on news beginning in the summer 1959, when the *Deutsche Wochenschau* filmed their *Dynamo* exhibition in Wiesbaden as a news segment. Piene remarked that upon seeing his *Light Ballet* on the newsreel at the local theater, he came close to visualizing how his work would appear in a large space.[39] German television also reported on the first Fluxus Festival in Wiesbaden in 1962, and they were taped for a television-only performance aired in 1964.[40] In the United States news anchor David Brinkley ran a segment on Nouveau Réalisme in France in December 1961.[41] And in emulation of the *Art News* magazine articles on "Artist X Paints a Picture," Mike Wallace and CBS recorded Rauschenberg producing the monumental print *Barge* (1962–62) in a television program that aired in 1962.[42]

From its beginning in 1955 WDR was committed to broadcasting the arts to its viewership.[43] Rolf Wiesselmann, a producer for WDR beginning in the late 1950s, especially wanted to introduce his audience to recent art and new music, targeting the viewers who would probably not go to a museum, an art exhibition, or a new music concert. He produced footage of Mathieu's painting performance in Piene's studio in 1958, Tinguely's kinetic art, and Kultermann's *Monochrome Malerei* exhibition with the aspiration that he could foster a better understanding and appreciation of some of the more controversial art among Germans. In the fall of 1961 WDR broadcast his television film *Avantgarde*, for which he spliced together footage from his work with Mathieu, Tinguely, and *Monochrome Malerei*, as well as a segment on Neo-Dada "Art from Waste" into a visual expose on contemporary art. This landmark of experimental art television stirred debate among an educated audience (Figure 6.3). The film was screened in Düsseldorf in December 1961 at a symposium organized around the question, What form should the presentation of avant-garde art take on television? The assembled audience disputed whether the program actually achieved its purpose and whether the art shown could even be considered avant-garde any longer. Wiesselmann's *Avantgarde* marks the beginning of broadcasting the advances of postwar artists, transcending journalistic reportage and attempting to engage the visual qualities of the avant-garde artists in a television film. Anna Klapheck appreciated Wiesselmann's film calling him a prophet of the arts to the public.[44]

The involvement of second generation of postwar artists with television would unfold over the 1960s. Beginning with the 1959 *Wochenschau* coverage of Piene's *Light Ballet* at the Dynamo exhibition in Wiesbaden, Group ZERO realized the ability of television to reach a vast audience. They invited Düsseldorf television stations to their first Demonstration at Galerie Schmela in July 1961. Rochus Kowallek, who opened his Galerie dato in Frankfurt with an installation of Piene's *Light Ballet* in April 1961, attended the ZERO Demonstration in July and the subsequent one in

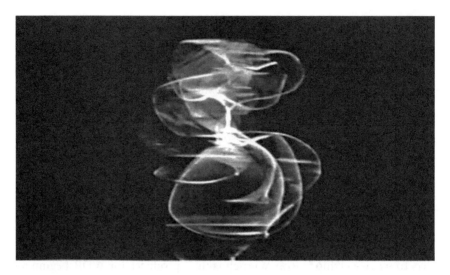

FIGURE 6.3 *Still from* Avantgarde, *1961 (06:45). Produced by Rolf Wiesselmann, Westdeutscher Rundfunk, Cologne.*

Arnhem in December 1961. Before he was an art dealer, Kowallek was an employee of the Hessian Broadcasting. Motivated by the spectacle of the ZERO demonstrations, Kowallek proposed to his colleague Gerd Winkler at Hessian Broadcasting that the avant-garde ZERO group would make excellent programming.[45]

Winkler, a journalist, had begun to develop cultural programming on Hessian Broadcasting, including producing a segment on an exhibition, *Complex Colors*, of new tendency painters (including Gotthard Graubner and Piero Dorazio) at a Frankfurt gallery in February 1962. Aware of the widespread fascination with and popularity of ZERO, Winkler agreed and met with the artists on January 8, 1962. At that meeting they sketched out a program that focused on staging a ZERO Demonstration on the banks of the Rhine in April[46] and encompass the larger network of ZERO artists, who, in Winkler's words, created art "without paint or brush." In advance of the shoot, Winkler published an interview with the artists in the television magazine to promote the upcoming program. He informed the artists that as many as five million people might see the broadcast. The artists expressed some apprehension about televising their work to such a vast public. Piene recounted his previous experience in seeing the *Wochenschau* news clip in the theater, where the audience "slapped their thighs whilst roaring with laughter," derisively ridiculing the ZERO presentation. Winkler asked the artists to help the television audience understand their work. They responded with conviction that their work did relate to contemporary life in its modern materials and engagement with the audience. Winkler concurred that the ZERO artists represented the "sentiment of the epoch" and yet was "completely new."[47]

On April 2, Winkler and the crew from Hessian television filmed a six-hour reenactment of the ZERO Demonstration on the banks of the Rhine as part of the program. Winkler and his crew also compiled existing films from a number of artists in the ZERO network. The 30-minute film, *0 x 0=Kunst: Maler ohne Farbe und Pinsel (0 x 0=Art: Painters without Color or Brush)*, was broadcast on Hessian television on June 27, 1962.[48] The broadcast began with the leader counting down from 10 to 0 and then opening with the audience in the middle of the ZERO Demonstration with ZERO girls in conical ZERO dresses blowing soap bubbles and crowds carrying balloons and flags (Figure 6.4). The film then sequenced through the ZERO network of artists, including Manzoni creating his infinite line, Uecker shooting his *Arrow Pictures*, Tinguely playing with his kinetic sculptures, and Mack spinning his rotors, and concluded with Piene's *Light Ballet*. In the coda, Winkler visually contextualized ZERO in the culture of the moment with a mélange of images from protests and soldiers to fashion shows and football matches.

Winkler's television broadcast, which was subsequently screened in London, Paris, Austria, Italy, and Poland,[49] contributed tremendously to the exposure and the notoriety of ZERO, resulting in invitations to present their demonstrations across Europe. Despite the popularity and the recognition

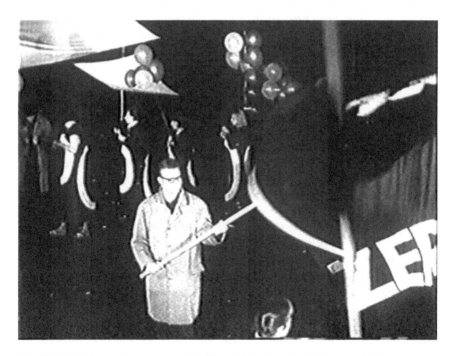

FIGURE 6.4 *ZERO Demonstration, 1962. Still from* 0 × 0=Kunst. Maler ohne Farbe und Pinsel, *1962. Produced by Gerd Winkler. Hessischer Rundfunk, Frankfurt.*

accorded to them by progressive art critics, certain German journalists disdained the work of ZERO and the new tendencies. A television reviewer commenting on Winkler's film expressed the lingering antimodern sentiment among many people, stating that some people "want to commit these henchmen of chance to the madhouse" and, with hints of Hans Sedlmayr, scolding the artists as "the ailing, overconfident avant-garde."[50] Despite the disbelieving journalists, Winkler earned considerable critical recognition for this film. Owing much to the precedence of Wiesselmann, Winker tightly edited the film, featuring avant-garde art and actions, with accompanying noise and electronic sound track. It was an inventive and imaginative program, winning the Prix Italia for the best television film of 1963.[51] It also encouraged Winkler to continue producing experimental art for television. In his correspondence with Mack he proposed future films on Mack's Sahara Project and Lucio Fontana.[52]

Following the success of his ZERO film, Winkler produced a three-minute segment on Uecker's exhibition *Flood of Nails* at the gallery dato in Frankfurt (September 1963), when he nailed household furniture and appliances.[53] Having featured Uecker's performance shooting his *Arrow Pictures* in *0 x 0=Kunst*, Winkler staged Uecker shopping for household goods, including television set, and carrying them back to the gallery, where he pounded nails into them and finished by spraying them with white paint.[54] (Figure 6.5) While the broadcast utilized television for its capabilities as a communication device, Uecker also used the television set as an object of his action and as a sculpture. He treated the television as a talisman, nailing into this expensive commodity with a violence and aggression to ward off the demons of television culture.[55]

The end product of Uecker's action was a fetish object. At this point in the early sixties a number of artists utilized television as an object as well as the subject of their artwork. These artists did not use the audio-visual technology of television; rather they appropriated and portrayed the electronic appliance that had invaded the household without changing the nature of their work. Cultural aggression is characteristic of these artists' engagement with television.[56] Ed Kienholz appropriated the ready-made housing of a television set in 1961 in a parody of a popular television show to mock an art critic for a negative review of his work.[57] In 1962 the Nouveaux Réaliste César stripped a television of its cabinet, awkwardly balanced it on a crumbling pedestal, and encased in sheathing. During the exhibition César threatened the television with a gun, clearly conveying his animosity toward television.[58] Other Neo-Dada and Nouveaux Réaliste artists seized upon the television as emblematic of the postwar consumer culture against which they rebelled, producing assemblage sculptures. Christo wrapped a number of televisions in the late 1960s with the intention of encapsulating cultural icons. When Paik and Piene collaborated on a television set in 1968 (Figure 6.6), Paik programmed the television to produce a sine wave with accompanied static as an abstract electronic audio-visual signal, while

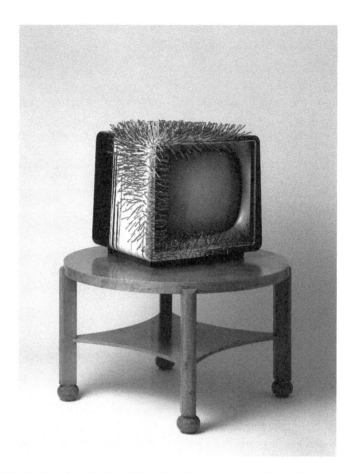

FIGURE 6.5 *Günther Uecker, TV auf Tisch, 1963, wood, TV, nails, and paint, 47 ¼ × 39 3/8 in. (120 x 100 cm). Skulpturenmuseum Glaskasten Marl. © 2017 Artists Rights Society (ARS), New York/VG-Bildkunst Bonn.*

Piene covered the fixture with faux plastic pearls, recognizing the device as a false goddess.

In 1963 television's pervasive influence on postwar Euro-American culture became evident, and artists began to utilize the technology as a creative medium. It is the year that McLuhan published his *Understanding Media* (1964), in which he acknowledged that "for good or ill, the TV image has exerted a unifying synesthetic force on the sense-life of these intensely literate populations."[59] Lee Friedlander published his awareness of television's influence in a series of photographs, *The Little Screen* (1961–62), in the February 1963 issue of *Harper's Bazaar*.[60] Friedlander photographed the television screen in domestic settings, prominently placing the television set with menacing eyes and faces watching the viewer, that, in

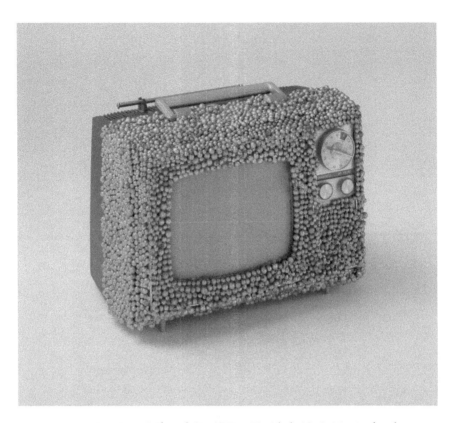

FIGURE 6.6 *Nam June Paik and Otto Piene*, Untitled, *1968, Manipulated television set and plastic pearls. 9 × 13 × 10 in (22.9 × 33 × 25.4 cm). Gift of the Junior Associates of the Museum of Modern Art, New York, The Greenwich Collection Ltd. Fund, and gift of Margot Ernst. © 2017 Artists Rights Society (ARS), New York/VG-Bildkunst Bonn. Image © The Museum of Modern Art/ Licensed by SCALA/Art Resource, New York.*

the accompanying notes by Walker Evans, produced "deft, witty, spanking little poems of hate."[61] In November 1963 millions of Americans watched the assassination of US president John F. Kennedy live in their living rooms. Afterward, the Western world became engrossed in watching the subsequent capture and assassination of Lee Harvey Oswald. Broadcast television maneuvered the news coverage to produce a state of mourning across the Western world. Critical observers recognized the impact of television in controlling popular emotions. Bruce Conner, deeply troubled by what he perceived as network televisions' manipulation of mass hysteria, edited the footage of the assassination into a critique of corporate television and an homage to President Kennedy in *Report* (1963–67).[62]

In 1963 artists also revealed their initial experiments utilizing television as an electronic medium for making art, not just as a vehicle to present their work, or as the object of their practice, or the subject of sociopolitical critique. Two artists working in Germany, Nam June Paik and Wolf Vostell, friends and colleagues in neighboring Cologne and Leverkusen, began to employ the television to project and broadcast images. They appropriated the television set as an emblem of current culture and utilized it as a medium of generating light images by manipulating broadcast signals. Paik's exhibition, *Exposition of Music/Electronic Television*, at the Gallery Parnass in Wuppertal, Germany, is widely acknowledged as the first significant transformation of television technology in the hands of an artist. The exhibition has been extensively analyzed in the literature on Paik, yet its position as the primary catalyst in the creation of electronic imagery in television is important to the following summary that draws from previously unpublished resources.[63]

Rolf Jährling, an architect, operated Galerie Parnass, what was described as an "eccentric" art gallery, out of his stately home in Wuppertal.[64] He attended Stockhausen's *Originale* in 1961 and invited Paik to hold a performance in his gallery.[65] At that time Paik's artistic interests had changed from his extreme performances and he was captivated by the idea of producing electronic imagery with the technology of television. Paik wrote, "While I was devoting myself to research on video, I lost my interest in action music to a certain extent. After 12 performances of Karlheinz Stockhausen's *Originale*, I started a new life from November 1961. . . . I read and practiced only on electronics."[66]

After working secretly for more than a year in his studio on his televisions, Paik's exhibition at Galerie Parnass marked a comprehensive statement of his artistic interests in a fully developed environmental, multimedia installation involving electronics, sound, performance, and interactivity. But, as the title suggests, the exhibit focused on experimental music and electronic television images. Paik filled three floors and the garden of the Jährling residence with four prepared pianos, a selection of music-making devices, twelve televisions, an assortment of Neo-Dada assemblage, a parachute as a projection screen, and a freshly butchered bull's head, hanging over the front door, dripping blood and becoming increasingly putrid in the winter weather.[67] After confronting the grotesquerie at the front door, visitors were greeted with a sequence of pianos and the invitation to perform on them.[68] The television room was considerably less noisy and less interactive (Figure 6.7). It contained a number of monitors that Paik had re-engineered to distort the signals in a variety of manners with circular patterns, grid lines, and a point of light. For the only interactive television, *Participation TV* (1963), Paik rigged a microphone through which the spectator's voice modulated the television signal.[69] Because German television broadcast only in the evening, the exhibition was open during the unusual hours of

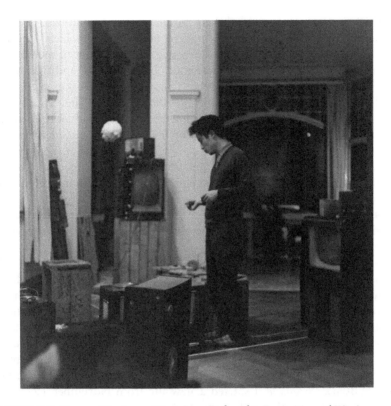

FIGURE 6.7 *George Maciunas, Nam June Paik at his* Exposition of Music— Electronic Television, *March 1963, Galerie Parnass, Wuppertal. Gelatin silver print, 18 7/8 × 18 7/8 in. (48 × 47.9 cm). The Gilbert and Lila Silverman Fluxus Collection Gift. The Museum of Modern Art, New York. © 2017 George Maciunas Foundation/Artists Rights Society (ARS), New York. Image © The Museum of Modern Art/Licensed by SCALA/Art Resource, New York.*

7:30–9:30 pm, in order for Paik's television sets to receive the signals that his modified sets distorted into their various forms.[70]

The installation of the exhibition recalls Kurt Schwitters's *Merz-Bau* in its immersive environmental arrangement of found objects encompassing the total space experienced by the spectators. The prepared pianos reflect John Cage's profound influence on Paik, and the assemblage aesthetic and participation aspects partake of the Neo-Dada aesthetic practiced by the Nouveaux Réalistes, Paik, Vostell, and Fluxus. The novelty of the exhibition led reviewers to describe the experience in great detail. Thwaites reported that on opening night he heard a great commotion in the entryway, and, he rushed downstairs to find Beuys, armed with a hammer and axe, destroying one of the pianos.[71] By the time the reviewer for the local *Wuppertaler Stadtnachrichten* departed from the din and confusion of the exhibition, he

reported that the sight of the decapitated bull's head at the exit gave him a sense of assurance.[72]

The flyer published after the exhibition printed a variation on the title of the exhibition with question marks, *Exposition of Music (?) Electronic Television (?)*, encouraging the public to question the works that the artists presented. The verso of the flyer contained two essays, one by Jean-Pierre Wilhelm and the other by Paik. In his essay Wilhelm emphasized the musical aspects of the exhibition, while Paik focused on the electronic television.[73] Paik discussed his innovation of producing electronic imagery with the medium of television and the Zen concept of nothingness. He stated that his interest in electronics began in November 1961 and credited Karl Otto Götz's essay on "Electronic Painting" in *Das Kunstwerk* as the catalyst.[74] In his article Götz discussed his formative influence as a German soldier operating radar and utilizing the device to produce electronic imagery that was ephemeral and improvisatory, but could not be composed, controlled, or fixed in any permanent manner. To solve this problem Götz devised a mathematical formula for manually producing a number of raster paintings (1959–61) and a film (1962–63) that simulated the effect of the television screen with its 480,000 dots of information. However, he never successfully developed an electronic mechanism to fix the ephemeral images of the oscilloscope into static images, and he returned to his production of *informel* paintings. In January 1963, just before opening his exhibition, Paik requested that Wilhelm send Götz his essay for the exhibition. In the margins of Götz's response, Paik scribbled notes, seizing on Götz's idea that the television could be a productive, not a reproductive, image-making device.[75] Paik viewed his challenge to engineer the television's mechanism to produce kinetic, electronic imagery that was indeterminate, unlike Götz's desire to fix the electronically "painted" image, but perpetually produced.

Paik's exposure to Group ZERO also played a fundamental role in his adoption of technology, particularly his recognition of light and electronic media as part of his artistic repertoire. Paik had met Piene several times; initially he witnessed the light ballet in Mary Bauermeister's studio in the spring 1960, which he said "would change my life many times."[76] He also visited Piene's studio for the second *Festival for Light* in October 1960, where he was photographed wandering in wonder among Piene's electric lights fixtures. Paik also attended ZERO's Demonstration July 1961 at which he met Joseph Beuys, who was also participating in the action.[77] And, over the course of his career, Paik maintained a close, collaborative relationship with Piene. The *Exposition of Music/Electronic Television* marked a transitional moment in Paik's career at which he summarized his formative influences as a musician and performer and began to work with video and television, drawing upon the work of his German colleagues, not just Götz, but also Piene and ZERO's use of electronic, light imagery in a performative context.

In the flyer for the exhibition Paik also acknowledged Vostell for his work in television. Vostell evolved an aesthetic of "de-coll/age" and ventured into

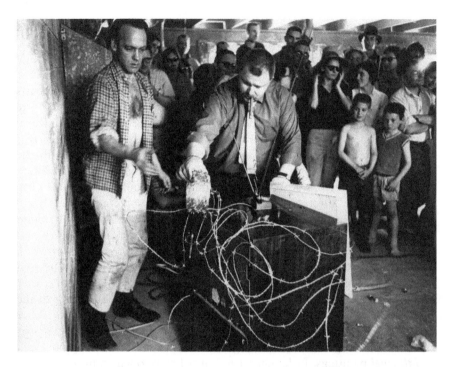

FIGURE 6.8 *Wolf Vostell,* TV Burial, *1963. © 2017 Estate of Wolf Vostell/ Artists Rights Society (ARS), New York/VG Bild-Kunst, Bonn. Photo by Fred W. McDarrah/Getty Images.*

electronic media. He claimed to have made the first installation where he placed television sets, behind a punctured canvas in 1959; however, scholars have disputed the artist's statements based on documentary evidence.[78] His first confirmed exhibition involving televisions was his May 1963 exhibition, *TV De-Coll/age* at George Segal's farm in upstate New York in association with Smolin Gallery, New York. He wrapped the TV set with barbed wired, with the help of assistants, carried the set to the grounds, and buried it (Figure 6.8). As the event progressed the TV set became a sculptural signifier of the culture against which the artist was rebelling; the broadcast technology was not the focus of Vostell's artistic statement. [79]

Vostell achieved the combination of Götz's ideas of producing and reproducing electronic imagery with television technology *Sun in Your Head* (1963, Figure 6.9). In this video/film Vostell distorted television broadcast signals by adjusting the tuning, while Edo Janssen filmed the images. The resulting film was edited and transferred to video in order to be played on monitors.[80] Vostell's film marks the first successful use of a manipulated television broadcast to produce images and to reproduce them on film for subsequent playback. Vostell screened *Sun in Your Head* in September 1963 as the first station on his bus tour Happening *9 Nein Décollagen* (9 No—

De-coll/ages) in Wuppertal, in cooperation with the Galerie Parnass. His most ambitious Happening to date, Vostell staged the screening in a cinema, set up with spotlights and noise devices. The audience was invited to do such things as brush their teeth and gargle, effectively utilizing the television film as the backdrop to the Happening.[81] Screening the film in a cinema, the audience did not associate *Sun in Your Head* with television, rather with avant-garde film.

Paik and Vostell's exceptionally innovative exhibitions in 1963 mark the beginning of artists utilizing television technology in order to produce and reproduce electronic imagery.[82] It was not until 1965 that manufacturers such as Ampex, Norelco, and Sony introduced consumer-grade video tape recorders to the market at a price threshold that permitted artists to acquire the technology to record and replay their own videos. Between 1965 and 1967 Paik, Tambellini, and Warhol began to experiment with videotape recorders, exploring the potential of the medium and shaping the direction of video art into the 1970s. When Sony introduced the portable, battery-operated Porta Pak video camera first in Japan in 1967, and then in North

FIGURE 6.9 *Wolf Vostell, still from* Sun in Your Head, *1963. Museo Vostell Malpartida. © The Wolf Vostell Estate. Courtesy of the Vostell Happening Archive, Junta de Extremadura, Spain. © 2017 Estate of Wolf Vostell/Artists Rights Society (ARS), New York/VG Bild-Kunst, Bonn.*

America in 1968,[83] video art spread rapidly. Although the technological foundation of television was video, the application of video in the artist's studio posed an entirely new set of formal and contextual issues. The technological limitations in recording and playback quality, duration of tapes, and lighting forced artists to formulate a new visual language for video that distinguished it from television and film. Segregated from the mass broadcast communication of television, working in their studio and the street, video artists cut themselves off from the larger social organization that connected broadcast viewers.[84] As Kathy Rae Huffman asked in her 1990 essay on video art, "What's TV Got to Do with It?"[85]

Warhol experimented with new video equipment beginning in the summer of 1965. After making a series of films that Gerard Malanga described as "stillies,"[86] *Sleep* (1963) and *Empire* (1964), in which narrative is eliminated by making the camera and the subjects stationary, Warhol began to cast his factory superstars into narrative actions. In August Tape magazine secured the loan of video equipment for Warhol to experiment and to promote.[87] He filmed a number of people at the factory, including Edie Sedgwick in conversation. On September 29, the magazine hosted an underground party, under the Waldorf Astoria Hotel, to debut *Outer and Inner Space* and videotaped the crowd, playing the tape back to the amazement of the audience. *Outer and Inner Space* (1965) was one of Warhol's more innovative early films, in which he conversed with Edie Sedgwick while a video of her plays on a television monitor. Later, he expanded the piece two screens, creating a film within a film edited into a complex interplay of cinematic space and emotionally disconcerting dialogue. However, Warhol did not work with video again until the 1980s.

At the same time Paik attempted to build and/or acquire video recorders. As Paik had recognized the potential of television, he also recognized the significance of video as a tool for his artistic practice. With money from the Rockefeller Foundation Paik bought a videotape recorder in 1965[88] and immediately filmed himself doing an action in the electronics store, of buttoning and unbuttoning his jacket, *Button Happening* (1965).[89] Excited by the possibility of immediate visual recording and playback, he then took the camera to Madison Avenue where he filmed the *Papal Parade* of Pope Paul IV in New York. These two early documentary videos are considerably different from his early abstract television signals. The videotape recorder resurrected Paik's interest in performance and allowed him to integrate performance into his electronic art practice. He screened his videos for friends in October at the Café a Go Go as a preview of the videos to be included in his exhibition at Gallery Bonino in November. In the flyer for this presentation, Paik wrote that it was a "5 year old dream of me [*sic*] the combination of Electronic Television & Video Tape Recorder." In this flyer Paik prophesied that "a new decade of electronic television should follow to the past decade of electronic music."[90]

Paik continued to explore the medium and experimented with means of manipulating the tape to create effects like those he had achieved with

the prepared televisions. In November 1965, he videotaped Mayor John Lindsay of New York City directly from the television broadcast and took a brief source tape and manually controlled the tape feed, producing distortions, editing it into a five-minute videotape (1965).[91] He continued his work videotaping Moorman during her January 1966 appearance on the Johnny Carson show. In these pieces Paik established the practice of taping directly from broadcast television, then manipulating the source files into finished videos. At the same time he continued to seek more advanced editing equipment in order to extend the range of his video manipulations to approach his manipulations of broadcast signals in 1963.

Tambellini was also intrigued by the electronic magnetism of the television, and he began to film television programs beginning around 1965, accumulating enough footage to be combined into *Black TV* that he eventually released as a 16 mm film in 1968 (Figure 6.10). Tambellini

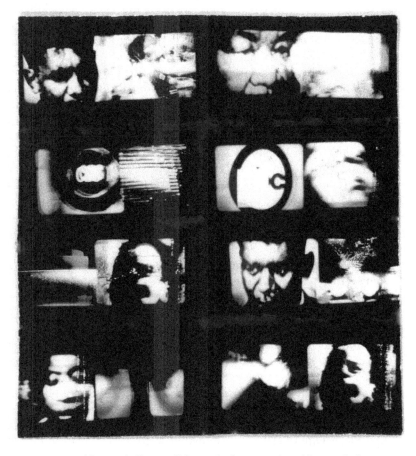

FIGURE 6.10 *Aldo Tambellini, still from* Black TV, *1968. Aldo Tambellini Archives © Aldo Tambellini Foundation.*

employed the technique that Vostell and Edo Janssen had used to create *Sun in Your Head* (1963), which Jud Yalkut coined the "video/film." While working on *Black TV*, Tambellini acquired enough money to purchase one of the new Sony CV-200 video recorders at Willoughby' s electronics store in the spring of 1966. He returned to the Gate Theater, where his wife, Elsa, was programming experimental film screenings, and began to use his new equipment. Unlike Paik's and Warhol's documentary recording of actions, Tambellini turned the technology of the video camera on itself and created a series of video and audio feedbacks, shining lights into the lens to burn exposures onto the tape, eventually burning out the vidicon tube. The result was edited into *Black Video I* (1966, Figure 6.11), an abstract audio-visual tape of swirling circles, dizzying light flashes, and aggressive electronic sound for approximately 40 minutes. The effects approached the style that the artist had cultivated in his paintings, hand-painted slides, and cameraless films. He had devised a strategy for creating video without reliance upon imagery, although one can periodically see the shadowy figures of the audience at the Gate Theater in the video. He took the tape to one of the few video labs to have it reproduced and became engrossed in the lab's editing equipment. He convinced the lab to work with him to produce additional variations on the source material that became *Black Video II and III* (1966). Video played back on television monitors provided an additional tool in Tambellini's electromedia arsenal, and he developed a unique vocabulary consistent with the distinct properties of the medium. Other artists working with television and video acknowledged Tambellini's position in establishing the vocabulary of this new media. Woody Vasulka regarded "Tambellini's and Paik's concerns in the sixties as the true and direct inspiration to our generation of 'synthesizing' artists."[92]

With the technology of video recording in their hands a group of artists in the circle of ZERO began to integrate video and television into their new media practice for its electronic imagery, but also recognizing the immense capacity of broadcast television to expose their work to an audience of millions. During 1968 and 1969 four different projects were produced in television studios and then broadcast in 1969 in Europe and the United States. These four television programs mark the emergence of the artist as producer and art as subject of broadcast television: Tambellini and Piene's *Black Gate Cologne* (1968), Mack's *Tele-Mack* (1968–69), WGBH's *The Medium Is the Medium* (1969), and Gerry Schum's *Land Art* (1969).

Tambellini and Piene inaugurated their electromedia theater, The Black Gate, in March 1967, as "an experimental light theater involving all aspects of the arts."[93] The emergence of the Lower East Side of Manhattan as an arts center attracted the attention of the local ABC news affiliate that broadcast a clip on the evening news on December 21, 1967. Tambellini was interviewed for a segment during which he demonstrated the striking videotape *Black Video I* (1966). In animated gestures he explained his tele-visual art as a manifestation of modern physics: "That light is energy and

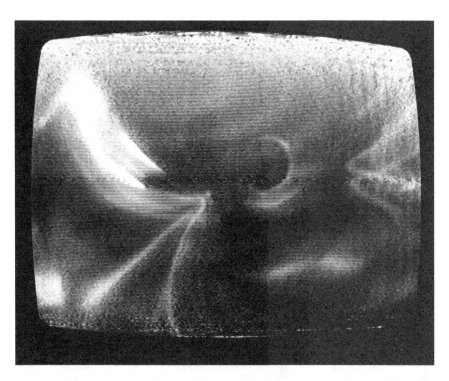

FIGURE 6.11 *Aldo Tambellini, still from* Black Video I, *1966. Aldo Tambellini Archives © Aldo Tambellini Foundation. Photo: Peter Moore.*

energy is going through us, the same energy which is going through the universe today." He advocated the role of the artist in broadcasting, working "with this idea of energy rather than the idea of making pictures, then we will come to . . . a new exploration which is for all."[94] The widespread exposure confirmed Tambellini's realization of television as a medium of mass artistic communication to achieve his democratic ambitions for art.

Piene already had extensive experience with broadcast television since the 1959 filming of the ZERO *Dynamo* exhibition in Wiesbaden. He proposed that they approach Wibke von Bonin at WDR to re create their multimedia performances in a television studio, and produce what became *The Black Gate Cologne*, the first television broadcast to involve artists in collaboration with television producers, a novel, noncommercial, visual experience for television. Piene staged his participatory inflatable sculpture environment with the crowd gleefully playing in the studio. Halfway through the program Piene's performance merges into Tambellini's film with an increasingly frenetic mélange of abstract hand-painted slide and cameraless film images montaged onto the studio shoot that dissolves into news broadcasts announcing the recent assassination of Robert F. Kennedy

(June 6, 1968, Figure 6.12). The drastic shift from the innocent play to the harsh reality of current events characterized the maddening swings of the 1960s from love and peace to violent protests in the streets and combat in the jungles of Vietnam, all available on the television in a family's living room. Tambellini and Piene repeatedly stated their sincere belief that television could become the new medium of the postwar technological age. Tambellini compared the potential of television by emphasizing that "television is not an object. It's a live communication media,"[95] comparing the significance of its development to the unleashing of atomic energy and space travel.[96]

Upon completion of the shooting and editing of *Black Gate Cologne*, Tambellini and Piene drove to Düsseldorf to present an open-air demonstration of the multimedia event that they just performed in the WDR studios.[97] Piene's friends and former ZERO partners, Mack and Uecker, may have attended this event held on the same Rhine river bank as their 1962 ZERO Demonstration for Hessian television. Simultaneously, Mack embarked on his own television film, *Tele-Mack* (1968–69), in coordination with Saarland Broadcasting and WDR. Mack scripted and produced his program in the vein of Wiesselmann and Winkler's television films from the early 1960s, a documentary on his work with imaginative visual effects.

FIGURE 6.12 *Aldo Tambellini and Otto Piene,* Black Gate Cologne, *1968 (35:24). Aldo Tambellini Archives © Aldo Tambellini Foundation and © 2017 Artists Rights Society (ARS), New York/VG-Bildkunst Bonn.*

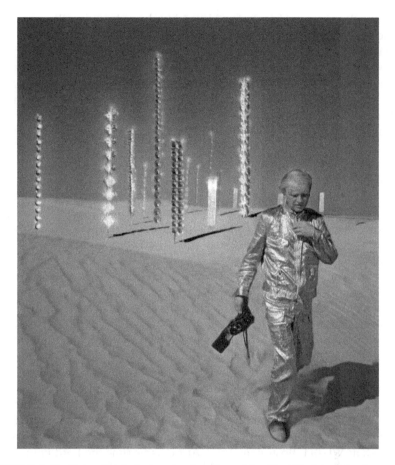

FIGURE 6.13 *Heinz Mack during the shooting of the film* Tele-Mack *in the Tunisian desert, 1968. Camera: Edwin Braun. Saarland Broadcasting and Westdeutscher Rundfunk. © 2017 Artists Rights Society (ARS), New York/ VG-Bildkunst Bonn.*

The program begins with the artist driving a Jaguar on the Autobahn with the narrator intoning that an automobile "is the perfect kinetic object." The 45-minute film follows Mack through his studio and exhibitions and for the final half focuses on his realization of the 1959 Sahara Project in the Tunisian desert. Staged in November 1968, Mack wears a foil suit and becomes one of the reflective light objects in the "artificial garden" that he created in the desert (Figure 6.13).[98] The film records Mack's manipulations of light to create his dematerialization of art in seemingly limitless space of uninhabited nature. Certainly, this is important documentation of what was among the earliest installations of land art, based on ideas Mack had developed over the previous decade. In 1970 his film won the Adolf

Grimme Prize, named for the founder of Nordwestdeutscher Rundfunk, for a television film.[99]

Mack had participated in Gerry Schum's early *Konsumkunst/ Kunstkonsum* in October 1968, a film for WDR in which Mack outlined his ambition to create an exhibition of his work for broadcast television that would be disseminated to a mass public, but not exist in a museum or gallery.[100] This he achieved with *Tele-Mack*. The timing, concurrent with Tambellini and Piene's WDR broadcast indicates the level of interest among artists of this generation in the potential of television as a cultural mass communication medium.

The US Congress formed the Public Broadcasting Corporation in 1967 to "make public telecommunications services available to all citizens of the United States."[101] In response to this act of Congress, foundations and granting agencies began to sponsor programs that catalyzed innovative collaborations between artists and educational television networks. The Ford Foundation, concerned about the educational and information value of commercial television, established the "Public Broadcasting Laboratory" (1967) to underwrite noncommercial television with the goal to "produce superior cultural and public affairs programs for a nationwide audience." At the same time the Rockefeller Foundation initiated a grant for "artists-in-television" to provide the opportunity for artists to create more imaginative programming.[102]

Among the artists already working in video and television, these opportunities for sponsorship stimulated a great deal of interest. Paik received a grant from the Rockefeller Foundation in 1965, which he used to purchase his first video recorder. The Rockefeller Foundation continued to support him, by awarding him an "artist-in-television" grant to work at WGBH, Boston, in 1967. At the same time the Ford Foundation granted sponsorships in their "Public Broadcast Laboratory" initiative to WGBH, Boston, and KQED, San Francisco.[103] The Ford and Rockefeller Foundations granted these awards to WGBH because they had taken notice of the experimental television work developed by the young producer, Fred Barzyk, particularly his recent series *What's Happening, Mr. Silver?* (1967). The programs produced by Barzyk for WGBH are among the earliest examples of experimental art television broadcasts in America.

After completing studies in theater, Barzyk began at WGBH as a graduate intern in 1958. The nascent television company had only been on the air since 1955 and gave Barzyk the assignment to produce cultural programming, which then meant going to the symphony and videotaping a performance. He asked the executives, "Why couldn't the cameras paint pictures instead of showing old men blowing horns and bowing violin strings?" Barzyk wanted to produce more imaginative, adventuresome programs. Finally, executives gave him permission to work on some ideas at night, when the station was otherwise closed. Barzyk persuaded some engineers and camera people to work into the night. The result was among the earliest

visual art ventures designed by and for broadcast television, *Jazz Images* (1961).[104] In retrospect Barzyk observed that educational television was in a formative stage and he was permitted to experiment with possibilities. With each successful venture, he was given another opportunity to develop his programming concepts.

The station responded positively to *Jazz Images* and encouraged Barzyk to apply his strategies to the program, *What's Happening, Mr. Silver?* (1967, Figure 6.14). This program, in the words of colleague Brian O'Doherty, "became the vehicle for Fred's relentless attack on television's conventions."[105] A student of theater, Barzyk was intrigued by Bertolt Brecht's ideas of alienating the audience through dissonance, the theater of the absurd, and John Cage's ideas about chance as an organizing principle.[106] Barzyk combined all of these into his production of *What's Happening?* Barzyk considers the episode "Madness and Intuition" to be the ultimate realization of these ideas from performance and music. The host, Mr. Silver, begins the program by announcing, "We have a very special show for you tonight." Then the camera pans out to him sitting in a bed interviewing a woman about popular independent scholar Immanuel Velikovsky's ideas on the catastrophic extinction of dinosaurs. In the background sit an elderly couple who appeared confused by the commotion in the studio, consisting

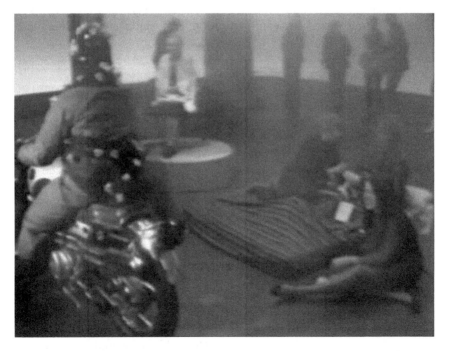

FIGURE 6.14 *Still from* What's Happening, Mr. Silver?, *1967 (26:43) Fred Barzyk, producer. WGBH, Boston.*

of a surrealistic combination of a motorcycle riding past, children playing, and an artist drawing. The production wildly shifted from one segment to another unconnected by a narrative. Barzyk described his strategy,

> The premise was all non-related images can become a television show when selected by chance. I invited 15 people into the control room and asked them to yell out when they were bored and we would change the images. . . . There were thirty slide projections in the studio and every film and slide chair in master control was filled with random slides and films. I gave Will Morton, the audio person, a stack of records and told him to play whatever he wanted. I left the control room 20 minutes into the show, letting it direct itself. I returned shortly after to bring things to a "close."[107]

The radical nature of Barzyk's program demanded the viewer's attention and jolted their expectations of consuming relaxing entertainment. The program came to the attention of David Davis at the Ford Foundation, who granted WGBH its "Public Broadcasting Laboratory" support. Subsequently, Howard Klein at the Rockefeller Foundation funded an "artist-in-television" residency program for which Barzyk selected Paik as the first artist. Barzyk said, "Nam June came into this place like a whirling Korean dervish. . . . Nam June's vision was immense. His language was somewhat limited and his communication with engineers (and his ideas had a lot to do with engineering) were threatening to a lot of people."[108] Following Paik, Barzyk selected five other artists, who, over the course of 1968, produced programs that he combined into the March 23, 1969, broadcast of *The Medium Is the Medium*,[109] only two months after WDR broadcast *Black Gate Cologne*.

Barzyk produced *The Medium Is the Medium* with Allan Kaprow, Paik, Piene, James Seawright, Thomas Tadlock, and Tambellini. They were invited to work in the WGBH studio over the course of 1968 and early 1969 to utilize the advanced equipment of the television studio to produce "electronic art" for broadcast. All of the artists had worked with video, television, or new media in the past and were assigned a team of engineers to realize their ideas. Barzyk edited each of their segments to approximately 3–4 minutes to produce the 30-minute broadcast. The program opened with an electronic American flag undulating with electronic imagery. The narrator then asked, "What happens when artists take control of television?" He answered that artists use television "as a way of reaching a vast audience and creating a museum for millions."

The program began with Tambellini's ongoing series on *Black*, utilizing over 1,000 slides, sixteen films, electronic sound and footage of black children in the studio and a playground. The children conclude the program with the civil rights chant "I'm black and I'm proud." Kaprow produced a "tele-happening," *Hello!*, in the WGBH studios linking several locations

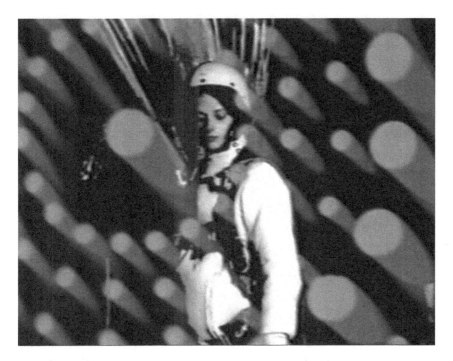

FIGURE 6.15 *Still from Otto Piene,* Electronic Light Ballet, *from* The Medium is the Medium, *1969, (04:38), color, sound, WGBH, Boston. © 2017 Artists Rights Society (ARS), New York/VG-Bildkunst Bonn.

to establish a communications link between people in distant locations. The novelty of instant, closed circuit videography led the participants to enthusiastically identify their distant friends. Piene expanded on his work with *Black Gate Cologne* to produce an *Electronic Light Ballet* in the studio incorporating video footage of his Sky Art event, *Manned Helium Sculpture,* in which he levitated an MIT student in January 1969 with helium balloons (Figure 6.15). Piene utilized his rasters to produce psychedelic light patterns against which the footage was montaged. The program concluded with Paik's *Electronic Opera #1* (Figure 6.16), that began with the narrator announcing that "This is participation TV," and proceeded through 5 minutes of electronic imagery, closing with verbal instructions to "close your eyes," "open your eyes," and finally to, "Please turn off your television set," at which point the program goes to black and ends. *The Medium Is the Medium* culminated the formative phase of artist's engagement with television and catalyzed a series of educational television programs and exhibitions on video and television as art.

Although media historian Rudolf Frieling makes the case that the introduction of new technology was slower in Europe than the United

FIGURE 6.16 *Nam June Paik,* Electronic Opera #1, *from* The Medium is the Medium, *1969. Fred Barzyk, producer. WGBH, Boston. Courtesy Electronic Arts Intermix (EAI), New York.

States, it did not deter artists from responding to the powerful new medium of video/television.[110] Wibke von Bonin realized the potential of creative television programming and gave Tambellini and Piene the opportunity to produce a program at WDR. She went on to produce a full career of cultural programming for WDR. Mack also worked with WDR to broadcast his television film. In Düsseldorf Gerry Schum worked with Sender Freies Berlin to establish a *Fernseh Galerie* (Television Gallery) in 1969. Convinced that the dematerialization of the object in contemporary art necessitated a similar ephemeral system to deliver the art as information, Schum stated, "The TV Gallery is more or less a mental institution, which comes only into real existence in the moment of transmission by TV."[111] It did not exist as a physical entity and operated outside of the gallery/museum system. Schum's vision lead him to produce his first broadcast, *Land Art*, on April 15, 1969, featuring an international roster of artists who also had broken from the art object in the gallery and worked in nature. The film (it was originally shot as film, not video) was purely visual without the interference of narration only a few text captions.[112] Schum collaborated with artists involved in the emerging fields of land art, concept art, and process art such as Dennis Oppenheim, Lawrence

Weiner, Richard Serra, Gilbert and George, Daniel Buren, Joseph Beuys, Mario Merz, and Robert Smithson in developing special presentations for television.

Schum followed in 1970 with a program he called *Identifications* (1970) that included Jan Dibbets's *TV as Fireplace* (Figure 6.17) and Beuys in a re-creation of his *Felt TV* performance. The approach of the *Television Gallery* was purely conceptual, unlike the more maximal stimulation of the other multimedia broadcast programs. Schum held idealistic notions that television was the "modern system of communication," advocating that television could deliver art to the masses and that it was "the only chance" to save art. Yet, the public essentially ignored his program, forcing him to close his *Television Gallery* and reopening his operation as a *Video Gallery* in 1971, with a physical location in Düsseldorf from which he could sell editioned videotapes. Although his idealistic *Television Gallery* failed, he continued to promote video art in Germany, being involved establishing a video art department for the Museum Folkwang in Essen and participating in the video portion of *documenta* in 1972.[113]

The Medium Is the Medium spawned a sequence of exhibitions and a flurry of activity at WGBH and other educational television stations across the United States. Only two months after the broadcast of *The Medium Is the Medium* the Howard Wise Gallery, New York City, opened an exhibition

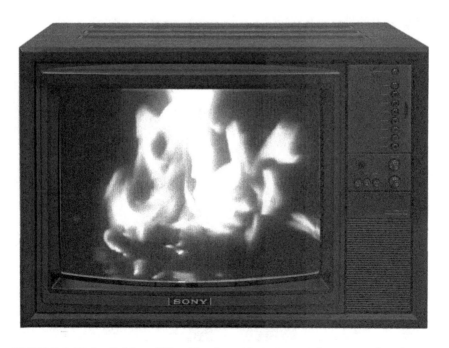

FIGURE 6.17 *Jan Dibbets,* TV as Fireplace, *1969. Gerry Schum Fernseh Galerie. Stedelijk Museum, Amsterdam. © 2017 Jan Dibbets/Artists Rights Society (ARS), New York.*

described by video artist Ira Schneider as "the first art gallery group show presenting *TV as a Creative Medium*"[114] (1969). The exhibition announced the arrival of video and television in the contemporary art community. Howard Wise, known in the art community for working "against the mainstream,"[115] with this exhibition became recognized as a key figure in promoting the alternative programming for the television industry and for positioning video as a viable art form.[116] Wise identified thirteen different artists and engineers working at the intersection of art and technology for this exhibition, including several who were in the WGBH broadcast, Paik, Tambellini, and Tadlock. Wise organized the exhibition because of his growing awareness of the "tremendous force" that television exerted in "transforming our civilization." And he noted that only with the current generation, the first generation to have been raised with the introduction of television, have artists realized "the potential of TV as the medium for their expression."[117]

The exhibition consisted of approximately twenty-five innovative approaches to television as an audio-visual medium. Visitors to the exhibition were greeted by Frank Gillette and Ira Schneider's *Wipe Cycle* (1969, Figure 6.18), a mural of nine monitors stacked on one another in a closed-circuit loop that included a shot of the viewer entering the gallery,

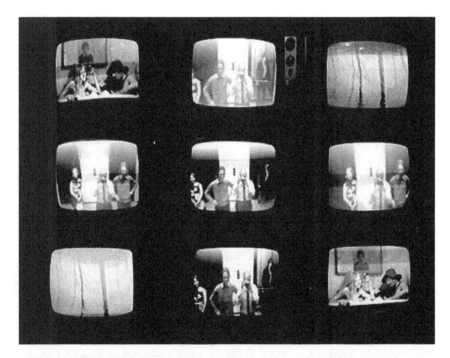

FIGURE 6.18 *Frank Gillette and Ira Schneider,* Wipe Cycle, *1969. Courtesy Electronic Arts Intermix (EAI), New York.*

with other monitors set to 2-, 4-, and 8-second delays intermixed with segments of daily television programming. The effect of seeing oneself in the middle monitor in the midst of broadcast television captured the visitor's attention and placed them directly in the distant world of television. The other monitors, set for a sequence of delays, conveyed the passage of time and brought past events into the present. The manipulation of time, image, and place, in the words of Schneider, integrated "the audience into the information," triggering the spectator to respond to his/her own image, thereby "realizing one's own potential as an actor."[118] Paik introduced his new performance piece with Charlotte Moorman, *TV Bra for Living Sculpture* (1969), for which Moorman was fitted with a bra constructed from two small television sets. The television signals were distorted by her bowing the strings of her cello. Paik's purpose was to "humanize technology" by appending television to a personal undergarment.[119] It certainly humored the *Village Voice* reviewer, who noted that the New York Yankees were playing during her visit, so Moorman had a mirror set up in front of her so she too could watch the game.[120] Beyond the humor, Paik's premise was to integrate various art forms—in this case sound, image and performance. Tambellini also exhibited a television that manipulated broadcast signals. The New York State Council on the Arts awarded him a grant in 1969 to collaborate with television engineers. He established relationships with Tracy Kinsel and Hank Reinbold of Bell Labs, who engineered his idea into *Black Spiral* (1969, Figure 6.19) a television tube that projected in a spiral, instead of a grid, creating continuous, dynamic distortion of broadcast television signals.[121]

Tambellini saw his work in electronics as an extension of his work in painting and film, "scratching and drawing lines . . . similar to TV lines." Another exhibitor, Earl Reiback described his practice as "painting the walls of the tube with color phosphors." Eric Siegel, an engineering prodigy in his *Psychedelevision in Color* (1969) viewed his purpose to counteract the problems caused by broadcast television and to design his electronic transmissions as a "mass healing device" that enter the public's subconscious.[122] The public was indeed enthralled with the magnetizing, sensory impact of the artists' imagery, making the exhibition exceptionally popular, forcing Wise to extend the run of the show. Arts reviewers were generally excited about the novelty of the electronic image-makers. John Margulies in his *Art in America* review of the exhibition concluded that "television is clearly ready to be recognized as an educational device and an artistic medium of great influence."[123] However, there were critical voices that had difficulty connecting with the technology as a medium of art. The *Village Voice* critic took exception to Paik's goal of humanizing technology and found it "off-putting," merely "a collection of technical details waiting for a unifying aesthetic genius."[124] Art historian Barbara Rose, was more damning in her description of the exhibition as "the pinnacle of pretension and the nadir of achievement," dismissing "the level of imagination in these

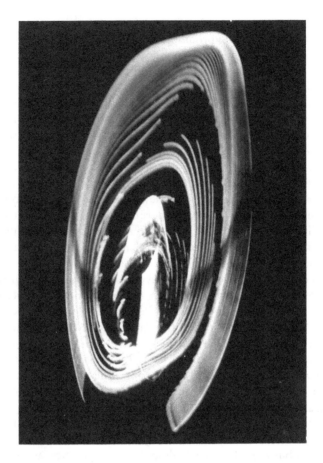

FIGURE 6.19 *Aldo Tambellini,* Black Spiral, *1969. Aldo Tambellini Archives ©*
Aldo Tambellini Foundation.

works was so low that the tube was merely treated as a kind of animated
easel picture."[125]

Despite these critical opinions, the new media art community and the
public discovered in Howard Wise's exhibition a vital, new medium of
audio/visual art that directly related to the new reality of postwar culture.
The exhibition caught the attention of Russell Connor, curator at the
Rose Art Museum, Brandeis University, who proposed to Howard Wise to
present an expansion of *TV as a Creative Medium* in Massachusetts as an
exhibition titled *Vision & Television* (1970), the first museum to host an
exhibition devoted to the new media of video and television. [126] Connor was
professionally interested in television as a medium of art, having worked on
cultural programming at WGBH and serving as host of the series "Museum
Open House" before joining the Rose.[127] He saw Barzyk's *The Medium Is*

the Medium (1969) and recognized that television had graduated from the living room and deserved presentation in the museum. Connor conceived of *Vision & Television* as an integrated tele-visual experience that involved artists, the audience and the academic community of Brandeis. Connor included many of the artists from the Howard Wise show including Gillette and Schneider, Paik, Siegel, Tambellini, but also included Jud Yalkut (who had been working with Paik), USCO, and the Video Freex, who filmed the installation, performance, and engaged the community in the videotaping the programs. Several evenings were dedicated to live electronic programs, including a Tambellini multimedia event *Moonblack* about "the madness of America as seen through the TV tube," and Paik and Moorman performing *TV Bra*.

Among the new works in the installation was Paik's *9/23/69* (Figure 6.20), created in the studios of WGBH working with David Atwood, Fred Barzyk, and Olivia Tappan learning the technical range of broadcast equipment from the engineers and producers. Paik worked "live" with Atwood, mixing abstracted electronic distortions with footage of studio personnel (including Barzyk and Olivia Tappan) as well as a mixture of live and pre-recorded sound. The 80-minute video was never broadcast in its entirety; however, like most of Paik's videotapes, it became source material for later video installations and broadcast programs. For Paik, the experience of working directly with a skilled engineer made him aware of the limitations of television studio equipment.[128] As Barzyk noted, television studio equipment was designed and fabricated to create a perfect image. Paik wanted to distort the image. It was based on this production that Paik and Barzyk persuaded the executives of WGBH to underwrite Paik returning to Japan, where he could work with Shuya Abe to create a video synthesizer, not unlike the audio synthesizer that was widely used by this time. Upon his return, WGBH presented the first broadcast of the Paik-Abe Synthesizer in live improvisation, *Video Commune: Beatles from Beginning to End* (1970). Broadcast on WGBH on August 1, 1970 Paik worked in the studio with a selection of his source materials, appropriated film and television footage, live and recorded sound, Paik pieced together a four-hour display of the visual capabilities of his visual synthesizer. In his recounting of the broadcast Barzyk remembered that the head engineer rhetorically asked, "What's television coming to?" Paik was genuinely pleased with the results saying it was, "Beautiful. Like video wall paper."[129]

The success of these artist innovations in broadcast television and video fostered the exponential growth in both fields during the 1970s. Barzyk established "The WGBH Project of New Television" in 1970, which became the New Television Workshop in 1974. Over the course of his time at WGBH he brought in over one hundred and fifty artists and produced some of the most imaginative experimental broadcast television on the air. In San Francisco, KQED had been producing experimental television since

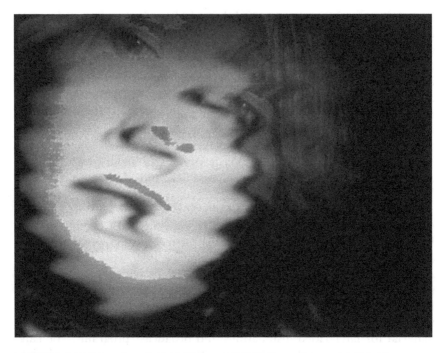

FIGURE 6.20 *Nam June Paik, Still from 9/23/69*: Experiment with David Atwood, *1969, 80 min, color, sound, WGBH, Boston. Courtesy Electronic Arts Intermix (EAI), New York.*

1967.[130] By the time of the *Vision & Television* exhibition several video art collectives were founded including Ant Farm (1968), Video Freex (1969) and Raindance (1969), the latter two were included in the exhibition. After the exhibition Connor was lured away from Brandeis by the Rockefeller Foundation to direct their media division in 1970.[131] He went on to advise the New York State Council for the Arts, who helped fund WNET, New York, to start an artist in residency program the *TV Laboratory* in 1972. In 1971 Ralph Hocking established the Experimental Television Center in Binghamton, New York, out of a student video organization.[132] And, Woody and Steina Vasulka established the Kitchen in 1971 as a venue for artists to present their intermedia work. The 1970s witnessed an explosion of institutional and independent interest in and support of video and television.

In 1970 Gillette and Schneider of Raindance joined with Beryl Korot and Michael Shamberg to launch *Radical Software* magazine, dedicating its first issue to "The Alternative Television Movement." Over the four years of its existence *Radical Software* became the voice for alternative cultural expression through electronic and communications media. In their inaugural editorial, the publishers unequivocally state their recognition that

the international communications network was (other than weaponry) the most "powerful tool" of controlling society. The editor's wanted to use the pages of their magazine to "design and implement alternative information structures which transcend and reconfigure . . . the existing system."[133] Applying the lessons of McLuhan they couched their philosophy of electronic arts media in terms of communications and information theory. They too sought to humanize technology by democratically providing people access to communications systems.

Circa 1970 was a highpoint of idealistic vision of television. When Howard Wise closed his gallery in 1970 to start the nonprofit organization Electronic Arts Intermix, he did so with the ambition of supporting and providing access for video artists. When the United States Congress the CATV (community access television) act for public access cable television, it was to ensure a diversity of public expression through the communications network. *The Nation* magazine hailed it as "America's 'National Highway' of communications."[134] However, despite the tremendous growth in institutional support for artists in television, artists never actually gained significant control over programming in the vast commercial communications network. By the end of the 1970s, commercial television had completely consumed the broadcast system. The ideal vision for artistic control and access of the airwaves disappeared.

Television, and by extension, video attracted the attention of numerous ZERO and postwar new tendency artists, who adopted the new media into their art and technology practice in the 1960s. The electronic technology of television and video contained many of the characteristics that interested them: kinetic, light projections that synthesized a variety of art forms and could be broadcast to a vast audience. These artists profoundly shaped an experimental vision of television and video. Paik, Vostell, and Tambellini were clearly the principle artistic figures, who developed the television as an artistic medium. However, among these early progenitors of the vocabulary of video and television only Paik and Tambellini continued to work actively with these media after 1970. Paik created the landmark artist-engineered television broadcasts such as his satellite linked *Global Groove* (1973, WNET). Tambellini continued to develop communications arts with closed circuit systems, global satellite telecommunications, and picture-phones at MIT.[135] However, Mack turned away from television to pursue his ambitious land and urban art projects. Piene focused on developing his Sky Art public arts projects as director of the CAVS at MIT. Vostell abandoned the television to continue his happenings and assemblage constructions. Yet, their formative efforts in this medium mark the beginning of the artist's co-opting the television and its broadcasts both as the subject and object of their work. In a very brief flourish of a few years around 1970 artists created programs for broadcast TV with the idealistic vision that television could be the medium of the future, that television could succeed cinema and become a vehicle for the mass distribution of artistic experience.

Notes

1 Otto Piene's archives contain a series of letters between Piene and Wibke von Bonin and Aldo Tambellini that document the development of this television program. Piene initially sketched a set of ideas to Tambellini, then he outlined his telephone conversation with von Bonin by letter, and followed with a letter to Tambellini confirming that WDR had agreed to the proposal, noting the dates for studio shoot. His correspondence also states that Dr. Hansen, the music editor of NDR (Norddeutscher Rundfunk), Hamburg, and WNET, New York, also wanted to air the television program. *Black Gate Cologne* was not subsequently aired at WNET, but it is not known if the program was broadcast from NDR. Otto Piene, correspondence with Wibke von Bonin (August 5, 1968); Otto Piene, correspondence with Aldo Tambellini (August 6, 1968); Otto Piene, correspondence with Aldo Tambellini (April 16, 1968). Otto Piene Archives. The multimedia installation was videotaped on August 30, 1968.

2 *Winterprogramm, 1.Oktober 1968 bis 30. April 1969.* WDR, Westdeutsches Fernsehen. Otto Piene Archives.

3 Christine Mehring, "Television Art's Abstract Starts: Europe circa 1944–1969," *October*, vol. 125 (Summer 2008): 61.

4 Otto Piene correspondence with Aldo Tambellini (April 16, 1968). Otto Piene Archives. Piene's quote in the letter to Tambellini paraphrases his remarks published in Otto Piene, "The Proliferation of the Sun," *Arts magazine*, vol. 41, no. 8 (Summer 1967): 26.

5 Jud Yalkut, "TV as a Creative Medium," *Art in America*, vol. 44, no. 1 (September/October 1969): 21.

6 Remarks by Aldo Tambellini in conversation with Otto Piene at a screening of *Black Gate Cologne* at Pierre Menard Gallery, Cambridge, MA (December 3, 2009).

7 Marshall McLuhan, *Understanding Media: The Extensions of Man.* Originally published 1963 (Cambridge and London: MIT Press, 1994), 315.

8 Draft letter of invitation titled "Black Gate Cologne/ein Lichtspiel," (August 24, 1968). Otto Piene Archives.

9 Nam June Paik, "TV Bra for Living Sculpture," in *TV as a Creative Medium.* Exhibition catalogue (New York: Howard Wise Gallery, 1969), n.p.

10 The early history of the Electronic Music Studio of the WDR under Herbert Eimert and Karlheinz Stockhausen and the Groupe de Recherche Musicale (GRM) established by Pierre Schaeffer and Pierre Henry in the 1950s is essential for understanding the development of sound in immersive, multimedia environments. Chris Meigh-Andrews develops a whole chapter on the relationship between music, magnetic tape, and video in his *A History of Video Art: The Development of Form and Function* (Oxford, New York: Berg, 2006), 89–100.

11 Gene Youngblood, *Expanded Cinema* (New York: E.P. Dutton & Co., 1970), 281. Youngblood devoted Part Five of his book to "Television as a Creative Medium" linking experimental television, expanded cinema, and multimedia environments, 257–344.

12 John E. Margolies, "TV-The Next Medium," *Art in America* (September-October 1969): 50.

13 McLuhan, *Understanding Media*, 333.
14 Richard Lorber, "Epistemological TV," *Art Journal*, vol. 34, no. 2 (Winter 1974–75): 132.
15 Eric Siegel, "Psychedelevision," in *TV as a Creative Medium*, n.p.
16 Dieter Daniels, "Television—Art or Anti-Art? Conflict and cooperation between the avant-garde and the mass media in the 1960s," http://www.medienkunstnetz.de/themes/overview_of_media_art/massmedia/ (accessed 2004).
17 Michael Rush, *New Media Art* (London: Thames & Hudson, 2005), 80.
18 Dieter Daniels references 1953 as the first year of broadcast television in postwar West Germany in "Television—Art or Anti-Art?" However, the year reported by Richard Shephard was 1958, see Richard F. Shephard, "Around the World with TV," *The New York Times* (February 9, 1958).
19 Josef Othmar Zöllner, ed. *Massenmedien die geheimen Führer* (Augsburg, 1965), 179, quoted in Daniels, "Television—Art or Anti-Art?"
20 Daniels, "Television—Art or Anti-Art?"
21 Wolf Vostell, 1970, quoted in *40jahrevideokunst.de—Teil 1*, edited by Rudolf Frieling and Wulf Herzogenrath. Exhibition catalogue (Ostfildern-Ruit: Hatje Cantz, 2006), 25.
22 Frank Gillette, "Random Notes on the Special Case or (Loop-de-Loop)," *Radical Software*, no. 1 (1970): 6; Schneider quote from Yalkut, "TV as a Creative Medium," 20.
23 Youngblood, *Expanded Cinema*, 302.
24 Gerry Schum, "Land Art" (1969). http://www.medienkunstnetz.de/werke/land-art/ (accessed 2008).
25 Grace Glueck, "T-Visionaries," *The New York Times* (March 23, 1969).
26 Siegel, "Psychedelevision in Color." n.p.
27 Daniels, "Television—Art or Anti-Art?"
28 Naomi Sawelson-Gorse, "Sound Bites & Spin Doctors," in *The New Frontier: Art and Television 1960-65*, edited by John Alan Farmer. Exhibition catalogue (Austin, TX: Austin Museum of Art, 2000), 69.
29 Yalkut, "TV as a Creative Medium," 18.
30 Christine Mehring proposed that European artists initially developed television as an art medium in her article, "Television Art's Abstract Starts," 29–64.
31 "Manifesto blanco," 1946, reprinted in Germano Celant, *The Italian Metamorphosis, 1943-1968*. Exhibition catalogue (New York: Guggenheim Museum, 1994), 709–10.
32 Luigi Moretti, "Arte e televisione," *Spazio*, no. 7 (December 1952–April 1953): 74. Courtesy Fondazione Lucio Fontana.
33 Mehring, "Television Art's Abstract Starts," 42, 41, 45, 42.
34 Gerhard Eckert, *Die Kunst des Fernsehens* (Hamburg: Verlag Lechte Emsdetten, 1953), 102, quoted in Daniels, "Television—Art or Anti-Art?"
35 Lynn Spigel, *TV by Design: Modern Art and the Rise of Network Television* (Chicago and London: The University of Chicago Press, 2008), 4. This is a good accounting of the development of the look and content of American commercial television and its relationship to modern art. See also Laura Mulvey and Jamie Sexton, eds., *Experimental British Television* (Manchester and New York: Manchester University Press, 2007), for an examination of the growth of experimental public television in Great Britain as an extension of the theater tradition beginning around 1955.

36 Sawelson-Gorse, "Sound Bites & Spin Doctors," 75.

37 Spigel, *TV by Design*, 3.

38 Sawelson-Gorse, "Sound Bites & Spin Doctors," 69.

39 Gibson, Eleanor Jess Atwood. *The Media of Memory: History, Technology and Collectivity in the Work of the German Group Zero 1957-1966*. Ph.D. Dissertation, Yale University, 2008, 79.

40 Daniels, "Television—Art or Anti-Art?"

41 Sawelson-Gorse, "Sound Bites & Spin Doctors," 81–82.

42 John Alan Farmer, "Pop People," in Farmer, *The New Frontier: Art and Television*, 24.

43 Daniels, "Television—Art or Anti-Art?"

44 Anna Klapheck, "Avantgarde und Fernsehen," *Rheinische Post* (December 5, 1961). ZADIK, G001 XIII 004 0003, Zeitungskritiken, 1957–62.

45 Anette Kuhn, *ZERO: Eine Avantgarde der sechziger Jahre* (Frankfurt am Main and Berlin: Propyläen Verlag, 1991), 48–49.

46 Kowallek brought the *Complex Colors* exhibition and the television program to the attention of Mack and Piene in a letter on February 5, 1962 (Mack Archive, ZERO Foundation, Düsseldorf). Piene's Archives also contain an excerpt from Winkler's program "Panorama" that was aired on February 5, 1962, on the exhibition (Otto Piene Archives). Mack preserved a series of letters exchanged between him and Winkler in the process of planning the film (March 1, 1962; March 21, 1962; May 2, 1962). Mack Archive, ZERO Foundation, Düsseldorf.

47 Gerd Winkler, "0 x 0=Kunst," 9. Mack Archive, ZERO Foundation, Düsseldorf.

48 *0 x 0=Kunst: Maler ohne farbe und pinsel*, (1962), 30', black and white with sound. Gerd Winkler, producer. Hessischer Rundfunk, 1962.

49 Gerd Winkler, correspondence with Heinz Mack (n.d.). (approx. November 1963). Mack Archive, ZERO Foundation, Düsseldorf.

50 Helmut Alt, "Die Stunde Null. Bewegende Strawinsky-Ehrung//Maler ohne Pinsel und Farbe," *Neu-Ulmer Zeitung* (July 1961). Otto Piene Archives.

51 Kuhn, *ZERO*, 49.

52 Gerd Winkler, correspondence with Heinz Mack (n.d.). Gerd Winkler to Lucio Fontana (November 17, 1963). In these letters to Mack and Fontana Winkler states that he cannot find sponsors for these films at this time, but wishes to pursue them once financing is secured. Mack Archive, ZERO Foundation, Düsseldorf.

53 Klaus Gereon Beuckers and Günther Uecker, *Günther Uecker. Die Aktionen* (Petersberg: Imhof, 2004), 52.

54 Eleanor Jess Atwood Gibson, "The Media of Memory: History, Technology and Collectivity in the Work of the German Group Zero 1957-1966" (Ph.D. Dissertation, Yale University, 2008), 67. In footnote 161, Gibson states that "Uecker's nailing performance may even have been determined by the film: Gerd Winkler asserts that the idea of nailing the television was his, not Uecker's." See also Gerd Winkler, "Die Günther Uecker Story. Exclusiver Vorabdruck des 14. Kapitels aus 'Der Zero-Roman' von Gerd Winkler," *Kunst*, vol. 8/9 (1965): 163.

55 Mehring, "Television Art's Abstract Starts," 58–60.

56 Russell Connor, *Vision & Television*. Exhibition catalogue (Waltham, MA: Rose Art Museum, Brandeis University, 1970), n.p.

57 Farmer, "Pop People," 23.

58 Edith Decker-Phillips, *Paik Video* (Barrytown, NY: Barrytown, Ltd., 1998), 19.

59 McLuhan, *Understanding Media*, 315.

60 Although the photographs were shot between 1961 and 1962, they were not published until February 1963. Farmer, "Pop People," 24. Although he does not state it, Farmer makes the convincing case that 1963 is the year that television appears as a pervasive cultural influence in the work of artists.

61 Lee Friedlander, "The Little Screens," Fraenkel Gallery, New York, http://fraenkelgallery.com/exhibitions/the-little-screens-2 (accessed 2014).

62 Farmer, "Pop People," 55–64.

63 The exhibition occurred from March 11 to 20, 1963. The principal resources on the exhibition are Wulf Herzogenrath, ed. *Nam June Paik. Werke 1946-1976. Musik-Fluxus-Video.* Exhibition catalogue (Cologne: Kölnischer Kunstverein, 1976); Will Baltyer and Alfons W. Biermann, eds. *Treffpunkt Parnass Wuppertal 1949-1965.* Exhibition catalogue (Cologne: Rheinland-Verlag, GmbH in Kommission bei Rudolf Habelt Verlag GmbH, 1980); and Decker-Phillips, *Paik Video.*

64 Wolf Schön, "Viel Klamauk—wenig Einfälle. Junger Koreaner wollte schockieren—Zurück blieb ein schales Gefühl," *Wuppertaler Stadtnachrichten* (March 15, 1963). ZADIK A5, VIII, 65. The only thorough discussion of Jährling's gallery is Baltzer and Biermann's, *Treffpunkt Parnass Wuppertal 1949-1965.*

65 Decker-Phillips, *Paik Video*, 32.

66 Nam June Paik, "Beuys Vox Paik," in *Fluxus Today and Yesterday*, edited by Johan Pijnappel (London: Academy Editions, 1993), 54.

67 Tomas Schmit, who collaborated with Paik on the installation, published a thorough description and photographs in "Exposition of Music," in Herzogenrath, *Nam June Paik. Werke 1946-1976,* 66–85. The most comprehensive archival source on Paik's exhibition is the collection of Rolf Jährling and Jean-Pierre Wilhelm in the Zentralarchiv des internationalen Kunsthandels, Cologne. Their holdings on Paik are published in *Sediment: Mitteilungen zur Geschichte des Kunsthandels,* heft 9 (2005). See "Exposition of Music—Electronic Television, Nam June Paik, Galerie Parnass, Wuppertal, 11.20.3.1963," 65–79. See also Susanne Neuburger, ed. *Nam June Paik Exposition of Music Electronic Television* (Wien: Museum Moderner Kunst Stiftung Ludwig, 2009).

68 Wolf Schön, "Viel Klamauk—wenig Einfälle," ZADIK A5, VIII, 65.

69 Decker-Phillips, *Paik Video*, 36.

70 Dieter Daniels points out that just after the Paik exhibition, Germany opened its second broadcast channel and began to expand the hours. Daniels, Dieter, "Television—Art or Anti-Art?"

71 John Anthony Thwaites, "Der Philosoph und die Katze. Nam June Paik in der Galerie Parnass in Wuppertal," *Deutsche Zeitung* (April 9, 1963). ZADIK, A5, VIII, 65. Tomas Schmit amends the tale of Beuys's action in *Nam June Paik Exposition of Music Electronic Television Revisited*, 115–23. Schmit was an artist involved with Fluxus, who collaborated with Paik to create the installation at Galerie Parnass.

72 Schön, "Viel Klamauk."

73 Wilhelm had hosted Paik's first performance of "Homage a John Cage" in 1959 and, after closing his Düsseldorf Galerie 22 in 1960 due to his illness,

became the spokesperson for Fluxus. In his essay Wilhelm stressed that Paik had transcended the Wagnerian idea of the "Gesamtkunstwerk," had discarded all of the tonalities and systems of Western music, had passed through electronic music, and had embraced the totality of sound. ZADIK.

74 Karl Otto Götz, "Elektronische Malerei und ihre Programmierung," *Das Kunstwerk*, vol. 12/XIV (June 1961): 14–23. My original source for this information was Mehring, "Television Art's Abstract Starts," 33–36. In this article Paik also acknowledged the contributions of Swedish artists Knud Wiggen and his colleague Wolf Vostell.

75 Karl Otto Götz, correspondence with Nam June Paik (January 20, 1963). Nam June Paik Archive, Smithsonian American Art Museum, Box 2, Folder 1. The source of Götz's idea is László Moholy-Nagy's essay on "Production Reproduction" that he published in *Painting, Photography, Film*, (1969, orig. 1925), 30–31.

76 Nam June Paik, "Two Rails Make One Single Track," in *Otto Piene Retrospektive 1952-1996*, ed by. Stephan von Wiese and Susanne Rennert. Exhibition catalogue (Düsseldorf: Kunstmuseum Düsseldorf im Ehrenhof, 1996), 46.

77 Paik, "Beuys Vox Paik," 54.

78 Edith Decker-Phillips outlines a case that disputes Vostell's claim in her *Paik Video*, 41–50. Daniels agrees and contributes to the dialogue in his "Television—Art or Anti-Art?"

79 *Das Theater ist auf der Straße: Die Happenings von WOLF VOSTELL.* Exhibition catalogue (Museum Morsbroich Leverkusen und Museo Vostell Malpartida. Bielefeld: Kerber Verlag, 2010), 152.

80 Rudolf Frieling and Wulf Herzogenrath, eds. *40yearsvideoart.De*. Digital Heritage, Study Edition of Video Art in Germany from 1963 to the Present. Part 1, DVD 1, 1963–69 (Ostfildern: Hatje Cantz, 2006), 76–81.

81 *Das Theater ist auf der Straße*, 153–58.

82 Rudolf Frieling begins his informative essay, "VT = TV—The Beginnings of Video Art," www.medienkunstnetz.de/source-text/63/ (accessed 2011) with the statement, "The German press missed the birth of Video Art in Wuppertal in 1963." However, both the popular and the critical press generally acknowledged that they witnessed the transformation of consumer television into an artwork.

83 Siegfried Zielinski, *Zur Geschichte des Videorecorders* (Berlin: Wissenschaftsverlag Volker Spiess, 1986), 168. Zielinski notes on page 168 that the Sony Portapak (AB-3400) was released in Japan in 1967, but only reached the North American market in 1968.

84 David Antin, "Video: The Distinctive Features of the Medium," in *Video Culture, A Critical Investigation*, edited by John Hanhardt (New York: Visual Studies Workshop Press, 1986), 151.

85 Kathy Rae Huffman, "Video Art: What's TV Got To Do With It?," in *Illuminating Video: An Essential Guide to Video Art*, edited by Sally Jo Fifer and Doug Hall (New York: Aperture in Association with the Bay Area Video Coalition, 1990), 80–90.

86 Wayne Kostenbaum quoting Gerard Malanga quoted in Ric Burns, *Andy Warhol: A Documentary Film* (Steeplechase Films, Inc., 2006), Part 2, 1:13:30.

87 Callie Angel, "Outer and Inner Space," in *From Stills to Motion and Back Again: Texts on Andy Warhol's Screen Tests and Outer and Inner Space*, Geralyn Huxley, ed. (Vancouver, BC: Presentation House Gallery, 2003), 15.

88 In his flyer for the October screening of his first videos "Nam June Paik Electronic Video Recorder," Paik wrote that his first video was realized "through the grant of JDR 3rd (1965 spring term)" and that "it was the long long way, since I got this idea in Cologne Radio Station in 1961." He continued by referencing an early attempt to build his own video recorder: "I look back with a bitter grin of having paid 25 dollars for a fraud instruction 'Build the Video Recorder Yourself' and of the desperate struggle to make it with Shuya Abe last year in Japan." Flyer for "Nam June Paik Electronic Video Recorder" performance, October 4 and 11, 1965. Howard Wise Gallery Records (SC 17), folder 934 [2/2]. Harvard Art Museums Archives, Harvard University, Cambridge, MA. However, Paik's nephew Ken Hakuta relates a different accounting of the artist's purchase of a video recorder. "In 1962 or 1963, while he was living with us in Tokyo, Nam June brought home a Sony Port-a-Pak, the first commercially available portable videotape recorder. I remember playing with it and being enthralled by it. It must have been one of Sony's first units that would come on the market. It has been said that the first video art/recording in history took place in October 1965, when Nam June videotaped the visit of Pope Paul VI to the United Nations in New York, and he played it for friends at the Café Au Go Go in Greenwich Village. Some have claimed this account to be a myth, given that the first commercial Sony video recorder was not available in the United States until after that date. But I was with Nam June when he was experimenting with the Sony Port-a-Pak early in the decade at my house in Tokyo. How did Nam June have access to the Port-a-Pak? He was a good friend of Nobuyuki Idei, an executive at Sony who; later became its president. . . . I believe Mr. Idei wanted Nam June to have an early prototype of the Port-a-Pak. My uncle experimented with it in Tokyo and then took it with him to New York when he moved there in 1964." Ken Hakuta, "My Uncle Nam June," in *Nam June Paik: Global Visionary*, edited by John Hanhardt and Ken Hakuta (Washington, DC: Smithsonian American Art Museum in association with D Giles Ltd, London, 2012), 19–20.

89 Nam June Paik, *Button Happening* (1065), 2 minutes, black and white, sound. http://www.eai.org/title.htm?id=779

90 "Nam June Paik Electronic Video Recorder," flyer. October 4 and 11, 1965. Harvard Art Museums Archive. Series 2: Artist Reference File, Box 6 of 6, Howard Wise gallery records, c. 1960s–1980s, ARCH.2007.1, Misc. Light Artists [B]. The flyer does not list what videos were shown. I assume that he showed the *Button Happening* and the *Papal Parade* as they are the only known videos that he had produced at this time.

91 Nam June Paik, "Mayor Lindsay," (1965). http://www.medienkunstnetz.de/works/mayor-lindsay/

92 Woody Vasulka quoted in Peter Weibel, Woody and Steina Vasulka, and David Dunn, eds. *Eigenwelt der Apparate Welt: Pioneers of Electronic Art*. Exhibition catalogue (Linz, Austria: The Vasulkas in coordination with Ars Electronica, 1992), 110.

93 Press release "Announcing the opening of The Black Gate," (March 1967). Aldo Tambellini Archives, Salem, MA.

94 *Aldo Tambellini Cathodic Works 1966-1976*. DVD Von Archives, (2012), VON014.

95 Youngblood, *Expanded Cinema*, 313–14.

96 Tambellini, Aldo, "Electromedia: On Impermanency," typescript of a symposium at the Black Gate Theater (January 15, 1968). Aldo Tambellini Archives, Salem, Massachusetts.

97 Otto Piene, correspondence with Aldo and Elsa Tambellini (August 6, 1968); Otto Piene, correspondence with the Polizeipräsident der Stadt Düsseldorf (September 4, 1968). Knoth, Stadtvermessungsamtmann Düsseldorf, correspondence with Otto Piene (September 5, 1968); Otto Piene Archives. Black Gate Düsseldorf was performed on the banks of the Rhine in Oberkassel on September 9, 1968.

98 Heinz Mack and Hans Emmerling, *Tele-Mack*, (1968–69), 45 minutes, color, sound. Saarländischen Rundfunks und des WDR, Westdeutsches Fernsehen. Heinz Mack Archives, ZERO Foundation, Düsseldorf.

99 *Mack. The Sky over Nine Columns*, Fondazione Georgio Cini, Venice, 2011. Press release from Beck & Eggling International Fine Art, Düsseldorf.

100 Wibke von Bonin in conversation with the author (June 1, 2017). See also Ulricke Groos, Barbara Hess, and Ursula Wevers, eds. *Ready to Shoot: Fernsehgalerie Gerry Schum*. Ausstelungs Katalog (Düsseldorf: Kunsthalle Düsseldorf, 2003), 19.

101 "The Public Broadcasting Act of 1967, as amended," http://www.cpb.org/aboutpb/act/

102 James A. Nadeau, "The Medium is the Medium: the Convergence of Video, Art and Television at WGBH (1969)," (MS Thesis, MIT, 2006), 31–2.

103 The KQED experimental television program in San Francisco produced important work in this field. Yet, it was not connected with the European ZERO network or the artists involved in the New Tendency circles; therefore, it falls outside of the purview of this study.

104 Fred Barzyk, "Paik and the Video Synthesizer," in *Fred Barzyk: The Search for a Personal Vision in Broadcast Television*. Exhibition catalogue (Milwaukee, WI: Haggerty Museum of Art, 2001), 73.

105 Brian O'Doherty, "Barzyk Electronic Visionary," in *Fred Barzyk,* 33.

106 Joseph Ketner, interview with Fred Barzyk (March 9, 2017). See also Silvio Gaggi, "Sculpture, Theater and Art Performance: Notes on the Convergence of the Arts," *Leonardo*, vol. 19, no. 1 (1986): 45, and references to the theater of the absurd in Chapter 4.

107 Brian O'Doherty, "Barzyk Electronic Visionary," in *Fred Barzyk,* 33.

108 Fred Barzyk, "Paik and the Video Synthesizer," in *Fred Barzyk,* 65.

109 The MS Thesis of James A. Nadeau, *The Medium is the Medium,* is a useful, but not always an accurate discussion of the program.

110 Frieling, "VT = TV—The Beginnings of Video Art."

111 Daniels, "Television—Art or Anti-Art." The most comprehensive catalogue on the Fernsehgalerie is Ulrike Groos, Barbara Hess, and Ursula Wevers, eds. *Ready to Shoot: Fernsehgalerie Gerry Schum videogalerie schum*. Exhibition catalogue (Düsseldorf: Kunsthalle Düsseldorf, 2004).

112 Frieling and Herzogenrath, *40jahrevideokunst.de.*, 104–109.

113 Gerry Schum, "Land Art." http://www.medienkunstnetz.de/works/land-art/
114 The Howard Wise Gallery, New York, hosted *TV as a Creative Medium*
 from May 18 to June 14, 1969. Ira Schneider's "TV as a Creative Medium,"
 (1969/2001), is an 11:40 videotape with sound that provides Schneider's
 view point on the installation of the exhibition at the Howard Wise Gallery.
 Courtesy of Ira Schneider and Aldo Tambellini.
115 See Joseph D. Ketner II, "Against the Mainstream: Howard Wise and the
 New Artistic Conception of the 1960s," in *Howard Wise: Exploring the New*.
 Exhibition catalogue (Berlin: Moeller Fine Art, 2012).
116 The first quote is from Willoughby Sharp. Frank Gillette viewed Wise as "one
 of the people who is responsible for the idea of an alternative television"
 quoted by Marita Sturken in "TV as a Creative Medium: Howard Wise and
 video Art," *Afterimage*, vol. 11, no. 10 (May 1984): 5.
117 *TV as a Creative Medium*. Exhibition catalogue (New York: Howard Wise
 Gallery, 1969), n.p.
118 Yalkut, "TV as a Creative Medium," 20.
119 Nam June Paik-Charlotte Moorman, "TV Bra for Living Sculpture," in *TV as
 a Creative Medium*, n.p.
120 Stephanie Harrington, "TV: Awaiting a Genius," *The Village Voice* (May 29,
 1969).
121 Joseph D. Ketner II, "Electromedia," in *Aldo Tambellini Black Zero*.
 Exhibition catalogue (New York: Boris Lurie Art Foundation and the Chelsea
 Art Museum, 2011), 45.
122 *TV as a Creative Medium*, n.p.
123 Margolies, "TV-The Next Medium," 48.
124 Harrington "TV: Awaiting a Genius."
125 Barbara Rose, "Television as Art, 'inevitable'," *Vogue* (August 15, 1969): 36
 quoted in Marita Sturken in "TV as a Creative Medium: Howard Wise and
 video Art," *Afterimage*, vol. 11, no. 10 (May 1984): 8.
126 Connor, *Vision & Television*, n.p
127 "Russell Connor with Eleanor Heartney," *The Brooklyn Rail* (December
 6, 2016). http://brooklynrail.org/2016/12/art/russell-connor-with-eleanor-
 heartney
128 Nam June Paik, "9/23/69: Experiment with David Atwood." http://www.eai.
 org/title.htm?id=3271
129 Barzyk, "Paik and the Video Synthesizer," 74–75.
130 KQED was one of the earliest educational television stations to explore
 experimental television programming with artists. They were, along with
 WGBH, recipients of the Rockefeller Foundation "Artists-in-Television" fund
 and eventually formed the National Center for Experiments in Television.
 However, KQED did not work with the artists who are the subject of this
 manuscript.
131 Nadeau, "The Medium is the Medium," 3.
132 *Experimental Television Center, 1969-2009*. DVD and Catalogue (Owego,
 NY: Experimental Television Center, 2009), 16–17.
133 *Radical Software: The Alternative Television Movement*. No. 1 (1970),
 publisher's page.
134 *Radical Software*, 2.
135 Ketner, "Electromedia," 46.

CHAPTER SEVEN

Coda

By 1970 the second generation of postwar artists involved in ZERO and the new tendencies were officially recognized for their work in a variety of international fora, confirming that they had transitioned from a rebellious avant-garde that began around 1955 to become part of artistic discourse. In 1970, a decade after Piero Dorazio won the Prize for a Young Painter at the Venice Biennale in 1960, the German Pavilion featured the work of the remaining German contingent of the former Group ZERO, Heinz Mack and Günther Uecker at the Venice Biennale. They were established artists, or, in the words of Gerd Winkler, journalist for Hessian Broadcasting, they had become "the classics of modern art."[1] At the same time the subsequent generation of younger artists—the third postwar generation—began to assert their presence, responding to the sociopolitical ferment of the late 1960s, asking questions of their elders, and forcing intense debates over the subsequent course of artistic practice. A sequence of international exhibitions marked the tumultuous transition from ZERO and the new tendencies to the third postwar generation between 1968 and 1970: the Venice Biennale (1968 and 1970); *documenta* (1968); the *Prospect* exhibitions (1968 and 1969); the *Conceptual art. Arte Povera. Land Art* exhibition at the Modern Art Museum, Turin (1970); and the World's Fair in Osaka (1970).

A few tense months after the student riots erupted in Paris and New York in 1968, the Venice Biennale was greeted with violent protests. Only two weeks later on June 27, 1968, Arnold Bode opened his fourth and final *documenta* as a survey of contemporary art during the 1960s. After the rocky European reception to Rauschenberg receiving the Golden Lion at the 1964 Venice Biennale, the protests in Venice and Kassel in 1968 were decidedly anti-American and anti-Vietnam. The *documenta* administration chose approximately 150 artists for its international survey, nearly 60 from North America, only 18 of whom were German, and only a few among the Group ZERO and new tendency artists of the previous decade. Because of the prominence of the Americans Richard Anuszkiewicz, James Rosenquist,

and Warhol, this exhibition has become recognized as the Pop and Op art *documenta*. The artists' perception that the *documenta* selection was imbalanced, combined with the rebellious climate of the moment, destined the fourth installment of the quinary exhibition to be a site of protest.

Conspiratorial parties accused the *documenta* administration, as they had the Biennales, of succumbing to the overweening market influence of American art dealers. Numerous invited artists, including César and Martial Raysse (formerly a Nouveaux Réaliste) and Julio Le Parc and François Morellet (formerly in GRAV), threatened to withdraw their works because the selection process was not "free and objective." At a public forum convened by the *documenta* administration to discuss the controversy, Wolf Vostell and Jörg Immendorff staged a protest. Vostell wore an armband indicating that he was blind, and stridently argued against a selection purporting to represent the 1960s that could exclude Fluxus, happenings, environmental art, the Capital Realists, and ZERO. He argued that such an exhibition selection was only for the blind who could not see what had been happening over the past decade. In particular, he was disturbed that the Americans had received such extended representation. His travels in the United States, he claimed, "taught him that the actual modern impulses come from Europe."[2]

The ZERO artists had been involved in protests to attract the attention of the *documenta* administration at the second and third presentations in 1959 and 1964, belatedly earning admission to the third because of the intercession of Rochus Kowallek and Alfred Schmela. The very nature of Vostell's protest recalled the previous ZERO disputes with *documenta*. Yet, among the works submitted to *documenta*, the influence of ZERO and new tendencies was evident. Although art history viewed the 1968 *documenta* as dominated by Pop and Op art, the German reviewers noted the substantial presence of the kinetic light movements of the 1960s, including Christo, Le Parc, and Morellet.[3] Christo, for example, had been involved in the Nouveaux Réalistes and ZERO exhibitions and presented a helium balloon to generate spectacle, recalling Klein's balloons and Piene's inflatables.

In opposition to the official discourse on contemporary art presented in Kassel and Venice, Konrad Fischer and Hans Strelow jointly curated an exhibition they titled *Prospects* in September 1968 at the Düsseldorf Kunstverein. In their curatorial selection these two distanced themselves from historical surveys of the 1960s and introduced the third generation of international artists who were practicing minimal and conceptual art, including Marcel Broodthaers, Bruce Nauman, and Blinky Palermo. Fischer had been a practicing artist under his family name Lueg, working with his colleagues from the Düsseldorf Art Academy, Sigmar Polke and Gerhard Richter as the Capital Realists. In 1967 Konrad Lueg opened an art gallery next door to his friend Uecker's club *Creamcheese*, and changed to his mother's maiden name Fischer as a curator and art dealer. Instead of showing the work of his colleagues and friends, he launched his gallery with an exhibition of Carl Andre in October 1967, following with exhibitions of

Hanne Darboven, Sol LeWitt, Bruce Nauman, and Robert Smithson. For *Prospect* Fischer and Strelow made a prescient selection of artists, introducing international minimal and conceptual art to Europe. They continued to present these artistic directions with a second *Prospect* in September 1969, directions that Harald Szeemann confirmed in his exhibition at the Bern Kunsthalle, *When Attitudes Become Form* (March 1969).[4]

While the third-generation artists were introduced to Europe through the exhibitions organized by Fischer and the Fernsehgalerie of Gerry Schum, it was Germano Celant who curated an ambitious survey of *Conceptual art. Arte Povera. Land Art* at the Modern Art Museum, Turin (1970). In this exhibition Celant not only presented the artists who practiced minimal, conceptual, and land art, but also made visible links to the European art of the early 1960s with the inclusion of Joseph Beuys, Christo, Yves Klein, and Piero Manzoni.[5] This occurred simultaneously with Kynaston McShine's *Information* exhibition at the Museum of Modern Art (1970), where he curated an international assembly of artists who he felt utilized art as vehicles for communication and information.[6] The exhibition included a cross section of the younger generation, including several who had participated in ZERO, notably Hans Haacke. Haacke applied his ideas of natural and biological systems from his ZERO-related projects to social and political systems. At the entrance of the *Information* exhibition, he situated a voting booth asking visitors whether to vote for or against incumbent Governor Nelson Rockefeller in consideration of his support for President Richard Nixon's Indo-China policies. Visitors overwhelmingly voted against Rockefeller, a member of the museum board, generating a powerful political backlash. Subsequently, Guggenheim Museum director Thomas Messer canceled Haacke's scheduled retrospective the following year (1971).

In contrast to the tempest of the 1968 Biennale and *documenta*, the response to the 1970 Biennale was relatively tame. Strelow accused Werner Schmalenbach, director of the German Pavilion, of having made a lame selection by nominating four artists who represented artistic conventions: Mack and Uecker, formerly in ZERO, and Pop sculptors Thomas Lenk und Georg Karl Pfahler. Winkler found Schmalenbach's choices disingenuous in light of the fact that Schmalenbach did not include these artists in the art collection of the state of Nordrhein-Westfalen, of which he was director. In a review of the German Pavilion aired on the North German Broadcasting, the journalists informed their viewers that anyone who had seen *Prospect* or *documenta* need not bother to attend, because there were "no new aspects or tendencies in art to report." Winkler concurred with the chorus of negative sentiment, noting that ZERO "had long since arrived." Even the efforts of the highly regarded German art commissioner Dieter Honisch could not compensate for Schmalenbach's lack of prescient choices. However, Honisch, aware of the emerging trends in art, chose to be prospective and noted, "In the next few years, the German art scene will be the most interesting in the world."[7]

The ZERO network of artists revived the art and technology tradition during the postwar period, but was evolving into its next phase by 1970, following the advancements in technology and the ascendancy of communications and information theory. Arguably, the consummation of postwar art and technology trends occurred in 1970 at the Osaka World's Fair, popularly known as Expo '70, the first World's Fair to be held in Japan after the Second World War. The Japanese selected a group of architects to reestablish their presence in world culture. Lead architect Arata Isozaki articulated the desire to produce the first "post-industrial" exposition "initiating a new century of design and planning and visitor participation."[8] Each of the participating countries called upon their architects, designers, and artists to create environments in which the interface was transparent and the visitors themselves could generate new levels of sensory experience. Early in the planning for the American Pavilion, Pepsi-Cola, the corporate sponsor, engaged Billy Klüver and the Experiments in Art and Technology (E.A.T.) organization to organize the artist-engineer collaborations necessary to realize the organizer's concept. Klüver and Robert Rauschenberg had formed E.A.T. to produce 9 Evenings in October 1966, an ambitious display of art, performance, and technology, at the 69th Regiment Armory in New York City.[9] Working with Robert Breer, David Tudor, and Robert Whitman, Klüver coordinated over 75 artists, engineers, and corporations to fabricate the American Pavilion, a domed structure in which the visitor experience "should involve choice, responsibility, freedom, and participation." With floating sculptures, fog machines, virtual imagery, and interactive sound environments, the pavilion was a participatory, sensory experience (Figure 7.1). The artists achieved a new level of the technological imaginary. They created what they believed was "a new form of theatre space, which completely surrounded the audience" and "the visitor became part of the total theatre experience."[10]

The idea of an immersive environment activated by electronic technologies to produce an interactive, multisensory experience directly extends from ZERO and the art and technology tradition. Piene had invoked the Bauhaus notion of the total theater by breaking down the staged barrier between the actor and the audience through the intermediary of light, projections, and sound, creating a transfer of energy via the senses. By this time, he and Mack had been creating immersive light environments for a decade, and, naturally, the groups involved in the Osaka World's Fair approached Mack and Piene to submit proposals. The organizers of the German Pavilion secured composer Karlheinz Stockhausen to conceive of an immersive sound environment that was housed in a Spherical Concert Hall with speaker systems built into the floor. The audience sat or lay on the floor to absorb the vibrations. Stockhausen recruited Mack, who worked with the physics institute at the University of Stuttgart, to wire the joints of the dome with light sources that were then connected to Stockhausen's sound system to respond to the dynamics of the music (Figure 7.2).[11] With reminiscences of Le Corbusier's

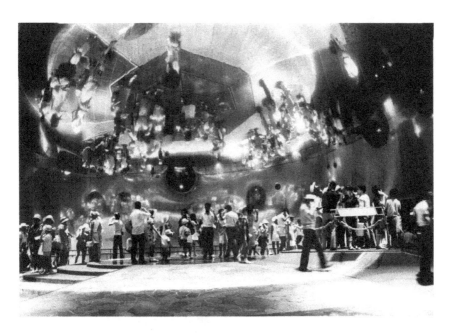

FIGURE 7.1 *Mirror Dome Room, Pepsi-Cola Pavilion, Expo '70, Osaka, Japan. Daniel Langlois Foundation. Collection of Documents Published by Experiments in Art and Technology (E.A.T.). Courtesy of E.A.T. and the Daniel Langlois Foundation. Photo: Shunk-Kender © J. Paul Getty Trust. Getty Research Institute, Los Angeles (2014.R.20).*

Philips Pavilion at the Brussels World's Fair (1958), Stockhausen created a total physical immersion in sound and light for over 1 million spectators who heard him perform *Spiral*, as well as recorded music over the 180 days of the fair.[12]

Simultaneously, Piene was also collaborating with Stockhausen to produce Sky Art events orchestrated to the composer's sound for the Osaka World's Fair. However, Piene's proposal was rejected by the German administration, in Stockhausen's words, due to "inner-German politics." However, they had another opportunity to collaborate when Maurice Tuchman of the Los Angeles County Museum of Art (LACMA) approached Stockhausen about participating in their Art and Technology program. Stockhausen responded to the invitation to state that he had an unrealized project to work with Piene to "combine sound (on multi-channel tape) with the movements of his air-sculptures in a really meaningful polyphony," which promises to be "a wonderful thing, if he can get Piene."[13]

As the curator of modern art at LACMA, Tuchman organized the Art and Technology program as a mechanism for getting the profusion of high-tech industries in Southern California involved in the museum and with

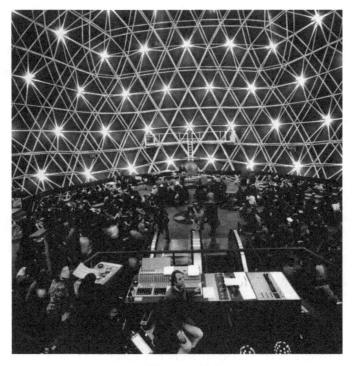

World Fair Expo '70 in Osaka, Japan
(March 14th to September 15th 1970);
In a spherical auditorium designed by Stockhausen,
20 instrumentalists
and singers performed 51/2 hours daily for 183 days most of
Stockhausen's works which had been composed until 1970
for more than a million listeners.
Photograph: Stockhausen at the mixing console.

FIGURE 7.2 *Stockhausen Performing at Expo '70, West German Pavilion, Osaka, Japan.* © *Stockhausen Foundation for Music, Kuerten.*

artists. He launched the program in 1967, parallel to E.A.T. in New York, and recruited twenty-three artists to work with a host of corporations. The original plan was to present the results of these collaborations in an exhibition in 1970; however, the timing conflicted with the Osaka World's Fair. Tuchman negotiated an agreement with the fair organizers to postpone the Los Angeles exhibition until 1971 and to contribute eight of the projects he organized to the American Pavilion. In the *Report* published on the occasion of the *Art and Technology* exhibition, Jane Livingston made the point that the premise of Tuchman's Art and Technology program was not the realization of a utopian union of art and technology in the service of humanity as pursued by the Bauhaus and Group ZERO. She observed that by the late 1960s artists were suspicious of corporate control of technology and viewed their collaborations as related to information theory and a "systems" approach to art making.[14]

Unfortunately, the reality of corporate control of technology did restrict the participation of some artists in the Art and Technology program and caused a dispute between Pepsi-Cola and E.A.T. in Osaka. Piene and Stockhausen were unable to realize their proposed Sky Event due to the extraordinary expense and logistics of realizing the high-tech materials for the massive inflatables and the high fidelity and power requirements of the exterior sound installation. No corporation was willing to assume the cost and effort. However, both Piene and Stockhausen were independently able to realize related projects later: Piene's *Sky Kiss* with Charlotte Moorman in 1982 (Figure 7.3)[15] and Stockhausen's *Helicopter Quartet* in 1995. Despite its success in securing many corporate collaborators, the Art and Technology program also felt the repercussions of the issues of control and copyright

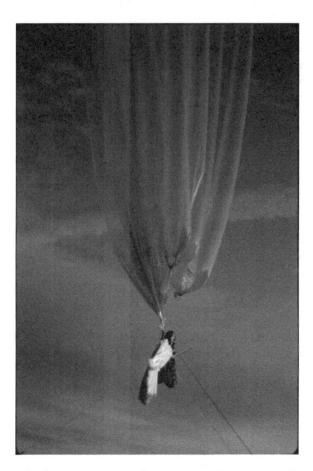

FIGURE 7.3 *Charlotte Moorman performing,* Sky Kiss *(Jim McWilliams), at Sky Art Conference in Linz, Austria, 1982. Photo: Elizabeth Goldring. © Massachusetts Institute of Technology. Courtesy Center for Advanced Visual Studies Special Collection, MIT Program in Art, Culture and Technology.*

that plagued the Pepsi Pavilion in Osaka. As the Pepsi Pavilion prepared for opening in March 1970, the Pepsi Corporation assumed control of the pavilion and its contents, violating the artists' perception of their proprietary rights to their creations. Klüver explained that the company had rushed the artists into production and the issue of the copyright and control over their creations was not addressed. In negotiating a settlement Klüver proposed that the two parties agree upon a "legal distinction between a work of fine art and a commercial product, or more specifically between the creative artist and the commercial artist or designer."[16] Pepsi-Cola did not agree to these terms and commandeered the Pavilion from the artists, utilizing the commissioned artwork for promoting their product, generating considerable discontent among the participating artists.

The various pavilions at the Osaka World's Fair employed advanced technology to produce extraordinary art environments that generated sensory, phenomenological experiences to a degree previously unrealized. The deployment of electrical, optical, and aural waves and new metal alloys created an environment in which the interface became invisible to the spectators. By this time, digital, computer, and satellite technology superseded the technology of the late 1950s. By the mid-1960s artists began to gain access to advanced digital technology and embarked on the creation of virtual realities, yet another dimension of the technological imaginary. Frieder Nake and Georg Nees in Stuttgart and A. Michael Noll and Kenneth Knowlton at Bell Labs in New Jersey had begun to develop computer-imaging capabilities in 1963. Stan VanDerBeek, pushing the dimensions of technology as a communication tool, joined with Kenneth Knowlton at Bell Labs to write programming for moving images and created among the earliest computer-animated films. Vera Molnar distanced herself from the group GRAV in order to pursue her ambition to use computers to create images, "never seen before, neither in nature nor at a museum: It helps to create inconceivable images."[17] The Zagreb New Tendency group evolved into "Computers and Visual Research" in 1968, focusing on computer- and systems-generated art and launching the magazine *Bit international*. All of these tendencies stemmed from the art and technology and kinetic art revival beginning in the late 1950s, and grew with the philosophical foundation of communications and information theory. After a number of smaller gallery presentations, the advances of digital technology became the subject of two art exhibitions that announced the emergence of computer art: *Cybernetic Serendipity* (1968) at the ICA, London, and *Software* (1970) at the Jewish Museum in New York.

Piene regretted that the Osaka World's Fair and the Art and Technology program rejected his project with Stockhausen. He viewed this moment as the end of the first phase of the postwar art and technology movement that he and many of his ZERO colleagues had initiated.[18] Not only had the technology evolved beyond the practices of the ZERO artists, the ideology of linking art, man, and technology was questioned after the civil rights and political

protests of the late 1960s and was no longer relevant in the face of potential nuclear holocaust wrought by technology. The phenomenological basis of ZERO's artistic experience had evolved into conceptual "systems" that employed information and communications theory to articulate the role of art as a means of communicating ideas. As Manfred Schneckenburger observed,

> In 1970 [*sic*, 1971] the exhibition "Art and Technology" at Los Angeles signaled the denouement. Why should I conceal the fact that thereafter the official art life was rather open to currents removed from technology, indeed hostile to it. . . . Of the boundless optimism, the spirited alliance with technology, and a tendency towards lightning storms of light, there would soon remain for Laszlo Glozer only "the rusting rubble of applied Utopia."[19]

The times had indeed changed. Mack reflected on this period when he grappled with the reality that current events, the assassination of political figures, Vietnam, and the student protests "offset the optimism that everything is 'doable'" and caused him to adjust his utopian beliefs in a new dynamic relationship between nature, technology, and art.[20]

In the years after the three primary German organizers of Group ZERO disbanded in 1966, each of them pursued independent paths. Piene became a fellow at György Kepes's Center for Advanced Visual Studies (CAVS) at MIT in 1967, its director in 1974, and for three decades pursued his ideal of a Sky Art, continuing to advance his earliest principles, "My greatest dream

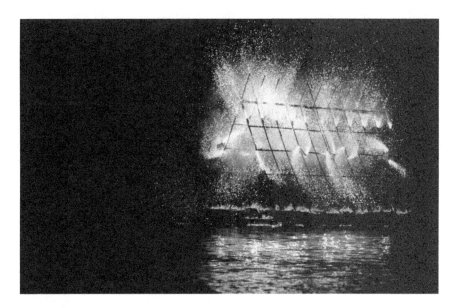

FIGURE 7.4 *Heinz Mack,* Feuerschiff, *1968/2010. Photo: Norbert Zitz. Atelier Mack. © 2017 Artists Rights Society (ARS), New York/VG-Bildkunst Bonn.*

is the projection of light into the vast night sky . . . the world of space is the only one to offer man practically unlimited freedom."[21] Mack announced his individual artistic identity with the publication of his *Mackazin* in 1967, summarizing his accomplishments and presenting proposals to take his concept of land art into nature and urban landscapes in what he called Ars Urbana.[22] He continued to create spectacular actions involving light, but with the realization of a new sociopolitical reality tempering his idealism that added a critical edge to his artist's actions (Figure 7.4). Uecker was profoundly moved by the student protests of 1968 against Vietnam, evoking memories of his youthful experience of war. He pursued the study of world religions seeking to answer the question why humanity perpetuated its cruelty. His performances at this time manifest his frustration as a child of the Second World War (Figure 7.5). For Uecker the inhumanity that he witnessed was embodied in the memorial at Auschwitz:

> All the evidence of the existential threat to mankind is gathered here. . . . Men are being destroyed by men. . . . The proportion between the accumulation of human beings and what survives of them disappoints the notion of beauty.
>
> What remains after the fleeting shadow of the incinerate beings? A dark memory, a light hope, a disillusioning truth.[23]

The Second World War profoundly shaped the worldviews of everyone who witnessed it. Artists of the second postwar generation possessed a profound need to move beyond the culture of their fathers represented by modern art. In conversation with Wieland Schmied for the 1965 Kestner-Gesellschaft exhibition, Piene recognized the significant differences between the first postwar generation, who experienced the war as adults, and the children of the war. The former tried to purge their anxieties through the materials on the canvas, whereas the younger generation wanted to leave that past and pursue "unlimited possibilities to design a better, a brighter world" than the one they inherited.[24] The second generation questioned modern art, particularly painting, as a valid form of expressing the altered realities of post–Second World War Europe. But the problem was not painting as a medium. Rather, the problem was painting as the bearer of a cultural history that was disparaged. Painting regained vitality in the post-historical contemporary art world. For the postwar Europeans and Americans it was the emblem of a culture that must be overturned. Rejecting this model of culture and turning to other means for fashioning postwar art was in itself a rebellious act. As Max Ernst, painter of the visionary surrealist image of *Europe after the Rain*, remarked, "The creation of a work of art, regardless of its final outward appearance, was inevitably also a political act."[25]

Through the pages of this manuscript I reconstructed a narrative of artistic transformation in Europe between approximately 1955 and 1970 by drawing upon the voices of the artists, their critics, and their contemporaries.

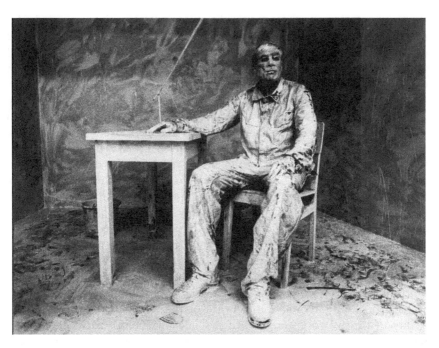

FIGURE 7.5 *Günther Uecker,* Black Room White Room, *1972/75. © 2017 Artists Rights Society (ARS), New York/VG-Bildkunst Bonn. Foto: Lothar Wolleh.*

This manuscript narrates the substantive contributions of artists involved in Group ZERO and the new tendencies as an addition to the received history of postwar art. Around 1955 Mack, Piene, and Uecker embarked on their trajectories as artists, a rather audacious choice during the reconstruction of Germany. Reflecting on the postwar German environment of his youth, Mack recalled that it was "a kind of poorhouse, comparatively speaking; in the back yard, surrounded by ruins, we were enclosed by a cultural cemetery, an information vacuum that is unimaginable today."[26] Enmeshed in the trauma of cultural desolation, these German artists questioned the culture bequeathed to them. In response, they navigated a path beyond modern art, particularly painting, and created a new model, to borrow from Bois. Cultivating associations with other second-generation artists across Europe, they formed Group ZERO and a network of other new tendency groups that fashioned a variety of artistic strategies that transcended painting. The visual experience that they created manifest in a variety of forms and new media, including monochrome painting, kinetic art, assemblage, performance, technology, and environmental installations. At this time we witness the dematerialization of the art object into ephemeral, sensory experiences in which the artist's hand is no longer in evidence. In the course of a long decade they introduced some fundamental changes to

the visual arts, incorporating nontraditional materials and new technologies that divorced the artistic enterprise from the mark, the touch and individual expression. They developed an artistic practice that abandoned the easel and the studio and moved into the public sphere, transforming the function of art.

The scope of the pan-European artistic network encompassed by ZERO and the new tendencies was diverse, bringing together artists who worked in divergent styles, and drew from diverse sources for their work from Duchamp and Dada, to László Moholy-Nagy and the Bauhaus. Yet they shared similar artistic sentiments beyond simply rebelling against gestural painting. They all sought a new vocabulary of media and forms to address their evolving postwar conception of reality. Employing a theoretical foundation of phenomenology the artists transformed the artistic experience from the contemplative objet d'art to a sensory one, diverging from the idea of the artist's hand as conveying artistic authority, to create a remarkable confluence of image, energy, sound, and physical experience, transforming the perception of artistic reality from an observed world into one of sensory experience. Pierre Restany advocated that art embark on "the passionate adventure of the real" (1960), meaning the reality of postwar consumer culture, while the ZERO artists worked to harmonize man, nature, and technology in phenomenological experiences that sought to convey the postwar physics and electronic reality. Their mutual aspiration was to stimulate spectators' senses with sight, sound, and touch and, thereby, animate the spectator's engagement in the artistic experience. Their goal was to bring about awareness and understanding of physical reality that transcended painted representations of objects or abstracted emotions.

ZERO and new tendency artists introduced a host of new media and ideas into art. They appropriated the interwar Bauhaus and Dada forms and content, not blindly copying the past styles as a neo-avant-garde, rather crafting an artistic expression from these models that was relevant to their generation. ZERO altered the course of visual arts, helped reestablish Düsseldorf as a center of art,[27] a position the city has maintained through Beuys, Richter, the Bernd and Hilla Becher, and Markus Lüpertz, and to link artistic practice across international geopolitical boundaries.

The first postwar generation needed the emotional exorcism of *art informel*. The second generation sought a path beyond painting to renew artistic enterprise. They did not advocate an artistic practice based on style. They ignored the hierarchy of materials, media, and subjects, and emphasized the artistic process, concept, and perceptual results. The overriding concept was the creation of the physical, sensory experience that they materialized in a variety of forms and media. The medium did not matter. Piene clarified that "Group ZERO is . . . only a human relationship among several artists and an artistic relationship among different individuals . . . without killing our spirit by the fixed terms of a program."[28]

Each of these artists introduced some of the key tenets of contemporary art. By advocating that the medium and execution were not important, rather it was the idea, they not only liberated art from traditional ideas of style, they dramatically expanded the definition of what constitutes a work of art, embracing assemblage, mediated images, and new technology. They assumed interdisciplinary and collaborative approaches to art. Artists of this era introduced the idea that art was not just self-reflective—like abstract expressionism—but could critically question the basic premise of art, and the artistic process became "a charged proposition about the nature and limits of art itself."[29] Pursuing this approach they altered the material forms and the studio practice of making art, catalyzing the transition away from modern art, establishing some of the basic principles of contemporary art, and providing the precedent for the development of Fluxus, minimal, conceptual, land art, and new media art in the 1960s forward.

With echoes of Alexander Dorner, Michel Tapié and Arthur Danto proposed that this cultural transformation of the 1960s was a defining moment that marked the "the end of art."[30] Danto was not proposing the end of the creation of art, rather the end of a linear historical progression from mimicry of nature and abstract modernism to what he described as "post-historical" art. From this point forward, art was no longer bound by a historical progression of styles, materials, or format. The end of the historical phase of art occurred in the wake of ZERO. Each of the second-generation postwar artists discussed in these pages contributed to dismantling the master narrative of modernism and led to what we now know as contemporary art. In the early 1970s the term "contemporary" began to displace the use of the word "modern" to define the art beginning with the third postwar generation. The term "Modern" came to define a style, typically abstract art, and a time period, the early twentieth century. Contemporary art, on the other hand, means more than simply being made in the present, or the "style" of the present; it is the art that responds to the distinctive aspects of the present. It is an attitude about the conception, creation, and reception of art that addresses issues distinctive to our moment. It is based upon an idea or a concept that is a critical reflection on our condition and addresses fundamental questions of reality and our existence. And in so doing the material manifestation of contemporary art is diverse. Contemporary art is heterogeneous. It is both the subject and the condition of much contemporary art.[31] In considering the qualities that constitute contemporary art, one can appreciate the formative role of the second-generation of postwar European artists in conceiving the principles that are the foundation of contemporary art.

When looking back from the position of contemporary art, the significance of ZERO and the new tendency artists of the second generation become more pronounced. Bertolt Brecht writing during the midst of the Second World War recognized that his generation was guilty of the trauma and misery that surrounded him. He addressed this poem "To those born later,"

the so-called grandchildren of the war, the third postwar generation, who had no direct experience of the war, but who he knew would question the previous generations. He began by reminding them, "Truly, I live in dark times" (1940),

> You who will emerge from the flood
> In which we have gone under
> Bring to mind
> When you speak of our failings
> Bring to mind also the dark times
> That you have escaped
> But you, when the time comes at last
> When man is helper to man
> Think of us
> With forbearance.[32]

With this message, Brecht asked that his successors consider the extraordinary circumstances through which he lived, an era that wrought death and destruction. However, the third generation of Brecht's vision did not live to see a time "when man is helper to man." Rather they matured with the very real potential of atomic holocaust. The second generation witnessed the disgrace of Europe as civilization's greatest cultural achievement and accepted the challenge to attempt to formulate new models of artistic practice that they, in turn, bequeathed "to those born later."

Notes

1 Gerd Winkler, "Wenn aus Avantgardisten Klassiker werden. Die Gruppe 'Zero' und die Folgen," *Frankfurter Allgemeine Zeitung* (August 15, 1969). Otto Piene Archives.
2 Rudolf Krämer-Badoni, "Bekenntnis zu Pop und Lichtkinetik. Vorbesichtigung der 'Documenta'; Wolf Vostell protestiert gegen die Auswahl," *Die Welt* (June 28, 1968). ZADIK, Zentral Archiv des internationalen Kunsthandels, Köln, Kritikerin Anna Klapheck Zeitungsausschnitte, 1959–75, G1, IX, 005. The same article reports that they actually did not withdraw their works, but kept them in their respective national pavilions.
3 Krämer-Badoni, "Bekenntnis zu Pop und Lichtkinetik."
4 Benjamin Buchloh, Rudi Fuchs, Konrad Fischer, John Matheson, and Hans Strelow, eds. *ProspectRetrospect. Europa 1946-1976*. Exhibition catalogue (Düsseldorf: Kunsthalle, 1976), 107, 119, 124, and 132.
5 Tony Godfrey, *Conceptual Art* (London: Phaidon, 1998), 209.
6 Press Release, *Information*, The Museum of Modern Art, New York, no. 69, Thursday, July 2, 1970.

7 Gerd Winkler, "Weltmeisterschaft ohne Tore. 35. Kunstbiennale Venedig: Keine
 Preise, Konvention und die Hoffnung auf Reform," *Stuttgarter Nachrichten*
 (July 10, 1970): 19. ZERO Foundation, Düsseldorf.

8 Isozaki paraphrased by Nilo Lindgren, "Into the Collaboration," in
 Experiments in Art and Technology: Pavilion, edited by Billy Klüver, Julie
 Martin and Barbara Rose (New York: E.P. Dutton, 1972), 4.

9 Catherine Morris, ed. *9 Evenings Reconsidered: Art, Theater, and Engineering,
 1966.* Exhibition catalogue (Cambridge, MA: MT List Visual Arts Center, 2006).

10 Billy Klüver, "The Pavilion," in *Experiments in Art and Technology: Pavilion*,
 ix, x.

11 *Heinz Mack. Licht-Raum-Farbe. Light-Space-Colour.* Exhibition catalogue
 (Bonn: Kunst- und Ausstellungshalle der Bundesrepublik Deutschland,
 2011), 34.

12 Karlheinz Stockhausen, "Spherical Concert Hall," http://www.
 medienkunstnetz.de/works/stockhausen-im-kugelauditorium/

13 Maurice Tuchman, ed. *A Report on the Art and Technology Program of the
 Los Angeles County Museum of Art, 1967-1971.* Exhibition catalogue (Los
 Angeles: Los Angeles County Museum of Art, 1971), 322.

14 Jane Livingston, "Thoughts on Art and Technology," in *A Report on the Art
 and Technology Program of the Los Angeles County Museum of Art* , 43–47.

15 For more on Piene's Sky Art see Susanne Rennert and Stephan von Wiese, *Otto
 Piene. Sky Art 1968-1996* (Köln: Wienand, 1999).

16 Klüver, "The Pavilion," in *A Report on the Art and Technology Program of the
 Los Angeles County Museum of Art*, xv.

17 Vera Molnar, *Lignes, Formes, Couleurs.* Exhibition catalogue (Budapest:
 Vasarely Museum, 1990), 16.

18 Joseph Ketner, interview with Otto Piene, December 6, 2009.

19 Glibota, *Otto Piene*, Paris: Delight Editions, 2011, 360

20 Heinz Mack, "Traum und Wirklichkeit: Ein Kommentar," in *Gruppe Zero.*
 Exhibition catalogue (Düsseldorf: Galerie Schoeller, 1988), 21.

21 Otto Piene, "Paths to Paradise," ZERO (Cambridge, MA: MIT Press, 1973), 149.

22 *Mack Szene/Mack Seen/Mack-a-zine/ Mackazin. Die Jahre/The Years/Les
 Annees 1957-57* (Mönchengladbach: Heinz Mack, 1967). See also my essay
 "Mackazine" in *Mack Szene/Mack Seen/Mack-a-zine/ Mackazin. Die Jahre/The
 Years/Les Annees 1957-57*, vol. 2 (Mönchengladbach: Heinz Mack, 1967 with
 Sperone Westwater, New York, 2011), n.p.

23 Dieter Honisch, *Uecker* (New York: Harry N. Abrams, Inc., Publishers, 1986),
 122–23.

24 Valerie Hillings paraphrasing Schmied and translating Piene, Hillings,
 "Experimental Artists' Groups in Europe, 1951-1968: Abstraction, Interaction
 and Internationalism" (Ph.D. Dissertation, Institute of Fine Arts, New York
 University, 2002), 240.

25 Jimmy Ernst quoting his father, Max Ernst, in *A Not So Still Life: A Memoir*
 (New York: St. Martins/Marek, 1984), 110. Postwar art historian David
 Hopkins also observed, "The European refusal to separate art from politics
 was infiltrating the very networks which had once groomed Modernism for
 export." In Hopkins, *After Modern Art: 1945-2000* (Oxford and New York:
 Oxford University Press, 2000), 167–68.

26 Hillings, "Experimental Artists' Groups in Europe, 1951-1968," 119.

27 "Paris on the Rhine," *Time* (June 2, 1967).

28 Otto Piene, "Group ZERO," *London Times Supplement* (September 8, 1964).

29 Thomas Crow, *The Rise of the Sixties: American and European Art in the Era of Dissent* (New York: Harry N. Abrams Inc, 1996), 11.

30 Arthur Danto, *After the End of Art* (Princeton, NJ: Princeton University Press, 1997).

31 These characterizations stem from a lecture that I have been giving since 2001 titled "What Is Contemporary Art?" Terry Smith also articulated his ideas on this subject in *What Is Contemporary Art?* (Chicago and London: University of Chicago Press, 2009), and subsequently in an article "The State of Art History: Contemporary Art," *Art Bulletin*, vol. XCII, no. 4 (December 2010): 366–83.

32 Bertolt Brecht, "An die Nachgeborenen," in *Gesammelte Werke*, vol. 4 (Frankfurt am Main: Suhrkamp, 1967), 722–25 (Translation author's own).

SELECTED BIBLIOGRAPHY

Archival sources

Aldo Tambellini Archives, Salem, Massachusetts.

Alfred Schmela Papers. Getty Institute, Los Angeles, California.

Howard Wise Archives. Harvard Art Museum Archives, Cambridge, Massachusetts.

Joseph D. Ketner II. *Interviews with Otto Piene*, November 18, 2007; December 7, 2009; December 15, 2009; March 30, 2012.

Nam Jun Paik Archives. Smithsonian American Art Museum, Washington, DC.

Otto Piene Archives, Düsseldorf, Germany; Groton, Massachusetts.

Udo Kultermann Archives. Washington University, St. Louis.

Zentralarchiv des internationalen Kunsthandels, Cologne.

ZERO Foundation, Düsseldorf.

Primary and secondary resources

Adorno, Theodor W., and Max Horkheimer. *Dialektik der Aufklärung*. Frankfurt am Main: S. Fischer, 1969.

Alberro, Alexander. "Periodizing Contemporary Art?" In *Theory in Contemporary Art since 1985*, edited by Zoya Kocur and Simon Leung. Chichester: John Wiley & Sons, Ltd, 2013, 64–71.

Aldo Tambellini Cathodic Works 1966-1976. Curated by Pia eBolognesi and Giulio Bursi. Von, 2012. DVD.

"*Als der Krieg zu Ende war*": *Kunst in Detuschland 1945-1950*. Exhibition catalogue. Berlin: Akademie der Künste, 1975.

Arning, Bill and Joao Ribas, eds. *Stan VanDerBeek: The Culture Intercom*. Exhibition catalogue. Cambridge and Houston: The MIT List Visual Arts Center and Contemporary Arts Museum, Houston, 2011.

Aronson, Arnold. "Theatres of the Future." *Theatre Journal*, vol. 33, no. 4 (December 1981): 489–503.

Art in Western Europe: The Postwar Years, 1945-1955. Exhibition catalogue. Des Moines, IA: Des Moines Art Center, 1978.

AZIMUTH, Vol. 1. Edited by Enrico Castellani and Piero Manzoni. Milan, 1959.

AZIMUTH, Vol. 2. Edited by Enrico Castellani and Piero Manzoni. Milan, 1960.

Barczyk, Freddir. *The Medium is the Medium.* Boston: WGBH. September 23, 1969. Featuring Aldo Tambellini, Thomas Tadlock, Allan Kaprow, Otto Piene, James Seawright, and Nam June Paik.

Baltzer, Will, and Alfons W. Biermann. *Treffpunkt Parnass Wuppertal, 1949-1965.* Exhibition catalogue. Cologne: Rheinland-Verlag, 1980.

Barron, Stephanie, and Sabine Eckmann, eds. *Art of Two Germanys: Cold War Cultures.* Exhibition catalogue. New York: Abrams in association with the Los Angeles County Museum of Art, 2009.

Baumeister, Willi. *Das Unbekannte in der Kunst.* Orig. pub. 1947. Cologne: DuMont Buchverlag, 1988.

Becker, Jürgen, and Wolf Vostell. *Happenings: Fluxus, Pop Art,* Nouveau Réalisme. Reinbek: Rowohlt, 1965.

Behne, Adolf. "Was will die moderne Kunst?" *Bildende Kunst,* vol. 2, no. 1 (1948): 3–6.

Belting, Hans. *Die Deutschen und ihre Kunst.* Munich: C. H. Beck, 1993.

Berggruen, Oliver, Ingrid Pfeiffer, and Max Hollein, eds. *Yves Klein.* Exhibition catalogue. Ostfildern-Ruit: Hatje Cantz, 2004.

Beßlich, Barbara. "Können Dichter die Welt ändern?: Medialer Wirkungswille in Benns Rundfunkdialog und Brechts Radiotheorie." In *Gottfried Benn – Bertolt Brecht. Das Janusgesicht der Moderne.* Edited by Achim Aurnhammer, Werner Frick and Günter Saße. Würzburg: ERGON Verlag, 2009, 233–54.

Bernstein, David W., ed. *The San Francisco Tape Music Center: 1960s Counterculture and the Avant-Garde.* Berkeley, Los Angeles and London: University of California Press, 2008.

Beuckers, Klaus Gereon. *Zero-Studien: Aufsätze zur Düsseldorfer Gruppe Zero und ihrem Umkreis.* Karlsruher Schriften zur Kunstgeschichte, vol. 2. Münster: Lit, 1997.

Beuckers, Klaus Gereon, and Günther Uecker. *Günther Uecker. Die Aktionen.* Petersberg: Imhof, 2004.

Bois, Yve-Alain. *Painting as Model.* Cambridge, MA and London: MIT Press, 1990.

Borchardt-Hume, Achim. *Albers and Moholy-Nagy: From the Bauhaus to the New World.* Exhibition catalogue. New Haven, CT: Yale University Press, 2006.

Brett, Guy. "Three London Exhibitions." *The Guardian* (July 4, 1964).

Brett, Guy. *Force Fields: Phases of the Kinetic.* Exhibition catalogue. Barcelona: Museu d'Art Contemporani de Barcelona, 2000.

Brodzky, Anne, and Greg Curnoe, "A Conversation About Mixed Media from New York." *20 Cents Magazine* (Toronto) (November 1966).

Brockmann, Stephan. "German Culture at the 'Zero Hour'." Dept. of Modern Languages paper 7, 1996. http://repository.cmu.edu/cgi/viewcontent.cgi?article=1007&context=modern_languages

Bürger, Peter. "The Significance of the Avant-Garde for Contemporary Aesthetics: A Reply to Jürgen Habermas." *New German Critique,* no. 22, Special issue on Modernism (Winter 1981): 19–22.

Bürger, Peter. *Theory of the Avant-Garde.* Minneapolis, MN: University of Minnesota Press, 1984.

Buchloh, Benjamin H. D. "The Primary Colors for the Second Time: A Paradigm Repetition of the Neo-Avant-Garde." *October,* vol. 37 (Summer 1986): 41–52.

Buchloh, Benjamin H. D. *Neo-Avant-Garde and the Culture Industry: Essays on European and American Art from 1955 to 1975*. Cambridge, MA and London: MIT Press, 2000.

Buchloh, Benjamin, Rudi Fuchs, Konrad Fischer, John Matheson, and Hans Strelow, eds. *ProspectRetrospect: Europa 1946-1976*. Exhibition catalogue. Düsseldorf: Kunsthalle, 1976.

Burnham, Jack. *Beyond Modern Sculpture: The Effects of Science and Technology on the Sculpture of this Century*. New York: Braziller 1968.

Cabañas, Kaira M. *The Myth of Nouveau Realisme: Art and the Performative in Postwar France*. New Haven and London: Yale University Press, 2013.

Caianiello, Tiziana. *Der "Lichtraum (Hommage à Fontana)" und das "Creamcheese" im museum kunst palast: Zur Musealisierung der Düsseldorfer Kunstszene der 1960er Jahre*. Bielefeld: Transcript, 2005.

Cann, Tyler, and Wystan Curnow, eds. *Len Lye*. Exhibition catalogue. New Plymouth, New Zealand: Govett-Brewster Art Gallery and Len Lye Foundation, 2009.

Canaday, John. "Machine Tries to Die for its Art." *The New York Times* (March 18, 1960).

Canaday, John. "Odd Kind of Art. Thoughts on Destruction and Creation After a Suicide in a Garden." *The New York Times* (March 27, 1960).

Canaday, John. "The Sculptor Nowadays is the Favorite Son." *The New York Times* (November 22, 1964).

Carter, Curtis L., and Karen K. Butler, eds. *Jean Fautrier 1898-1964*. Exhibition catalogue. New Haven and London: Yale University Press, 2002.

Celant, Germano. *Roma-New York, 1948-1964: An Art Exploration*. Exhibition catalogue. Milan: Edizioni Charta, 1993.

Celant, Germano. *The Italian Metamorphosis, 1943-1968*. Exhibition catalogue. New York: Guggenheim Museum, 1994.

Celant, Germano. *Piero Manzoni: A Retrospective*. Exhibition catalogue. Milan: Skira editore in collaboration with the Gagosian Gallery, 2009.

Celant, Germano. *Lucio Fontana. Ambienti Spaziali: Architecture, Art, Environments*. Exhibition catalogue. Milan: Skira editore in collaboration with the Gagosian Gallery, 2012.

Colomina, Beatriz. "Enclosed by Images: The Eameses' Multimedia Architecture." *Grey Room*, #2 (Winter 2001): 5–29.

Connor, Russell. *Vision & Television*. Exhibition catalogue. Waltham, MA: The Rose Art Museum, Brandeis University, 1970.

Coplans, John, ed. Andy Warhol. Exhibition catalogue. New York: New York Graphic Society, Ltd., 1970

Crimp, Douglas. "The End of Painting." *October*, vol. 16 (Spring 1981): 69–86.

Crow, Thomas. *The Rise of the Sixties: American and European Art in the Era of Dissent*. New York: Abrams, 1996.

Damsch-Wiehager, Renate. *Nul. Die Wirklichkeit als Kunst fundieren. Die niederländische Gruppe Nul, 1960-1965*. Exhibition catalogue. Esslingen: Galerie der Stadt Esslingen/Villa Merkel, 1993.

Damsch-Wiehager, Renate. *ZERO ITALIEN. Azimut/Azimuth 1959/60 in Mailand. Und heute*. Exhibition catalogue. Esslingen: Galerie der Stadt Esslingen/Villa Merkel, 1996.

Damsch-Wiehager, Renate. *ZERO und Paris 1960. Und heute*. Exhibition catalogue. Esslingen: Galerie der Stadt Esslingen/Villa Merkel, 1997.

Daniels, Dieter. "Television—Art or Anti-Art? Conflict and cooperation between the avant-garde and the mass media in the 1960s," http://www.medienkunstnetz.de/themes/overview_of_media_art/massmedia/. Accessed 2004.

Debord, Guy. *Society of the Spectacle*. Paris: Buchet-Chastel, 1967.

Decker-Phillips, Edith. *Paik Video*. Barrytown, NY: Barrytown, 1998.

del Rio, Elena. "The Technological Imaginary in the Cinema of Antonioni, Godard, and Atom Egoyan" (Ph.D. Dissertation, University of California, Berkley. Ann Arbor, MI: UMI Dissertation Services, 1996).

Engelbach, Barbara, ed. *Die Sonne kommt näher. Otto Piene. Frühwerk*. Exhibition catalogue. Siegen: Museum für Gegenwartskunst, 2003.

Evers, Hans Gerhard, ed. *Das Menschenbild in unserer Zeit: Darmstädter Gespräche*. Darmstadt: Darmstädter Verlagsanstalt, 1950.

Experimental Television Center, 1969-2009. DVD and catalogue. Owego, NY: Experimental Television Center, 2009.

Fallica, Sal. "Cinema Circuit: Intermedia at The Gate." *The Torch* (Undergraduate newspaper of St. John's University, Jamaica) (May 1, 1967).

Farmer, John Allan, ed. *The New Frontier: Art and Television, 1960-1965*. Austin: Austin Museum of Art, 2000.

Fifer, Sally Jo, and Doug Hall, eds. *Illuminating Video: An Essential Guide to Video Art*. New York: Aperture in Association with the Bay Area Video Coalition, 1990.

Flood, Richard, and Frances Morris. *Zero to Infinity: Arte Povera, 1962-1974*. Exhibition catalogue. Minneapolis and London: The Walker Art Center and the Tate Modern, 2001.

Foster, Hal. "What's Neo about the Neo-Avant-Garde?" *October*, vol. 70, The Duchamp Effect (Autumn 1994): 5–32.

Fred Barzyk. *The Search for a Personal Vision in Broadcast Television*. Exhibition catalogue. Milwaukee, WI: Haggerty Museum of Art, 2001.

Frieling, Rudolf, and Wulf Herzogenrath, eds. *40yearsvideoart.De*. Digital Heritage, Study Edition of Video Art in Germany from 1963 to the Present. Part 1, DVD 1, 1963-1969. Ostfildern, Germany: Hatje Cantz, 2006.

Fritz, Darko. "Notions of the Program in 1960s Art—Concrete, Computer-generated and Conceptual Art. Case Study: New Tendencies." In *Editions HYX*. Edited by David-Olivier Lartigaud (Architecture-Art-contemporain-Cultures numeriques), Orleans, 2011: 26–39.

Gablick, Suzi. "The Snake Paradise: Evolutionism in the landscapes of Max Ernst." *Art in America*, vol. 63 (May 1975): 34–39.

Gaggi, Silvio. "Sculpture, Theater and Art Performance: Notes on the Convergence of the Arts." *Leonardo*, vol. 19, no. 1 (1986): 45–52.

Gehlen, Arnold. *Zeit-Bilder. Zur Soziologie und Ästhetik der modernen Malerei*. Frankfurt am Main and Bonn: Athenäum Verlag, 1965.

Gerhard Hoehme Bildkontakte: Werke von 1948 bis 1988. Exhibition catalogue. Düsseldorf: Kunstmuseum Düsseldorf, 2000.

Gerstenberger, Katharine, and Patricia Herminghouse, eds. *German Literature in a New Century: Trends, Traditions, Transformations*. New York: Berghahn Books, 2008.

Gibson, Eleanor Jess Atwood. "The Media of Memory: History, Technology and Collectivity in the Work of the German Group Zero 1957-1966" (Ph.D. Dissertation, Yale University, 2008).

Gillen, Eckhardt. *Deutschlandbilder: Kunst aus einem geteilten Land.* Exhibition catalogue. Martin-Gropius-Bau Berlin, Köln, 1997.

Giles, Geoffrey J., ed. *Stunde Null: The End and the Beginning Fifty Years Ago.* Occasional Papers No. 20. Washington, DC: German Historical Institute, 1997.

Gioni, Massimiliano, and Gary Carrion-Murayari, eds. *Ghosts in the Machine.* Exhibition catalogue. New York: New Museum and Skira Rizzoli Publications, Inc., 2012.

Glibota, Ante. *Otto Piene.* Paris: Delight Editions, 2011.

Glueck, Grace, "Art Notes: Keeping up with the Rear Guard." *New York Times* (November 7, 1965).

Glueck, Grace, "Syndromes Pop at Delmonico's: Andy Warhol and His Gang Meet the Psychiatrist." *The New York Times* (January 14, 1966).

Glueck, Grace, "Art Notes. Rhapsody in Silver." *The New York Times* (April 17, 1966).

Glueck, Grace, "T-Visionaries." *The New York Times* (March 23, 1969).

Goepfert, Hermann, Ingrid Mössinger, and Peter Weiermair, eds. *Goepfert und Zero, Zero und Goepfert.* Exhibition catalogue. Frankfurt am Main: Frankfurter Kunstverein, 1987.

Götz, Karl Otto, "Elektronische Malerei und ihre Programmierung." *Das Kunstwerk*, vol. 12/XIV (June 1961): 14–23.

Götz, Karl Otto. *Erinnerungen, 1945-1959.* Aachen: Rimbaud Verlag, 1994.

Golan, Remy. "L'Eternal décoratif: French Art in the 1950s." *Yale French Studies*, no. 98, The French Fifties (2000): 98–118.

Goldberg, Rose-Lee. *Performance Art: From Futurism to the Present.* Third Edition. London: Thames and Hudson, 2011.

Grasskamp, Walter. *Die unbewältige Moderne: Kunst und Öffentlichkeit.* Munich: Beck, 1989.

Greenberg, Clement. *The Collected Essays and Criticism.* Edited by John O'Brien. Chicago: University of Chicago Press, 1986–93.

Groos, Ulrike, Barbara Hess, and Ursula Wevers, eds. *Ready to Shoot: Fernsehgalerie Gerry Schum videogalerie schum.* Exhibition catalogue. Düsseldorf: Kunsthalle Düsseldorf, 2004.

Gropius, Walter, and Arthur S. Wensinger, eds., *The Theater of the Bauhaus.* Originally published in 1924. Baltimore and London: Johns Hopkins University Press, 1961.

Group Zero. Mack, Piene, Uecker. Exhibition catalogue. New York: Howard Wise Gallery, 1964.

Group Zero: Mack, Piene, Uecker. Exhibition catalogue. London: McRoberts and Tunnard Gallery, 1964.

Group Zero. Exhibition catalogue. New York: Arno / Worldwide, 1968.

Gruppe Zero. Exhibition catalogue. Düsseldorf: Galerie Schoeller, 1989.

Guilbaut, Serge, ed. *Reconstructing Modernism: Art in New York, Paris, and Montreal 1945-1964.* Cambridge and London: The MIT Press, 1990.

Guilbaut, Serge. *Be-Bomb: The Transatlantic War of Images and all that Jazz. 1946-1956.* Exhibition catalogue. Madrid: Museu d'Art Contemporani de Barcelona and Museo Nacional Centro de Arte Reina Sofia de Madrid, 2007.

Günther Uecker: Twenty Chapters. Ostfildern-Ruit: Hatje Cantz, 2006.

Günther Uecker: The Early Years. Exhibition catalogue. New York: L&M Arts, 2011.

Haftmann, Werner. *Verfemte Kunst: Malerei der inneren und äußeren Emigration.* Cologne: DuMont Buchverlag, 1984.

Hamilton, Jaimey. "Strategies of Excess: The Postwar Assemblages of Alberto Burri, Robert Rauschenberg, and Arman" (Ph.D. Dissertation. Boston University, 2006).

Hanhardt, John G., ed. *Nam June Paik.* Exhibition catalogue. New York: Whitney Museum of American Art in association with W.W. Norton, 1982.

Hanhardt, John, ed., *Video Culture: A Critical Investigation.* New York: Visual Studies Workshop Press, 1986.

Hanhardt, John, and Ken Hakuta, eds., *Nam June Paik: Global Visionary.* Washington, DC: Smithsonian American Art Museum in association with D Giles, London, 2012.

Harten, Jürgen, ed. *Prospectretrospect, Europa, 1946-1976.* Exhibition catalogue. Düsseldorf and Cologne: Kunsthalle Düsseldorf and Buchhandlung Walther König, 1976.

Hartman, Geoffrey H. *Bitburg in Moral and Political Perspective.* Bloomington: Indiana University Press, 1986.

Hausenstein, Wilhelm. *Was bedeutet die moderne Kunst: Ein Wort der Besinnung.* Leutstetten vor München: Verlag Die Werkstatt, 1949.

Haverkamp, Anselm. *Latenzzeit: Wissen im Nachkrieg.* Berlin: Kulturverlag Kadmos, 2004.

Heibel, Yule F. *Reconstructing the Subject: Modernist Painting in Western Germany, 1945-1950.* Princeton, NJ: Princeton University Press, 1995.

Heidegger, Martin. *Poetry, Language, Thought.* New York: Harper & Row, 1971.

Heinz Mack: Early Paintings, 1957-1964. Exhibition Catalogue. New York: Sperone Westwater Gallery, 2009.

Heinz Mack: Licht in der ZERO-Zeit. Exhibition catalogue. Koblenz: Ludwig Museum im Deutschherrenhaus, 2009.

Heinz Mack. Licht-Raum-Farbe. Light-Space-Colour. Exhibition catalogue. Bonn: Kunst- und Ausstellungshalle der Bundesrepublik Deutschlland, 2011.

Heinz Mack: aus der ZERO-Zeit. Exhibition catalogue. Cologne: Galerie Heinz Holtmann, 2001.

Heinz Mack, Otto Piene, Günther Uecker, Lichtraum (Hommage à Fontana) 1964. Berlin, Düsseldorf: Kulturstiftung der Länder in Verbindung mit dem Kunstmuseum Düsseldorf im Ehrenhof, 1992.

Held, Jutta. *Kunst und Kunstpolitik 1945-49: Kulturaufbau in Deutschland nach dem 2. Weltkrieg.* Berlin: Verlag für Ausbildung und Studium in der Elefanten Press, 1981.

Heymer, Kay, Susanne Rennert, and Beat Wismer, eds. *Le grand geste! Informel und Abstrakter Expressionismus, 1946-1964.* Exhibition catalogue. Düsseldorf: Museum Kunst Palast, 2010.

Herzogenrath, Wulf. *Otto Piene.* Exhibition catalogue. Cologne: Kölnischer Kunstverein, Josef-Haubrich-Hof, 1973.

Herzogenrath, Wulf, ed. *Nam June Paik. Werke 1946-1976. Musik-Fluxus-Video.* Exhibition catalogue. Cologne: Kölnischer Kunstverein, 1976.

Herzogenrath, Wulf, ed. *Nam June Paik Fluxus/Video.* Exhibition catalogue. Bremen: Kunsthalle Bremen, 1999.

Heymsfeld, Jeremy. "Space World in 'Black Zero'." *New York World-Telegram and Sun* (December 16, 1965).

Higgins, Dick. *Synesthesia and Intersenses: Intermedia*. New York: Something Else Press, 1966.

Hillings, Valerie Lynn. "Experimental Artists' Groups in Europe, 1951-1968: Abstraction, Interaction and Internationalism" (Ph.D. Dissertation, Institute of Fine Arts, New York University, 2002).

Hoffmann, Tobias, ed. *Die Neue Tendenzen: Eine europäische Künstlerbewegung 1961-1973*. Exhibition catalogue. Ingolstadt: Museum für konkrete Kunst, 2006.

Honisch, Dieter. *Kunst in der Bundesrepublik Deutschland, 1945-1985*. Exhibition catalogue. Berlin: Nationalgalerie Staatliche Museen Preußischer Kulturbesitz, 1985.

Honisch, Dieter. *Uecker*. New York: Harry N. Abrams, 1986.

Honisch, Dieter. *Mack Sculptures, 1953-1986*. Düsseldorf and Vienna: Econ-Verlag, 1986-7.

Honnef, Klaus, and Hans M. Schmidt, eds. *Aus den Trümmern: Kunst und Kultur im Rheinland und Westfalen 1945-1952. Neubeginn und Kontinuität*. Exhibition catalogue. Cologne and Bonn: Rheinland-Verlag, 1985.

Huizinga, Johann. *Homo Ludens: A Study of the Play Element in Culture*. Originally published, 1938. Boston: Beacon Press, 1950.

Husslein, Uwe, ed. *Pop am Rhein*. Cologne: Buchhandlung Walther König, 2008.

Huxley, Geralyn, ed. *From Stills to Motion and Back Again: Texts on Andy Warhol's Screen Tests and Outer and Inner Space*. Vancouver, BC: Presentation House Gallery, 2003.

Huyssen, Andreas. *Present Pasts: Urban Palimpsests and the Politics of Memory*. Stanford: Stanford University Press, 2003.

Jean Tinguely. *Meta-Maschinen*. Exhibition catalogue. Duisburg: Wilhelm-Lehmbruck-Museum, 1979.

Jocks, Heinz-Norbert. *Das Ohr am Tatort: Heinz Norbert Jocks im Gespräch mit Gotthard Graubner, Heinz Mack, Roman Opalka, Otto Piene, Günther Uecker*. Ostfildern: Hatje Cantz, 2009.

Joseph Beuys: Parallelprozesse. Archäologie einer künstlerischen Praxis. Exhibition catalogue. Düsseldorf: Kunstsammlung Nordrhein-Westfalen, 2010.

Joseph, Brandon. "'My Mind Split Open': Andy Warhol's Exploding Plastic Inevitable." *Grey Room*, no. 8 (Summer 2002): 80–107.

Judd, Donald. "Mack, Piene, Uecker." *Arts magazine* (January 1965): 55.

Judt, Tony. *Postwar: A History of Europe Since 1945*. London, New York: Penguin Books, 2005.

Junker, Howard. "Films: The Underground Renaissance." *The Nation* (December 27, 1965).

Jürgen-Fischer, Klaus. *La Galleria Pagani del Grattacielo presenta Nuove tendenze tedesche, 1959*. Milan: Galleria Pagani del Grattacielo, 1959.

Jürgen-Fischer, Klaus. "Post Scriptum 'Neue Tendenzen'." *Das Kunstwerk*, vol. 5-6/XV (November/December 1961): 72.

Kaprow, Allan, "Legacy of Jackson Pollock." *Artnews* (October 1958): 24–26, 55–57.

Ketner II, Joseph D. "Profile: Otto Piene." *Art New England*, vol. 31, no. 3 (April/May 2010): 7–9.

Ketner II, Joseph D. "Electromedia." in *Aldo Tambellini Black Zero*. Exhibition catalogue. New York: Boris Lurie Art Foundation and the Chelsea Art Museum, 2011, 34–47.

Ketner II, Joseph D. "Against the Mainstream: Howard Wise and the New Artistic Conception of the 1960s." In *Howard Wise: Exploring the New*. Exhibition catalogue. Berlin: Moeller Fine Art, 2012, 8–11.

Klapheck, Anna. "Tachismus—Ende oder Anfang?: Zur Ausstellung der 'Gruppe 53' in der Kunsthalle Düsseldorf." *Rheinische Post* (January 30, 1957).

Klapheck, Anna. "Was ist monochrome Malerei? Zu einer Ausstellung in Schloß Morsbroich." *Rheinische Post* (March 26, 1960).

Klapheck, Anna. "Avantgarde und Fernsehen." *Rheinische Post* (December 5, 1961).

Klapheck, Anna. "Die intellektuellen Bastler. Piene, Mack und Uecker in Haus Lange Krefeld." *Rheinische Post* (February 1, 1963).

Klüser, Bernd, and Katharina Hegewisch, eds. *Die Kunst der Ausstellung: Eine Dokumentation dreßig exemplarischer Kunstausstellungen dieses Jahrhunderts*. Frankfurt am Main, Leipzig: Insel Verlag, 1991.

Klüver, Billy, Julie Martin, and Barbara Rose, eds. *Experiments in Art and Technology: Pavilion*. New York: E.P. Dutton, 1972.

Kostelanetz, Richard. *The Theatre of Mixed Means: An Introduction to Happenings, Kinetic Environments, and Other Mixed-Means Performances*. New York: The Dial Press, 1968.

Kugelberg, Johann, ed. *The Velvet Underground*. New York: New York Art, 2009.

Kuhn, Anette. *ZERO: Eine Avantgarde der sechziger Jahre*. Frankfurt am Main and Berlin: Propyläen Verlag, 1991.

Kultermann, Udo. *Monochrome Malerei*, Exhibition catalogue. Leverkusen: Städtisches Museum Leverkusen, Schloss Morsbroich, 1960.

KunstLichtKunst. Exhibition catalogue. Eindhoven: Stedelijk van Abbemuseum, 1966.

"Latenzzeit: Die Leere der Fünfziger Jahre. Ein Interview mit Anselm Haverkamp von Juliane Rebentisch und Susanne Leeb." *Texte zur Kunst* vol. 12, no. 50 (2003): 45–53.

Leisberg, Alexander. "Neue Tendenzen." *Das Kunstwerk*, vol. 10–11 (April/May 1961): 3–34.

Lenoir, Jean-Pierre. "Paris Impressed by Warhol Show." *The New York Times* (May 13, 1965).

Lieberman, William S. *Max Ernst*. Exhibition catalogue. New York: Museum of Modern Art, 1961.

Lorber, Richard, "Epistemological TV." *Art Journal*, vol. 34, no. 2 (Winter 1974–75): 132–34.

Mack, Heinz. *Mackazin: Die Jahre 1957-67*. Düsseldorf: Zentraldruckerei Wust, 1967.

Mack, Heinz. *Mack: Leben und Werk. Ein Buch vom Künstler über den Künstler// Life and Work. A Book from the Artist about the Artist, 1931-2011*. Cologne: DuMont Buchverlag, 2011.

Mack, Heinz, and Klaus Ulrich Düsselberg. *Mack .. dass silber meine farbe ist*. Duisburg: Guido Hildebrandt, 1977.

Mack, Heinz, Edwin K. Braun, and Hans Emmerling. *Tele Mack, Tele-Mack, Telemack: ein Film*. (1968-69), 45 minutes, color, sound. Saarländischer Rundfunk and Westdeutsches Fernsehen.

Mack: Licht im Schwarz. Exhibition catalogue. Düsseldorf: Galerie Schoeller, 2001.

Mack. Lichtkunst. Exhibition catalogue. Ahlen: Kunst-Museum, 1994.

Mack — Piene — Uecker. Exhibition catalogue. Krefeld: Kaiser Wilhelm Museum, 1963.

Mack Szene Mack Seen Mack-A-Zine Mackazin: Die Jahre The Years Les Annees 1957-67. Exhibition catalogue. Texts by Dieter Honisch and Joseph D. Ketner II. New York: Sperone Westwater, 2011.

Mack – ZERO! Exhibition catalogue. Düsseldorf: Beck & Eggeling Kunstverlag, 2006.

Mack – ZERO! Vol 2. Exhibition catalogue. Düsseldorf: Beck & Eggeling Kunstverlag, 2008.

Magerski, Christine, Robert Savage, and Christiane Weller, eds., *Moderne begreifen: Zur Paradoxie eines sozio-ästhetischen Deutungsmusters.* Heidelberg: Springer, 2007.

Mansoor, Jaleh. *Marshall Plan Modernism: The Monochrome as The Matrix of Fifties Abstraction.* Ph.D. Dissertation, Columbia University, 2007

Mansoor, Jaleh. "Fontana's Atomic Age Abstraction: The Spatial Concepts and the Television Manifesto." *October*, vol. 124 Postwar Italian A Special Issue (Spring 2008): 137–56.

Margolies, John E. "TV-The Next Medium." *Art in America* (September-October 1969): 48–55.

Martin, Jean Hubert. *ZERO: internationale Künstler-Avantgarde der 50er-60er Jahre : Japan, Frankreich, Italien, Deutschland, Niederlande-Belgien, die Welt.* Exhibition catalogue. Kunstpalast, Düsseldorf.Ostfildern: Hatje Cantz, 2006.

Mavignier. Ulm 1953-1958. Exhibition catalogue. Ingolstadt: Museum für konkrete Kunst, 2003.

McLuhan, Marshall. *Understanding Media: The Extensions of Man.* Originally published 1963. Cambridge and London: MIT Press, 1994.

Mehring, Christine. "Television Art's Abstract Starts: Europe circa 1944-1969." *October*, vol. 125 (Summer 2008): 29–64.

Meigh-Andrews, Chris. *A History of Video Art: The Development of Form and Function.* Oxford, New York: Berg, 2006.

Mekas, Jonas. *Film Culture*, special issue, Expanded Cinema, no. 43 (Winter 1966).

Mekas, Jonas. *Movie Journal: The Rise of a New American Cinema, 1959-1971.* New York: Macmillan, 1972.

Mekas, Jonas. *Screenings at Film-makers Cinematheque, 1962-1968.* New York: Jonas Mekas, 2014

Meister, Helga. *Die Kunstszene Düsseldorf.* Recklinghausen: Aurel Bongers, 1979.

Meister, Helga. *Zero in der Düsseldorfer Szene.* Düsseldorf: Dr.Helga Meister, 2006.

Mitscherlich, Alexander, and Margarete Mitscherlich. *The Inability to Mourn: Principles of Collective Behavior.* New York: Grove Press, 1975.

Moholy-Nagy, László. *Vision in Motion.* Chicago: Paul Theobald, 1947.

Moholy-Nagy, László. *Malerei, Fotografie, Film (Painting, Photography, Film).* Bauhaus Bücher 8. Originally published, Munich: Langen, 1925. Cambridge, MA: The MIT Press, 1969.

Morris, Catherine, ed. *9 Evenings Reconsidered: Art, Theater, and Engineering, 1966.* Exhibition catalogue. Cambridge, MA: MIT List Visual Arts Center, 2006.

Morris, Frances. *Paris Post War: Art and Existentialism, 1945-55.* Exhibition catalogue. London: Tate Gallery, 1993.

Morschel, Jürgen. "ZERO 3. Dokumente der neuen Kunst." *Schwäbische Donau-Zeitung* (July 26, 1961).

Morschel, Jürgen. "Die Avantgarde pflegt ihren Mythos. Zur Ausstellung 'Mack, Piene, Uecker' im Haus Lange in Krefled." *Schwäbische Donau-Zeitung* (March 5, 1963).

Murphy, Carol J. "Re-Presenting the Real: Jean Paulhan and Jean Fautrier." *Yale French Studies*, no. 106, The Power of Rhetoric, the Rhetoric of Power: Jean Paulhans Fiction, Criticism, and Editorial Activity (2004): 71–86.

The Museum Tinguely, Basel. The Collection. Heidelberg, Berlin: Kehrer Verlag, 2012.

Nadeau, James A. "The Medium is the Medium: the Convergence of Video, Art and Television at WGBH (1969)" (MS Thesis, MIT, 2006).

Neuburger, Susanne, ed. *Nam June Paik: Exposition of Music Electronic Television.* Wien: Museum Moderner Kunst Stiftung Ludwig, 2009.

1960. Les Nouveaux Réalistes. Exhibition catalogue. Paris: Musée d'Art Moderne de la Ville de Paris, 1986.

Nove tendencije 1. Exhibition catalogue. Zagreb: Galerija Suvremene Umjetnosti, 1961.

Nove Tendencile 2. Exhibition catalogue. Zagreb: Galerije Grada Zagreba, 1963.

Nul negentienhonderd vilf en zestig. Exhibition catalogue. Amsterdam: Stedelijk Museum, 1965.

October, no. 124, Postwar Italian Art Special Issue (Spring 2008).

"'On sunny days, count the waves of the Rhine...' Nam June Paiks frühe Jahre im Rheinland." In *Sediment. Mitteilungen zur Geschichte des Kunsthandels.* Zentralarchiv des internationalen Kunsthandels, Cologne; Nuremberg: Verlag für moderne Kunst, 2005.

Oren, Michel. "Anti-Art as the End of Cultural History." *Performing Arts Journal*, vol. 15, no. 2 (May 1993): 1–30.

Oren, Michel, "USCO: 'Getting Out of Your Mind to Use Your Head'." *Art Journal* (Winter 2010): 76–95.

Otten, Marie-Louise. *Auf dem Weg zur Avantgarde: Künstler der Gruppe 53.* Exhibition Catalogue. Bönningheim: Museum der Stadt Ratingen, 2003.

Otto Piene. Ölbilder. Rauchzeichnungen. Lichtmodelle. Lichtballett, Exhibition catalogue. Berlin: Galerie Diogenes, 1960.

Otto Piene: 10 Texte. Exhibition catalogue. Galerie Nota, Frankfurt März 1961, Galerie dato, Frankfurt, April 1961. Frankfurt am Main: Galerie nota, dato, 1961.

Otto Piene: Light Ballet. Exhibition catalogue. New York: Howard Wise Gallery, 1965.

Otto Piene: Paintings, Gouache, Drawings. Exhibition catalogue. Cambridge, MA: MIT Committee on the Visual Arts, 1975.

Otto Piene Retrospektive, 1952-1996. Exhibition catalogue. Düsseldorf: Kunstmuseum Düsseldorf im Ehrenhof, 1996.

Otto Piene: Spectrum. Exhibition catalogue. Dortmund: Museum am Ostwall, 2009.

Otto Piene: Sundew and Selected Works, 1957-2014. Essays by Joseph D. Ketner II, Joachim Jäger, and Michelle Kuo. Exhibition Catalogue. New York: Sperone Westwater Gallery, 2016.

Otto Piene: Zero im Theater. Exhibition catalogue. Berlin: Galerie Diogenes, 1963.

"Paris on the Rhine." *Time* (June 2, 1967).

Patterson, Clayton. *Captured: A Film/Video History of the Lower East Side.* New York: Seven Stories Press, 2005.

Petersen, Stephen. *Space-Age Aesthetics: Lucio Fontana, Yves Klein, and the postwar European avant-garde.* University Park, PA: The Pennsylvania State University, 2009.

Pfeiffer, Ingrid, and Max Hollein, eds. *László Moholy-Nagy Retrospective.* Exhibition catalogue. Munich: Prestel Verlag, 2009.

Piene, Otto. "The Development of Group Zero," *The Times Literary Supplement* (London) (September 3, 1964).

Piene, Otto, "Der Schlaf und das Theater." *Theater heute*, no. 5 (May 1965).

Piene, Otto. "The Proliferation of the Sun." *Arts Magazine*, vol. 41, no. 8 (Summer 1967): 24–31.

Piene, Otto. "Death is so Permanent." *Artscanada* (Toronto: Society for Art) (1968): 14–18.

Piene, Otto, and Elizabeth Goldring, eds. *Centerbeam*. Cambridge, MA: Center for Advanced Visual Studies, Massachusetts Institute of Technology, 1980.

Piene, Otto, and Heinz Mack. *Zero*. Köln: Dumont Schauberg, 1973.

Pijnappel, Johan, ed, *Fluxus Today and Yesterday*. London: Academy Editions, 1993.

Pörschmann, Dirk, and Mattijs Visser, eds. *4321 ZERO*. Düsseldorf: Richter/Fey Verlag and ZERO Foundation, 2012.

Rees, A.L., Duncan White, Steven Ball, and David Curtis, eds. *Expanded Cinema: Art Performance, Film*. London: Tate Publishing, 2011.

Rennert, Susanne, ed. *Die Unruhe wächst: Hoehme*. Exhibition catalogue. Cologne: DuMont Buchverlag, 2009.

Rennert, Susanne, Sylvia Martin, and Erika Wilton, eds. *"Le hasard fait bien les choses." Jean-Pierre Wilhelm, Informel, Fluxus und die Galerie 22*. Cologne: Verlag der Buchhandlung Walther König, 2013.

Rennert, Susanne, and von Wiese. Stephan *Otto Piene. Sky Art 1968- 1996*. Köln: Wienand, 1999.

Restany, Pierre. *Les Nouveaux Réalistes*. Exhibition catalogue. Milan: Apollinaire Gallery, 1960.

Ribas, Joao. *Otto Piene: Lichtballett*. Exhibition catalogue. Cambridge: MIT List Visual Arts Center, 2011.

Rickey, George. "The New Tendency (Nouvelle Tendance—Recherche Continuelle)." *The Art Journal*, vol. XXIII, no. 4 (1964): 272–79.

Robinson, Julia. *New Realisms: 1957-1962. Object Strategies Between Readymade and Spectacle*. Exhibition catalogue. Museo Nacional Centro de Arte Reina Sofia, Madrid, and The MT Press, Cambridge, MA/London, England, 2010.

Rothko, Mark. *Writings on Art, Mark Rothko*. Edited by Miguel Lopez-Remiro. New Haven: Yale University Press, 2006.

Rosen, Margit, ed. *A Little-Known Story about a Movement, a Magazine, and the Computer's Arrival in Art: New Tendencies* and *Bit International, 1961-1973*. Exhibition catalogue. Karlsruhe, Germany and Cambridge, MA/London: ZKM/ Center for Art and Media and the MIT Press, 2011.

Ruhrberg, Karl. "Die Revolution der Zeichenlehrer. Otto Pienes Lichtballett und der Rückzug auf die Nuance." *Düsseldorfer Nachrichten* (May 13, 1959).

Ruhrberg, Karl, ed. *Alfred Schmela. Galerist—Wegbereiter der Avantgarde*. Exhibition catalogue. Cologne: Wienand Verlag, 1996.

Schavemaker, Margriet, Barbara Til, and Barbara Wismer, eds. *Jean Tinguely*. Exhibition catalogue. Düsseldorf: Museum Kunstpalast in cooperation with the Stedelijk Museum, Amsterdam, 2016.

Schieder, Martin. "Alfred Schmela, Yves Klein, and a Sound Recording." *Getty Research Journal*, no. 5 (2013): 133–47.

Schimmel, Paul. *Destroy the Picture: Painting the Void, 1949-1962*. Exhibition catalogue. New York: Skira editore in association with The Museum of Contemporary Art, Los Angeles, 2012.

Schmalenbach, Werner. *Kurt Schwitters*. Exhibition catalogue. Hanover: Kestner Gesellschaft, 1956.

Schmied, Wieland. "Malerei ist keine Einbahnstrasse." *Die Zeit* (July 17, 1964).

Schmiele, Walter. "Vom Pinsel zur Lichtmühle. Auftritt eines Malers." *Handelsblatt* (April 28/29, 1961).

Schnapp, Jeffrey T. "Border Crossings: Italian/German Peregrinations of the 'Theater of Totality'." *Critical Inquiry*, vol. 21, no. 1 (Autumn 1994): 80–123.

Schubert, Hannelore. "Gibt es wieder eine Düsseldorfer Malerschule?" *Westdeutscher Rundfunk, Nachtprogramm* (9 July 1957).

Schubert, Hannelore. "Nachkriegsgeneration in Düsseldorf. Anmerkungen zur heutigen künstlerischen Situation." *Das Kunstwerk*, vol. 11, no. 1 (1957/58): 28–43.

Schubert, Hannelore. "H. Mack fand zu sich selbst. Rundgang durch die Düsseldorfer Galerien." *Kölner Stadt-Anzeiger* (October 4, 1958).

Schubert, Hannelore. "Kunstler am Werk: Atelierbesuch bei H. Mack." *Deutsche Zeitung* (June 27, 1959).

Schubert, Hannelore. "Kunstausstellungen im Rheinland." *Das Kunstwerk*, vol. XIII, no. 5–6 (November-December 1959): 72–73.

Sedlmayr, Hans. *Verlust der Mitte: Die bildende Kunst des 19. und 20. Jahrhunderts als Symptom und Symbol der Zeit*. Salzburg: Otto Müller Verlag, 1948.

Seitz, William. *The Responsive Eye*. Exhibition catalogue. New York: Museum of Modern Art, 1965.

Selz, Peter, and Christine Stiles, eds. *Theories and Documents of Contemporary Art. A Sourcebook of Artists' Writings*. Berkeley and Los Angeles: University of California Press, 1996.

Sharp, Willoughby. *Günther Uecker: 10 Years of a Kineticist's Work*. New York: Kineticism Press, 1966.

Smith, Michael. "Theatre Journal." *The Village Voice* (December 23, 1965).

Somma, Robert. "Rock Theatricality." *The Drama Review: TDR*, vol. 14, no. 1 (Autumn 1969): 128–38.

Sontag, Susan. *Against Interpretation and Other Essays*. New York: Farrar, Strauss & Giroux, 1966.

Spigel, Lynn. *TV by Design: Modern Art and the Rise of Network Television*. Chicago and London: The University of Chicago Press, 2008.

Stachelhaus, Heiner. "Günther Uecker—ein Demonstrant. Zur Eröffnung seiner Ausstellung in Pianohaus Kohl benagelte er ein Piano." *Stadt-Nachrichten* (Easter 1964).

Stegmann, Petra, ed. *"The Lunatics are on the loose…" European Fluxus Festivals, 1962-1977*. Exhibition catalogue. Berlin: Down with Art!, 2012.

Stonard, John-Paul. *Fault Lines: Art in Germany 1945-1955*. London: Ridinghouse, 2007.

Strategies de Participation—GRAV—Groupe de recherché d'art visuel—1960/1968. Exhibition catalogue. Grenoble: Le Magasin—Centre Nationale d'Art Contemporain de Grenoble, 1998.

Strelow, Hans. "Die Entwicklung der Flasche im Raum. Licht, Bewegung und ABC-Kunst auf der 33. Biennale von Venedig." *Frankfurter Allgemeine Zeitung* (June 28, 1966).

Sturken, Marita. "TV as a Creative Medium: Howard Wise and video Art." *Afterimage*, vol. 11, no. 10 (May 1984): 5–9.

Sutton, Gloria Hwang. *The Experience Machine: Stan VanDerBeek's Movie-Drome and Expanded Cinema*. Ann Arbor: UMI Press, 2009.

Suvin, Darko. "Reflections on Happenings." *The Drama Review: TDR*, vol. 14, no. 3 (1970): 125–44.

Tentoonstelling Nul. Exhibition catalogue. Amsterdam: Stedelijk Museum, 1962.

Das Theater ist auf der Straße: Die Happenings von Wolf Vostell/El teatro esta en la calle. Los Happenings de Wolf Vostell. Exhibition catalogue. Leverkusen and Malpartida: Museum Morsbroich and Museo Vostell Malpartida, 2010.

Thwaites, John Anthony. "Anno 1954." Unpublished manuscript. Thwaites Papers, G3, IX. Zentralarchiv des internationalen Kunsthandels, Cologne.

Thwaites, John Anthony. "Dada hits West Germany." *Arts Digest*, vol. 33, no. 2 (February 1959): 30–37.

Thwaites, John Anthony. "Das Blaue Wunder des Yves Klein." *Deutsche Zeitung*, no. 28 (Februart 2, 1961).

Thwaites, John Anthony. "Kritik der Kritik." *Deutsche Zeitung* (July 3, 1961).

Thwaites, John Anthony. "Dokumente für eine neue Entwicklung." *Deutsche Zeitung* (August 26/26, 1961).

Thwaites, John A. "Der Geist der Wüste stirbt." *Deutsche Zeitung* (March 29, 1962).

Thwaites, John Anthony. "Yves le Phenomene ist tot: Ein Nachruf für Yves Klein." *Deutsche Zeitung* (June 14, 1962): 14.

Thwaites, John Anthony. "Reaching the Zero Zone." *Arts Magazine*, vol. 36, no. 10 (September 1962): 16–21.

Thwaites, John Anthony. "Bilder, die Zeit brauchen." *Deutsche Zeitung* (September 29/30, 1962).

Thwaites, John Anthony. "Der neue Idealismus. Mack, Piene and Uecker im Museum Haus Lange in Krefeld." *Deutsche Zeitung* (February 26, 1963)

Thwaites, John Anthony. "Der Philosoph und die Katze. Nam June Paik in der Galerie Parnass in Wuppertal." *Deutsche Zeitung* (April 9, 1963).

Thwaites, John Anthony. "Tendenzen — neu und alt." *Deutsche Zeitung* (March 23, 1964).

Thwaites, John Anthony. "The Story of Zero." *Studio International* (London) vol. 170, no. 867 (July 1964): 2–9.

Tizt, Susanne, and Jee-Hae Kim, eds. *Mack, Kinetik*. Exhibition catalogue. Mönchengladbach: Museum Abteiberg, 2011.

TV As a Creative Medium. New York: Howard Wise Gallery, 1969.

Tuchman, Maurice, ed. *A Report on the Art and Technology Program of the Los Angeles County Museum of Art, 1967-1971*. Exhibition catalogue. Los Angeles: Los Angeles County Museum of Art, 1971.

Turner, Fred. *The Democratic Surround: Multimedia & American Liberalism from World War II to the Psychedelic Sixties*. Chicago and London: The University of Chicago Press, 2013.

Uecker. Exhibition catalogue. Essay by Willoughby Sharp. New York: Howard Wise Gallery, 1966.

USCO. "Our Time Base is Real." *The Tulane Drama Review*, vol. 11, no. 1 (Autumn 1966): 74–93.

Utopie und Wirklichkeit im Werk von Heinz Mack. Cologne: DuMont Buchverlag, 1998.

VanDerBeek, Stan. "The Cinema Delimina: Films from the Underground." *Film Quarterly*, vol. 14, no. 4 (Summer 1961): 5–15.

VanDerBeek, Stan. "'Culture: Intercom' And Expanded Cinema: A Proposal and Manifesto." *The Tulane Drama Review*, vol. 11, no. 1 (Autumn 1966): 38–48.

VanDerBeek, Stan. "Re: Vision," *Perspecta II* (1967): 113–19.

Vid*ea 'n' Videology: Nam June Paik (1959-1973)*. Exhibition catalogue. Syracuse, NY: The Everson Museum of Art, 1974.

Vis*ion in Motion — Motion in Vision*, Exhibition catalogue. Antwerp: Hessenhuis, 1959.

Visser, Tijs, and Colin Huizing, eds. *Nul=0: The Dutch Nul Group in an International Context*. Exhibition catalogue, Stedelijk Museum, Schiedam. Rotterdam: Nai Publications and the ZERO Foundation, 2011.

Von Kalnein, Wend. *ZERO Raum*. Düsseldorf: Kunstmuseum Düsseldorf, 1973.

von Wiese, Stephan, ed. *Günther Uecker: Schriften. Gedichte—Projektbeschreibungen—Reflexionen*. St. Gallen: Erker-Verlag, 1979.

von Wiese, Stephan. *Brennpunkt Düsseldorf*. Düsseldorf: Kunstmuseum Düsseldorf, 1987.

Weibel, Peter, Woody Vasulka, Steina Vasulka, and David Dunn. *Eigenwelt der Apparate-Welt: Pioneers of Electronic Art*. Exhibition catalogue. Linz, Austria: The Vasulkas in coordination with Ars Electronica, 1992.

Weibel, Peter, and Gregor Jansen, eds. *Light Art from Artificial Light. Light as a Medium in 20th and 21st Century Art*. Exhibition catalogue. Ostfildern: Hatje Cantz, 2005.

Weibel, Peter, Andreas Beitlin, and Philipp Ziegler, eds. *Otto Piene: Energiefelder*. Karlsruhe: Zentrum für Kunst und Medientechnologie; Nuremberg: Verlag für Moderne Kunst, 2013.

Weitemeier, Hannah. *Zero: Bildvorstellungen einer europäischen Avantgarde 1958-1964*. Exhibition catalogue. Zürich: Kunsthaus Zürich, 1979.

White, Anthony. "Industrial Painting's Utopias: Lucio Fontana's 'Expectations'." *October*, no. 124, Postwar Italian Art Special Issue (Spring 2008): 98–124.

White, Anthony. *Lucio Fontana: Bewteen Utopia and Kitsch*. Cambridge and London: MIT Press, 2011.

Wiehager, Renate, ed. *ZERO aus Deutschland 1957-1966. Und heute. Mack, Peine, Uecker und Umkreis*. Exhibition catalogue. Ostfildern: Hatje Cantz Verlag, 2000).

Wilhelm, Jürgen, eds. *Piene im Gespräch*. Munich: Hirmer Verlag, 2015.

Winkler, Gerd. "Wenn aus Avantgardisten Klassiker werden. Die Gruppe 'Zero' und die Folgen." *Frankfurter Allgemeine Zeitung* (August 15, 1969).

Winkler, Gerd. "Weltmeisterschaft ohne Tore. 35. Kunstbiennale Venedig: Keine Preise, Konvention und die Hoffnung auf Reform." *Stuttgarter Nachrichten* (July 10, 1970): 19.

Wolff, Stefan. *The German Question since 1919: An Analysis with Key Documents*. New York: Greenwood Publishing Group, 2003.

Yalkut, Jud. "TV as a Creative Medium." *Art in America*, vol. 44, no. 1 (September/October 1969): 18–21.

Yamamura, Midori. *Yayoi Kusama: Inventing the Singular*. Cambridge, London: The MIT Press, 2015.

Youngblood, Gene. *Expanded Cinema*. New York: E.P. Dutton, 1970.

ZERO 1-7. Abendausstellung "Das rote Bild": Bartels; Beckmann; Benrath; Bleckert; Boers [u. a.]; Bilder, deren bestimmende Farbe Rot ist. Düsseldorf: Heinz Mack und Otto Piene, April 1958.

ZERO, Vol. 2, 8. Abendausstellung "Vibration": Oskar Holweck, Heinz Mack, Almir da Silva Mavignier, Otto Piene, Adolf Zillmann. Düsseldorf: Heinz Mack und Otto Piene, October 1958.

ZERO, Vol. 3. Düsseldorf: Heinz Mack und Otto Piene, 1961.

ZERO. Cambridge, MA, and London: MIT Press, 1973.

ZERO: Künstler einer europäischen Bewegung Sammlung Lenz Schönberg 1956-2006. Exhibition catalogue. Salzburg: Museum der Moderne Salzburg Mönchsberg, 2006.

The ZERO Era: The Lenz Schonberg Collection: Living in Art. 2 vol. Ostfildern: Hatje Cantz Verlag, 2009.

"ZERO ist gut für Dich," in *Sediment: Mitteilungen zur Geschichte des Kunsthandels, Zentralarchiv des internationalen Kunsthandels*, vol. 10 (2006). Nuremberg: Verlag für Moderne Kunst, 2006.

ZERO, 1957-1966 NY. Exhibition catalogue. Ghent, Belgium: Mer. Paper Kunsthalle and Sperone Westwater, New York, in association with the ZERO Foundation, Düsseldorf, 2008.

ZERO: Countdown to Tomorrow, 1950s-60s. Exhibition catalogue. New York: Solomon R. Guggenheim Foundation, 2014.

Zielinski, Siegfried. *Zur Geschichte des Videorecorders.* Berlin: Wissenschaftsverlag Volker Spiess, 1986.

INDEX

Uecker 71, 161
Vision in Motion (1959) 78–9
ZERO exhibitions 102–4, 119–20,
 121, 128–30
ZERO magazines 69–71, 72,
 106–8
Polke, Sigmar 252
Pollock, Jackson 19, 33, 42, 85, 144
Ponge, Francis 30, 31
Putar, Radoslav 114, 116

Radical Software 240
Rauschenberg, Robert 8, 88, 91, 148,
 180, 186, 213, 251, 254
Raysse, Martial 180, 252
Reiback, Earl 237
The Responsive Eye (1965) 162, 182
Restany, Pierre 7, 50, 57–8, 62, 77,
 88–9, 91, 121, 262
Richter, Gerhard 134, 145, 155, 196,
 252, 262
Richter, Hans 176, 185
Rickey, George 118
Rockefeller Foundation 129, 224,
 232, 240
 artists-in-television
 residency 230, 232
Rodchenko, Alexander 91
Rotella, Mimmo 88
Rothko, Mark 89, 177
Rubin, Barbara 193–4
Ruhnau, Werner 74–5, 160
Ruttmann, Walter 176, 183, 185

Salentin, Hans 67
Salon d'Automne 19, 27–8, 51
Salon de Libération 19
Salon de Mai 19, 42
Salon des Réalités Nouvelles 19, 75
San Francisco Tape Music Center 186
Sartre, Jean-Paul 20–2, 32, 42, 54,
 110, 174
Schaeffer, Pierre 153
Schmela, Alfred (Galerie Schmela) 59,
 67, 68, 73, 76, 127, 158, 252
 Klein inaugural exhibition 60–2
 Mack exhibitions at 65, 73
 Piene exhibitions at 81–4, 102,
 110, 144, 148, 150

Tinguely exhibition at 76–8, 84,
 105, 144
ZERO, *Edition, Exposition,
 Demonstration* (1961) 102–6,
 158, 213
Schmied, Wieland 6, 128, 260
Schmiele, Walter 102, 184
Schneider, Ira 209, 236–7, 239–40
Schoonhoven, Jan 108–10
Schubert, Hannelore 5, 20, 57, 58, 62,
 65, 66–7
Schultze, Bernhard 40
Schum, Gerry (Gerry Schum Video
 Gallery, Fernseh galerie, video
 galerie) 209, 226, 230,
 234–5, 253
Schumacher, Emil 55, 60
Schwitters, Kurt 4, 88–9, 144, 153,
 176, 219
Seawright, James 232
Sedlmayr, Hans 28–9, 54,
 55, 70, 216
Seitz, William 162, 182
Serra, Richard 235
Siegel, Eric 208–9, 237, 239
Smith, Harry 184–5
Smithson, Robert 235, 253
Soto, Jesús Rafael 75
Soulages, Pierre 11, 38–9
Spoerri, Daniel 62, 77–8, 80, 88–9,
 106, 108, 196
 Autotheater 180
 Dylaby (1962) 180–1
 *Moving Movement (Bewogen
 Beweging)* (1961) 178–9, 180
 *Nouveau Réalisme (Nouveaux
 Réalistes)* 89, 180
 Simultaneous Reading 77, 105,
 144, 159
 Vision in Motion (1959) 78,
 177–8
Stachelhaus, Heiner 160–1
Stanczak, Julian 182
Stein, Joël 7, 115, 181
Stern, Gerd 186–8, 195
Stockhausen, Karlheinz 84, 152–3,
 155, 161, 182, 219, 254–8
Strelow, Hans 6, 133, 252–3
Summers, Elaine 185